THE AGES OF MAN

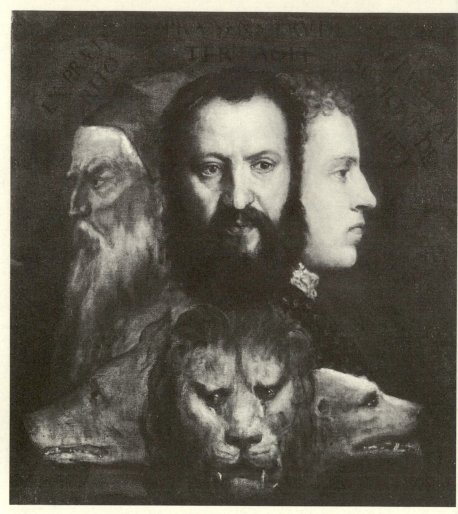

The Three Ages of Man: Titian, *An Allegory of Prudence*

THE AGES OF MAN

A Study in Medieval Writing and Thought

J. A. BURROW

CLARENDON PRESS · OXFORD

1988

Oxford University Press, Walton Street, Oxford OX2 6DP
Oxford New York Toronto
Delhi Bombay Calcutta Madras Karachi
Petaling Jaya Singapore Hong Kong Tokyo
Nairobi Dar es Salaam Cape Town
Melbourne Auckland
and associated companies in
Berlin Ibadan

Oxford is a trade mark of Oxford University Press

Published in the United States
by Oxford University Press, New York

© *J. A. Burrow 1986*

First published 1986
First issued as a paperback 1988

British Library Cataloguing in Publication Data
Burrow, J. A. (John Anthony)
The ages of man: a study in medieval
writing and thought.
1. England thought, 700–1500
I. Title
192
ISBN 0–19–811755–8

Library of Congress Cataloging in Publication Data
Burrow, J. A. (John Anthony)
The ages of man.
Bibliography: p.
Includes index.
1. Great Britain—Intellectual life—To 1066
2. Great Britain—Intellectual Life—Medieval period.
1066–1485. 3. Philosophy of nature—History.
DA152.2.B87 1986 189'.0942 85-28511
ISBN 0–19–811755–8

Set by Eta Services (Typesetters) Ltd.
Printed in Great Britain
at the University Printing House, Oxford
by David Stanford
Printer to the University

Preface

MANY friends and colleagues have helped me in the preparation of this book, among them C. J. Burrow, Gloria Cigman, Alex Comfort, Basil Cottle, Mary Dove, Paul Dutton, Tony Edwards, Tony Heath, Thomas Hill, Alastair Minnis, George Rigg, John Scattergood, Elizabeth Sears, Tom Shippey, Myra Stokes, J. B. Trapp, Christopher Williams, and Linda Voigts. I am particularly grateful to Mary Dove and Elizabeth Sears, both of whom have generously shared information on our common subject of interest. Their forthcoming publications will supplement the present book on many points, and no doubt correct it on some. The subject is a large one.

The staff of the Bristol University Library has been unfailingly helpful, and I am also indebted to other libraries for making their facilities available to me: the Bodleian Library; the British Library; the Cambridge University Library; the Library of the Warburg Institute; the Library of Gonville and Caius College, Cambridge; the Library of St John's College, Oxford. The following have generously granted me permission to use photographs supplied by them as illustrations in this book: the National Gallery, London; the Bodleian Library; the British Library; the Department of the Environment; the Syndics of the Fitzwilliam Museum; the Duke of Sutherland; the Master and Fellows of Gonville and Caius College, Cambridge; the President and Fellows of St John's College, Oxford. Members of the staff of Oxford University Press have been most efficient and helpful in the production of this book.

William Heinemann Ltd. and the Oxford University Press kindly made available material to be reproduced in the Appendix here. Throughout the book translations are my own, unless otherwise indicated.

Bristol, J.A.B.
August 1985

AFTERWORD The two books referred to above both appeared in the same year as this one: Mary Dove, *The Perfect Age of Man's Life* (Cambridge, 1986), and Elizabeth Sears, *The Ages of Man: Medieval Interpretations of the Life Cycle* (Princeton, NJ, 1986).

1988 J.A.B.

To Richard, Micky, and Colin,
all in their fourth year-week

Contents

List of Plates

Abbreviations

ANTS	Anglo-Norman Text Society
CCSL	Corpus Christianorum: Series Latina
EETS	Early English Text Society (OS—Original Series; ES— Extra Series; SS—Supplementary Series)
EHR	*English Historical Review*
ELH	*English Literary History*
JEGP	*Journal of English and Germanic Philology*
Med. Aev.	*Medium Aevum*
MLN	*Modern Language Notes*
MLR	*Modern Language Review*
PBA	*Proceedings of the British Academy*
PG	*Patrologia Graeca*, ed. J.-P. Migne
PL	*Patrologia Latina*, ed. J.-P. Migne
RES	*Review of English Studies* (NS—New Series)
SATF	Société des Anciens Textes Français
Spec.	*Speculum*
STS	Scottish Text Society
Walther, *Initia*	H. Walther, *Initia Carminum ac Versuum Medii Aevi Posterioris Latinorum* (Göttingen, 1959)

Angustissimam etatem alii in quattuor, alii in sex particulas, aliique in plures etiam distribuunt; ita rem minimam, quia quantitate non licet, numero tentatis extendere. Quid autem sectio ista confert? Finge quotlibet particulas; omnes in ictu oculi prope simul evanescunt.

[Some divide our narrow little life into four parts, some into six, some into even more. In this way you seek to extend that smallest of things by increasing, not its length, which cannot be, but the number of its parts. But what is the use of such divisions? Invent as many little parts as you please, they vanish every one almost at once, in the twinkling of an eye.]

Petrarch, *Secretum*

Then we to see a piece of clockwork made by an Englishman; endeed, very good, wherein all the several states of man's age, to 100 year old, is shown very pretty and solemne, and several other things more cheerful; and so we ended and walked up and down to get a coach.

Pepys's Diary

Nowadays people have greatly confused childhood and middle life and old age; those who succeed in spite of civilization in reaching old age seem to have less and less wisdom, and children who are usually put to some business as soon as they can walk and talk, seem to have more and more 'common sense'; and, perhaps, in the future little boys with long beards will stand·aside and applaud, while old men in short trousers play handball against the side of a house.

James Joyce, *The Soul of Ireland*

Introduction

As people grow up and grow old, they change. Individuals change in different ways, but there are held to be certain established norms in this matter, to which individual life-histories will more or less closely conform. These norms are most commonly stated in terms of certain 'ages' into which the life-span is divided. There are, as we shall see, many different ways of making such divisions; but the sequence of the ages can still be seen as broadly representing a single natural order in the life of man. Thus Cicero, in his *De Senectute*: 'Cursus est certus aetatis et una via naturae eaque simplex, suaque cuique parti aetatis tempestivitas est data' ['Life's racecourse is fixed; Nature has only a single path and that path is run but once, and to each stage of existence has been allotted its own appropriate quality'].[1] The idea is an entirely familiar one. The *cursus aetatis* involves physical growth and decay, and also certain changes, thought to be equally natural, in character and conduct. Thus some kinds of behaviour are held to be natural in young people but not in old ones. That is what Cicero means by *tempestivitas* or 'seasonableness'.

The present study concerns itself with this idea of naturalness as it appears in medieval writings, mainly from England, from the time of Bede to the end of the Fifteenth Century.[2] Like their predecessors in

[1] *De Senectute*, ed. and trans. W. A. Falconer (Cambridge, Mass., and London, 1923), x. 33. Dante renders Cicero's words as follows: 'Certo corso ha la nostra buona etade, e una via semplice è quella de la nostra buona natura; e a ciascuna parte de la nostra etade è data stagione a certe cose', *Il convivio*, ed. G. Busnelli and G. Vandelli, 2nd edn., rev. A. E. Quaglio (Florence, 1964), IV. xxvii. 2.

[2] The restriction to material 'mainly from England' is not meant to imply any suggestion of singularity in that country. Medieval thought about the ages of man was chiefly transmitted by Latin writers, whose work did not respect national or linguistic boundaries. I have cited such writers with little regard to their nationality, and have also included some examples from foreign vernacular writers, notably Dante. The subject is a vast one. So far as writings in English are concerned, I can claim that I have probably missed no major evidence in Anglo-Saxon and possibly missed no more than a few in the much larger field of Middle English. But no such claim can be made for my treatment of Latin, French, or Italian writings.

Antiquity and their successors in the Renaissance, medieval scholars thought of the ages of man in schematic terms. They speak of three, or four, or six, or seven *aetates hominum*.[3] The first part of this study (Chaps. 1 and 2) will be concerned with such schemes. In Chapter 1 I discuss schemes which may be called scientific, in so far as they seek to distinguish and explain the ages in terms of natural causes. The biologists divide life into three stages, the physiologists into four, the astrologers into seven. The effect in each case was to integrate the life of man into the larger order of the natural world, as that was understood at the time. In Chapter 2 the main authorities cited are not scientists, but preachers, exegetes, and historians. Employing a variety of schemes, these writers seek to relate the ages of man to temporal patterns observable elsewhere—in the cycles of year, month, and day, and in the linear time of history. Thus the most widely known of these schemes relates the six ages of the individual man to the six ages of history, as if each of us might experience in his or her own life-span something equivalent to the whole history of mankind. The schemes considered in this chapter differ from those discussed in Chapter 1 in that they are not directly concerned with natural causes, as those would now be understood; but the distinction cannot be sharply drawn. According to a frequently quoted text in the Book of Wisdom, God has 'ordered all things in measure, and number, and weight.' The same hand is at work, measuring, numbering, and weighing, in the two orders of nature and time. Hence correspondences are to be looked for in the two orders, not only by theologians, but also by scientists. Thus the scientific theory which explains the ages of man in physiological terms, as governed successively by the four bodily humours, also draws attention to the corre-

[3] On the ages of man in Classical Antiquity, see especially F. Boll's fundamental study, 'Die Lebensalter: Ein Beitrag zur antiken Ethologie und zur Geschichte der Zahlen', *Neue Jahrbücher für das klassische Altertum* xxxi (1913), 89–145. I quote from the reprint in Boll, *Kleine Schriften zur Sternkunde des Altertums* (Leipzig, 1950), 156–224. For the Latin material, see also E. Eyben, 'Die Einteilung des menschlichen Lebens im Römischen Altertum', *Rheinisches Museum für Philologie*, NF cxvi (1973), 150–90. On the ages in the Renaissance, see S. C. Chew, *The Pilgrimage of Life* (New Haven, Conn., 1962), Chap. 6, 'The Path of Life'. There is at the time of writing no general guide to the medieval material, but the following may be consulted: A. Hofmeister, 'Puer, Iuvenis, Senex. Zum Verständnis der mittelalterlichen Altersbezeichnungen', in A. Brackmann (ed.), *Papsttum und Kaisertum* (Munich, 1926), 287–316; J. de Ghellinck, 'Iuventus, Gravitas, Senectus', in *Studia Mediaevalia in Honorem R. J. Martin* (Bruges, 1948), 39–59; Philippa Tristram, *Figures of Life and Death in Medieval English Literature* (London, 1976); Ulrich Helfenstein, *Beiträge zur Problematik der Lebensalter in der mittleren Geschichte* (Zurich, 1952).

spondence between the four ages of man and the four seasons of the year, in which the same succession of qualities is to be observed. This correspondence was also part of the explanation.

In the second part of this study (Chaps. 3 and 4) I shall consider how, in medieval narratives, these natural norms enter into the treatment of individual cases. In a famous passage in his *Ars Poetica* Horace advised writers to observe in their portrayal of dramatis personae the differing characteristics of boyhood, youth, maturity, and old age:

> Aetatis cuiusque notandi sunt tibi mores,
> Mobilibusque decor naturis dandus et annis. (ll. 156–7)

[You must represent the distinctive behaviour of each age and assign what is appropriate to the characters as they change with the changing years.]

Medieval writers on the art of poetry duly repeat this advice;[4] but it is in any case obvious, and little purpose would be served here by an elaborate demonstration to prove that it was in fact followed in the narratives of the period. Only the most dogmatic of 'historical' critics who sees in medieval works nothing but medieval people will fail to notice that some of them are young and some of them old, and that their *mores* differ accordingly. This truth, in any case, will be sufficiently illustrated in the course of the present discussion—which nevertheless will, in its second part, concentrate on some rather more specific questions. The various schemes might each provide a programme for a normal *cursus aetatis*; but no individual, of course, was constrained to follow such a programme. In so far as individuals are free to conform or not to conform to natural order, certain interesting varieties of ethical judgement arise. People may be praised for conforming to the order of things, or else blamed (as in the case of the *senex amans*) for failing to do so. Alternatively, they may be praised for transcending that order and rising above its natural limitations (as in the case of the *puer senex*), or else blamed for failing to do so. These two sets of epideictic possibilities involve, respectively, what I shall call the 'nature' and the 'transcendence' ideals. Chapter 3 will be devoted to the transcendence ideal, Chapter 4 to the nature ideal.

[4] e.g. Matthew of Vendôme, *Ars Versificatoria*, I, paras. 41–2, in E. Faral (ed.), *Les Arts poétiques du XII^e et du XIII^e siècle* (Paris, 1924), 119.

1

Nature

MEDIEVAL science inherited from Antiquity a number of different theories purporting to explain why the course of human life runs as it does. This chapter will deal in turn with the three most important of these traditions: the biologists' theory of three ages, the physiologists' theory of four, and the astrologers' theory of seven. Not all the three-, four-, and seven-age schemes to be found in medieval writings belong to these scientific traditions. Schemes of the three ages, in particular, are simple and obvious enough to occur independently in quite different connections. The present chapter is concerned with such schemes only in so far as they serve to relate human life to the natural world and so provide a scientific foundation for the widely held opinion that the *cursus aetatis* itself follows (or ought to follow) a natural order.

I

In his discussion of the ages of man in *The Foreste*, the Elizabethan writer Thomas Fortescue observes that natural philosophy distinguishes only three: an age of growth, an age of stasis, and an age of decline. For this opinion he cites the authority of Aristotle, followed by 'the most parte of the Arabian Physitions'.[1] In the passage to which Fortescue refers, Aristotle is concerned with a power or capacity shared by all living things, including plants—that capacity to grow, develop, and reproduce, which depends in turn upon the capacity to take nourishment. These are the functions of the vegetative part of the soul, which Aristotle distinguishes from the sensitive

[1] Thomas Fortescue, *The Foreste or Collection of Histories* (1571), 48ʳ. Aristotle is also cited as authority for the three ages by Henry Cuffe, *The Differences of the Ages of Mans Life* (1607), 166.

part (lacking in plants) and the intellectual part (found only in human beings). To establish that all living things (man as well as animals and plants) must have the vegetative function, he writes: 'All living things have the vegetative soul; and this from generation to corruption. For every thing generated must grow, maintain itself and then decay; and this is impossible without nutriment. Of necessity, then, a vegetative power is found in all that is born and dies.'[2] In the Latin version by William of Moerbeke (1215–86), the key passage runs as follows: 'Necesse est enim quod generatur, augmentum habere, et statum, et decrementum.'[3] Aristotle speaks here as a biologist concerned with all living things, not just man; but his triadic scheme of *augmentum*, *status*, and *decrementum* will apply to human beings in so far as they share the vegetative power with animals and plants. Aristotle himself makes this application in another treatise, where he is speaking of the lungs: 'Youth [*iuventus*] is the period of the growth [*augmentatio*] of the primary organ of refrigeration, old age [*senectus*] of its decay [*decrementum*], while the intervening time [*medium*] is the prime of life [*status*].'[4]

This passage is cited by Dante in the course of his extended discussion of the ages of man in *Il convivio*:

E però che lo maestro de la nostra vita Aristotile s'accorse di questo arco di che ora si dice, parve volere che la nostra vita non fosse altro che uno salire e uno scendere: però dice in quello dove tratta di Giovinezza e di Vecchiezza, che giovinezza non è altro se non accrescimento di quella.

[And inasmuch as the master of our life, Aristotle, was aware of this arch of which we are now speaking, he seemed to maintain that our life was no other than a mounting and a descending, wherefore he says in his treatise on Youth and Age that youth is no other than the growing of life.][5]

[2] *De Anima*, Bk. III, Chap. 12, (434ᵃ 22–6), cited from the translation of William of Moerbeke's Latin version in K. Foster and S. Humphries, *Aristotle's 'De Anima' in the Version of William of Moerbeke and the Commentary of St Thomas Aquinas* (London, 1951), 483. See p. 486 for St Thomas's observations on the passage.

[3] *S. Thomae Aquinatis in Aristotelis Librum de Anima Commentarium*, ed. A. M. Pirotta (Turin, 1936), 274.

[4] *De Iuventute et Senectute, De Vita et Morte, De Respiratione*, Chap. 24 (Chap. 18 of *De Respiratione*), cited from W. D. Ross (ed.), *The Works of Aristotle*, iii (Oxford, 1931), 479ᵃ 30–2. The medieval Latin version is cited by Busnelli and Vandelli in their note to *Il convivio* IV. xxiii. 8.

[5] *Il convivio*, IV. xxiii. 8. Here as elsewhere my translation follows P. H. Wicksteed, *The Convivio of Dante Alighieri* (London, 1903). On Dante's conception of the 'arc of life' see, besides the notes of Busnelli and Vandelli, the excellent discussion by B. Nardi, 'L'Arco della Vita', in his *Saggi di filosofia dantesca*, 2nd edn. (Florence, 1967), 110–38.

As Dante's somewhat tentative wording suggests, Aristotle did not himself use the image of the semi-circular 'arc' in the passage cited; but the image, as the Italian poet develops it, represents exactly Aristotle's triadic scheme of *augmentum*, *status*, and *decrementum*. Dante divides man's regular life-span of seventy years into three: a period of growth (*adolescenza*, up to the age of twenty-five), a period of maturity (*gioventute*, from twenty-five to forty-five, with its highest point at thirty-five), and a period of decline (*senettute*, from forty-five to seventy). His use of analogues from the plant world, furthermore, indicates that he, like Aristotle, sees human life in a broad biological context:

La nostra buona e diritta natura ragionevolmente procede in noi, sì come vedemo procedere la natura de le piante in quelle; e però altri costumi e altri portamenti sono ragionevoli ad una etade più che ad altra, ne li quali l'anima nobilitata ordinatamente procede per una semplice via, usando li suoi atti ne li loro tempi ed etadi sì come a l'ultimo suo frutto sono ordinati. E Tullio in ciò s'accorda in quello De Senectute.

[Our nature, when good and straight, follows a seasonable procedure in us, as we see the nature of plants doing in them; and therefore different ways and different deportment are suitable at one age more than at another, wherein the ennobled soul proceeds in due order, exercising its acts in their times and ages according as they are ordained for its ultimate fruit. And Cicero agrees with this in his *De Senectute*.][6]

At this point in *Il convivio*, Dante is commenting on a *canzone* of his own, 'Le dolci rime d'amor', which is concerned with *gentilezza* or nobility. Hence he speaks here only of the noble soul, 'l'anima nobilitata'. Yet even such a soul will follow that common natural path, 'simplex via naturae', of which Cicero wrote. Indeed, it can be compared even to the lowest order of living things, plants, not only in the vegetative power which it shares with them, but also in its higher functions. For the same natural order that governs the physical development of human beings also governs the development of their behaviour (*costumi . . . portamenti . . . atti*). Aristotelian biology here combines with Ciceronian ethics to produce one of the most powerful of all medieval statements of the idea with which this book is chiefly concerned.

[6] *Il convivio*, IV. xxiv. 8. Dante here refers to the passage from Cicero's *De Senectute* cited in the Introduction above. He makes other comparisons with plants at IV. xxvii. 4 (the open rose) and at IV. xxviii. 4 (the ripe apple).

The term *status*, used in medieval Latin to designate the middle of Aristotle's three ages, renders an original Greek word, ἀκμή, which better expresses the dominance of that age in this biological scheme. It is indeed the *acmē*, or as Dante puts it the 'colmo' or summit, of our life.[7] Since the age of growth (*augmentum*) is completed and the age of decline (*decrementum*) has not yet begun, the powers of any living thing should be at their height in this middle age. This is how Aristotle represents the pattern of life in his major discussion of the ages of man, reproduced here in the Appendix: Book II, Chapters 12–14 of his *Rhetoric*. Aristotle is advising public speakers to adapt their performances in such a way as to please and persuade different kinds of audience—kinds which he specifies in terms of fortune (birth, wealth, and power) and age. The latter consideration prompts him to a brilliant thumb-nail sketch of the three ages, in which the moral superiority of the middle age is most strongly emphasized. The lively and shrewd characterizations of youth (Bk. II, Chap. 12) and old age (Bk. II, Chap. 13) serve to show how both ages depart, in opposite directions, from the ideal moral mean. Thus, in their judgement of others, young people 'look at the good side rather than the bad, not having yet witnessed many instances of wickedness. They trust others readily, because they have not yet often been cheated.' By contrast, old people 'tend to put the worse construction on everything. Further, their experience makes them distrustful and therefore suspicious of evil.' So, for precisely opposite reasons, both young and old will tend to err in their judgements of others. Men in the prime of life, on the other hand, 'neither trust everybody nor distrust everybody, but judge people correctly.'[8] Such men 'have a character between that of the young and that of the old, free from the extremes of either . . . All the valuable qualities that youth and age divide between them are united in the prime of life, while all their excesses or defects are replaced by moderation and fitness.'[9]

The standard Latin version of Aristotle's *Rhetoric* was made about 1270 by William of Moerbeke, after which the treatise came to be widely known in the West, but less as a textbook of rhetoric than

[7] *Il convivio*, IV. xxiv. 3.
[8] *Rhetoric*, trans. W. Rhys Roberts (Oxford, 1924), 1389ª 16–19, 1389ᵇ 19–22, 1390ª 32–4. See Boll, 168–70.
[9] *Rhetoric*, 1390ª 20–30, 1390ᵇ 7–9.

as 'an adjunct to the study of ethics or politics'.[10] Such was certainly the context in which many late medieval readers would have encountered Aristotle's thought about the three ages of man; for *Rhetoric* Book II, Chaps. 12–14 was extensively summarized by Giles of Rome in his *De Regimine Principum*, a treatise on the proper character and conduct of kings and princes which became extremely popular in the fourteenth and fifteenth centuries.[11] In England it was translated, perhaps by John Trevisa, and also imitated by poets such as Thomas Hoccleve.[12] Book I, Part iv of the *De Regimine* is concerned with what the Middle English translation calls the 'maneres and þewes' proper to a ruler, and in this context Giles's Aristotelian account of the ages fits very naturally. Indeed, Aristotle's stress on the supremacy of the middle age makes better sense here than it does in the *Rhetoric* itself, for it is easier to see why the qualities of that age are appropriate in a ruler than to see why they should particularly concern a public speaker. However, Giles manages to boil off much of the spirit of Aristotle's discussion, reducing it in true scholastic fashion to a list of numbered points: the six virtuous qualities of *juvenes* and their six bad ones; the six bad qualities of *senes* and their four (*sic*) virtuous ones; and the qualities of those *in statu* (in their prime), all of which are good.[13] Although Giles does find, with considerable difficulty, good points for youth and age in Aristotle's dry and worldly descriptions, he fully maintains the philosopher's stress on the outstanding excellence of the middle age:

Quicquid laudabilitatis e[s]t in senibus vel in iuvenibus totum reperitur in hiis qui sunt in statu, et quicquid vituperabilitatis est in eis totum removetur ab illis. Nam, ut supra pluries dicebatur, semper extrema sunt vituperabilia et medium est laudabile.

[10] J. J. Murphy, 'Aristotle's *Rhetoric* in the Middle Ages', *Quarterly Journal of Speech* lii (1966), 114. Moerbeke's translation is edited, together with the earlier anonymous translation, by B. Schneider: *Rhetorica*, Aristoteles Latinus xxxi. 1–2 (Leiden, 1978).

[11] Giles of Rome (Aegidius Romanus) had written a commentary on the Latin *Rhetoric* about 1280. The *De Regimine* is dated about 1285. I have used the 1482 Rome edition.

[12] The sole manuscript of the Middle English version is Bodleian Library MS Digby 233. There is no printed edition. Hoccleve's *Regement of Princes* draws on Giles, among other sources.

[13] Bk. I, Pt. iv, Chaps. i–iv; MS Digby 233, fols. 54r–58v. Giles is followed in *Les Echecs amoureux*: trans. as 'The Chess of Love' by J. M. Jones, Univ. of Nebraska, Ph.D. diss. (1968), 758–68.

[Whatever praiseworthy qualities there are in the old and the young are found all together in people in their prime, and their blameworthy qualities are completely absent from them. For, as has often been remarked before, extremes are always to be blamed and the mean to be praised.][14]

Thus those *in statu* are neither foolishly credulous nor unduly sceptical: they 'demen by sothnesse and trouþe', as the Middle English version puts it. Such considerations lend strong support to the opinion, frequently expressed in medieval writings, that the ideal ruler will be neither young nor old. Government is the proper business of middle age—if by that we understand, not the drab and apologetic 'middle age' of modern English, but that age of grand and regal maturity symbolized in Titian's painting 'An Allegory of Prudence' by the king of beasts, the lion (Frontispiece). In *Il convivio*, Dante cites Giles of Rome ('Egidio eremita'), along with Virgil's *Aeneid* allegorically interpreted and Cicero's *De Officiis*, as a prime authority on the middle age, *gioventute*; but these are authorities which, he says, he will not follow, preferring to be guided by reason alone.[15] The mention of Giles in such exalted company is indeed noteworthy; yet I can find nothing to contradict Dante's claim that he does not draw on the *De Regimine*. As we have seen, Dante did adopt Aristotle's *augmentum–status–decrementum* as a biological scheme, represented in the image of an arc; but he could not take over the corresponding ethical scheme from the *Rhetoric*, because this, even in Giles's version, was completely inconsistent with his purpose, which was to expound the virtues natural to *all* the ages named in his *canzone*. Where 'the ennobled soul proceeds in due order', as Dante has it, every age will be equally, though variously, admirable. There could be no place here for Aristotle's observations on the warm follies of youth or the chill follies of age.

The influence of Aristotle's thinking on other vernacular writers is difficult to trace with certainty. One does not have to be a student of the *De Anima* to distinguish in life periods of growth, maturity, and decline. Nor was Aristotle alone in regarding maturity as the time when human powers are at their height. As I have suggested elsewhere, however, the Aristotelian tradition—and in particular, perhaps, Giles of Rome—may have played a part in Geoffrey Chaucer's

[14] Giles of Rome, I. iv. iv.

[15] *Il convivio*, IV. xxiv. 9. On the *Aeneid*, see below, pp. 118–20. It is surprising that Dante does not refer to Aristotle's *Rhetoric*, which he mentions elsewhere (*Conv.* III. viii. 10).

reworking of Boccaccio's *Teseida*.[16] His *Knight's Tale* certainly
implies, more clearly than its Italian original, a scheme of three ages.
By adding old Saturn, father of Jupiter and grandfather of Venus, to
the company of gods, Chaucer creates an Olympus in which all three
generations of the typical human family are represented. In ad-
dition, he distinguishes the aged Egeus more sharply from his son
Theseus; and the latter's medial role of 'lord and governour' marks
him off also from the two young devotees of Mars and Venus, Arcite
and Palamon. Such versions of the simple triadic scheme lie too
close to ordinary experience for their learned affiliations, if any, to
be securely determined; but, although the *Knight's Tale* probably
also owes something to a quite different three-age tradition,[17] its
treatment of the middle age represented by Duke Theseus can best
be understood from the political point of view taken by Giles of
Rome. In comparing Chaucer's poem with its Italian original, Piero
Boitani observes that 'the *Knight's Tale* is much more of a "Teseida"
than the *Teseida* itself'.[18] Indeed, the prominence of Chaucer's The-
seus is remarkable, given that his role in this story of love and adven-
ture is no more than an ancillary one. In this respect, the poem may
be compared with Titian's painting (Frontispiece). Here the light
shining from the right and throwing the old man into shadow illumi-
nates the face of the young man; but the picture is commanded by
the bearded, mature countenance which gazes into the spectator's
eyes—a fitting image for Chaucer's hero. When Giles of Rome speci-
fies that ideal rulers, men in the prime of life, should be 'viriles cum
temperantia et temperati cum virilitate', manly in a temperate way
and temperate in a manly way, he describes a condition which is not,
in Theseus, an easy or settled one; for in him the moderation which
comes so easily to old men is continually challenged by passions
which they no longer feel. Yet in a universe dominated by malign
gods, he plays the ruler's part, making as best he can a virtue of the
harsh necessities of passion, conflict, and death by means of the hu-
mane institutions of marriage, tournament, and funeral. It is a
noble, though not unflawed, image of a human being at the *acmē* of
his biological and political life.

[16] 'Chaucer's *Knight's Tale* and the Three Ages of Man', in J. A. Burrow, *Essays on Medieval Literature* (Oxford, 1984), 27–48.
[17] See below, p. 69.
[18] *Chaucer and Boccaccio*, Medium Aevum Monographs, NS viii (Oxford, 1977), 147.

II

The physiological theory of the four ages of man, to which I now turn, can claim to have provided the most powerful and the most influential of all older attempts to explain scientifically the changes which human beings go through in the course of their life. Its first English expositor was the Venerable Bede, in his *De Temporum Ratione*, composed in the year 725. The main concern of this treatise is indicated by its title, which might be rendered 'Understanding the Calendar'; but in Chapter xxxv, 'On the Four Seasons, Elements, and Humours', Bede expounds a scheme, known to modern scholars as the Physical and Physiological Fours, in which the ages of man regularly figure. Dealing first with the seasons, he explains how they are to be understood in terms of the four qualities: hot and cold, dry and moist. Taken together, these two fundamental binary oppositions serve both to distinguish the seasons from each other and to link them together in an endless, hand-over-hand cycle. Winter is cold and moist, spring moist and hot, summer hot and dry, autumn dry and cold, winter cold and moist, and so on until the end of time. Thus:

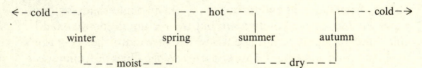

Bede goes on to explain that the four elements are distinguished and linked in just the same way: earth is dry and cold like autumn, water cold and moist like winter, air moist and hot like spring, fire hot and dry like summer. He then turns to man, 'whom sages call "microcosmos" or lesser world'. According to this passage, which is reproduced in the Appendix here, human life is also fourfold, governed in turn by each of the four humours in the body, and harmonized with the macrocosmic order of the seasons and the elements through the same system of qualities that governs them all. The result is a comprehensive set of tetrads:

Qualities	Age	Humour	Season	Element
moist and hot	childhood	blood	spring	air
hot and dry	youth	red choler	summer	fire
dry and cold	maturity	black choler	autumn	earth
cold and moist	old age	phlegm	winter	water

The balance of humours in any individual person is affected by a number of independent variables, of which age is only one. The various humours will gain and lose strength, as Bede explains, with the passing of the seasons, and also at different times of the day and night. Furthermore, each individual has a permanent temperament, his 'natural complexion', in which one of the humours will be stronger than the rest. Hence the medical authorities would have had no difficulty in explaining why, for instance, old people did not all exhibit the predicted phlegmatic characteristics of sluggishness and forgetfulness. An old person of a sanguine natural complexion might become quite skittish in the spring—especially in the small hours when, as Chaucer's Squire observes, 'blood was in his domynacioun'.[19] Yet the theory of the four humours provided a powerful account of what in any particular case might be ascribed to the age-variable. Its strength was twofold. It offered an immediate physiological explanation for age-characteristics in terms of known bodily fluids; and its account of the effects of these fluids (in Bede's version, at least) matched observable facts about young and old so well that it might have been invented for the purpose—which, as a matter of fact, it was not. Children *are* 'merry, delightful, tender-hearted, and much given to laughter and talk'; young people *are* 'lean (even though they eat heartily), swift-footed, bold, irritable, and active'; maturity *does* make people 'solid, serious, settled in their ways, and guileful'; and old people *are* 'sluggish, sleepy, and forgetful'.

The Physical and Physiological Fours thus furnished medieval scholars both with a satisfying scientific explanation for the *cursus aetatis* and also, through the theory of the qualities, with an account of how the order observable in the human microcosm was related to a larger macrocosmic order. The development of this tetradic scheme in Antiquity is a much-studied subject which lies outside the scope of this book. The earliest English authority on the ages of man already had behind him a long tradition, which I can do no more than sketch here.[20]

The Pythagorean philosophers of pre-Socratic Greece regarded

[19] *Canterbury Tales*, v. 352. All quotations from Chaucer are from F. N. Robinson's 2nd edn. (Boston, Mass., and London, 1957).

[20] For discussions of the four-age tradition in Antiquity, see Boll, 171–6, and R. Klibansky, E. Panofsky, and F. Saxl, *Saturn and Melancholy*, (London, 1964), 3–15, 55–66.

the number four as 'the root and source of eternal nature'; and it was Pythagoras himself, according to tradition, who first observed a correspondence between the four seasons of the year and the four ages of man. Diogenes Laertius reports that Pythagoras 'divides man's life into four quarters thus: "Twenty years a boy, twenty years a youth, twenty years a young man, twenty years an old man; and these four periods correspond to the four seasons, the boy to spring, the youth to summer, the young man to autumn, and the old man to winter", meaning by "youth" one not yet grown up and by a "young man" a man of mature age.'[21] Ovid puts the same doctrine into the mouth of Pythagoras, in a passage in his *Metamorphoses* which must have introduced many readers to the age-season analogy in the Middle Ages and after:

> Quid? non in species succedere quattuor annum
> Adspicis, aetatis peragentem imitamina nostrae?
> Nam tener et lactens puerique simillimus aevo
> Vere novo est . . .

[Then again, do you not see the year assuming four aspects, in imitation of our own lifetime? For in early spring it is tender and full of fresh life, just like a little child . . .][22]

Ovid does not speak technically here, for his Pythagoras is simply expanding upon the theme of universal transience ('cuncta fluunt'); but by his time the Pythagorean analogy was well on its way to being incorporated in a larger scientific system. As early as about 400 BC a Greek medical treatise ascribed to Hippocrates, in the course of recommending that a right regimen of health should observe differences of season and age, had analysed the four ages of man in terms of the four qualities, exactly as in Bede's *De Temporum Ratione*: childhood moist and hot, youth hot and dry, maturity dry and cold,

[21] *Lives of Eminent Philosophers*, ed. and trans. R. D. Hicks (New York and London, 1925), viii. 10. The explanation about 'young man' points to the difficulty in Greek, as also in Latin and English, of naming the 'man of mature age' without making him sound either too young or too old. For a survey of the Pythagorean tradition, see S. K. Heninger, jun., *Touches of Sweet Harmony: Pythagorean Cosmology and Renaissance Poetics* (San Marino, Cal., 1974).

[22] *Metamorphoses*, ed. and trans. F. J. Miller (New York and London, 1916), xv. 199–202. For the whole passage, see Appendix. The association of the four ages with Pythagoras is still observed by Renaissance authorities: Fortescue, *The Foreste*, 47ʳ; Cuffe, *The Differences of the Ages*, 115; Petrus Bungus, *Numerorum Mysteria* (Paris, 1618), 215–17.

old age cold and moist.[23] It is easy to see how later medical authorities developed the whole system, since Hippocratic thought also analysed seasons and humours in terms of the same qualities.[24] The greatest of these later writers was the physician Galen (second century AD). In several works associated with his name, one finds the parallels between ages, seasons, and humours plainly stated, always in terms of the four qualities.[25] In late Antiquity Galenic and Hippocratic medical lore was widely copied and epitomized. The latest editor of the *De Temporum Ratione* believes that Bede learned of the Physical and Physiological Fours from just such a Hippocratic epitome.[26]

Whatever his exact source may have been, Bede evidently had access in his monastic library at Wearmouth-Jarrow to Hippocratic material; and the *De Temporum Ratione* itself would have made the Fours further available. Yet only one of the one hundred and four manuscripts of that work examined by its editor is thought by him to come from pre-Conquest England; and even Bede's fellow-monk Ælfric, whose *De Temporibus Anni* is clearly based on Bede's treatise, entirely omits the Fours.[27] Indeed, we do not meet these again in English sources until the early eleventh century, when Byrhtferth,

[23] *Regimen* (Περὶ διαίτης), i. 32–3, in *Hippocrates*, ed. W. H. S. Jones (New York and London, 1923–39), iv. 273–81.

[24] See *Saturn and Melancholy*, 8–10, referring to the treatise *Of the Nature of Man* (Περὶ φύσιος ἀνθρώπου).

[25] Galen, *Opera Omnia*, ed. C. G. Kühn (20 vols., Leipzig, 1821–33), xix. 373–5, etc. See Kühn's index under *aetates*. C. and D. Singer, *Annals of Medical History* iii (1921), 136–49, note that some later manuscripts add the four elements. For further medical references, see Boll, 175.

[26] C. W. Jones (ed.), *Bedae Opera de Temporibus* (Cambridge, Mass., 1943), 370, suggesting *Vindiciani Epistola*: ed. V. Rose, *Theodori Prisciani Euporiston* (Leipzig, 1894), 484–92. Vindician, however, follows a tradition different from Bede's, according to which the first age is associated not with blood but with phlegm, and the rest accordingly. On this tradition, see pp. 21, 26, 38 below, and *Saturn and Melancholy*, 10–11, 122 n. 163. See M. L. Cameron, 'The Sources of Medical Knowledge in Anglo-Saxon England', *Anglo-Saxon England* xi (1983), 135–55, who accepts Vindician as Bede's source (p. 146).

[27] Jones, *Opera de Temporibus*, 142. However, Jones concludes from a comparison of the one pre-Conquest English manuscript (MS Salisbury 157, ninth century) with those from after the Conquest that 'there was an Insular text which survived the period of the Danish invasions'. Ælfric's *De Temporibus Anni* is edited by H. Henel, EETS, os 213 (1942). Henel implausibly explains the omission of the Fours by suggesting that Ælfric 'may have felt that it bordered upon superstition to offer a glib equation between the macrocosm and man, the microcosm'. More likely, Ælfric simply considered the doctrine of humours and ages inappropriate in a computistical treatise.

a monk of Ramsey, compiled his *Manual*; and it is thought that Byrhtferth had to rely for his materials mainly upon books brought to Ramsey from continental centres—where scientific studies had, since the time of Alcuin, flourished more vigorously than in England.[28] The *Manual* is a mainly calendrical treatise, part Latin and part Anglo-Saxon, which draws heavily upon Bede. Byrhtferth's discussion of the Fours, though taken from Bede's treatise, has its own interest as much the earliest known attempt, in England at least, to make the doctrine available to those who could not read Latin. After expounding it first in the learned language, he continues: 'Hec de qualitate temporum et elementorum simul et de aetate hominum sint a nobis eviscerata: iam alio modo dicamus qualiter sint clericis nota, que monachis sint perspicue cognita' ['Now that we have expounded these facts relating to the nature of the seasons and the elements, and to the ages of man, let us now express what is clearly known by monks in such a way that it may be understood by clerks'].[29] There follows Byrhtferth's attempt to instruct simple priests ('clerici') in their own recalcitrant vernacular. He first speaks of the parallels between the four seasons and the four ages of man: *cildhad, cnihtiugoð, geðungen yld*, and *swyðe eald yld*. His evident difficulty in finding vernacular equivalents for some of the Latin terminology appears further in what follows:

Lengtentima ys wæt and wearm; þæt lyft ys wæt and wearm; cildyld byð wæt and wearm, and hyra blod byð wæt and wearm. *Aestas* ys sumor: he byð wearm and drigge; fyr byð wearm and drigge; cnihtiugoð byð wearm and drigge; *colera rubea*, þæt synt reade incoða, beoð on sumera: hig beoð wearme and drigge. *Autumnus*, þæt byð hærfest: his gecynd ys þæt he beo ceald and drigge; eorðe ys ceald and drigge; geþungen yld byð drigge and ceald; on hærfeste beoð *colera nigra*, þæt synt swearte incoðan: þa beoð drige and cealde. *Hiemps* ys winter: he byð ceald and wæt; wæter ys ceald and wæt; swa byð se ealda man ceald and snoflig: *flegmata*, þæt byð hraca oððe geposu, deriað þam ealdan and þam unhalan.

[Spring is moist and hot; air is moist and hot; childhood is moist and hot,

[28] On the sources of the *Manual*, see C. Hart, *EHR* lxxxv (1970), 29–44, and *Med. Aev.* xli (1972), 95–109. Jones, *Opera de Temporibus*, 142, notes the rapid multiplication of manuscripts of Bede's *De Temporum Ratione* in French schools from Alcuin's time.

[29] *Byrhtferth's Manual*, ed. S. J. Crawford, EETS, os 177 (1929), 10. There is another exposition of the Fours on p. 204. For a valuable study of the *Manual*, see P. S. Baker, 'Byrhtferth's *Enchiridion* and the Computus in Oxford, St John's College 17', *Anglo-Saxon England* x (1982), 123–42.

and their blood is moist and hot. *Aestas* is summer: it is hot and dry; fire is hot and dry; adolescence is hot and dry; *colera rubea*, which are red biles, occur in summer: they are hot and dry. *Autumnus*, that is, harvest: its nature is to be cold and dry; earth is cold and dry; maturity is dry and cold; in autumn occur *colera nigra*, which are black biles: they are dry and cold. *Hiemps* is winter: it is cold and moist; water is cold and moist; an old man likewise is cold and snuffly: *flegmata*, that is expectoration or catarrh, afflict the aged and infirm.][30]

Byrhtferth's *Manual* is also notable for its use of diagrams—employed, he explains, 'so that the young priest who sees these things may be the wiser for it.'[31] Like most products of monastic learning in that age of few books, before the information explosion which was to occur in the two centuries after Byrhtferth's death, these diagrams were intended to be marked, learned, and inwardly digested at leisure, as a rich and rare source of knowledge and wisdom. Today they serve as vivid illustrations of how the ages of man could be seen as integral parts of a larger order created by God—that God who, in the Biblical verse twice quoted by Byrhtferth, has 'ordered all things in measure, and number, and weight.'[32] The diagram reproduced from the *Manual* as Plate 1 here takes the circular form best adapted to display the four ages, just as an arc best displays the three.[33] In the central circle, at the still point of the turning world, are inscribed the four letters of God's Latin name: DEUS. Corresponding to these are the four letters of the name of the first man, ADAM, inscribed in the next circle, to signify the close relationship between man and the creator in whose image he is formed. But man is also related outwards, towards the circumference of the diagram, with the rest of creation. The four letters of his name mark the four points of the compass, named in Greek: '*A*nathole' (east), '*D*isis' (west), '*A*recton' (north), and '*M*isinbrios' (south).[34] The next circle names the four ages, *pueritia*, *adolescentia*, *iuventus*, and

[30] Crawford, 12, with altered punctuation. Byrhtferth's term for the second age, 'cnihtiugoð' (corresponding to Latin *adolescentia*), reflects a late Old English specialization of the term 'cniht', found also in Ælfric: see H. Bäck, *The Synonyms for 'Child'*, '*Boy*', '*Girl*' *in Old English*, Lund Studies in English ii (Lund, 1934).

[31] Crawford, 86.

[32] Crawford, 8, 198, citing Wisdom 11: 21.

[33] The diagram appears on p. 85 of the sole surviving manuscript, Bodleian Library MS Ashmole 328, in connection with a discussion of the summer solstice.

[34] Byrhtferth explains this later, Crawford, 202.

senectus, each coupled with the corresponding season of the year. The outer three rings name the twelve months, together with the twelve signs of the zodiac in both Latin and English. These are divided among the seasons by four spokes representing the solstices and equinoxes; and to each of these spokes is attached one of the four elements: air to the spring equinox, fire to the summer solstice, earth to the autumn equinox, water to the winter solstice. Thus the diagram expresses the relation of man both to God and to the whole sublunary world, in so far as that world consists of matter (elements) disposed in space (points of the compass) and time (seasons and months).[35]

Plate 2 reproduces another, more complex diagram, also ascribed to Byrhtferth though not found in the sole surviving copy of his *Manual*. It is preserved in the so-called 'Ramsey Computus'.[36] Among other features which do not figure in the *Manual* diagram, this includes the qualities fundamental to the Fours. The seasons are defined in terms of these qualities on the four sides of the outer, paler lozenge: 'Estas calida & sicca', etc. The sides of the inner, darker lozenge do the same for the corresponding elements: 'Ignis calidus & siccus', etc. The roundels half-way along the sides of the outer, paler lozenge present the familiar concordances between seasons and ages of man: 'estas' with 'adolescentia', etc. They add the interesting extra information that the first age, here called 'puericia vel infantia' (boyhood and infancy), ends after fourteen years, the second ('adolescentia') after twenty-eight, the third ('iuventus') after forty-eight, and the last ('senectus') after seventy or eighty years. The ages themselves are not defined by qualities; but that is implicit in the disposition of the diagram.

The Ramsey Computus was made towards the end of the eleventh century. There is another copy of the same diagram in another

[35] Another diagram setting out the correspondences of ages, seasons, and elements is to be found on p. 94 of the *Manual*, reproduced by Crawford opposite p. 92. Here Byrhtferth cites the opening line of Bk. III, Metre ix of Boethius, *De Consolatione Philosophiae*: 'O qui perpetua mundum ratione gubernas' ['O thou who governest the universe in everlasting order'].

[36] St John's College, Oxford, MS 17, fol. 7ᵛ. On this manuscript, see the article by Baker (n. 29 above), arguing that it is a copy of a collection of computistical material made by Byrhtferth himself, and that the *Manual* is to be understood as a commentary upon that collection.

manuscript, dating from the early twelfth century.[37] By that time, however, the state of learning in England had already begun to improve, with the development of new centres of scholarship and teaching alongside the older monastic schools; and the old Latin sources of medical lore, such as Bede knew, were being supplemented by new Latin translations from Greek and Arabic authorities.[38] The massive programme of translation carried out in the twelfth and thirteenth centuries brought, as we shall see, a rival scientific theory of the ages of man to England: the astrologers' scheme of the seven ages, familiar from Shakespeare's *As You Like It*. Yet the new learning of the Twelfth-Century Renaissance did not by any means abandon the old cosmological system of the Physical and Physiological Fours. Among the Platonists of the time the idea of man as 'microcosmos' or lesser world was a commonplace;[39] and the theory of the four qualities continued to underpin the traditional set of parallelisms between the humours and ages of man and the cosmic order of seasons and elements. These parallels are neatly stated in some widely-circulated mnemonic lines composed in the thirteenth century, probably at the great medical centre of Salerno:

> Consona sunt aer, sanguis, puericia verque.
> Conveniunt estas, ignis coleraque iuventus;
> Autumpnus, terra, melancholia, senectus.
> Flecma, latex et hyemps, senium sibi consociantur.

[Air, blood, boyhood, and spring are in harmony. Summer, fire, choler, and maturity agree together; as do autumn, earth, melancholy, and old age. Phlegm, water, and winter take decrepitude as their companion.][40]

[37] Hart dates the Ramsey Computus between 1086 and 1092: *EHR* lxxxv (1970), 29–44. The later copy is in British Library MS Harley 3667, made at Peterborough abbey about 1110. Its diagram is reproduced in R. W. Southern, *Medieval Humanism and Other Studies* (Oxford, 1970), Plate IV. Another diagram, including humours as well as ages, seasons, elements, and qualities, is reproduced in B. Stock, *Myth and Science in the Twelfth Century* (Princeton, NJ, 1972), Plate III B. One may compare the sixteenth-century tetradic diagrams reproduced by Heninger, *Touches of Sweet Harmony*, 165–72.

[38] On these translations, see C. H. Haskins, *Studies in the History of Medieval Science*, 2nd edn. (Cambridge, Mass., 1927).

[39] See Stock, *Myth and Science*, 197–8.

[40] The so-called 'Salernitan verses', cited from *Saturn and Melancholy*, 114. It will be noted that the sequence of age-terms differs from that in Bede's account. For other similar verses see, for example, Giraldus Cambrensis on 'microcosmus homo', *Opera*, ed. J. S. Brewer, vol. i, Rolls Series xxi (London, 1861), 347.

A much fuller exposition of the system is to be found in the Latin *Tractatus de Quaternario* or 'Treatise on the Fours', dating from some time in the twelfth century, perhaps about the middle.[41] In his prologue, the anonymous author speaks of the four elements, the four regions of the world, the four humours in 'that microcosm or lesser world that is man', his four ages, the four seasons, the four principal winds, and the four divisions of the signs of the zodiac. All these fours, he says, are 'coniuncta et compacta et associata' by the qualities, simply or in combination.[42] His discussion is divided, appropriately enough, into four books, the first two of which concern the elements and the four humoral temperaments. The discussion of the ages follows in Book III, Chapters i–vii, preceded by the diagram of the four ages reproduced here as Plate 3.[43] The first chapter expounds the qualities of the four ages, following the order observed by Bede and Byrhtferth, beginning with moist-and-hot in the first age and ending with cold-and-moist in the last. The discussion also illustrates, however, that confusing instability both in the naming of the ages and in the defining of their extent which marks medieval treatments of the subject. The first age is here said to extend to twenty-five or thirty (fourteen in Byrhtferth), the second to forty-five or fifty (twenty-eight in Byrhtferth), the third to fifty-five or sixty (forty-eight in Byrhtferth), and the last until death (seventy or eighty in Byrhtferth). In the naming of these ages, the *Tractatus* is not even consistent with itself. Medieval Latin inherited a stable set of terms to describe the early part of life: *infantia*, followed by *pueritia*, followed by *adolescentia*. But these distinctions are too fine for the purposes of four-age schemes, which can find room for only one or, at most, two of the three terms.[44] The *Tractatus* author, whose first age is very long, calls it *pueritia* in his diagram, but in the text it

[41] This treatise, which has not been printed, is known to me only in Gonville and Caius College, Cambridge, MS 428/428. See M. R. James, *A Descriptive Catalogue of the Manuscripts in the Library of Gonville and Caius College* (Cambridge, 1908), ii. 500–2. I am grateful to the College Librarian for his help, and also to Dr P. E. Dutton, who has communicated to me his belief that the manuscript is of Continental origin and that the treatise was probably composed in the mid twelfth century.

[42] Fol. 2ʳ.

[43] The diagram is on fol. 28ᵛ. Discussion of the ages begins on fol. 29ʳ and ends on fol. 32ᵛ. There follows a discussion of the four seasons and the four winds.

[44] Thus Bede has the series *infantes, adolescentes, transgressores, senes*, whereas Byrhtferth has *pueritia, adolescentia, iuventus, senectus*.

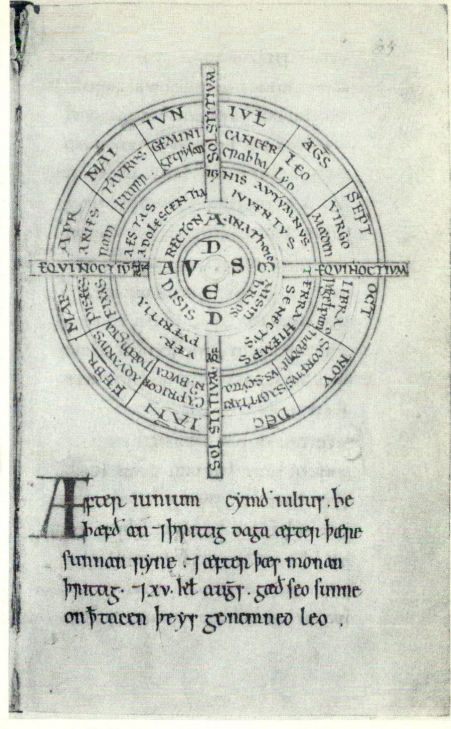

After iunium cynd'ultur þe
hæfð an 7 þrittig daga æfter þære
sunnan ryne. 7 æfter þær monan
þrittig. 7 .xv. kt augt. gæð seo sunne
on ftacen þeyr genemned leo.

1. The Physical and Physiological Fours: Byrhtferth's *Manual*

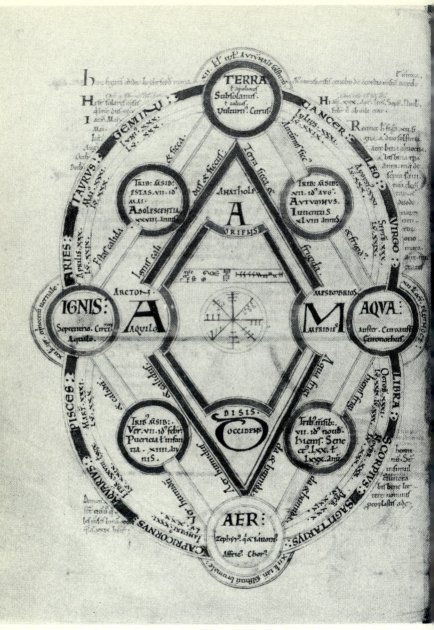

2. The Physical and Physiological Fours: Byrhtferth's Diagram

is either *pueritia* or *adolescentia*. Similarly, he calls the last age either *senium* or *decrepitas*—terms which are synonymous in a four-age context, though in schemes that recognize more ages than four they may be distinguished.

Further complications arise in the following chapters, where the author goes on to distinguish between the four-age scheme of the *physici*, or medical authorities, and the seven-age scheme, which he ascribes to *philosophi*. I shall return later to these *philosophi*, who, according to the *Tractatus*, divide life up 'secundum vii planetas et secundum vii planetarum naturas', in accordance with the seven planets and the seven natures of the planets. It remains to note here that when the author returns to a discussion of the four ages, in Chapters v and vi, he gives a different version from that presented in Chapter i. The sequence of qualities now begins with cold-and-moist (not moist-and-hot) and ends accordingly with dry-and-cold (not cold-and-moist). Hence, the first age is associated with phlegm instead of blood, the second with blood instead of red choler, the third with red choler instead of black, and the last with black choler instead of phlegm. This alternative version of the physiology of the four ages, which the *Tractatus* author prefers to the version given in his first chapter, represents a genuine rival tradition.[45] The disagreement points to a fundamental difficulty in the 'qualitative' analysis of the ages of man. According to the old physiology, the two essential conditions of life are heat and moisture. Without heat there can be no life, and without moisture there can be no heat; for moisture is regarded as a kind of fuel which is consumed to give heat, as oil is consumed in a lamp.[46] Hence, one would expect a life-cycle to begin as moist-and-hot and end as dry-and-cold. But this is not possible according to the established cycle, in which switches between hot and cold alternate with switches between moist and dry. If one begins such a cycle with moist-and-hot, as Bede does, then the fourth and last stage must be cold-and-moist; and if one ends with dry-and-cold, as the *Tractatus* author prefers, then one must begin

[45] See n. 26 above. The diagram at the beginning of the *Tractatus* discussion follows this alternative order: *Saturn and Melancholy*, 292–3. A different order again is found in a treatise on the humours in British Library MS Sloane 146: phlegm with blood in the first age, red choler in the second, melancholy (black choler) in the third, phlegm again in the fourth.

[46] The image is Avicenna's. The idea is commonplace: thus, Dante speaks of 'l'umido radicale' as 'subietto e nutrimento del calore, che è nostra vita', *Il convivio*, IV. xxiii. 7.

with cold-and-moist. Neither solution is satisfactory, since in the former case one has to explain away the presence of moisture in the last age, and in the latter case one has to explain away the absence of heat in the first.[47]

Despite this fundamental difficulty, and despite unfixed terminology and uncertainties about where the age-divisions should be located, medical authorities persisted in their division of life into four ages. One of the first Latin writers who made new translations from Graeco-Arabic science in this period, Constantinus Africanus (d. 1087), observes that 'omnis aetas quadrifaria apud medicos est divisa: aut pueritia, aut iuventus, aut senectus, aut senium' ['every life-span is divided into four according to medical writers: boyhood, maturity, old age, and decrepitude'].[48] Of the many *medici* he may have had in mind, two influential Arabic authorities deserve special mention. The first is Ḥunain ibn Isḥāq, a ninth-century writer known in the West as Johannitius. His *Isagoge* (an introduction to the basic textbook of Galenic medicine) was translated into Latin towards the end of the eleventh century and thereafter came to stand as the first item in the standard anthology of medical texts.[49] Any student of medicine, accordingly, would soon have come across Johannitius's concise exposition of the four ages:

Quattuor sunt etates, scilicet adolescentia, iuventus, senectus, et senium. Adolescentia complexionis videlicet calide et humide est, in qua crescit et augetur corpus usque ad 25 vel 30 perveniens annum. Hanc iuventus sequitur que calida est et sicca, perfectum sine diminutione virium corpus conservans, que 35 vel 40 anno finitur. Hinc succedit senectus, frigida et sicca, in qua quidem minui et decrescere corpus incipit, tamen virtus non deficit,

[47] Thus it was commonly argued that the moisture of the phlegmatic age, where that came last, was to be distinguished from the beneficent natural moisture which fuelled life. *Aetas decrepita*, according to Albertus Magnus, is 'frigida et humida, non quidem intrinseca humiditate et naturali, sed extrinseca et accidentali' ['cold and moist, not on account of intrinsic and natural moisture, but on account of moisture which is extrinsic and accidental']: *De Aetate*, in *Opera*, ed. A. Borgnet, vol. ix (Paris, 1891), Tractatus I, Chap. vi. Conversely, the author of the *Tractatus* argues that the heat evident in the first age (which he, it will be recalled, prefers to associate with the cold humour phlegm) is not intrinsic but accidental, being generated by the vigorous movements of the young (fol. 31ᵛ).

[48] *De Communibus Medico Cognitu Necessariis Locis*, I. xxi, 'De Mutatione Propter Aetatem', in *Opera* (Basel, 1539). Constantine is mentioned along with Avicenna among the medical authorities known to Chaucer's Doctor of Physic: *Canterbury Tales*, I. 433.

[49] The curriculum for students in the Medical Faculty of the University of Paris in the thirteenth century began with twenty lectures on the *Isagoge*: C. H. Talbot, *Medicine in Medieval England* (London, 1967), 66.

quinquagesimo quinto anno vel sexagesimo persistens. Huic succedit senium, collectione phlegmatis humoris frigidum et humidum, in quo virtutis apparet defectus, quod suos annos vite termino metitur.

[The ages are four, namely adolescence, maturity, old age, and decrepitude. Adolescence is of a hot and moist complexion, and in it the body grows and increases up to the twenty-fifth or thirtieth year. Maturity follows, which is hot and dry and preserves the body in perfection without any decrease in its powers; it ends in the thirty-fifth or fortieth year. After that follows old age, cold and dry, in which the body does indeed begin to lessen and diminish, but still without loss of power; it lasts until the fifty-fifth or sixtieth year. After that follows decrepitude, cold and moist through the gathering of the phlegmatic humour, during which a loss of power becomes evident; its years run to the end of life.][50]

The second and greater Arabic *medicus* is Avicenna (980–1037). His *Canon*, translated into Latin by Gerard of Cremona towards the end of the twelfth century, represented 'the final codification of Graeco-Arabic medicine'.[51] His exposition of the four ages, which was extremely influential, runs as follows:

Aetates omnes sunt quattuor. Aetas adolescendi, quae vocatur aetas adolescentiae et est fere usque ad xxx annos. Postea est aetas consistendi, quae vocatur aetas pulchritudinis, et est fere usque ad xxxv aut xl annos. Aetas minuendi cum virtus non amittitur, et haec est aetas senectutis, quae fere est usque ad annos lx. Et est aetas minuendi cum manifesta virtutis debilitate, et haec quidem est aetas senium et finis vitae.

[The ages are four in all. There is the age of growing up, which is called the age of adolescence and commonly lasts until the age of thirty. Then there is an age of standing still, which is called the age of beauty and commonly lasts until the age of thirty-five or forty. Then there is an age of diminution in which power is not lost, and that is old age, which commonly lasts until the age of sixty. There is also another age of diminution marked by a manifest loss of power, and this is the age of decrepitude and the end of life.][52]

[50] *Isagoge Joannitii ad Tegni Galieni*, cited from *Articella* (Venice, 1493), in which it is the first item. There is a complete translation of the *Isagoge* in H. P. Cholmeley, *John of Gaddesden and the Rosa Medicinae* (Oxford, 1912), 136–66. A version of the present passage is given by Roger Bacon, citing 'quidam auctor medicinae', in the discussion of the ages of man in his *Compotus*, ed. R. Steele, *Opera Hactenus Inedita Rogeri Baconi*, vi (Oxford, 1926), 5–6.

[51] Talbot, *Medicine in Medieval England*, 31.

[52] *Canon* (Venice, 1486), Bk. I, Fen i, Doctr. 3, Chap. 3, 'De Complexionibus Etatum et Generum'. The passage is reproduced by Vincent of Beauvais, *Speculum Naturale* (Douai, 1624), Bk. xxxi, Chap. lxxv.

It will be noticed that both these medical authors see in the four ages a process of bodily growth and decline, rise and fall. Writers such as Bede, Byrhtferth, and the author of the *Tractatus de Quaternario*, who are concerned with the whole set of Physical and Physiological Fours, do not present the ages in this way. For them, the four ages, like the four elements and the four seasons, all enjoy equal status, as quadrants of the great circle which, in Byrhtferth's diagrams, has its centre in God. Johannitius and Avicenna, on the other hand, are influenced by Aristotelian life-sciences; and the underlying image here, as in the three-age schemes previously discussed, is that of an arc, not a circle. In this case, however, the arc cannot be a symmetrical image of *augmentum, status,* and *decrementum.* Avicenna's *aetas consistendi,* his age of *status,* occupies the second position in a set of four, not three.[53] The result is, one might say, rather truer to actual experience; but the distinction drawn between the two *aetates minuendi* which follow the prime of life and complete the quaternion raises problems. Johannitius and Avicenna base their distinction on the supposed fact that the body passes through a stage of diminution or shrinkage in the third age before its actual power or *virtus* goes in the fourth. Perhaps more convincingly, Albertus Magnus reverses the order. In a passage of scholastic precision, which places mankind firmly in its larger biological context, Albertus writes:

Aetas autem in omnibus aetate participantibus in quatuor aetates dividitur, scilicet in aetatem congregantem tam substantiam quam virtutem, et in aetatem standi tam in substantia quam in virtute, et in aetatem diminuendi virtutem sine diminutione substantiae, et in aetatem minuentem tam substantiam quam virtutem.

[The life-cycle of all things that have a life-cycle is divided into four ages: an age in which both substance and power are accumulating, an age of standstill both in substance and in power, an age when power diminishes without loss of substance, and an age when substance as well as power diminishes.][54]

These age-distinctions are particularly clear in the life of man, Albertus explains, and it is therefore in man that they receive specific

[53] Compare, however, the sequence in Isidore of Seville's *Liber Numerorum: initium, augmentum, status, declinatio (PL* 83. 184).

[54] *De Aetate,* ed. Borgnet, Tractatus I, Chap. II.

names: *aetas puerilis, iuventus* or *aetas virilis, senectus*, and *senium* or *aetas decrepita*.

Albertus Magnus died in 1280. By the time he wrote his *De Aetate* the theory of the four ages, for centuries a commonplace of scholarly writings in Latin, had begun to be expounded to wider audiences by vernacular authors. The sole surviving manuscript of Byrhtferth's *Manual* suggests that his early attempt to reach a wider audience (albeit only the *clerici*) met with little success. I do not know of any other vernacular expositions of the Fours before the thirteenth century; and it is only in the fourteenth and fifteenth centuries, in England at least, that they become at all common. Let me first give three examples from French writings, which will illustrate the wide variety of contexts in which vernacular authors might draw on the learned tradition.

Towards the end of his life, in about 1265, the Lombard jurist and historian Philippe de Novare composed in French a moral treatise on the education and conduct of noble persons entitled *Les Quatre Âges de l'homme*. For this purpose, he divides life into four ages of twenty years each and treats each in turn: *enfance, jovens, moien aage*, and *viellesce*. This division certainly derives from the learned theory under consideration here; but Philippe is, he confesses, an 'hons lais' or layman, so he avoids the technical theory of qualities and humours (apart from passing references to the hotness of *jovens*). At one point he sets out the parallelism between ages and seasons; but he refrains from explaining it:

Rainablement puet on deviser et monstrer comment et pour quoi chascuns des iiii tens d'aage d'ome sorsamble la saison de l'an a cui il est comparé et affiguré, si comme il est desus moti; mès por ce que longue riote seroit, li contes tient sa droite voie.

[One could show good reason how and why each of the four ages of man should resemble that season of the year to which it is compared and matched, as was said above; but since the explanation would be lengthy, the narrative will keep to its direct path.][55]

By Philippe's time, however, more technical explanations were beginning to appear in French for the benefit of the 'hons lais'. The Italian physician Aldobrandino of Siena, who died at Troyes about

[55] *Les Quatre Âges de l'homme*, ed. M. de Fréville, SATF (Paris, 1888), 42.

1287, wrote in his French treatise *La Régime du corps* a chapter headed 'Comment lon se doit garder es iiii eages et tarder de viellece et soi maintenir lonc', in which he prescribes a regimen for the various ages.[56] The chapter opens, in the Sloane Manuscript, with an illuminated capital E showing, in its four quarters, figures representing the four ages (Plate 4); for, as the author asserts, 'Coumunaument li fisitien dient que les eages sunt quatre, si com *adolescentia*, *iuventus*, *senectus*, *senium*'. Like many later vernacular writers, Aldobrandino evidently prefers Latin terminology for the ages; but he goes on to give what is virtually a rendering into French of the passage cited above from the *Isagoge* of Johannitius, explaining that the age of bodily growth, *adolescentia*, is hot and moist and lasts until the age of twenty-five or thirty, and so on.[57]

About a generation after Aldobrandino, we find a French poet expounding the cosmological theory of the fours. In the second book of *Le Roman de Fauvel*, completed in 1314, Dame Fortune speaks of the changefulness of the universe, explaining how the four qualities war with each other in man the microcosm, just as they do in the macrocosm. The hot consumes the moist, just as a lamp consumes its oil. From these qualities, Nature has compounded the four complexions of humanity: phlegmatic, sanguine, choleric, and melancholy; and upon these complexions the course of life depends. The author, Gervais du Bus, then expounds the cycle of the humours, in the order preferred by the *Tractatus de Quaternario*, beginning with phlegm:

> De ces quatre est humaine vie
> Fondee, si comme Nature
> Les porpocionne et mesure
> Es corps naturelz qui ont amez.
> Fleume est aus enfans et aus famez.
> Le sanc vient demander sa rente

[56] 'How one should look after oneself in the four ages and put off old age and keep fit for a long time', Pt. I, Chap. 20, occupying fols. 31r–32v of British Library MS Sloane 2435, from which I quote. On the subject of putting off old age, see also Roger Bacon, *De Retardatione Accidentium Senectutis*, ed. A. G. Little and E. Withington (Oxford, 1928).

[57] MS Sloane, fol. 31r. However, Aldobrandino goes on to divide life 'un po plus sutilment' into seven ages, and it is this scheme (to be discussed in the next chapter here) which he follows in his ensuing regimen.

D'entour xv ans jusqu'en tour xxx.
Et puis après vient dame Cole
Soubz lx ans tenir s'escole.
Puis vient tantost Merancolie,
Qui toute en tristece se lie,
Par viellesce.

[The course of human life is founded upon these four, according as Nature measures their proportions out in bodily creatures which have souls. Phlegm is for children and women. Blood comes to demand its dues from about fifteen years to about thirty. Then follows mistress Choler, ruling the roost up to sixty years. Then soon comes Melancholy, all bound up in the sorrow of old age.][58]

After the customary correlation with the four elements, Gervais goes on to draw a less familiar parallel, with the four ages of the world: phlegmatic like a child until the time of King David, sanguine thereafter until the Incarnation, when it entered its choleric age, and now in modern times old and 'trestout plain de merancolie' (3059–84). As will appear in the following chapter, such parallelisms between the ages of man and the ages of the world are most frequently found in the Augustinian tradition of six ages. They have no regular place in the physiological theory of the Fours.[59] None the less, the *Roman de Fauvel* well illustrates how learned ideas about the natural order of the ages were, by the beginning of the fourteenth century, becoming available to Frenchmen who did not read Latin.

The same process of popularization can be traced in England, most evidently in the vernacular medical texts which proliferated in the later fourteenth century and especially in the fifteenth. It has been estimated that there are more than a thousand manuscripts surviving which contain medical material in Middle English. Many of these are simply books of remedies; but there is also a substantial group of 'Middle English versions of learned medicine, the writings of antique and Arabic authors and members of the faculties of medicine of medieval universities.'[60] The importance of these versions for

[58] *Le Roman de Fauvel*, ed. A. Langfòrs, SATF (Paris, 1914–19), ll. 3026–37.
[59] On the four ages of the world, see A. Luneau, *L'Histoire du salut chez les Pères de l'Église: La Doctrine des âges du monde* (Paris, 1964).
[60] L. E. Voigts, 'Editing Middle English Medical Texts: Needs and Issues', in T. H. Levere (ed.), *Editing Texts in the History of Science and Medicine* (New York and London, 1982), 47. See also R. H. Robbins, 'Medical Manuscripts in Middle English', *Spec.* xlv (1970), 393–415.

the present subject cannot be assessed until the manuscripts have been properly studied; but they must have played the leading part in disseminating knowledge of medical theory in later medieval England. Technical discussions of the four ages are easily found among them: in a translation of the *Isagoge* of Johannitius, in a treatise on the regimen of health, in a dialogue on medical matters, and in two medical miscellanies compiled by fifteenth-century barber-surgeons.[61] Two specimens must suffice here. The first is a short exposition of the four ages, taken from one of the miscellanies just mentioned:

What is age? Age is spase of þe life of a best whenne it begynnys for to encrese as in youthe, or for to stonde as in myddil age, or for to lesse prively as in helde, or for to be lesse opynly as in olde age. As Galen seyþ *in libro de complexionibus*, whe be made in þe uttermost limosite and humidite, and þe hete of our bodi sesiþ not for to ete or waste his moistenes unto þat deþ come, which is disteyned to every man. Wherfor seiþ Seneca, he þat growith up with me and þat quekenyþ me sleþ me. Þe example of þis is schewid in a lampe and oyle.[62]

In the dialogue on medical matters in MS Sloane 3489, the fourth chapter is devoted to 'change in complexion'. The instructor has already mentioned this as one of three causes of illness. He first explains that there are two distinct kinds of complexion:

On is cleped a natural complexion, and that nys nat chaunged, but is ever-more of on kynd fro tyme that a man is born for to he be ded. And that complexion cometh of humours, and they ben in the sad membres of a man, as of his bones, and of his senywes, and of his other parties. But his other com-

[61] British Library MS Sloane 6 (early fifteenth-century) contains a Middle English version of Johannitius (fols. 1–9). Unfortunately, the first folio, containing the discussion of the ages, is badly worn. The treatise on regimen is to be found on the last eight leaves (bound out of order) of Bodleian Library MS Ashmole 189. Discussion of the ages is on fol. 216r. The medical dialogue occupies fols. 29–42 of British Library MS Sloane 3489 (fifteenth-century). Discussion of the ages is on fol. 31r. British Library MS Sloane 5, a fifteenth-century miscellany formerly owned by Richard Dodd, a London barber-surgeon, contains a treatise on the government of the planets, in which the four ages are specified (fol. 182v). Gonville and Caius College, Cambridge, MS 176/97, also once owned by a fifteenth-century barber-surgeon, treats the ages on p. 19. Examples could no doubt easily be multiplied.

[62] Gonville and Caius MS 176/97, p. 19. On this manuscript, see Voigt, art. cit. 42, 48–9. Galen explains the heat and humidity (*limosite*: slimyness) of the new-born by their origins in sperm and blood, both moist and hot substances: *De Complexionibus*, in R. J. Durling (ed.), *Burgundio of Pisa's Translation of Galen's ΠΕΡΙ ΚΡΑΣΕΩΝ, 'De Complexionibus'* (Berlin and New York, 1976), 53.

plexioun is cleped accidental complexioun that may be changed, for that
cometh of the iiii humours that ben spoke of rather.

Changes in the 'accidental complexion' are of two sorts, natural and
unnatural. The latter cause disease, but the former do not:

Complexioun is changed kyndelich many sythes or than he deye. For a man
hath iiii tymes of his lyfyng. In the first tyme he hath mochel hete and moys-
tenes, and so in that tyme he is of sangwyne complexioun. In the second
tyme he is hote and dryce, and so he is of colorik complexioun. In the thrid
tyme a man wexeth cold and druye, and than he is malencolik in complex-
ioun. In the fourth tyme he is cold and moyst, and than he is flematik in
complexioun; and that complexion dryeth til a man be ded. And thus this
accidental complexion is kyndelich changed withouten eny fallyng in to
syknes.[63]

But the studying of vernacular medical treatises was by no means
the only method by which Englishmen could learn about the four
ages. Going to dinner with Humphrey Duke of Gloucester was
another. In his *Boke of Nurture*, the former usher and marshal of the
Duke's household, John Russell, describes how each of the four
courses of an elaborate fish dinner may be accompanied by an ap-
propriate 'subtlety' or ornamental device. During their first course,
diners were to contemplate the representation of a 'galaunt yonge
man, a wanton wight', standing on a cloud (air) at the beginning of
ver (spring), and named Sanguineus (blood). The second subtlety is
to represent a 'man of warre', standing in fire, red and angry
(choler), and named Estas (summer). The third represents a 'man
with sikelle in his hande' in 'þe thrid age of man', standing in a river
(water and phlegm), and named Hervist (autumn). In the fourth and
last subtlety, which came in with the spices and wine, Yemps (win-
ter) 'with his lokkys grey, febille and old' sits on a cold hard stone
(earth), 'nigard in hert and hevy of chere' (melancholy). Each device
is to be accompanied by a couplet from the Salernitan verses, setting
out the characteristics of the appropriate humour.[64] Thus, as Duke
Humphrey's guests worked their way through this very unpeniten-

[63] MS Sloane 3489, fols. 30ᵛ–31ʳ.

[64] *Iohn Russells Boke of Nurture*, ed. F. J. Furnivall in *The Babees Book*, EETS, OS
32 (1868), ll. 719–94. The order of humours here, with phlegm instead of melancholy
following choler, breaks the rule that only one of the two pairs of qualities can be
switched at a time: cold-and-moist cannot directly adjoin hot-and-dry. For the Saler-
nitan verses, see *Saturn and Melancholy*, 114.

tial fish banquet, they were invited to see in it the four courses of their own life's feast.

Another writer connected with Duke Humphrey of Gloucester, John Lydgate, expounded the Physical and Physiological Fours in his *Secrees of Old Philisoffres*, a free version of the *Secretum Secretorum* left unfinished at his death in 1449. The pseudo-Aristotelian *Secretum* was one of the most widely read of all the Arabic treatises which became known in the West during the twelfth and thirteenth centuries. In his section on health, the author advises that diet and regimen should be varied according to the seasons, and this leads him to expound the seasons with their qualities and humours, and to compare them to the four ages of woman—a refreshing departure from the overwhelmingly masculine character of such descriptions elsewhere. In spring, 'the world becomes like a young girl adorned and resplendent before the onlookers'; in summer, 'the earth becomes like a bride laden with riches and having many lovers'; in autumn, it is 'like a mature matron who has passed the years of her youth'; and in winter, 'the world becomes like a decrepit old woman to whom death draws near'.[65] These exotic comparisons are preserved more or less complete in six of the Middle English versions of the *Secretum* published by the Early English Text Society.[66] However, it is only in Lydgate's version that they are fully incorporated into the scheme of Fours. The long passage on the seasons in *Secrees of Old Philisoffres* is introduced, as in the *Secretum*, by advice about adjusting one's regimen to the time of year; but the emphasis in the passage itself is more moral than medical. Lydgate describes the seasons themselves quite fully, with imagery drawn from both the *Secretum* and Chaucer's *Canterbury Tales*, and with the customary specifications of qualities, elements, and humours; but their chief function here is to hold up to man a mirror in which he can contemplate the inevitable course of his own life through its four seasons:

Thus four tymes makith us a merour cleer

[65] I quote from the translation of the Arabic treatise in *Secretum Secretorum*, ed. R. Steele, *Opera Hactenus Inedita Rogeri Baconi*, Fasc. v (Oxford, 1920), 200–2. For the corresponding passage in the thirteenth-century Latin version, see ibid. 76–80.

[66] *Three Prose Versions of the Secreta Secretorum*, ed. R. Steele, EETS, ES 74 (1898), 28–9, 72–5, 246; *Secretum Secretorum: Nine English Versions*, ed. M. A. Manzalaoui, EETS, OS 276 (1977), 56–8, 153–5, 346–8.

> Off mannys lyff and a ful pleyn ymage.
> Ver and iuventus togedir have sogeer;
> Estas folwith, longyng to saddere age;
> To us autumpne bryngeth his massage
> Off senectus; wynter last of alle,
> How dethys orlogge doth on us calle.[67]

Lydgate also displays his familiarity with the Fours in another, more interesting poem, his *Testament*. Here, writing as an old man, he confesses to the sins of his childhood:

> Thus in vi thynges be order men may seen
> Notable accord and iust convenience,
> Blod, eyre, and ver, south, and meridien,
> And age of chyldhood by naturall assistence,
> Which, whill thei stonde in ther fressh premynence,
> Hete and moysture directeth ther passages,
> With grene fervence to force yong corages.[68]

The second section of the *Testament* gives a general account of spring and childhood as times of joy and lustiness, particularly subject to 'chaunges ful sodeyne' (278–394); and in the fourth section (607–753) Lydgate describes his own spring season in similar terms, as a time when, 'lyke a yong colt that ran without brydell', he scorned discipline and pursued his own frivolous pleasures:

> Redier cheristones for to telle
> Than gon to chirche, or here the sacryng belle. (ll. 647–8)

Scholars are no doubt right to warn against taking such confessions as simple autobiographical truth. Lydgate is writing a moral poem and employing a schema which, as we have seen, had been known to English monks for seven hundred years. Yet his account of his child-

[67] *Lydgate and Burgh's Secrees of Old Philisoffres*, ed. R. Steele, EETS, ES 66 (1894), ll. 1457–63. At l. 1476 Lydgate names the last age *decrepitus*, distinguished in customary fashion from a preceding *senectus*. Like many other authors, however, he finds difficulty in naming the first two ages of the tetrad. In the stanza quoted, *iuventus* is the first age; but earlier it was the second: 'Fyr, colour, estas, and juventus age, | Togidre accorde in heete and drynesse' (ll. 1352–3).

[68] H. N. MacCracken (ed.), *The Minor Poems of John Lydgate*, vol. i, EETS, ES 107 (1911), ll. 318–24. 'Meridien' perhaps signifies the south wind.

hood does suggest how that schema might provide a framework within which the details of individual experience could be observed and understood.[69]

The Physical and Physiological Fours continued to interest English writers long after the time of Russell and Lydgate. The very popular *Kalendar and Compost of Shepherdes*, for instance, expounds a regimen of health, ostensibly for shepherds, in which seasons, ages, humours, and elements are compared in terms of the four qualities, exactly as in Bede; and in the December Eclogue of Spenser's *Shepheardes Calender*, Colin Clout 'proportioneth his life to the foure seasons of the yeare'.[70] To conclude this selection of examples, however, let me turn back to the most remarkable of all vernacular writers on the ages of man, Dante Alighieri.

Dante's discussion of the ages in *Il convivio* has a double ancestry. As has already been demonstrated in the previous section, it derives in part from Aristotelian biology, according to which all living things traverse an arch of three ages, *augmentum*, *status*, and *decrementum*. Yet Dante in fact distinguishes four ages, not three. One way of adapting Aristotle to a scheme of four ages, as we have seen in the writings of Johannitius, Avicenna, and Albertus Magnus, was simply to divide the arch, at some cost to its symmetry, into four instead of three. Dante takes a different course. He preserves the symmetrical arch of three ages as representing the normal life-span of seventy years, with its exactly central culmination at the age of thirty-five.[71] But he adds an extra-curricular age, *senio* or decrepitude, which may last, he says, for roughly ten years after the age of seventy.[72] The result is a four-age scheme which clearly declares its debt to the tradition under discussion here, despite Dante's claim to be following reason alone and not the authority of 'li filosofi e li medici'.[73] His four ages are designated by learned vernacular terms

[69] More specifically autobiographical is *Opicinus de Canistris*, written in 1336 by an Italian clerk in his fortieth year. He sets out in four ages the events of his life to date (*pueritia, adolescentia, iuventus, etas perfecta*): R. Salomon (ed.), *Opicinus de Canistris*, Studies of the Warburg Institute, vol. 1a (London, 1936), 204–20.

[70] On the *Kalendar and Compost of Shepherdes*, see below, pp. 78–9. For the four ages in Renaissance England, see Chew, *The Pilgrimage of Life*, 154–60.

[71] *Il convivio*, IV. xxiii. 9. As is well known, Dante refers to the age of thirty-five (his own age in 1300) in the first line of *Inferno*: 'Nel mezzo del cammin di nostra vita'.

[72] Ibid. IV. xxiv. 5.

[73] Ibid. IV. xxiv. 3.

which correspond to those used in the Latin Johannitius: *adoles-cenza* (*adolescentia*), *gioventute* (*iuventus*), *senettute* (*senectus*), and *senio* (*senium*). Each of the ages, Dante says, is appropriated to one of the four possible combinations of contrary qualities: thus, the first age 's'appropria al caldo e a l'umido', the hot and the moist. In this way the ages correspond to the four seasons of the year—and also, he adds, to the four parts into which the day is divided by tierce, noon, and vespers,[74] Yet Dante does not here include the customary reference to the four humours. Indeed, his extended discussion of the characteristics of the four ages is notable for its avoidance of medical theory.[75] Being concerned with the progress through life of the noble soul, he concentrates on the noble virtues to be looked for in each age; and these he explains, not by invoking physiological doctrine, but by showing how each virtue is 'necessary' (a recurrent word) to its particular stage in the noble life. He writes as a moral philosopher, not as a *medicus*.

No other medieval writer, indeed, more eloquently recommends the order of the ages, each with its seasonable virtues and graces, as a lofty moral ideal to be aimed at. Thus, in *adolescenza*, occupying the first twenty-five years of life, nobility of soul manifests itself, he says, in the appropriate qualities of *obedienza*, *soavitade*, *vergogna*, and *adornezza corporale*. *Obedienza*, or submissiveness, is necessary if the growing youth is to learn from his elders how to keep to the right path in the wandering wood of this life. *Soavitade*, or agreeableness, is also necessary, because this is the age at which most friendships are formed. His third term, *vergogna*, denotes a readiness to be ashamed, embarrassed, and overawed—feelings which inspire a due reverence for the great things in life and restrain unseemly juvenilities in word and deed. And finally, since nobility manifests itself in body as well as in soul, the growing youth will be recognizable also by his beauty and grace of person: *adornezza corporale*.[76] Such a characterization of the first age is no doubt consistent with that of the first, sanguine, age given by the *medici* ('merry, delightful, tender-hearted, and much given to laughter and talk'); but it is distinguished as Dante's both by its intense moral seriousness and also by that passionate scholastic intellectuality which seeks always to

[74] Ibid. IV. xxiii. 13–16. On this division of the day, see below, pp. 57–8.
[75] Though Dante does acknowledge the influence of the humours ('la complessione del corpo') upon the mind in *Il convivio*, IV. ii. 7.
[76] Ibid. IV. xxiv–xxv.

uncover the rational necessities lying beneath the apparently random contingency of things.

Dante's passion for rational order appears most clearly in his discussion of the exact extent in years of each of the ages: *Il convivio* IV. xxii–xxiv. It will already have become evident to the reader that anyone who goes to medieval discussions of the ages of man with the intention of ascertaining at what age youth was then thought to end, or old age to begin, will find no easy answers. The texts offer, indeed, a bewildering profusion of different answers.[77] Simple human error (active in the scribal transmission of Roman numerals) accounts for some of the confusion; but a more important cause lies in the variety of rival age-schemes. When, for instance, the term *adolescentia* is employed, as by Dante, to denote the first of four ages, its range will necessarily differ from that which it has when used to denote the third of six ages. Seen from this point of view, the various schemes represent alternative structures, more or less stable, within the semantic field covered by age-terminology. The denotation of any individual term (the range of years to which it is taken to refer) will depend upon its place in whichever system it happens to belong to at the time. What is more, considerable variations occur even within such relatively stable systems as that of the four ages, as we have seen. Within this system the second age, for instance, may be said to end at twenty-eight (Byrhtferth), thirty (*Fauvel*), thirty-five or forty (Johannitius, Avicenna), forty (Pythagoras), and forty-five or fifty (*Tractatus de Quaternario*). It can by no means be assumed that such numbers bear any relation to the social or biological realities of the time. Very often they are based upon numerological considerations, such as the concept of the 'year-week' or seven-year cycle, according to which seven, fourteen, twenty-one, twenty-eight, thirty-five, etc., become critical years; and such considerations can, of course, produce many different results.[78]

Dante bears witness to this deplorable state of affairs, when he observes that the range of the second age is estimated variously (*diversamente*) by the many authorities.[79] He himself turns aside from the natural philosophers and medical men, offering a solution based

[77] For a survey of Roman Antiquity, see Eyben's article (cited in Introduction, n. 3), pp. 171–9, and J.-P. Neraudau, *La Jeunesse dans la littérature et les institutions de la Rome républicaine* (Paris, 1979), Pt. III: 'Rome et les âges de la vie'. For the Middle Ages, see the articles by Hofmeister and de Ghellinck cited in Introduction, n. 3.

[78] On 'year-weeks', see below, pp. 73–4.

[79] *Il convivio*, IV. xxiv. 3.

upon reason alone—or so he claims. His reasoning runs as follows. Human life is like a symmetrical arch, with its highest and middle point in the thirty-fifth year.[80] Since 'every sage agrees' (or so he avers) that the first age lasts until the twenty-fifth year, and since the second age must have as long a time to run after the peak at thirty-five as it had before, the latter must extend for twenty years from twenty-five to forty-five. And since the period of decline, *senettute*, should last as long as that of growth, *adolescenza*, it is fitting that it should run for twenty-five years, from forty-five to seventy. To this symmetrical pattern of three ages (25–20–25) must be added the years of *senio* or decrepitude; but even these are found a counterbalance of sorts, in the nameless eight months in the womb (*sic*) which precede the beginning of the first age.[81]

This extraordinary piece of argumentation prompts some concluding reflections on the non-empirical character of the four-age theory. The scheme belongs, as we have seen, to a system of parallelisms which reaches back to Pythagorean speculations about the number four as 'the root and source of eternal nature'. The Greek thinkers who identified four primary constituents in matter (the elements) and four primary fluids in the human body (the humours), and who analysed both tetrads in terms of two pairs of contrasting qualities, did not arrive at these coincidences by accident. They were looking for fours—as was Pythagoras himself when he distinguished four ages of man. It is hard to know what biological, psychological, or social evidence could have been produced to justify this division, in Antiquity or in the Middle Ages.[82] Pythagoras assigned to each age twenty years; but the numerous variations in this matter among later authorities (of which many more examples could have been cited) suggest that the three points of transition required by the scheme could be put, one is tempted to say, almost anywhere. Considerations of symmetry and numerology clearly played a larger part

[80] This point he arrives at, not by halving the three score years and ten of the Psalmist, but by a subtle argument based on the fact that Christ died in his thirty-fourth year: see below, p. 143.

[81] *Il convivio*, IV. xxiv. 5. Busnelli and Vandelli prefer the reading 'otto anni' to 'otto mesi'; but see Wicksteed's note to his Temple Classics translation, pp. 352–3.

[82] It may be noted, however, that the American psychologist Daniel J. Levinson, in his book *The Seasons of a Man's Life* (New York, 1968), claims that a division of life into four ages is 'grounded in the nature of man as a biological, psychological and social organism' (p. 322). He therefore adopts it for his study and even, in blissful ignorance of the history of the subject, employs the ancient parallel with the seasons as a bit of 'useful imagery'.

in their determination than any observable norms of puberty, marriage, senescence, and the like. Nor did the division of life into four receive much support from linguistic usage. In naming their four ages, vernacular writers such as Philippe de Novare, Dante, and Lydgate commonly resorted to Latin terminology, more or less naturalized, or else to calques from Latin; but the age-vocabulary of Latin itself was ill-adapted for use in four-age schemes, as the variations in nomenclature already encountered sufficiently show. Common experience, so far as that is represented by common linguistic usage, simply did not distinguish four ages, in fact; and medieval scholars were therefore obliged to assemble their terminology *ad hoc* out of the ragbag of real language.

Yet educated persons in the Middle Ages certainly did not regard the Physical and Physiological Fours in any such sceptical way. All these tetrads bore witness rather to that great structure of nature which God had ordered 'in measure, and number, and weight'. Perhaps the modern reader, who finds it only too easy to deconstruct the rest of the system, can best appreciate what the Fours once meant to intelligent men by reflecting on the only one of them which still holds a place in our own model of nature: the four seasons. The solar year can indeed be divided into four by the solstices and equinoxes; but the divisions which these produce by no means coincide with the seasons as those are normally understood.[83] Nor would it be easy to produce other scientific or empirical explanations of why we recognize *four* seasons. Why not two, or three, or five? The truth is that this tetrad, just like the tetrad of the ages, had its origin in Pythagorean number-speculation, and that knowledge of it was spread through medieval Europe by precisely the same learned treatises that expounded the other fours—treatises such as Bede's *De Temporum Ratione*, the *Isagoge* of Johannitius, and the *Secretum Secretorum*. It is not a natural way of dividing the year at all. Yet the seasons still have for us that unquestioned 'naturalness' which a writer such as Dante would have seen also in the four ages of man.

III

The author of the *Tractatus de Quaternario* distinguishes between

[83] This can be clearly seen in Byrhtferth's diagrams (Plates 2 and 3), which identify January–March as spring, April–June as summer, July–September as autumn, and October–December as winter.

two kinds of authoritative writer on the ages of man: the *physici*, or medical men, who speak of four ages, and the *philosophi*, who speak of seven: 'Philosophi vero secundum vii planetas et secundum vii planetarum naturas descripserunt vii etates' ['Astrologers indeed have distinguished seven ages, in accordance with the seven planets and the seven natures of the planets'].[84] The prime authority for the latter view, throughout the Middle Ages and beyond, was the second-century astronomer Claudius Ptolemaeus. In his astrological treatise *Tetrabiblos*, Ptolemy observed that an astrologer should take account of an individual's age when making predictions about his future: 'and in truth the accidental qualities of each of the ages are those which are naturally proper to the planet compared with it, and these it will be needful to observe.'[85] He goes on to elaborate upon this comparison, taking the planets in order of increasing distance from the earth, and assigning to each age a number of years derived from the cycle or 'period' of the corresponding planet. Thus according to the 'ordinary course of nature' (in the unlikely event, that is, of all other things being equal) a human life will work its way outwards through the seven planets, displaying successively, and in each case for an appropriate period of years, the qualities proper to each planet, starting with the Moon and ending with Saturn. In the first four years (infancy) the Moon produces in a human being 'the changeability of its condition, and the imperfection and inarticulate state of its soul'; in the following ten years (childhood) Mercury 'begins to articulate and fashion the intelligent and logical part of the soul'; in the third age, youth, which lasts eight years, Venus 'implants an impulse toward the embrace of love'; in the following nineteen years, from twenty-two to forty-one, the Sun 'implants in the soul at length the mastery and direction of its actions, desire for substance, glory, and position, and a change from playful, ingenuous error to seriousness, decorum, and ambition'; in the fifteen years from forty-one to fifty-six, Mars brings unhappiness and a desire to accomplish something before the end; the following twelve years, ruled over by Jupiter, bring thoughtfulness, dignity, and de-

[84] Gonville and Caius College, Cambridge, MS 428/428, fol. 30ᵛ.

[85] Ptolemy, *Tetrabiblos*, ed. and trans. F. E. Robbins (Cambridge, Mass., and London, 1940), 441. The whole passage, which occurs in Bk. IV, Chap. 10 ('Of the Division of Times'), is reproduced in the Appendix here. The best account of the development of seven-age schemes in Antiquity is in Boll, 183–202.

corum, in place of the hectic activity of preceding years; and the last age, extending for an unspecified period after sixty-eight, is the age of Saturn, when man cools and slows down, becoming 'worn down with age, dispirited, weak, easily offended, and hard to please.'[86]

If asked to provide a causal explanation for the changing ages of man, most educated people in the Middle Ages or Renaissance would have offered either this astrological theory or else the medical theory of the four ages. One might have a preference between them, as the author of the *Tractatus de Quaternario* prefers the Fours; but they were certainly not regarded as incompatible. Ptolemy himself, in a discussion of the seasons elsewhere in the *Tetrabiblos*, speaks of the corresponding four ages to be observed in all living creatures.[87] Medicine and astrology were kindred disciplines, and it did not prove difficult to find ways of harmonizing their two models of human development. Thus, the cold-and-moist phlegmatic humour sometimes assigned to the first of the four ages (in the order preferred by the *Tractatus*) corresponds neatly with the cold-and-moist planet Moon assigned by Ptolemy to his first age, just as the dry-and-cold humour of melancholy then assigned to the last age corresponds with Ptolemy's dry-and-cold planet of old age, Saturn.[88] Such eclecticism was encouraged by the fact that the *physici* had their own authority for dividing life into seven ages—none other than Hippocrates himself, or so it was thought. Long before Ptolemy wrote his *Tetrabiblos*, in fact, a Greek medical treatise commonly ascribed to that great medical authority had included the seven ages of man in its exposition of the 'septenarius ordo' of the world; and the idea had been taken up by the Hellenized Jew Philo in his celebration of the number seven. Philo quotes 'Hippocrates' as follows:

In man's life there are seven seasons, which they call ages, little boy, boy, lad, young man, man, elderly man, old man. He is a little boy until he reaches seven years, the time of the shedding of his teeth; a boy until he reaches puberty, i.e. up to twice seven years; a lad until his chin grows downy, i.e. up to thrice seven years; a young man until his whole body has

[86] See Appendix.
[87] Robbins, 61.
[88] *Tractatus de Quaternario*, III. iv, describes the seven planetary ages in terms of the four qualities, from cold-and-moist to dry-and-cold.

grown, till four times seven; a man till forty-nine, till seven times seven; an elderly man till fifty-six, up to seven times eight; after that an old man.[89]

Despite the formidable double authority of Hippocrates and Ptolemy, the scheme of the seven ages seems not to have played a significant part in the thinking of the Latin West until the twelfth century. There is, so far as I know, no trace of the famous Seven Ages of Man in any pre-Conquest English writer. Bede speaks of three, four, and six ages, but never of seven. Latin writers do occasionally refer to the Hippocratic scheme. Censorinus includes it in his interesting survey of age-schemes; Ambrose refers to it, following Philo, in a letter; and Isidore of Seville draws upon it in a chapter on the number seven.[90] Scholars at this time were indeed familiar with the ancient idea of the world's 'septenarius ordo'; but it is noteworthy that the exposition of this order best known to medieval writers, that by Macrobius in his commentary on the *Somnium Scipionis*, does not distinguish seven ages. When Macrobius observes that the whole life of man is regulated by the number seven, he has in mind the division of life into seven-year periods, the 'year-weeks'—a division which yields not seven but ten ages.[91] Nor does Macrobius here reveal any knowledge of the astrological theory of the ages. Ptolemy's *Tetrabiblos* was much copied and commented upon by Greek-speaking

[89] Philo Judaeus, *On the Account of the World's Creation Given by Moses* (*De Opificio Mundi*), ed. and trans. F. H. Colson and G. H. Whitaker (New York and London, 1929), 87. The Hippocratic treatise cited by Philo is Περὶ ἑβδομάδων. The Greek text of this treatise is lost, but an old Latin translation (very corrupt) is printed by É. Littré in Vol. 8 of his *Œuvres complètes d'Hippocrate* (Paris, 1853), 634–73, under the title 'Des Semaines'. The passage on the seven ages in this translation (Littré, 636) differs in places from the Greek cited by Philo.

[90] Censorinus, *De Die Natali Liber*, ed. O. Jahn (Berlin, 1845), 14. 3 ('Hippocrates medicus in septem gradus aetates distribuit'); Ambrose, *Ep.* 44, *PL* 16. 1189 ('Celebratur itaque hebdomas, eo quod per septem aetatum cursus vita hominum usque ad senectutem transcurritur, sicut Hippocrates medicinae magister scriptis explicuit suis'); Isidore, *Liber Numerorum qui in Sanctis Scripturis Occurrunt*, Chap. 8, *PL* 83. 188. Among later writers who derive seven-age schemes from medical authorities are Roger Bacon and Aldobrandino of Siena: Bacon's *Compotus*, ed. Steele, 6; *Régime du corps*, British Library MS Sloane 2435, fol. 31ʳ.

[91] *Commentary on the Dream of Scipio*, trans. W. H. Stahl (New York and London, 1952), Bk. i, Chap. 6. The prime authority for dividing life into ten year-weeks was the early Athenian lawgiver Solon, whose verses on the subject are quoted by Philo Judaeus and reproduced in the Appendix here. See Boll, 186. The Hippocratic seven-age scheme draws on the theory of the year-weeks in that its boundary ages, unlike those of the Ptolemaic scheme, are all multiples of seven.

scholars, and it was one of the first works of Greek science to be
translated into Arabic; but the Ptolemaic tradition of the seven ages
did not become familiar in the West until as late as the first half of
the twelfth century, when the *Tetrabiblos* was first translated into
Latin (from an Arabic translation of the Greek) by Plato of Tivoli. It
was the revival of astrology in this period that was chiefly respon-
sible for establishing the scheme of the seven ages as a scientific
hypothesis which could stand alongside that of the four ages, as it
does already in the *Tractatus de Quaternario*.

From this period onwards seven-age schemes occur quite fre-
quently in Latin and, later, in vernacular works; but the tradition is
neither quite so dominating nor quite so distinct as a modern reader
might suppose. The well-known speech by Jaques in Shakespeare's
As You Like It represents for most English readers nowadays their
only contact with the rich and multifarious thinking about the ages
to be found in the texts of Antiquity, the Middle Ages, and the
Renaissance. For us, therefore, the Ages of Man usually means the
Seven Ages of Man. Thus, in *Letters from Iceland*, Auden and Mac-
Neice can speak of a painting by Titian which clearly shows only
three ages as 'a picture of the seven ages'.[92] But in the Middle Ages,
the division of life into seven was only one among several schemes,
some of them equally well-known. It offered, in the influence of the
seven planets, a plausible natural explanation for human develop-
ment; but medieval scholars (less interested in astrology, on the
whole, than their successors in the Renaissance) were inclined, like
the author of the *Tractatus*, to prefer the language of qualities and
humours. Indeed, where seven-age schemes do occur, they quite
often display no trace of astrological character.

A notable vernacular exception is to be found in a *dit amoreux*
composed by Jean Froissart in 1373, *Le Joli Buisson de Jonece* ('The
Fair Arbour of Youth'). Here Froissart devotes nearly one hundred
lines (ll. 1611–707) to a formal exposition of the seven ages and the
corresponding planets in their Ptolemaic order, 'selonc l'astrologe'.
Thus:

[92] The Titian painting is reproduced here, Plate 5. Modern ignorance of the subject
is illustrated in Levinson's book, *The Seasons of a Man's Life*. Levinson and his as-
sociates identify a life-cycle of four ages as 'universal', and observe that, 'in exploring
the question of universality, it would help if we had more data on the life cycle of
earlier cultures'. The authors go on to cite three old schemes, from the Talmud, Con-
fucius, and Solon, evidently unaware that their own scheme of four 'seasons' has a
long and distinguished history: *The Seasons*, 324–6.

La Lune coustumierement
Gouverne tout premierement
L'enfant, et par iiii ans le garde,
Et sus sa nourechon regarde.

[Customarily the Moon takes charge first of the infant, and guards him for four years and watches over his nurturing.][93]

There is no reason to doubt that by the later fourteenth century persons of quality in France, and England, would have known something of the seven ages, through books or otherwise. King Charles V of France possessed a tapestry representing 'Sept Ars et Estats des Ages des gens'.[94] But Froissart's exposition is notable both for its fullness of specification and also, especially, for its subtle relation to its context. *Dits amoreux* were poems of spring, love, and youth, like so much courtly poetry; but at the beginning of this *dit* the author presents himself as a greying thirty-five-year-old who is beginning to feel too old for such vanities. Prompted, oddly enough, by Lady Philosophy, he attempts to recover his youthful inspiration by recalling a forgotten mistress; but it is only when he falls asleep and dreams that he is young again, and in love again, that the sources of courtly love poetry are once more unlocked. Guided by Venus and Youth, the dreamer re-enters the 'fair arbour of youth'. This strange spherical growth represents, he discovers, nothing less than the whole created world of nature, bounded by the firmament, with the fixed stars as leaves and the seven planets as branches. It is Youth himself who explains the astrological mystery according to which these last govern the seven ages of man. Not surprisingly, therefore, this account of the matter exhibits a bias towards the young and happy (a bias opposite to that of Jaques's account in *As You Like It*). Thus in Ptolemy's account Mars, ruler of the fifth age, 'introduces severity and misery into life, and implants cares and troubles in the soul and in the body, giving it, as it were, some sense and notion of passing its prime';[95] but Froissart's Youth speaks of this as the age when men

[93] *Le Joli Buisson de Jonece*, ed. A. Fourrier (Geneva, 1975), ll. 1616–19.

[94] For this and other pictorial representations, see R. van Marle, *Iconographie de l'art profane* (La Haye, 1931), ii. 156–9. A French Duke had a tapestry of the seven ages made in 1402. Henry V of England owned a set of tapestries, with French inscriptions, representing among other things the seven ages: J. Evans, *English Art 1307–1461* (Oxford, 1949), 93.

[95] *Tetrabiblos*, ed. Robbins, 445.

delight in winning by battle or by 'art' honour, power, and pos-
sessions. Yet even this sanguine version of the matter strikes the
dreamer, in the intoxication of his restored youth, as untimely:

> Espoir, uns temps encor venra
> Que plus penser m'i couvenra,
> S'en sentirai lors mieuls les gloses,
> Car leurs saisons ont toutes coses. (ll. 1732–5)

[No doubt there will come a time when I will need to think more about that
and will understand its meaning better, for all things have their season.]

Meeting his lady once more, the dreamer recovers the experience—
and the lyric poetry—of youthful passion; yet even as he does so, the
curious double consciousness of dream prompts him to ask Youth
how his lady can still be as young and fresh as she once was. Youth
reassures him, maintaining that the spirit of true love can rise above
nature and transcend the ravages of time; but the two examples
which he offers in support of this 'moult courtois' doctrine serve in
fact to undermine it, for one concerns two lovers who are blinded by
love to each other's ageing and the other concerns a dead mistress
who stays young only in her lover's dreams (2013–209). It proves im-
possible even for lovers, in fact, to be 'toutdis en un point'; and the
dreamer's fear that 'il faut son cours Nature avoir' is realized when
at last he wakes from his dream of youth and love to the wintry
realities of the present time, with its thoughts of approaching death
and judgement. Here, then, the Ptolemaic scheme of the seven ages
of man is adopted to represent, in a *dit amoreux*, that ineluctable
'course of nature' which casts its shadow even across the springtime
landscape of courtly love. In the end it is the sense of a passed or
passing prime which prevails in *Le Joli Buisson*, as it does in Gower's
Confessio Amantis and in the poems of Charles d'Orléans.

I know of nothing in the English poetry of the time to match
Froissart's exposition of the Ptolemaic seven ages. The French
poet's contemporary, Chaucer, refers to 'the wise astrologien, Daun
Ptholome', and probably knew the Latin *Tetrabiblos*.[96] Yet the rela-
tionships of Venus, Mars, Diana, Jupiter, and Saturn to the ages of

[96] *Canterbury Tales*, III. 324. J. D. North assumes, without being able to prove,
that *Tetrabiblos* was Chaucer's principal astrological source: *RES*, NS xx (1969), 134.

man in Chaucer's *Knight's Tale* are mainly governed, not by their distance as planets from the earth, as in the Ptolemaic scheme, but by their positions as gods in the age-hierarchy of Olympus. The difference is most evident in the case of Jupiter. As the last planet but one, Ptolemy's Jupiter represents a sixth, elderly age of renunciation and retirement; but the Jupiter of the mythographers is at the height of his powers as the ruler of Olympus, standing between his superseded father, old Saturn, and the younger generation of Venus, Mars, and Diana. It is in the latter capacity, as king of the gods, that he corresponds to Duke Theseus, at the centre of that scheme of three ages which, as we have already seen, Chaucer adopts in his tale.[97] Thus Chaucer's version of the parallel between the ages of man and the planet-gods does not distinguish seven ages. Conversely, where seven-age schemes do appear in the art or literature of medieval England, we commonly find that the planetary parallel is not drawn. In the case of these writers and artists, as in the case of Shakespeare, it is therefore a matter of speculation to determine their affiliations, whether Ptolomaic, or Hippocratic, or possibly neither.

A case in point is the representation of the seven ages which forms part of the remarkable set of wall-paintings, dating from about 1330, which has been uncovered in modern times in the great chamber of Longthorpe Tower, near Peterborough, Northamptonshire (Plate 6).[98] Evidence from Italy suggests that by the later Middle Ages the theme of the seven ages had there become a favourite subject in the decoration of churches and great houses—woven in tapestries, painted on walls and façades, carved on capitals, and set in marble floors. Thus one of the columns supporting the lower storey of the Doge's Palace in Venice displays on seven sides of its octagonal capital figures representing the seven ages, each with an inscription nam-

[97] See n. 16 above. Treating the planets as gods makes it difficult, perhaps impossible, to maintain Ptolemy's seven-age scheme. Thus the astrologer Michael Scotus, cited by Boll as one of the first Western exponents of planet-age parallels, lists only five planetary gods (omitting the sun and moon): Mercury, Venus, Mars, Jupiter, Saturn (Boll, 202–3). In this shortened set, Jupiter can with some plausibility be described, as Scotus describes him, in terms appropriate to the ruler of Olympus: 'He has full and regular features, with all appropriate colouring, like a man of forty years, with flaxen hair and the beard a little grown after shaving.'

[98] The discovery at Longthorpe was first announced by E. C. Rouse in *Country Life* (1947), 604–8. The fullest account is by the same author and A. Baker, *Archaeologia* xcvi (1955), 1–57.

ing the age together with its ruling planet and its extent in years, both as in Ptolemy. The eighth face is occupied by death. Fourteenth-century frescos in the choir of the Eremitani in Padua also represent the ages with their corresponding planets, as do the frescos painted about 1420 in the Palazzo Trinci in Foligno.[99] A most elaborate example, no longer extant, is the frescoed façade of Sforza Almeni's house in Florence, painted to a design by Vasari in 1554 and recorded by him in his *Lives of the Painters*. Above the spaces marked out in the façade by the six windows of the first floor were seven ovals representing the seven ages of man, each accompanied by a theological or cardinal virtue: infancy/charity, boyhood/faith, adolescence/hope, youth/temperance, manhood/prudence, old age/fortitude, decrepitude/justice. In the corresponding seven positions on the ground floor below were painted the seven liberal arts, while the spaces between the six windows above on the second floor were occupied by the planetary gods with their zodiacal signs.[100] The interior murals at Longthorpe are equally elaborate but (so far as can be determined) less systematically planned. Among the many subjects represented on the walls and vault of the great chamber are birds, beasts, and dragons, saints, hermits, apostles, and evangelists, the Nativity, musicians, kings, coats of arms, the three living and the three dead, the five senses, the twelve labours of the months, and the seven ages of man. This last subject, as can be seen in Plate 6, follows the line of an arch over a recess, from left to right: *infans* in a cot, *puer* with a whipping-top, *adolescens* almost obliterated, *juvenis* at the top of the arch with a hawk on his wrist, *senior* with a sword at his side (and also a hawk?), *senex* with a money bag, and *decrepitus* on crutches.[101] Thus, a visitor to the Thorpes of Longthorpe, entering their great chamber from the south, would have been confronted on the opposite wall by a vivid image of the arch of human life,

[99] See J. Seznec, *The Survival of the Pagan Gods*, trans. B. F. Sessions (New York, 1953), 127, 131–2. The marble floor of the Duomo in Siena was decorated in the fifteenth century with images of the seven ages, accompanied not by the seven planets but by the three theological virtues. The ages are *infantia, pueritia, adolescentia, iuventus, virilitas, senectus,* and *decrepitas.* As at Longthorpe, *iuventus* carries a hawk on his wrist.

[100] Vasari's Life of Cristofano Gherardi. *The Lives of the Painters*, trans. A. B. Hinds (London, 1963), iii. 227–31.

[101] The Longthorpe painting of the ages is discussed by Rouse and Baker, 10, 43–4. I am indebted to Dr Mary Dove for letting me see her discussion, from which the reading *senior* and the conjecture *juvenis* is taken.

rising from the cradle to its summit in *juventus* and descending from there to the brink of the grave.

The planets have no place at Longthorpe, and I can see nothing distinctively astrological in these representations, unless it be the fact that the figure of the fifth age, assigned by Ptolemy to Mars, carries a sword.[102] Nor do the other paintings on the same wall, with the doubtful exception of the Nativity, serve to elucidate the artist's conception. Perhaps this version of the ages was designed, like the painting of the three living and the three dead elsewhere in the chamber, to prompt reflection on the transient nature of life. The worldly felicity of *juvenis*, standing four-square at the top of the arch with his hawk, may be seen as challenged by the images of infantile and senile impotence which flank it. Thus we were, and thus we will be. Such a moral and didactic emphasis distinguishes many medieval English versions of the ages. The Longthorpe painting may be compared in this respect with the Wheel of Life paintings to be found in certain native churches and psalters. Murals representing the ten ages of man in the form of a wheel were painted in the thirteenth century in the churches of Kempley, Gloucestershire, and Leominster, Herefordshire; and there is a magnificent version of the same subject in the psalter of Robert de Lisle (Plate 7).[103] These pictures do not, of course, belong to the tradition of the seven ages; but the psalter page in particular, dating from about the same time as the Longthorpe picture, displays a similar didactic intention. At the hub of the wheel is God's head, surrounded by an inscription: 'Cuncta simul cerno, totum ratione guberno' ['I see everything at once and govern by reason']. The eternal God sees the whole of time as eternally present, including the times of man's life, which are all equidistant from him: the four ages at the corners (*infantia, iuventus, senectus,* and *decrepitus*), with the ten ages into which they can be subdivided forming a circle

[102] See Rouse and Baker, 44 n. 5.

[103] On all three, see G. McN. Rushforth, 'The Wheel of the Ten Ages of Life in Leominster Church', *Proceedings of the Society of Antiquaries of London*, 2nd Ser. xxvi (1913–14), 47–60. The Leominster picture is now almost obliterated, and the Kempley version, though better preserved, is very indistinct. The early fourteenth-century de Lisle psalter forms the second part of British Library MS Arundel 83. The Wheel of Life occupies fol. 126ᵛ, preceded on fol. 126ʳ by a diagram of the twelve ages of man and followed on 127ʳ by a version of the three living and the three dead. There is another, more complicated version of the Wheel of Life by William de Brailes (mid-thirteenth-century) in Fitzwilliam Museum, Cambridge, MS 330 iv, also probably from an English psalter. See Plate 10 and p. 90 below.

of medallions around him. Yet whereas the circular diagrams of Byrhtferth's *Manual* convey a neutral view of the ages as forming part, with the seasons and elements, of the great order of nature, the pictures and inscriptions of the de Lisle wheel convey moral messages: the folly of youthful hope ('I shall never suffer a fall'), the pride of maturity ('King I am, I rule the world'), and the bitter disillusionment of the dying ('Life has deceived me').[104] The figure of *juvenis* high on the Longthorpe wall differs iconographically from the royal figure that dominates the psalter picture (where the hawk is carried by the age immediately preceding); but both represent the same short *acmē* to which human life climbs and from which it soon declines.

A more explicitly didactic version of the seven ages is to be found in a short English poem, probably dating from the early fifteenth century, which is headed 'Of þe seven Ages' in its one manuscript copy.[105] This piece bears some relation to a tradition of Latin verses in which representatives of the ages makes short characterizing statements, as they do in the de Lisle Wheel of Life. On another page of the de Lisle psalter, a diagram of the twelve ages of man introduces an interlocutor, Ratio, with whom each of the ages has a two-line exchange, thus:

> *Ratio*: Tu sublimatus, in quo sis, quero, beatus?
> *Vir*: Viribus ornatus, in mundo vivo beatus.

[Reason: O thou exalted one, in what, I ask, are you blessed? The mature man: Adorned with strength I live blessed in the world.][106]

[104] 'Numquam ero labilis' in the second medallion (whose picture belongs in the third and vice versa); 'Rex sum, rego seculum' in the fifth; 'vita me decepit' in the ninth and tenth. This version of the ten ages may be regarded as a seven-age scheme (up to and including *Decrepitas*, seen with his customary staff as at Longthorpe) which has been extended by the addition of three further 'ages'—dying, dead, and entombed—to make it more frightening and moral. Similar extensions of what are basically seven-age schemes are to be found in four Latin *memento mori* poems in Corpus Christi College, Cambridge, MS 481 (thirteenth-century), pp. 421–6. Here speakers representing the seven ages up to *decrepitus* are followed by a dying speaker (in the second and fourth poems) or by a dying and a dead speaker (in the first and third poems). I am indebted to Dr Dove's discussion of these.

[105] Reproduced in Plate 8 from British Library MS Additional 37049, fols. 28ᵛ–29ʳ. The poem was first printed by R. H. Bowers, *Shakespeare Quarterly* iii (1952), 109–12.

[106] MS Arundel, fol. 126ʳ. Dr Dove lists four other copies of these verses, which begin, 'Parvule, cur ploras?' (Walther, *Initia*, 13757 and 13759). The third of the four Latin poems referred to above (n. 104) takes the form of a dialogue between each of the nine ages and Death (Walther, *Initia*, 9709).

In the English poem, after each of the seven ages has made his state-
ment, he is addressed both by his good angel and by the fiend. Inno-
cence in the child and repentance in 'þe last old age' frustrate the
fiend; but in the intervening five ages he encourages man in an ap-
propriate vice: frivolity in boyhood, womanizing in adolescence,
pride of life in maturity, avarice in old age, and continued postpone-
ment of repentance in decrepitude. Thus the ages are here character-
ized morally, rather than astrologically or medically, as in the
following exchange between 'Man' (mature man, in his fourth age)
and his two counsellors:

> *Man spekes to hym selfe and says*:
> Now I am in strenthe; who dar to me say nay?
> *Angel*: Man, hafe mynde of þine endyng day.
> *þe fende*: Whils þou art ȝonge, be joly and lyght,
> With al ryall and ryche aray.
> When þou art olde and fayles myght,
> Þan is tyme to do foly away.
> *Angel*: Be war of þe fendes cownsell, I þe say,
> And of þine amendment make no delay.

As can be seen in Plate 8, the speeches in this poem are set in bal-
loons and linked by lines with crude representations of the speakers:
angel, devil, and man in his seven ages.[107] This format suggests their
kinship with the *tituli* of pictures such as the de Lisle Wheel of Life.
They were certainly not intended for dramatic performance. Yet 'Of
þe seven Ages' has been aptly described as 'an embryonic morality
play', for it represents just the sort of didactic writing out of which
the morality plays developed.[108] Plays such as *The Castle of Persever-
ance* and *Mundus et Infans* fill out a similar outline of human life and
display a similar didactic interest in the ages of man. In the early-fif-
teenth-century *Castle of Perseverance*, we can distinguish a first age
of childish innocence, a second age of 'ȝonge Foly' (l. 520), a moral
recovery—unusually—in middle life ('Þou art forty wyntyr olde, as I
gesse', (l. 1575)), and a wretched old age of covetousness and decre-

[107] The ages are represented by a naked babe, a boy, a youth, a man (with hal-
berd), an older man (with money bag), a 'crepil' (with black hood, rosary, and
crutch), and a dying man (naked again, with his soul flying out of his mouth).
[108] E. C. York, 'Dramatic Form in a Late Middle English Narrative', *MLN* lxxii
(1957), 484.

pitude (ll. 2482 ff.).[109] *Mundus et Infans*, printed in 1522, clearly distinguishes the first three ages, *infantia*, *pueritia*, and *adolescentia*, assigning to each a 'week' of seven years, as in the Hippocratic version of the seven-age scheme.[110] At the age of twenty-one, the World renames the protagonist 'Manhode', knights him, and introduces him to the Seven Deadly Sins. Finally, as 'Age', he repents of his wickedness and ends in the hope of heaven, like the protagonist of 'Of þe seven Ages' in his last old age.

For a fuller development of the seven-age scheme itself, however, we must now turn to Scotland. *Ratis Raving* was probably written in the early fifteenth century.[111] Its curious title, 'the ravings of Rate', is presumably ironical, applied as it is to a work of parental counsel designed to instruct young readers in virtuous and gentle discipline. The author first treats some of the well-worn themes of confessional literature: the right use of the five senses, the four cardinal and the three theological virtues, and so on. But Rate himself is, he admits, 'noþir monk nore frere', and he refers his young readers for more expert guidance to 'the buk of confessiouns'. He himself writes, it appears, as a pious layman; and in what follows he stresses, not without a certain worldly shrewdness, the importance of self-knowledge and the exercise of reason in a happy and virtuous life. It is in this connection that he introduces his long exposition of the seven ages, which occupies the second half of the poem (ll. 1098–736):

> Tak gud kep al-wais to this pase,
> Fore here are vrytin in lytill space
> Sum thingis that may help and sped
> To knaw the cours of thi ʒouthede,
> And of the mydys, and of thin eild. (ll. 1098–102)

[109] M. Eccles (ed.), *The Macro Plays*, EETS, os 262 (1969).

[110] G. A. Lester (ed.), *Three Late Medieval Morality Plays* (London, 1981). As 'Infans' the protagonist takes service with the World at the age of seven (l. 115) and is renamed 'Wanton'. 'Wanton' is a schoolboy, who plays with a whipping-top like *puer* at Longthorpe. At the age of fourteen (l. 70) he is renamed 'Lust and Liking' and speaks as a lover. At the age of twenty-one (l. 155) he becomes a man. Boll, 204, incorrectly cites *Mundus et Infans* as a seven-age text.

[111] *Ratis Raving*, ed. R. Girvan, STS, 3rd Ser. xi (1939). Girvan argues on linguistic grounds for a date 'not later than the opening decades of the fifteenth century' (p. lxxii). If ll. 626 and 1759 echo Chaucer's *Canterbury Tales* (i. 940, vii. 3265), as they seem to do, it cannot be earlier. The author, Rate, has not been identified.

To understand themselves and others, young gentlemen must know
of the seven 'tymis' or ages through which they are to pass; for each
has its own particular desires, preoccupations, and purposes:

> Ilkan of thaim hass sere ȝarnyngis
> And sere entent and sere etlyngis. (ll. 1106–7)

Elsewhere in his 'ravings' Rate speaks about the influence of the
planets upon men's dispositions (ll. 849, 900); but he does not refer
to them in his account of the ages. Here he emphasizes rather the ex-
ercise of reason and moral judgement, as these may be influenced
but not constrained by 'kindly inclynacioune'. His is an intelligently
eclectic discussion, in which Aristotelian biology and Hippocratic
medical lore play a larger part than Ptolemaic astrology.[112] Follow-
ing Aristotle's *De Anima*, he distinguishes three living powers in
man: vegetative (the capacity for physical growth and reproduction,
depending on nourishment), sensitive (the capacity for sensation and
movement, shared with beasts), and intellectual (peculiar to man).
In the first three years of life, the baby does little more than eat,
drink, and sleep, growing like a vegetable and feeling like a beast.
The only sign of its higher, intellectual soul at this stage is its
capacity to laugh and cry, which animals cannot do (ll. 1112–25). In
the second age, up to the end of innocence at seven, all three powers
develop, but judgement is still lacking (ll. 1142–9). From seven to fif-
teen, in the third age, reason and judgement are still weak and can-
not restrain the boy from spending his time in games. The poet gives
a lively account of the characteristic activities of the second and
third ages: the child making 'a cumly lady of a clout', and the boy
playing 'at the caich'. The fourth age is 'joly, proud and gay', extend-
ing from fifteen to thirty and dominated by the sanguine humour:

> In this eild, I say to thee,
> Growis of body and quantite,
> And blud haboundand is in hicht. (ll. 1382–4)

The powers of the rational soul are still developing, but they do not

[112] As authorities for the opinion that reason can overcome passion, Rate cites
'Arestotyll and Ypocras' (l. 1354).

fully ripen until the age of thirty, which ushers in the fifth age, from thirty to fifty, when reason reigns in man. This age carries with it the special obligation to do justice and foster the 'comon profit'. It is at this time that men's powers are at their height, an *acmē* represented by Rate, much in the manner of Aristotle's *Rhetoric*, as the ideal mean between youth and age:

> This eild can trawail best endure
> And wyne worschip and gret honore;
> May nothir auld na ȝonge it blame
> Bot gyf thai do thaim-selwyn scham,
> For it has part of gud ȝouthed
> And of gret eild it havis, na dreid. (ll. 1562–7)

After this the sixth age (to seventy or eighty) and the last (after eighty) bring a progressive cooling in the body and eventually, in decrepitude, a second childhood in which the rational soul fails. Old men should be wise and holy, but too often they are 'covatous and swere'—listless and grasping. Thus Rate sees the rational soul as developing slowly, and under continual threat from baser faculties, towards a perfection—or what ought to be perfection—in middle life, after which it most often declines into mere oblivion at the end:

> Fra tyme haif woirn awaye resoun,
> Sik is of eild conclusioun;
> As gryt ȝouthed has na knaving,
> Richt sa grit eild has tynt þat thing
> That it eir knev. (ll. 1732–6)

Aristotelian biology here yields a version of the progress of the soul much more pessimistic than that of Dante in *Il convivio*—a version darkened by the late-medieval sense of sin and mortality.

I cannot conclude this section on the seven ages without referring to Shakespeare. The excellent survey of the theme of the ages in England from 1485 to 1642 given by Samuel Chew in his book *The Pilgrimage of Life* makes it clear, to anyone acquainted with what had gone before, that Tudor and Stuart writers followed in the main the same authorities as their medieval predecessors and recognized the same schemes.[113] The state of learned opinion in Shakespeare's day may be gauged from the chapter 'Of the distinction of the Age of

[113] *The Pilgrimage of Life*, Chap. 6: 'The Path of Life'.

Man' in Thomas Fortescue's *The Foreste* (1571).[114] Fortescue gives
pride of place to the Ptolemaic seven-age scheme: 'By the common
division of Astrologians, as well *Arabies*, *Caldees*, *Greekes*, and
Latines: as also by the particuler opinion of Proclus, Ptolomie, and
Al Rasellus, the life of Man is devided in seven Ages, over every one
of which ruleth and governeth one of the seven Planetes.'[115] After
expounding Ptolemy's system, Fortescue goes on to specify other
divisions 'whiche wee finde geven us of renowmed Philosophers,
Physitions, and Poetes, whiche were emonge them selves of divers
and different opinions.' His survey of these ancient writers singles
out Aristotle (three ages), Pythagoras, Horace, and Avicenna (four),
Varro (five), Isidore of Seville (six), Hippocrates (seven), and Solon
(ten)—all authorities who would have been recognized as such by
medieval scholars.

The full title of Fortescue's chapter is 'Of the distinction of the
Age of Man, according to the opinion of moste Astrologians'; and
it is in giving such prominence to the astrologers that he differs most
from his medieval predecessors. Observant readers will have noticed
that I have not produced a single Middle English example of the full
Ptolemaic system of planetary ages. No doubt others will be able to
produce such examples, perhaps from some unpublished iatromath-
ematical treatise. Present evidence suggests, however, that the pla-
nets did not figure as large in the thinking of medieval Englishmen
about their natural span as they were to do in the Renaissance, when
astrology gained a new lease of life. Chew cites, for instance, a
majestic version of the Ptolemaic scheme from Sir Walter Raleigh's
History of the World (1614):

Our Infancie is compared to the Moon, in which we seem only to live and
grow, as plants; the second age to Mercury, wherein we are taught and
instructed; our third age to Venus, the days of love, desire, and vanity; the
fourth to the Sun, the strong, flourishing, and beautiful age of man's life; the
fifth to Mars, in which we seek honour and victory, and in which our
thoughts travail to ambitious ends; the sixth age is ascribed to Jupiter, in
which we begin to take accompt of our times, judge of ourselves, and grow
to the perfection of our understanding; the last and seventh to Saturn,
wherein our days are sad and overcast, and in which we find by dear and

[114] Bk. I, Chap. 17. Fortescue's book is an English version of a French version of
the *Silva de Varia Leccion* of Pedro Mexia (Seville, 1542).

[115] *The Foreste*, 45ʳ. The *Paraphrase* of Ptolemy's *Tetrabiblos*, attributed to Pro-
clus, was printed in 1554.

lamentable experience, and by the loss which can never be repaired, that of
all our vain passions and affections past, the sorrow only abideth.[116]

No one who is acquainted with the literature of the subject will
expect to find in it an exact source for the famous speech of Jaques in
As You Like It, II. vii. Shakespeare's characterizations of the ages of
man, like those of Aristotle in his *Rhetoric* and Horace in his
Ars Poetica, display an independence of observation and a lapidary
brilliance of expression which are the marks of his own genius. So
Shakespeare's commentators may perhaps be forgiven for failing to
recognize what has for some time been perfectly clear—that Jaques's
speech is to be understood as a version of that 'common division of
Astrologians' expounded by Fortescue and Raleigh.[117] Admittedly
the speech does not follow the Ptolemaic order throughout; but the
departures from that order lend themselves readily to a parallactic
explanation—as displacements, that is, arising from the observer's
point of view. For the melancholy Jaques, like Youth in Froissart's
Le Joli Buisson, is an observer with a bias. He speaks 'invectively' of
the life of man, seeing the worst in every age: babies vomiting, boys
whining, young men sighing or rushing to their deaths, mature men
smug, elderly men stingy, and old ones 'sans everything'. It is in
keeping with this jaundiced view that Jaques should displace, as he
evidently does, the Sun from its position as lord of what Raleigh
calls 'the strong, flourishing, and beautiful age of man's life'.[118] Up
to this central point, his little 'scenes' have displayed, albeit invect-
ively, the character of the planets in their Ptolemaic order. First

[116] Bk. I, Chap. 2, Sect. 5, cited by Chew, 165.

[117] This is the opinion of Chew (p. 165), citing E. Panofsky and F. Saxl, *Dürers
'Melencolia I'*, Studien der Bibliothek Warburg ii (Leipzig, 1923), 56. See also Kli-
bansky, Saxl, and Panofsky, *Saturn and Melancholy*, 149 n. 74, and earlier, Boll, 206–
11. For a recent discussion, see A. Fowler, 'Pastoral Instruction in *As You Like It*',
John Coffin Memorial Lecture (London, 1984), 8. D. C. Allen, *MLN* lvi (1941), 601–
3, suggested that Shakespeare read about the seven planetary ages in a French trans-
lation (Allen does not mention the English version) of Mexia's *Silva*. It is extraordi-
nary that a recent editor of the play should have contented herself with recording the
opinion that 'division into *seven* ages was in fact uncommon' (!) and citing as a rare
example *Batman uppon Bartholome*, which in fact belongs to a quite different, six-age,
tradition: *As You Like It*, ed. A. Latham (London, 1975), note to II. vii. 143. The
claims of Bartholomaeus Anglicus ('Bartholome' in the Tudor version) were urged,
quite unconvincingly, by J. W. Draper, *MLN* liv (1939), 273–6. On Bartholomaeus,
see below, pp. 88–9.

[118] The omission of the Sun is observed by Chew, following Panofsky and Saxl,
and by Fowler.

ipse minor. mundi sustinet inse. ide; homo.
incrochosin i est qui dicit minor. mud? Q
in aut ipsi humores. simphonius modula
tionib; sine quinciati in tetuur. iiii. ele
idcus u desimphosius y glerene enrtitla
ui reperenti. Ad ccca. viii quiq restart festi
nando. dissure dourtus.

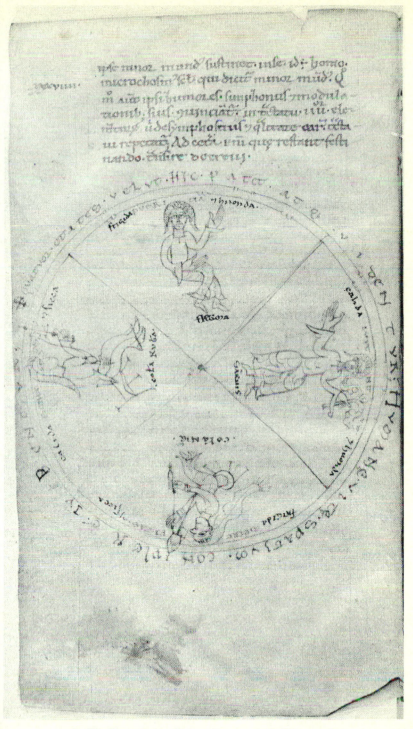

3. The Four Ages of Man: *Tractatus de Quaternario*

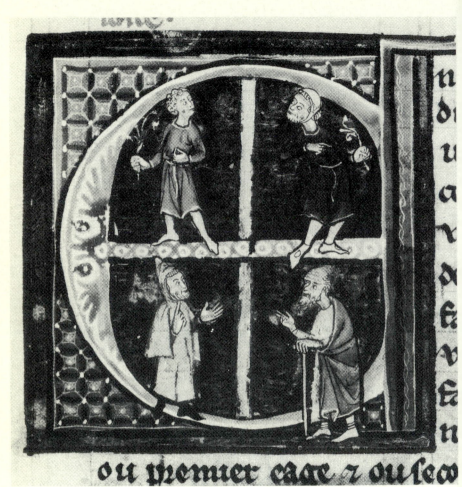

4. The Four Ages of Man: Aldobrandino of Siena, *La Régime du corps*

comes the age of the Moon, 'in which we seem only to live and grow':

> At first the infant,
> Mewling and puking in the nurse's arms.

Second, the age of Mercury, 'wherein we are taught and instructed':

> And then the whining school-boy, with his satchel,
> And shining morning face, creeping like snail
> Unwillingly to school.

Third, the age of Venus, 'the days of love, desire, and vanity':

> And then the lover,
> Sighing like furnace, with a woeful ballad
> Made to his mistress' eyebrow.

But the lord of Jaques's fourth age cannot be the Sun. This must be the age of Mars, fifth in Ptolemy's order, 'in which we seek honour and victory':

> Then a soldier,
> Full of strange oaths, and bearded like the pard,
> Jealous in honour, sudden and quick in quarrel,
> Seeking the bubble reputation
> Even in the cannon's mouth.

By thus skipping the Sun, Jaques creates complications later in the set; but his next age conforms to the traditional order, for its lord is clearly Jupiter, the next planet after Mars. Indeed, the casting of man at this stage of his life in the role of a justice is itself one of the best indications that Shakespeare did have the planet-gods in mind; for Jupiter was customarily associated with lawgiving and judgement, as in Dante's *Paradiso*, where the sphere of Jupiter is occupied by the just.[119] Not that Jaques's justice could claim a place in that heaven:

> In fair round belly with good capon lin'd,
> With eyes severe, and beard of formal cut,
> Full of wise saws and modern instances.

In Ptolemy's system Jupiter rules the sixth age, extending up to the

[119] The distinctly Jovian character of this fifth age rules out the suggestion, made by Boll, that Jaques has not omitted the Sun but rather followed an order in which it exchanges positions with Mars.

age of sixty-eight. This is followed only by that of Saturn, during which both body and soul decline into querulous weakness. At the same point Jaques, having omitted the solar age, is left with two ages, which he describes with gloomy relish:

> The sixth age shifts
> Into the lean and slipper'd pantaloon,
> With spectacles on nose and pouch on side,
> His youthful hose well sav'd, a world too wide
> For his shrunk shank; and his big manly voice,
> Turning again toward childish treble, pipes
> And whistles in his sound. Last scene of all,
> That ends this strange eventful history,
> Is second childishness and mere oblivion,
> Sans teeth, sans eyes, sans taste, sans everything.

The sixth age offers a scene of physical shrinkage and decline appropriate to the age of Saturn. Also, the purse is an attribute of Saturn, denoting the niggardly closeness into which old people were said to fall.[120] What follows, in the last scene of all, is only too clearly decrepitude. Fowler sees in it 'a second Saturnian age', whereas Chew takes the phrase 'second childishness' as indicating a return to the first age, lunar infancy. Either interpretation may be right. In his discussion of the matter, Fortescue remarks that a man may return to his lunar beginnings in extreme old age; yet it is also entirely apt, as Fowler argues, that melancholy Jaques should exaggerate the domain of the planet whose association with his own humour has been amply demonstrated in *Saturn and Melancholy*. On either interpretation, this last age forms a fitting conclusion to Jaques's pessimistic survey of the *cursus aetatis*. Life, as Shakespeare himself observed in his fifteenth sonnet, is nothing but a series of shows, governed by the unseen power of the planets:

> this huge stage presenteth nought but shows
> Whereon the stars in secret influence comment.[121]

[120] *Saturn and Melancholy*, 284–6. Covetousness is commonly treated by medieval moralists as the sin of old age, as in *The Castle of Perseverance*, 91–5. Chaucer's Criseyde remarks that 'elde is ful of coveytise' (*Troilus*, IV. 1369).

[121] Later lines in this sonnet suggest Shakespeare's acquaintance with biological thought about the ages: 'men as plants increase, | Cheered and check'd e'en by the self-same sky, | Vaunt in their youthful sap, at height decrease, | And wear their brave state out of memory'.

2

Time

In the hands of biologists, *medici*, and astrologers, the schemes discussed in the last chapter offered several different ways of explaining the changes to which human beings are subject. Such authorities might speak of the heat of life burning away the moisture on which it fed, or of the supersession of one humour by another, or of the successive influence of the planets. These are scientific explanations (however outmoded the science) in so far as they posit physical causes for the processes of human growth and decline. The present chapter, however, will be concerned with explanations which rest, not on natural causes, but on temporal relations: parallels or *comparationes* drawn between the divisions of man's life and divisions in diurnal, annual, and historical time. To a modern reader such analogies may seem at best poetic and at worst merely fanciful; and they are indeed, as we shall see, expounded by medieval writers with considerable freedom of invention. As in so much older analogy-spotting, however, this freedom rested on a firm conviction that speculation could hardly go wrong. The order of time, like the order of nature upon which it largely depends, issues from the hand of God; and God does nothing arbitrary or random. He fashioned man as a *microcosmos* or little world; so what could be more natural than to seek out the analogies—surely God-given—between the ages of man and divisions of time in the larger world? Such investigations could hardly fail to disclose further patterns of order and meaning in the *cursus aetatis*. The survey which follows will look first at patterns involving the cycles of natural and liturgical time: day and night, week, month, and year. The remainder of the chapter will be concerned with the most common of all such analogies: that between the ages of man and the ages of the world.

I

> In me thou see'st the twilight of such day
> As after sunset fadeth in the west,
> Which by and by black night doth take away,
> Death's second self, that seals up all in rest.

Such comparisons as this, in Shakespeare's seventy-third sonnet, between the course of man's life and the course of the day would be understood, one suspects, in any culture whatsoever, No editor need annotate Shakespeare's reference to the evening of his days. Nor will any reader fail to see the point when, in a Middle English poem, Youth tells Age:

> Þe sunne is past fer bi þe sowthe,
> And hiȝeth swiþe in to þe weste.[1]

It is characteristic of medieval writers, however, that they develop this eminently natural comparison in a number of more specific forms. In *The Kingis Quair*, for instance, Dame Fortune warns the dreamer to take a good grip of her wheel:

> 'Now hald thy grippis', quod sche, 'for thy tyme,
> An hour and more it rynnis over prime:
> To count the hole, the half is nere away—
> Spend wele, therfore, the remanant of the day.'[2]

One might even respond to this passage, on the back of an envelope, as follows. If prime marks the end of the third of the twelve hours of the day (9 a.m.), then the dreamer's day has reached, say, 10.30 a.m. ('an hour and more' later) and is approaching the half-way point, midday. Taking the conventional life-span of seventy years, we would then arrive at an age of about twenty-six for the dreamer.[3]

[1] *The Mirror of the Periods of Man's Life*, ed. F. J. Furnivall, *Hymns to the Virgin and Christ*, EETS, os 24 (1867), ll. 347–8. At l. 374, Age says 'It is past evensonge of my day'.

[2] James I of Scotland, *The Kingis Quair*, ed. J. Norton-Smith (Oxford, 1971), ll. 1194–7.

[3] If the poem was written after James's marriage, as its editor maintains (p. xxiv), he cannot have been less than twenty-nine years old. Perhaps 'and more' should be interpreted more generously. A similar calculation seems to be called for by the statement in a fifteenth-century poem, *The Nightingale*, that Warwick died 'entryng the oure of tierce' in his life: O. Glauning (ed.), EETS, es 80 (1900), l. 332. Warwick died shortly after completing his twentieth year.

Such comparisons between life and the hours of daylight involve a variety of age-schemes. The most obvious pattern is the simple triadic one of *augmentum*, *status*, and *decrementum*. According to Aristotle, human life may be compared to an arch, mounting and descending; so what could be more natural than to draw a parallel between the *cursus aetatis* and the sun's daily transit through the sky? The sun itself may be said to pass through the three ages of man in the course of its day. One statement of this idea, authoritative for the Middle Ages, is to be found in the *De Nuptiis Philologiae et Mercurii* of Martianus Capella, who describes the Sun-god as follows: 'Facie autem mox ingressus est pueri renidentis, in incessu medio iuvenis anheli, in fine senis apparebat occidui' ['He entered with the appearance of a beaming boy, in his middle course he was like a man panting for breath, and at the end he seemed an old man in decline'].[4] According to the commentary of John Scotus Erigena, this passage suggests the three conditions of the sun: 'For when he first rises above the horizon, he displays a bright countenance like a beaming boy until he climbs to the third hour; from the third to the ninth hour he looks like a mature man; from the ninth hour until sunset he has the appearance of old age, as if worn out by the effort of too great speed.'[5] In his seventh sonnet ('Lo, in the orient when the gracious light') Shakespeare develops the same idea of the three ages of the sun, devoting a quatrain to each. The sun rises in the orient, resembles 'strong youth in his middle age' at its zenith, and sinks wearily into 'feeble age' in the west.[6]

Another possibility was to divide the daylight hours into four. In that case, the day comes to be seen as governed by the same sequence of qualities as govern the other tetrads which make up the Physical and Physiological Fours. Thus the Renaissance numerologist Petrus Bungus, in his chapter on the number four, explains that, where the day from sunrise to sunset is divided into twelve hours (the so-called 'unequal' hours), the first three will be governed by the sanguine humour, the second three by red choler, and so on. To the resulting four divisions of the day, he observes, correspond the four seasons

[4] *De Nuptiis*, ed. J. Willis (Leipzig, 1983), I. 76.

[5] See *Annotationes in Marcianum*, ed. C. E. Lutz (Cambridge, Mass., 1939), 47.

[6] Shakespeare's sonnets, even more than his plays, reveal an acquaintance with traditional thinking about the ages. His phrase 'strong youth in his middle age', which seems to point in two directions at once, reflects the perennial difficulty in English of rendering *juvenis* where that Latin term denotes the middle of three ages.

of the year and the four ages of man.[7] Dante makes the same comparison in *Il convivio*, after introducing his division of life into four:

E queste parti si fanno simigliantemente ne l'anno, in primavera, in estate, in autunno e in inverno; e nel die, ciò è infino a la terza, e poi infino a la nona (lasciando la sesta, nel mezzo di questa parte, per la ragione che si discerne), e poi infino al vespero e dal vespero innanzi. E però li gentili, cioè li pagani, diceano che 'l carro del sole avea quattro cavalli.

[And these parts occur in like manner in the year, in spring, in summer, in autumn, and in winter; and also in the day, that is, up to tierce, and then up to nones (omitting sext between these two, for an obvious reason), and then up till vespers, and from vespers onward. And therefore the Gentiles (the pagans, that is) said that the chariot of the sun had four horses.][8]

Thus, in Dante's account, the day is divided into four three-hour segments by the canonical hours tierce (9 a.m.), nones (noon), and vespers (3 p.m.), these segments being represented by the sun's four horses, and corresponding to the four ages of man. Earlier in the same chapter, Dante employs a curious argument to show that this same correspondence determined the very hour of Christ's death on the cross. Having reached his thirty-fourth year, near enough to the central high point of man's seventy-year span, Christ wished to die at the corresponding high point of the day: 'onde dice Luca che era quasi ora sesta quando morio, che è a dire lo colmo del die' ['wherefore Luke tells us that it was about the sixth hour when he died, which is to say the apex of the day'].[9] So the sun was at its zenith, at the end of the sixth hour of its day, when Christ, the sun of justice, himself at the zenith of his life's arc, was exalted in death. It was not fitting that the Godhead should suffer the indignity of *decrementum*; but up to the point where the arc turns downwards, and even in the very hour of his death, Christ's perfect humanity fulfilled and made manifest that natural order to which other men can conform only imperfectly.

[7] *Numerorum Mysteria* (Paris, 1618), 216. The treatise on regimen in Bodleian Library MS Ashmole 189 includes among other customary Fours the four divisions of the twenty-four hour day, each apportioned to a humour (fol. 217ʳ).

[8] *Il convivio*, IV. xxiii. 14. On the omission of sext, see Wicksteed's note to his translation, p. 347.

[9] *Il convivio*, IV. xxiii. 11. The phrase 'hora quasi sexta' is in fact used by St John in his Gospel (19:14) of the time when Pilate delivered Jesus to be crucified. Luke (23: 44) says that when it was 'fere hora sexta' darkness covered the earth until the ninth hour. The hour of Christ's death was a matter of controversy: see Thomas Aquinas, *Summa Theologica*, 3 q. 46 a. 9. On Christ and the ages of man, see further Chap. 4 below.

The full set of the canonical hours, of which Dante mentions only three, amounts to seven: matins, prime, tierce, sext, nones, vespers, and compline. The liturgical practices of the Church were a favourite subject of allegorical interpretation in the Middle Ages, to which the general method of educing meanings by adducing parallels could be supposed, *a fortiori*, to have particular application. It is therefore not surprising to find the twelfth-century writer Honorius 'of Autun', in one of his liturgical works, associating the seven hours with (among other things) seven ages of the world and seven ages of man. His chapter on the latter parallel ('De Horis et Aetatibus') opens with these words: 'Dies etiam repraesentat nobis vitam uniuscuiusque, quo diversis aetatibus, quasi diversis horis, docetur ex lege Domini quasi in vinea laborare' ['The day also represents for us the life of every man, taught by God's law to labour in the "vineyard" in his various ages or "hours" '].[10] In each of the seven canonical hours we are to call to mind the corresponding age, and praise God for a gift associated with that age. Thus: 'per Matutinam commemoramus infantiam, in qua quasi de nocte ad diem orti sumus, dum de matribus in hunc mundum nati sumus. Juste itaque in hac hora Deum laudamus, qua de nocte erroris ad lucem veritatis in baptismo nos renatos exsultamus' ['in matins we remember infancy, in which we rose, as it were, from night to day, when we were born of our mothers into this world. Rightly then do we praise God at this hour, rejoicing to be reborn through baptism from the night of error into the light of truth.'][11] Another *comparatio* between the canonical hours and the ages may be found in a Middle English chanson d'aventure, *This World is but a Vanyte*. Here an old man is discovered reflecting upon the vanity of the world: 'Mannis lijf here is but a day'. Each of the seven 'hours' of his own day now, as death approaches, gives him occasion for weeping: the suffering of his mother and the lost innocence of infancy ('þe morewe'), the games and squabbles of childhood ('mydmore'), the frivolity and recalcitrance of the schoolboy ('undren'), the knightly pride and transient beauty of youth ('mydday'), the kingly arrogance of maturity ('hiʒ noon'), the loss of joy in old age ('mydovernoon'), and the chill and weakness of decrepitude ('evensong tyme'). Thus:

[10] *Gemma Animae*, Bk. II, Chap. liv (*PL* 172. 633).
[11] Ibid. Honorius's sequence of ages runs: *infantia, pueritia, adolescentia, juventus, senectus, aetas decrepita, finis vitae*.

> At hiȝ noon y was crowned king,
>> Þis world was oonli at my wille;
> Evere to lyve was my liking,
>> And alle my lustis to fulfille.
> Now age is cropen on me ful stille,
>> And makiþ me oold and blac of ble,
> And y go downeward wiþ þe hille;
>> Þis world is but a vanite.[12]

In Honorius, the seven 'hours' of life are marked by blessings and recalled with thanksgiving; but here they serve only to illustrate the vanity and folly of life in all its stages. It is a very medieval version of Jaques's theme.

In the passage quoted above, Honorius employs the ubiquitous word *quasi* to introduce a reference to Christ's Parable of the Vineyard: 'quasi in vinea laborare'.[13] He compares the ages of man to the hours at which the labourers were called into the vineyard. This parable plays such a significant part in medieval writing and preaching about the ages that it must be quoted here at length:

The kingdom of heaven is like to an householder who went out early in the morning [*primo mane*] to hire labourers into his vineyard. And having agreed with the labourers for a penny a day, he sent them into his vineyard. And going out about the third hour [*circa horam tertiam*], he saw others standing in the market place idle. And he said to them: Go you also into my vineyard and I will give you what shall be just. And they went their way. And again he went out about the sixth and the ninth hour [*circa sextam et nonam horam*] and did in like manner. But about the eleventh hour [*circa undecimam*] he went out and found others standing. And he saith to them: Why stand you here all the day idle? They say to him: Because no man hath hired us. He saith to them: Go you also into my vineyard. And when evening was come, the lord of the vineyard saith to his steward: Call the labourers and pay them their hire, beginning from the last even to the first.[14]

[12] Furnivall (ed.), *Hymns to the Virgin and Christ*, ll. 41–8. Lydgate's *Ditty upon Haste* speaks of a 'prime' and a 'mydday' in life, and identifies 'complyne' with death: *Minor Poems* II, ed. H. N. MacCracken, EETS, os 192 (1934), ll.51–6. Another fifteenth-century poem, *The Nightingale* (see n. 3 above), based on the *Philomena* of John Peckham in which the song of the bird at five canonical hours is associated with meditations on the life of Christ, adds *comparationes* between the hours and the ages to its Latin original: 'Fro morow to nyght betokenes all the tyme | Syth thou wast born streyght tyll þat thou dye' (ll. 197–8).

[13] In a later chapter of the *Gemma*, Honorius speaks of the daily office as itself an imitation of the work in the vineyard: *PL* 172. 634.

[14] Matthew 20:1–8, Douay version, with Latin from Vulgate.

The main point of Christ's story was to illustrate the puzzling doctrine that the last shall be first and the first last; but early exegetes felt obliged also to explain the five times of day specified: *mane, hora tertia, hora sexta, hora nona*, and *hora undecima*. One solution was to draw a parallel between the working day and a human life. Five-age schemes were by no means common in Antiquity, perhaps because they lacked supporting analogies such as were provided for other schemes by the planets and the seasons. Varro is the only ancient authority often cited.[15] However, Christ's parable could provide just such support, and was so taken by the Greek father Origen. In his commentary on Matthew's Gospel, Origen became the first, so far as I know, to interpret the parable in a fashion which was to be familiar to many later readers and church-goers. God, he says, calls some men to the work of his kingdom in early childhood, some in youth, some in maturity, some in age, and some in extreme old age when they are near death ('at the eleventh hour').[16]

In the Latin West throughout the Middle Ages Origen's interpretation was repeated and developed, mainly in Gospel commentaries and sermons. It is briefly summarized in two sermons by St Augustine; but the prime authority for later writers was St Gregory the Great.[17] Following Origen, Gregory first expounds the five hours as representing the five ages of the world in which God sends his messengers to men. He then turns to the ages of man:

Possumus vero et easdem diversitates horarum etiam ad unumquemque hominem per aetatum momenta distinguere. Mane quippe intellectus nostri pueritia est. Hora autem tertia adolescentia intellegi potest, quia quasi jam sol in altum proficit, dum calor aetatis crescit. Sexta vero juventus est, quia velut in centro sol figitur, dum in ea plenitudo roboris solidatur. Nona autem senectus intelligitur, in qua sol velut ab alto axe descendit, quia ea aetas a calore juventutis defecit. Undecima vero hora ea est aetas quae decrepita vel veterana dicitur.

[15] On five-age schemes in Antiquity, see Boll, 176–7. Varro's scheme is reported variously by Censorinus, *De Die Natali Liber*, 14. 2, and Servius on *Aeneid* V. 295. Eyben stresses the influence of Varro: art. cit. 164. He gives a list of five-age passages, 159–60.

[16] Origen, *Commentary on Matthew*, PG 13. 1359–60. See C. Gnilka, *Aetas Spiritalis: Die Überwindung der natürlichen Altersstufen als Ideal frühchristlichen Lebens* (Bonn, 1972), 105 n. 44.

[17] Augustine, *Sermones* XLIX and LXXXVII (*PL* 38. 320 and 533); Gregory, *XL Homiliarum in Evangelia*, Bk. I, Hom. 19 (*PL* 76. 1155), from which I quote.

[We can also apply the same distinction between these hours to the individual by virtue of the division of his ages. For the morning of our understanding is boyhood. The third hour can be taken as adolescence, because now the sun is climbing high, as it were, while the heat of life increases. The sixth hour is maturity, because the sun stands as if at its zenith when in that age the fullness of strength is established. The ninth hour is understood as old age, in which the sun descends, as it were, from the highest heaven, for that age has fallen away from the heat of maturity. The eleventh hour is that age called 'decrepit' or 'veteran'.]

Gregory's homily was intended for Septuagesima Sunday, when the Parable of the Vineyard was set as the Gospel reading at Mass; and it provided the model for many later homilies on that day of the Church's year. In the Carolingian period it was reproduced by Paul the Deacon in his *Homiliary*, by Hrabanus Maurus in his *Commentary on Matthew*, and by Haymo, in amplified form, in his Septuagesima homily.[18] Gregory was also the acknowledged source of Ælfric, whose *Catholic Homilies*, completed in 992, include a Septuagesima sermon in which the exposition of the five 'hours' of life is directly translated from the Latin. Ælfric's version is of some interest, since it represents the earliest known attempt (earlier than Byrhtferth's) to render an age-scheme in English vernacular terms, and illustrates the lexical difficulties which arose in the process. The distinction made by Ælfric between *cildhad* and *cnihthad* receives little support from earlier usage and appears to have developed in response to the difficulty of rendering the Latin distinction between *pueritia* and *adolescentia* in English.[19] *Fulfremed wæstm* ('completed growth') is an improvisation to meet the chronic problem of finding an English equivalent for *juventus* in such contexts. *Yld* serves well enough for *senectus*; but *forwerod ealdnyss* ('worn-out age') is a cumbrous rendering of *aetas decrepita*. Nevertheless, Ælfric manages to produce a version of Gregory's Latin so faithful that my own previous translation of the latter will serve also for the Anglo-Saxon:

We magon eac ðas ylcan mislicnyssa ðæra foresædra tida to anum gehwylcum menn þurh his ylda tidum todælan. Witodlice ures andgites merigen is

[18] For Paul's *Homiliary*, see Smetana, *Traditio* xv (1959), 169, item 69; Hrabanus, *PL* 107. 1027; Haymo, *PL* 118. 157.

[19] See the study by H. Bäck, cited in n. 30 to Chap. 1 above.

ure cildhad; ure cnihthad swylce underntid, on þam astihð ure geogoð, swa swa seo sunne deð ymbe þære ðriddan tide; ure fulfremeda wæstm swa swa middæg, forðan ðe on midne dæg bið seo sunne on ðam ufemestum ryne stigende, swa swa se fulfremeda wæstm bið on fulre strencðe þeonde. Seo nontid bið ure yld, forðan ðe on nontide asihð seo sunne, and ðæs ealdigendan mannes mægen bið wanigende. Seo endlyfte tid bið seo forwerode ealdnyss.[20]

The Gregorian interpretation of the Parable of the Vineyard continued to be repeated by preachers and exegetes throughout the Middle Ages. The earliest Middle English version appears in a Septuagesima sermon translated into the English of thirteenth-century Kent from a French original. This version is peculiar in that it reduces both the times and the ages to four: 'childhede', 'age of man', 'men of xxxti wyntre oþer of furti', and 'elde of man'.[21] Perhaps pressure from the much better-known four-age scheme had something to do with this reduction, which is effected by combining *hora sexta* and *hora nona* into one as 'middai'. Exactly the same alteration is made in a Latin sermon by the English preacher, Thomas Brinton. Preaching in the 1370s or 1380s on the theme of death, Bishop Brinton warned his congregation to repent while there was still time, since no one knows when death may come, 'in mane puericie, an in tercia adolescencie, an in meridie iuventutis, an in sero senectutis' ['in the morning of boyhood, or the third hour of adolescence, or the high noon of maturity, or the evening of age.'][22] Another popular English preacher of Chaucer's day, Thomas Wimbledon, taking the parable as his protheme in 1388, also specifies only four ages, adding scriptural examples: 'Also he clepeþ men in diverse agis: summe in childhod as Jon Baptist; summe on stat of wexenge as Jon þe Evangelist; summe in stat of manhod as Peter and Andrew; and summe in old age as Gamaliel and Josep of Aramathie. And alle þese he clepiþ to travayle on his vyne þat is þe chirche, and þat on diverse

[20] *Catholic Homilies: The Second Series*, ed. M. Godden, EETS, ss 5 (1979), 44 ('Dominica in Septuagesima'). Ælfric omits Gregory's reference to bodily *calor*, perhaps because he thought it too technical.

[21] *Kentish Sermons*, 'Dominica in sexagesima [*recte* septuagesima] sermo', in *Early Middle English Verse and Prose*, ed. J. A. W. Bennett and G. V. Smithers, 2nd edn. (Oxford, 1968), 221–2. Byrhtferth's *Manual* also reduces the hours of the vineyard to four, but by omitting *hora sexta* (ed. cit. 218).

[22] *The Sermons of Thomas Brinton, Bishop of Rochester (1373–1389)*, ed. M. A. Devlin, Camden Society, 3rd Ser. vols. lxxxv and lxxxvi (London, 1954), ii. 271.

maneres.'[23] However, a Lollard sermon of about the same time, again for Septuagesima Sunday, gives the full Gregorian list of five ages.[24]

Sermons such as these must have made Gregory's interpretation of the Parable of the Vineyard known to many English churchgoers, including some poets. In one English chanson d'aventure, the narrator is a young man setting out with his spaniel to hawk for pheasants at noon on a summer's day. He might well be that very *juvenis* who stands highest above the window at Longthorpe Tower with a hawk on his wrist. The poem describes how this representative of youthful pleasure is brought to repentance, when his leg becomes entangled with a briar on which is mysteriously inscribed the word *revertere*, 'turn again'. One would not have suspected Gregorian influence upon this strangely vivid poem had the poet not cited the Father by name, as his authority for likening the hour of noon to the age of youth:

> This noon hete of þe someris day,
> Whanne þe sunne moost hiȝest is,
> It may be likened in good fay,
> For Gregorie witnessiþ weel þis;
> For in ȝonge age men wide doon walke
> To dyvers synnis in fele degre.[25]

The poem *Pearl* presents a more complex case. Here the Pearl maiden retells the Parable of the Vineyard as part of her response when the dreamer has professed his unwillingness to believe that she, an infant girl not two years old when she died, could have been granted immediately the supreme reward of a heavenly crown: 'made queen on the first day!' She cites Matthew himself as her authority for the parable, but in a form which clearly shows that the poet has in mind the Gospel reading at Mass on Septuagesima Sunday:

[23] *Redde Racionem*, ed. N. H. Owen, *Mediaeval Studies* xxviii (1966), 178.

[24] British Library MS Additional 41321, fol. 62ʳ. I am grateful to Gloria Cigman for drawing this to my attention. For a more general reference to the parable, see *Mirk's Festial*, ed. T. Erbe, EETS, ES 96 (1905), 66.

[25] *Revertere*, ll. 41–6, ed. Furnivall, *Hymns to the Virgin and Christ*, from Lambeth Palace MS 853, where it immediately follows the poem discussed above, *This World is but a Vanyte*.

As Mathew meleȝ in your messe
In sothfol gospel of God almyȝt.[26]

It would have been easy for the poet to derive from the Gregorian homily associated with this reading an interpretation appropriate to the sad circumstances of the case—a child dying 'in mane puericie', as Brinton puts it. But whereas Brinton's is a funeral sermon concerned with the ever-present prospect of sudden death, *Pearl* addresses itself to the same problem with which Christ himself was concerned in the parable: the justice of God's rewards. The point at issue in both cases is the distinction between short service and long. As the story supposes that all workers in the vineyard knock off at the same evening hour, Gregory's interpretation assumes death at the end of a normal life-span. Hence, for him, late entry into the vineyard can only mean entry into a good Christian life in old age. But since in reality people do not always live to seventy, even a newly baptized infant may find herself, as Pearl does, dying after very short service. It is in this sense that she can speak of herself as a workman of the eleventh hour: 'In eventyde into þe vyne I come' (l. 582). In point of fact, such a case as Pearl's provides the strongest possible demonstration of the point which the parable sets out to make, that the last shall be first and the first last; for here is she enjoying her reward of heavenly felicity while others who have served God for a long time are still waiting for theirs:

> ȝet oþer þer werne þat toke more tom,
> Þat swange and swat for long ȝore,
> Þat ȝet of hyre noþynk þay nom,
> Paraunter noȝt schal to-ȝere more.　　(ll. 585–8)

This interpretation of the eleventh hour has its own roots in the Gregorian tradition. Gregory himself had cited the penitent thief on the cross (not an old man, presumably) as an instance of an eleventh-hour entrant who receives his reward before other workers; and later homilists such as Bruno Astensis and Honorius 'of Autun' developed the idea in the obvious direction: 'Dominus dicit sibi licere bona dare quibus velit, quia infantibus qui nichil laboraverunt,

[26] *Pearl*, ed. E. V. Gordon (Oxford, 1953), ll. 497–8. On the significance of these lines, see I. Bishop, *Pearl in its Setting* (Oxford, 1968), 124–5.

et in fine poenitentibus qui parum laboraverunt, prius quam his qui
tota vita laboraverunt aeterna gaudia impendit' ['The Lord claims
the right to bestow benefits on whomsoever he wishes, for he grants
eternal felicity to infants who have not worked at all, and to those
who repent at the last moment and therefore have worked very little,
in advance of those who have worked all their lives'].[27] Looked at
from this point of view, distinctions between old and young cease to
have much significance; and one can therefore understand why the
Pearl poet should fail, even in his very full paraphrase of the
vineyard story, to specify two of the five hours. The *cursus aetatis* is
not his concern. Rather, his poem shows how the natural order is
transcended in the spiritual realm, where one who was an infant on
earth can appear as a damsel, and where a damsel can take it upon
herself to instruct her own father. Such transcendence will be the
subject of the next chapter.

The canonical hours were determined by dividing the period of
daylight into twelve. They did not extend into the night. The night
was divided by the Church into *vigiliae* or watches—either four
according to the Roman custom, or three according to the Jewish.
The latter division was enshrined in the liturgy, in the night office of
vigils or mattins, which on festal days was divided into three noc-
turns representing the three night-watches of the Church Militant.[28]
The idea that man's life could also be divided into three or four such
watches had its origins in Biblical exegesis. Two of Christ's parables
on the theme *Vigilate*, 'keep watch', are particularly important in
this connection: the parable of the porter expecting his master's re-
turn from a far journey (Mark 13:33–7), and the parable of the ser-
vants waiting for their master to return from a wedding (Luke 12:
36–8). On both occasions Christ was in fact referring to the Second
Coming; but it was an easy matter for exegetes to interpret his words
moraliter as referring also to the life of the individual, whose course
mirrors and is mirrored in the course of world history. According to
this interpretation, the coming of the master of the house heralds not
the general Last Judgement but the particular judgement which
everyone faces at the moment of death. Since none can know when

[27] Honorius, *Speculum Ecclesiae*, *PL* 172. 858. Compare Bruno, *Commentary on
Matthew*: 'Undecima vero hora illa est, quae in qualibet aetate fini appropinquat et
morti proxima est' ['The eleventh hour is that which in any age approaches the end
and is near to death'], *PL* 165. 237. See Bishop, 122–5, and D. W. Robertson, *Essays
in Medieval Culture* (Princeton, NJ, 1980), 215–17.

[28] See Honorius, *Gemma Animae*, *PL* 172. 615–20.

Death will approach and knock at his door, man must live his life in a continual state of preparedness. Whereas the Parable of the Vineyard suggests that it is never too late to mend, the Parables of the Returning Master suggest that it is never too early.

Preaching on the theme *Vigilate* in 1376, Bishop Brinton cites the Marcan parable and interprets the four *vigiliae* listed there as representing the four ages of man:

Igitur cum tota vita hominis vigilia nuncupatur et per quattuor vigilias noctis, scilicet conticinium, intempestum, gallicinum, antelucanum, quattuor principales etates hominis describuntur, scilicet puericia, adolescencia, iuventus, et senectus, vel etas decrepita, consulo quod sic vigiletis Deo in puericia per innocenciam, in adolescencia per mundiciam, in iuventute per fortitudinem et iusticiam, in senectute per virtutum constanciam, ut de presenti vigilia transiatis ad festum eternaliter mansurum.

[And therefore, since the whole life of man is called a watch, and since the four principal ages of man, boyhood, adolescence, maturity, and old age or decrepitude, are represented by the four watches of the night, evening, midnight, cockcrow, and dawn, I bid you keep watch for God by innocence in boyhood, by purity in adolescence, by fortitude and justice in maturity, and by virtuous constancy in old age, so that you may pass from this present watch into that feast which lasts eternally.][29]

A Wycliffite contemporary of Brinton, preaching on Mark 13:33 ('Videte, vigilate, et orate'), derives a similar injunction from the parable: 'A nyʒt is partid in foure houres, as *evenynge and mydnyʒt, cockis crowinge and morewnynge*; and alle þes houres ben unknowun. For if we departe our lif to our deþ in foure houris, or tyme to þe laste dome in four houris, evene to hemsilf, we witen never how nyʒ or ferre is þe comynge of þis Lord. And algatis, ʒif we wole be saved, we moten waken fro synne'.[30]

In St Luke's Gospel, Christ compares his disciples to 'men who wait for their lord when he shall return from the wedding; that when

[29] *The Sermons of Thomas Brinton*, ii. 326. The passage is repeated in a later sermon, ii. 462.

[30] *Select English Works of John Wyclif*, ed. T. Arnold (3 vols., Oxford, 1869–71), i. 266. The four watches of the Marcan parable are referred to the ages of man also in an earlier homily, in connection with the shepherds watching their flocks by night: 'Al þis lif þe we on liven is to nihte iefned for þat it is swa þester of ure ateliche synnes. *Huius noctis sunt iiiior vigilie: sero, id est puericia, media nox adolescencia, galli cantus virilis etas, mane senium*', *Old English Homilies of the Twelfth Century*, 2nd Ser., ed. R. Morris, EETS, os 53 (1873), 39.

he cometh and knocketh, they may open immediately.' Vigilance is
again the theme: 'Blessed are those servants whom the Lord, when
he cometh, shall find watching. Amen I say to you that he will gird
himself and make them sit down to meat and passing will minister
unto them. And if he shall come in the second watch or come in the
third watch and find them so, blessed are those servants' (Luke 12:
37–8). The exegetical and homiletic tradition identifying the three
vigiliae of this parable with the three ages of man runs parallel with,
and at times crosses, the tradition of the five *horae* in the Parable of
the Vineyard. Here too the prime Latin authority is one of St Gre-
gory's homilies. Taking Luke's parable as his text, Gregory sees in it
both a testimony to the long-suffering of God and a warning against
presuming upon it. God may grant man three 'watches' in his life,
glossed by Gregory as *pueritia*, *adolescentia vel juventus*, and *senec-
tus*; but the call to death and judgement must not find him sleeping
when it comes:

Qui ergo vigilare in prima vigilia noluit custodiat vel secundam, ut qui con-
verti a pravitatibus suis in pueritia neglexit ad vias vitae saltem in tempore
juventutis evigilet. Et qui evigilare in secunda vigilia noluit tertiae vigiliae
remedia non amittat, ut qui in juventute ad vias vitae non evigilat saltem in
senectute resipiscat.

[So let him who has not been wakeful in his first watch look to it in his
second, so that if he has failed to turn from his wickedness in boyhood, he
may at least wake up to the ways of eternal life in the period of his maturity.
And let him who has not woken up in his second watch make sure to remedy
that in his third, so that if he has not woken up to the ways of eternal life in
maturity, he may at least come to his senses in old age.][31]

Like his exegesis of the five hours in the vineyard, Gregory's inter-
pretation of the three night watches was reproduced by Carolingian
writers.[32] It was also known to Anglo-Saxon monks. Bede copied it
verbatim into his commentary on Luke, and Ælfric adopted it in his
Vigilate homily, glossing the three watches in his buoyant rhythmi-
cal prose:

[31] Gregory, *XL Homiliarum in Evangelia*, Bk. I, Hom. 13 (*PL* 76. 1125). This inter-
pretation of the *vigiliae* is found earlier in the commentary on Luke by the Greek
father Cyril of Alexandria: *PG* 72. 746–7.

[32] By Paul the Deacon in his *Homiliary*; see Smetana, *Traditio* xv (1959), 178, item
109. Haymo follows Gregory in his homily 'De Confessoribus', *PL* 118. 789.

Seo forme wæcce is witodlice on cildhade,
and seo oðer wæcce is on weaxendum cnihthade,
and seo þridde wæcce is on forweredre ylde.

[Assuredly the first watch is in childhood, and the second watch is in grow-
ing youth, and the third watch is in worn-out age.][33]

In the later Middle Ages the Gregorian interpretation of the *vigi-
liae* retained its influence.[34] Indeed, it may be said to have played a
part in establishing a version of the three ages which, unlike that of
the biologists, has a distinct homiletic and moralizing character.
This tradition confronts the young, the middle-aged, and the old
with the ever-present possibility of death and judgement. Chaucer's
Knight's Tale may owe something to such a tradition, for in it we see
representatives of all three ages—Emily and Palamon, Theseus, and
Egeus—confronted by the fact of sudden death, when young Arcite
is thrown from his horse. Yet the homiletic point, partially stated by
Theseus (ll. 3027–30), never attains prominence in this essentially
secular poem.[35] Langland's *Piers Plowman*, on the other hand, owes
an unmistakable debt to Gregory, in a remarkable passage where
Ymaginatif addresses the forty-five-year-old dreamer-poet:

I have folwed thee, in feith, thise fyve and fourty wynter,
And manye tymes have meved thee to mynne on thyn ende,
And how fele fernyeres are faren, and so fewe to come;
And of thi wilde wantownesse whan thow yong were,
To amende it in thi myddel age, lest myght the faille
In thyn olde elde, that yvele kan suffre
Poverte or penaunce, or preyeres bidde:
Si non in prima vigilia nec in secunda &c.

[33] 'Sermo in Natale Unius Confessoris', ed. B. Assmann, *Angelsächsische Homilien
und Heiligenleben* (Kassel, 1889), 52. *Cnihthad* normally renders *adolescentia* in
Ælfric's English. Its use here for the middle of three ages rests on Gregory's equation
of *adolescentia* with *juventus*, a usage which Gregory justifies by citing the authority of
Solomon: 'adolescentia vel juventus, quae auctoritate sacri eloquii unum sunt, dicente
Salomone: *Laetare juvenis in adolescentia tua*' ['*adolescentia* or *juventus*, which
according to the authority of Holy Scripture are the same, for Solomon says "Rejoice,
O *juvenis*, in your *adolescentia*"'], *PL* 76. 1125. The reference is to Ecclesiastes 11:9.
For Bede's borrowing from Gregory, see *In Lucae Evangelium Expositio*, ed. D.
Hurst, CCSL cxx (Turnhout, 1960), 257.

[34] See, for instance, Honorius, *Gemma Animae*, *PL* 172. 629, and the *Glossa Ordi-
naria*, *PL* 114. 298.

[35] For further discussion, see *Essays on Medieval Literature*, 28–9.

Amende thee while thow myght; thow hast ben warned ofte
With poustees of pestilences, with poverte and with angres.[36]

Here, in what is evidently an act of painful self-examination, Langland identifies the three *vigiliae* of Luke's parable with the three ages of his own life ('yong', 'myddel age', 'olde elde') and sees in the approach of old age an urgent reason for amendment. For, as his pointedly adapted version of Luke 12:38 suggests, death and judgement, even if they do not come in youth or in maturity, are certain to come in old age.[37] In the last lines quoted, Langland evidently has in mind Gregory's interpretation of the lord's return in the parable: 'Venit quippe Dominus cum ad judicium properat, pulsat vero, cum jam per aegritudinis molestias esse mortem vicinam designat' ['The Lord "comes" when he hastens to judgement, and he "knocks" when he represents to us by afflictions of sickness that death is near'].[38] The association between death and the three ages appears also in an English poet of the next generation after Chaucer and Langland, Thomas Hoccleve. In his *Learn to Die*, part of the so-called 'Series' completed a few years before his own death in 1426, Hoccleve speaks of death ('shee') thus:

> Ful many a wight in youthe takith shee,
> And many an othir eek in middil age,
> And some nat til they right olde be.[39]

Later in the same poem, Hoccleve alludes directly to Luke's parable:

[36] Passus XII. 3–11. Cited from A. V. C. Schmidt's edition of the B text (London, 1978). See further J. A. Burrow, 'Langland *Nel Mezzo del Cammin*', in P. L. Heyworth (ed.), *Medieval Studies for J. A. W. Bennett* (Oxford, 1981), 21–41, in which it is argued that the age of forty-five marks the boundary between 'myddel age' and 'olde elde' for Langland, as it does for Dante and others. Langland's meditation at the end of the second of his three ages has a parallel in Surrey's poem beginning 'Laid in my quyett bedd', where white and grey hair in the poet's beard 'do wryte twoe ages past, the thurd now cumming in' (l. 22).

[37] Luke 12:38 reads in the Vulgate: 'Et si venerit in secunda vigilia, et si in tertia vigilia venerit, et ita invenerit, beati sunt servi illi'. Langland's wording appears to have been influenced by Gregory or some intermediary source.

[38] *PL* 76. 1124.

[39] *Hoccleve's Works: The Minor Poems*, ed. F. J. Furnivall and I. Gollancz, rev. J. Mitchell and A. I. Doyle, EETS, ES 61, 73 (1970), ll. 162–4. The poem derives from Suso's *Horologium Sapientiae*.

Þat man, as in holy writ is witnessid,
Which whan god comth and knokkith at the yate,
Wakynge him fynt, he blessid is algate. (ll. 614–16)

Against these lines, in the margin of the holograph manuscript, Hoc-
cleve has written an adaptation of Luke 12:36–7: 'Beatus quem cum
venerit dominus et pulsaverit' ['Blessed is he whom, when the Lord
comes and knocks . . .']. The application is entirely traditional. In
each of his three ages man must be prepared for the 'improvisa mors'
of which Gregory spoke.

The summons of death comes as a knock at the door in another
Middle English poem, where an old man says: 'Dethe dynges one my
dore, I dare no lengare byde'. This line heralds the end of the four-
teenth-century dream poem *The Parlement of the Thre Ages*.[40] The
old man is one of three figures personifying the three ages: Youthe,
Medill Elde, and Elde. Man's life, as seen by this poet in his dream,
is itself a kind of sleep, from which he is awoken only by the knock-
ing of death. The brilliant figure of Youth, dressed in green and
gold, passes his time engrossed in hawking, love-making, and joust-
ing. Middle Age, dressed in sober russet, loves ease and thinks only
of the profits from his estates. The argument between them is
brought to an end by Old Age, who calls them both fools. For him,
'improvisa mors' is an imminent reality:

And now es dethe at my dore that I drede moste;
I ne wot wiche daye ne when ne whate tyme he comes. (ll. 292–3)

Yet even Old Age has not fully woken up to the ways of eternal life,
for he is described as 'tenefull' (spitefully querulous) and 'envyous
and angrye'—unworthy feelings which colour, though they do not
invalidate, his ensuing discourse on the vanity of human wishes.
This discourse culminates in the knocking which marks the end of
the dream. The conclusion which follows is beautifully imagined. At

[40] On this poem, see T. Turville-Petre, 'The Ages of Man in *The Parlement of the
Thre Ages*', *Med. Aev.* xlvi (1977), 66–76, referring to Luke's parable. B. Rowland
explains the ages of the three figures in the dream (Youth is thirty, Middle Age sixty,
and Old Age a hundred years old) by reference to the Parable of the Sower: *Chaucer
Review* ix (1975), 342–52. See also P. Tristram, *Figures of Life and Death in Medieval
English Literature* (London, 1976), 85–6. Both Rowland (p. 351) and Tristram (p. 79)
also note that in the legend of the Three Living and the Three Dead the former are
sometimes represented as types of the three ages.

the beginning of the poem, before his dream, the narrator was por-
trayed as a man absorbed, like the narrator of *Revertere*, in the ac-
tivity of hunting: early one May morning, he killed a hart in the
woods. One might expect his ensuing vision of the vanity of life and
the certainty of death to act upon him as the word *revertere* does
upon the narrator in the other poem ('Þis worde made me to studie
sore'); but in fact the *Parlement of the Thre Ages* ends more like
Chaucer's *Book of the Duchess*, not with a homiletic conclusion but
with a plain account of the oncoming of night and the homecoming
of the hunter:

> Than the sone was sett and syled ful loughe;
> And I founded appon fote and ferkede towarde townn. (ll. 658–9)

The passage of the hunter's day, from dawn at the beginning of the
poem to dusk at the end, shadows forth truths about life to which
the homecoming suggests, even more shadowily, an appropriate re-
sponse. But as the vision of the three ages showed, it is no easy mat-
ter to transcend limitations imposed by the *cursus aetatis*; so it is
fitting that the poem should end, not with a dramatic conversion,
but with recollection of the mirths of May and a quiet prayer to
Mary to 'amende us of synn'. The narrator has not yet, in the deeper
sense of Luke's parable, woken up.

Thus the hours of the day and the watches of the night furnished
medieval moralists and poets with a rich source of *comparationes* in
their thinking about the ages of man. Another such source was the
larger cycle of the week, with its pattern of six working days and one
day of rest established by God in the act of creation. The author of
Dives and Pauper explains that one reason why Sunday has been set
aside from the rest of the week is 'to betokenyn þe endeles reste þat
we schul han from synne and peyne in hevene blisse for þe goode
warkys þat we don þe sexe dayys of our lyve, þat is to seye, alle þe
dayys of our lyve and þe sexe agys of our lyve'.[41] Medieval writers
most often expound this hebdomadal pattern of six *aetates hominis*
here and one hereafter in connection with St Augustine's scheme of
the *aetates mundi* or ages of the world (itself based on the Creation
week). That larger comparison will be discussed later in the present
chapter. Here we may notice another way of conceiving human life

[41] *Dives and Pauper*, ed. P. H. Barnum, vol. i, Pt. I, EETS, os 275 (1976), 265.

in hebdomadal terms: not as a week, but as a series of weeks. The idea that life may be divided into sets of seven years, or year-weeks, is very ancient. Some Greek elegiac verses attributed to the early Athenian lawgiver Solon distinguished ten such weeks in the seventy years of life.[42] Solon's verses were recorded by Philo Judaeus, expounding the 'dignity inherent by nature in the number seven'; and the doctrine of ten hebdomadal ages was transmitted to the Latin West by authors such as Censorinus and Macrobius.[43] After surveying a variety of alternative age-schemes, Censorinus concluded: 'ex iis omnibus proxime videntur accessisse naturam, qui hebdomadibus humanam vitam emensi sunt' ['of all these, those who have measured human life out in weeks seem to have come closest to nature.'] He summarizes the *elegia Solonis* as follows:

Ait enim in prima hebdomade dentes homini cadere, in secunda pubem apparere, in tertia barbam nasci, in quarta vires, in quinta maturitatem ad stirpem relinquendam, in sexta cupiditatibus temperari, in septima prudentiam linguamque consummari, in octava eadem manere (in qua alii dixerunt oculos albescere), in nona omnia fieri languidiora, in decima hominem fieri morti maturum.

[He says that in the first year-week men's teeth fall out, in the second pubic hair begins to appear, in the third a beard grows, in the fourth comes manly strength, in the fifth readiness to found a family, in the sixth a slackening of desires, in the seventh wisdom and eloquence are at their height, in the eighth they remain the same (an age in which others say the eyes grow white), in the ninth everything grows weaker, and in the tenth man becomes ready for death.]

None of these authorities succeeds in carrying the hebdomadal division convincingly through to the end. It works well for the early ages, but not for the later part of life where changes are more gradual. Indeed there is no ten-age scheme which does not suffer from this weakness. Ten ages are simply too many.[44] However, hebdoma-

[42] For the text, see Appendix.

[43] Philo Judaeus, *On the Account of the World's Creation*, ed. Colson and Whitaker, 85; Censorinus, *De Die Natali*, ed. Jahn, 14. 4, 7; Macrobius, *Commentary on the Dream of Scipio*, trans. Stahl, Bk. I, Chap. 6.

[44] An example is the de Lisle Wheel of Life, discussed above (pp. 45–6) and illustrated in Plate 7, which arrives at its ten ages by adding after the seventh, *decrepitas*, three further ages: dying, dead, and entombed. Compare *The Ten Stages of Man's Life*, ed. F. J. Furnivall, *Political, Religious, and Love Poems*, EETS, os 15 (1866), 267.

dal divisions are not confined to ten-age schemes. The theory of climacteric years is based upon them. Thus Censorinus explains that, just as the seventh day is considered critical in illness, so 'per omnem vitam septimum quemque annum periculosum et velut crisimon esse et climactericum vocitari' ['in all life each seventh year is deemed perilous and as it were critical and climacteric'].[45] The year-week also plays a large part in determining age-boundaries in schemes which distinguish less than ten ages. Here the most common multiples of seven, besides seventy and thirty-five, are seven, fourteen, and twenty-one or twenty-eight, marking the ends, respectively, of *infantia, pueritia*, and *adolescentia*.[46] In the Hippocratic seven-age scheme described in the last chapter, every boundary age is hebdomadal: seven, fourteen, twenty-one, twenty-eight, forty-nine, and fifty-six. No doubt Chaucer had in mind the significance of the first year-week when he described the young victim of the *Prioress's Tale* as 'a litel clergeon, seven yeer of age'. This specification of the boy's age (not found in the analogues) puts him just on the borderline between *infantia*, the age of innocence, and its successor, *pueritia*.[47] He is just young enough for the Prioress to refer to him as 'this innocent' and to number him among the Holy Innocents; but he is also, as his eager conversation with an older schoolmate shows, on the point of becoming a real schoolboy. It is one of those critical moments of transition from one age to another, delicately rendered by Chaucer.

Four weeks make up the lunar month of twenty-eight days; and this lunar cycle too, according to astrologers, bears a relation to the life of man. Albertus Magnus cites the opinion of Ptolemy himself that the different characteristics of the ages derive from the cycle of

[45] *De Die Natali Liber*, 14. 9. The grand climacteric is $7 \times 9 = 63$.

[46] Isidore of Seville rings the changes on the hebdomads. His *Liber Numerorum* presents just seven successive year-weeks up to the beginning of *senectus* (*PL* 83. 188); but his *Differentiae* distinguishes six ages as follows: one week of *infantia*, one of *pueritia*, two of *adolescentia* ('propter intellectum et actionem'), three of *juventus* ('propter tria illa, intellectum et actionem, corporisque virtutem'), and four of *senectus* (the three previous attributes, plus 'animi et corporis gravitatem'). The last age, *senium*, has no fixed length (*PL* 83. 81). See Eyben, art. cit. 177–9.

[47] *Canterbury Tales*, VII. 503. Carleton Brown regards this statement of the boy's age as one of Chaucer's additions to the story: *Sources and Analogues of Chaucer's Canterbury Tales*, ed. W. F. Bryan and G. Dempster (London, 1941), 465. St Kenelm, another child/boy martyr, is also said to have been seven years old, in the *Nun's Priest's Tale*, VII. 3117.

the moon.[48] He goes on to explain that the influence of the moon changes from quarter to quarter through the same sequence of qualities observable in the cycle of the seasons: moist and hot in its first quarter, hot and dry in its second, and so on. To anyone acquainted with the Physical and Physiological Fours it would therefore be evident that the moon's quarters correspond to the four ages of man. Thus an English astrological text, preserved in an early-fifteenth-century manuscript, states that each lunar quarter 'disposes' one of the four ages (adolescence, manhood, old age, and decrepitude).[49]

Albertus Magnus speaks of the moon as 'breviter explicans operationes solis', 'displaying in little the operations of the sun': 'quia quod sol facit in anno secundum variationem luminis et caloris, luna facit in mense, ut dicit Aristoteles' ['for what the sun does by virtue of variations of light and heat in a year, the moon does in a month, as Aristotle says.']50 The 'variatio luminis et caloris' of the sun gave rise, as we saw in the last chapter, to one particularly powerful *comparatio*, that between man's life and the four seasons. There remain to be considered here, in order to complete the present survey of temporal cycles, certain lesser correspondences drawn from the solar and also from the liturgical year. Allegorical interpretations of the latter yield two typically ingenious results. The seventy days in the liturgical calendar between Septuagesima Sunday (when the Parable of the Vineyard was read and expounded) and Easter Saturday are interpreted as betokening both the seventy-year captivity of the people of Israel and also 'al þe tyme of oure lif . . . al þe while it is subiect to synne oþir to peyne.' Just as the penitential period of Septuagesima is followed by the rejoicing of Easter, so 'þe septuagesme of þis lif', our seventy years of toil and affliction, may be rewarded in 'þe Sabooth of endeles reste'.[51] Everything in the liturgy of the Church must have a reason—probably more than one—if we can only see it. The same principle is applied to the Ember Days, the four short periods of fasting and prayer appointed for the four seasons of the year. The Middle English *Stanzaic Life of Christ* gives no fewer than eight reasons for this arrangement, including among other

[48] *De Aetate*, Tract. I, Chap. ii.
[49] Trinity College, Cambridge, MS O. 5. 26, fol. 39ᵛ.
[50] *De Aetate*, Tract. I. Chap. ii.
[51] John Trevisa's translation of Bartholomaeus Anglicus, *De Proprietatibus Rerum*, ed. M. C. Seymour and others, *On the Properties of Things* (Oxford, 1975), Bk. IX, Chap. 28, 'De septuagesima', citing the liturgical authority, John Beleth.

tetrads the four ages of man.[52] The argument is more concisely stated by Bishop Brinton in a sermon on fasting delivered in 1376:

Ver refertur ad puericiam, estas ad adolescenciam, autumpnus ad virilem etatem, hiemps ad senectutem; ieiunamus igitur in vere ut simus puri per innocenciam, in estate ut simus iuvenes per constanciam, in autumpno ut simus maturi per modestiam, in hieme ut simus senes per prudenciam et sanctam vitam.

[Spring corresponds to boyhood, summer to adolescence, autumn to man's estate, and winter to old age; and therefore we fast in spring that we may be pure through innocence, in summer that we may be young through constancy, in autumn that we may be mature through sobriety, and in winter that we may be old through wisdom and holy living.][53]

In ways such as these, the faithful were invited to see in the Church's year, as well as in the Church's day, a continually repeated image of their own individual course through life.

It seems that medieval authorities resisted for centuries the temptation to elaborate the time-honoured tetradic analogy between the seasons and the ages by breaking down man's life into twelve ages corresponding to the months of the year. The earliest to do so, as far as I know, was a fourteenth-century French poet, author of *Les Douze Mois figurez*.[54] His opening lines set out the scheme:

> Il est vray qu'en toutes saisons
> Se change douze foiz li hons:
> Tout aussi que les douze moys
> Se changent en l'an xii foiz
> Selon leur droit cours de nature,
> Tout ensement la creature ·
> Change de vi ans en vi ans
> Par xii foiz. (ll. 1–8)

[52] F. A. Foster (ed.), EETS, os 166 (1926), ll. 5073–104.

[53] *The Sermons of Thomas Brinton*, ii. 286. The source is *Legenda Aurea*, ed. T. Graesse, 2nd edn. (Leipzig, 1850), 153–4. For another Middle English version, see *Speculum Sacerdotale*, ed. E. H. Weatherly, EETS, os 200 (1936), 93.

[54] The earliest of the five surviving manuscript copies, said to have belonged to Charles V of France (d. 1380), contains the text printed by E. Dal and P. Skårup, *The Ages of Man and the Months of the Year* (Copenhagen, 1980), 42–50, from which I quote. An earlier edition, from a later manuscript, is by J. Morawski, 'Les douze mois figurez', *Archivum Romanicum* x (1926), 351–63.

[True it is that throughout his seasons man undergoes change twelve times. Just as the twelve months succeed each other twelve times in the year in accordance with the natural course of things, so created man changes twelve times, once every six years.]

The poet goes on to characterize each of his twelve six-year ages, comparing it with the corresponding month. Here, for instance, are his lines on the April age, from eighteen to twenty-four:

> Or vient avril et li bel jour
> Que toute chose s'esjoist:
> L'erbe croist et l'arbre fleurist,
> Li oysel reprennent leur chans.
> Et aussi a xxiiii ans
> Devient li enfes vertueux,
> Jolis, nobles et amoureux,
> Et se change en maint estat gay. (ll. 28–35)

[Now comes April and the fine days, when everything rejoices: grass grows, trees blossom, and birds begin to sing again. Just so up to twenty-four the young person becomes vigorous, gay, noble, and amorous, and adopts every kind of cheerful activity.]

Despite the evident difficulty of cutting life up so small, this poem enjoyed an extraordinary success. In France it was copied, reworked, and expanded.[55] In England it was evidently known to John Gower as early as 1390; for towards the end of his *Confessio Amantis*, where Amans is at last coming to terms with the fact that he is too old for love, he makes a *comparatio* or 'liknesse' between the course of his life and the course of the year:

> I made a liknesse of miselve
> Unto the sondri Monthes twelve,
> Wherof the yeer in his astat
> Is mad, and stant upon debat,
> That lich til other non acordeth.[56]

[55] One reworking is edited by Morawski, 359–63; another, printed in the 1480s, may be found in Dal and Skårup, 52–7. The latter introduces a series of authorities to make sententious comments: Cato (of the *Disticha*) in February, Solomon in March, Aristotle in April, Alexander of Villa Dei (author of the *Doctrinale*) in May, Tobias in June, Virgil in July and again in August, Hippocrates in September.

[56] *Confessio Amantis*, ed. G. C. Macaulay, *The English Works of John Gower*, EETS, ES 81, 82 (1900, 1901), VIII. 2837–41. Gower's Latin sidenote reads: 'Quod status hominis Mensibus anni equiperatur' ['How the condition of man is compared to the months of the year'].

In his ensuing reflections, however, Amans reverts to a simple binary division of the year into the summer months from March to September, which correspond to the 'myhty youthe' he no longer enjoys, and the winter months when 'despuiled is the Somerfare'. Chaucer shows similar restraint when, in the *Merchant's Tale*, he selects just two month-names to suggest the unnaturalness of the marriage between an old man and a young wife: January and May.[57]

In the course of the fifteenth century the scheme of the twelve months of life gained wider popularity by finding a place in the *Kalendar and Compost of Shepherdes* and in numerous books of hours. In the latter, the calendrical entry for each month may be accompanied by a quatrain describing the corresponding six-year age and a picture representing it.[58] Thus, in a *Prymer of Salisbury Use* printed in 1529, the month of June has a picture of a marriage ceremony together with the following quatrain, translated from the French:

> In June all thyng falleth to rypenesse
> And so dooth man at xxxvi yere olde
> And studyeth for to acquyre rychesse
> And taketh a wyfe to kepe his housholde.[59]

Le Grant Kalendrier et compost des bergiers, first printed at Paris in 1491 and many times thereafter, expounds the twelve calendrical ages, first in a prose paraphrase of the French poem which forms part of the Shepherd's prologue to the book, and later in the words of the poem itself.[60] The book appeared first in English in 1503, and this and many subsequent editions made the twelve-age scheme familiar to sixteenth-century English readers.[61] Spenser knew the book, and took from it the title of his first major work, the twelve

[57] In Gower's Latin verses following *Confessio Amantis* VIII. 2376, the contrast between *decrepitus* and *iuventus* is expressed by antitheses of summer and winter, May and December. See also n. 74 to Chap. 4 below.

[58] Dal and Skårup discuss books of hours on pp. 17–20 and 22–3. They print French and English quatrains on pp. 58–9, and reproduce pictures of the twelve ages on pp. 33–9.

[59] Dal and Skårup, 59.

[60] See Dal and Skårup, 14–16. They print the prose paraphrase, from an edition of 1493, on pp. 42–50.

[61] See Dal and Skårup, 20–2. There is a facsimile of the 1503 edition, together with a reprint of that of 1506, in H. O. Sommer, *The Kalender of Shepherdes* (London, 1892). G. C. Heseltine, *The Kalendar and Compost of Shepherdes* (London, 1931), presents a modernized version of the ?1518 edition.

eclogues 'which for that they be proportioned to the state of the xii monethes, he termeth the SHEPHEARDS CALENDAR, applying an olde name to a new worke.' In the December Eclogue, as has already been noted, Colin Clout draws the familiar parallel (also expounded in the *Kalender and Compost*) between the four ages of his life and the seasons of the year. One may look for signs elsewhere in the ec- logues of that more specific *comparatio* whereby the twelve ages are 'proportioned' to the months; but it seems that Spenser, like Gower, was content with broader parallels.[62]

<p style="text-align:center">II</p>

This survey of medieval age-schemes turns finally to those schemes which rest on a comparison, not with diurnal or annual cycles, but with the linear time of history. It has seemed natural in many cul- tures to make such a comparison. An institution, or a nation, or the whole of humanity may be seen as passing through the ages of an individual life; and the individual, conversely, may be seen as living in little through the whole history of his race or species. The history of the many and the history of the one appear, mysteriously, to fol- low the same course. When it comes to defining this common course, however, differences arise, for there seem to be as many ways of dividing history into periods as there are ways of dividing life into ages. Thus one Latin authority, the historian Florus, distinguishes four ages in the history of Rome (*infantia, adulescentia, iuventas,* and *senectus*), while another, the rhetorician Seneca, sees five (*infantia, pueritia, adulescentia, iuventus,* and *senectus*).[63] Similarly, when Christian authors come to divide Biblical history into what they call *aetates mundi* (as distinct from *aetates hominis*), they arrive at a number of different results. When writing about the Parable of the Vineyard, for instance, exegetes commonly distinguish five 'hours' not only in the life of individuals but also in the history of man- kind—represented, according to Origen, by Adam, Noah, Abra-

[62] For arguments to the contrary, see M. Parmenter, *ELH* iii (1936), 190–217; and P. Cullen, *Spenser, Marvell, and Renaissance Pastoral* (Cambridge, Mass., 1970), Chap. 2.

[63] Florus, *Epitomae Libri II*, ed. O. Rossbach (Leipzig, 1896), Prologue; Lactan- tius, *Divinae Institutiones*, Bk. VII, Chap. 15 (*PL* 6. 788–9). See Eyben, art. cit. 157, 159, 164–5.

ham, Moses, and Christ.[64] Yet other interpreters of the very same
parable divide history differently—Thomas Wimbledon into three,
for example.[65]

For our present purposes, however, there is one such comparison
that demands special attention, because it is the source of a major
tradition in medieval thinking about the ages of man. This is St
Augustine's division of temporal history and temporal life into six
ages. The two works most commonly cited by medieval writers in
this connection were *De Diversis Quaestionibus LXXXIII* and *De
Genesi contra Manichaeos*. The shorter account in *De Diversis
Quaestionibus*, to be found in the Appendix here, is prompted by St
Paul's reference to the present age as 'finis saeculorum', the end of
the world (1 Corinthians 10:11). The world, Augustine explains,
passes through six ages corresponding to those of the individual: an
infantia from Adam to Noah, a *pueritia* from Noah to Abraham, an
adolescentia from Abraham to David, a *juventus* from David until
the Babylonian captivity, a *gravitas* from the captivity until the com-
ing of the Lord, and the present *senectus* which will last until the end
of time.[66] In this last of the ages, 'the exterior or "old" man is wasted
by *senectus*, while the interior man is from day to day renewed.
Thence comes that sempiternal rest which is signified by the sab-
bath.' These parallels between the *aetates hominis* and *aetates mundi*
are supported by allegorical interpretation of the number of gen-
erations in each of the latter. The more elaborate account of the
same parallels in *De Genesi contra Manichaeos* adds further support-
ing arguments. The first age of the world ended with Noah's Flood,
just as *infantia* is obliterated in the memory by the flood of oblivion
('oblivionis diluvio'); but just as the second age suffered no flood, so
we do not forget our *pueritia*. The promise to Abraham that his seed
would possess the land establishes the parallel between his age and
adolescentia, the time when men first have the power to beget
children. The fourth Biblical age, of David and the kings of Israel,
resembles *juventus* because 'inter omnes aetates regnat juventus'
['*juventus* reigns over all the ages']. Just as the people of Israel
declined after the Babylonian captivity, so man in his fifth age
declines towards *senectus*; and when the temple and kingdom of the

[64] Origen on Matthew, *PG* 13. 1350–1, followed by Gregory (*PL* 76. 1154) and
others. Compare Augustine, *Sermo* LXXXVI (*PL* 38. 533).

[65] 'Tyme of lawe of kynde', 'tyme of þe Olde Lawe', and 'tyme of grace', *Redde
Racionem*, ed. Owen, *Mediaeval Studies* xxviii (1966), 178.

[66] *De Diversis Quaestionibus LXXXIII*, Bk. I, Qu. lviii (*PL* 40. 43).

Jews were finally destroyed, after the coming of Christ, the chosen people reached that age, the sixth and last.[67]

The extraordinary success enjoyed by this scheme no doubt owed most to the fact that it offered, with all the authority of St Augustine, a version of the ages of man and the world which was distinctively Christian in character. Pagan authors had not commonly distinguished six ages in either life or history.[68] Augustine's scheme was based, as he makes clear in *De Genesi contra Manichaeos*, upon the Judaic hexaemeral tradition. The six ages of man, like the six ages of the world, correspond to the six days of Creation: 'Video . . . easdem sex aetates habere similitudinem istorum sex dierum, in quibus ea facta sunt quae Deum fecisse Scriptura commemorat' ['I see that these same six ages have a resemblance to the six days in which those things were made which Scripture reports God to have made'].[69] This fundamental resemblance or *similitudo* leads Augustine to a view of human life which differs greatly from that of pagan authorities. For the sixth day of Creation, as recorded in Genesis, was the day on which God created man in his own image, just as the sixth age of the world was that in which God himself became man in Christ. Hence the sixth age of man, *senectus*, could not be adequately described in negative terms. For the 'exterior' or natural man, as Augustine explains, it does indeed represent nothing but a decline; but for the 'interior', spiritual man it can and should be an age of spiritual *renovatio*, in which he may recover on his own account that divine image implanted in man on the sixth day of Creation and manifested through Christ in the sixth age of the world. For the Christian may look forward to a seventh age of 'sempiternal rest', corresponding to the seventh, sabbath, day of Creation on which God himself rested.[70]

[67] *De Genesi contra Manichaeos*, Bk. I, Chap. 23–4 (*PL* 34. 190–3). For a full discussion of the *aetates mundi* in Augustine's works, including *The City of God*, see A. Luneau, *L'Histoire du salut chez les Pères de l'Église: La Doctrine des âges du monde* (Paris, 1964), 285–407. Also G. B. Ladner, *The Idea of Reform* (Cambridge, Mass., 1959), 222–38.

[68] Boll, 177–9, cites only two examples of the six ages of man from pagan Antiquity, neither very significant. In his survey in *De Die Natali* Censorinus makes no mention of any such scheme.

[69] *PL* 34. 190.

[70] The seventh age, lying on the other side of death, plays an essential part in Augustine's scheme (Luneau, 321–7), but not in the tradition under consideration here. Augustine may have been influenced by the astrological theory of the seven ages (Luneau, 51), but his divisions of life are quite distinct from Ptolemy's.

Augustine's vision of *senectus* as a time when 'the interior man is from day to day renewed'—a lofty spiritual conception, to be distinguished from mere respect for the wisdom of the old—proved too much for most of his successors, who were generally content to derive from it a workaday scheme of six natural ages.[71] The chief agent in this transformation was Isidore of Seville, who expounded Augustine's six-age scheme in his *Etymologiae* and so entered it into the mainstream of medieval encyclopaedic learning. In an earlier chapter, 'De Saeculis et Aetatibus', Isidore had set out the six Augustinian *aetates mundi*, but without reference there to the *aetates hominis*.[72] The latter are treated quite separately in a chapter 'De Aetatibus Hominum', the first part of which may be found in the Appendix here. This was in the Middle Ages perhaps the most widely known of all discussions of the matter. In it Isidore gives the bare bones of Augustine's scheme, employing his age-terms and borrowing material from the *De Genesi*; but he also shows an acquaintance with other authorities. He distinguishes *senium* as 'pars ultima senectutis' and 'terminus sextae aetatis'—but not, be it noted, as a separate, seventh age. He also gives, as Augustine does not, for each age a certain length in years: *infantia* up to seven, *pueritia* to fourteen, *adolescentia* to twenty-eight, *iuventus* to the fiftieth year, *aetas senioris* or *gravitas* to the seventieth, and *senectus* up to death.[73] The remainder of the chapter is occupied with a lengthy survey of age-linked terminology, male and female, in which Isidore offers his readers a profusion of etymologies which, whatever their philological value, powerfully demonstrate how the characteristics of the different ages could be seen as inscribed in the (Latin) language itself:

[71] In *De Vera Religione*, Chap. xxvi, Augustine sets beside the six ages of the 'old' or exterior man a corresponding series of 'aetates spirituales' to which ordinary considerations of age do not apply at all (*PL* 34. 143–4). Compare his *Sermo* ccxvi (*PL* 38. 1081), and see Gnilka, *Aetas Spiritalis*, 101–3.

[72] *Etymologiarum sive Originum Libri XX*, ed. W. M. Lindsay (Oxford, 1911), Bk. v, Chap. xxxviii. Isidore refers in this connection to the ages of man as three: *infantia*, *iuventus*, and *senectus*.

[73] Bk. xi, Chap. ii. The influence of this chapter is stressed particularly by Hofmeister, art. cit. 292. There is another influential discussion of the six ages by Isidore in his *Differentiae*, Bk. ii, Chap. xix (*PL* 83. 81). Here as in his *Liber Numerorum* (*PL* 83. 185) Isidore calls the two ages after *iuventus senectus* and *senium*. Elsewhere he speaks of four and of seven ages: J. Fontaine, *Isidore de Séville et la culture classique dans l'Espagne wisigothique* (Paris, 1959), 377.

Infans dicitur homo primae aetatis; dictus autem infans quia adhuc fari nes-
cit, id est loqui non potest. Nondum enim bene ordinatis dentibus minus est
sermonis expressio. Puer a puritate vocatus, quia purus est, et necdum lanu-
ginem floremque genarum habens.

[Man in his first age is called *infans*; he is called *infans* because he does not
yet know how to *fari*, that is, he cannot speak. For when the teeth are not
yet well set in place, he cannot express himself properly. The *puer* is so called
from purity, for he is pure and does not yet have even the first downy hairs
of a beard.]

Since Isidore entirely dispensed with the Biblical matrix which
shaped Augustine's account, the result could as well be the work of a
pagan grammarian as of a Christian writer. But it made an excellent
entry for an encyclopaedia.

Backed by the authority of two saints, and readily available in the
best of all encyclopaedias, the doctrine of *sex aetates mundi et homi-
nis* soon became common coin. In Anglo-Saxon England it was the
aetates mundi which appealed most to monks and scholars, whose
unsatisfied hunger for universal knowledge evidently found less to
appease it in the theory of *aetates hominis*.[74] The idea that the world
itself was now in its last age attracted them especially, and we find
not only homilists but also poets lamenting *senectus mundi*:

<div align="center">

Blæd is gehnæged,

Eorþan indryhto ealdað ond searað,

Swa nu monna gehwylc geond middangeard.

</div>

[Glory is fallen, and all the nobility of the earth grows old and sere, just as
all men now do throughout the world.][75]

Yet the theme of the six *aetates hominis* was not entirely neglected.
We have seen that Bede was the first Englishman to expound, in his

[74] See the valuable survey by M. Förster, 'Die Weltzeitalter bei den Angelsachsen',
Die neueren Sprachen, 6 Beiheft, Festgabe K. Luick (1925), 183–203; to which may be
added the unpublished piece ascribed to Ælfric by J. C. Pope, 'De Sex Etatibus Huius
Seculi', in British Library MS Cotton Otho C. i (vol. ii), fols. 151ᵛ—152ᵛ, 154ʳ⁻ᵛ, which
follows the Augustinian division. N. R. Ker, *Catalogue of Manuscripts Containing
Anglo-Saxon* (Oxford, 1957), 520, in his record of 'notes on commonplaces', registers
seven notes on the *aetates mundi* but none on the *aetates hominis*.

[75] *The Seafarer*, ll. 88–90. On this theme, see J. E. Cross, 'Aspects of Microcosm
and Macrocosm in Old English Literature', in S. B. Greenfield (ed.), *Studies in Old
English Literature in Honor of A. G. Brodeur* (Eugene, Oregon, 1963), 1–22. Ælfric, in
a vivid phrase, speaks of his generation as 'endemenn ðyssere worulde': *Catholic
Homilies*, ed. B. Thorpe (2 vols., London, 1844–6), i. 476.

De Temporum Ratione, the four ages of man. He was also the first to expound the six, in *De Temporum Ratione* and more briefly in an earlier work on chronology, *De Temporibus*.[76] The discussion in *De Temporum Ratione* opens with a reference back to an earlier chapter in which Bede had expounded the *aetates mundi* in their relation to the days of Creation:

De sex hujus mundi aetatibus, ac septima vel octava quietis vitaeque coelestis, et supra in comparatione primae hebdomadis in qua mundus ornatus est aliquanta perstrinximus, et nunc in comparatione aevi unius hominis, qui μικρόκοσμος Graece a philosophis, hoc est, minor mundus solet nuncupari, de iisdem aliquanto latius exponemus.

[We have previously discussed briefly the six ages of this world, together with the seventh and eighth ages of rest and of celestial life, in comparison with that first week in which the world was made beautiful. Now we will explain at somewhat greater length about these same ages in a comparison with the life-span of an individual man, whom philosophers call in Greek *microcosmos*, that is, a lesser world.][77]

Bede's terminology for the six *aetates hominis*, both here and in *De Temporibus*, differs from that of Augustine and Isidore, in that he names the fifth age *senectus* and the sixth *aetas decrepita*; and he adds a new reason for comparing the second world-age with *pueritia*.[78] Otherwise he follows Augustine quite closely.

In the Carolingian period, the *Disputatio Puerorum per Interrogationes et Responsiones*, once ascribed to the eighth-century English scholar Alcuin, takes its account of the 'aetates mundi minoris' directly from the *Etymologiae* of Isidore, as does the widely-used encyclopaedia compiled by Hrabanus Maurus, *De Universo*.[79] Like so many other such schemes, too, the *sex aetates hominis* make their appearance in Biblical exegesis. In his commentary on St John's Gospel, Alcuin discusses John 4:6, a verse which records how Jesus

[76] For the latter passage, see *Bedae Opera de Temporibus*, ed. Jones, 303: Chap. xvi 'De mundi aetatibus', serving as an introduction to a short chronicle, which Jones does not print. The corresponding, but fuller, chapter of the *De Temporum Ratione* (Chap. lxvi) is omitted by Jones, along with the longer chronicle which it introduces. I quote from *PL* 90. 520–1.

[77] *PL* 90. 520.

[78] In this age the Hebrew language was created (at Babel), just as 'in his *pueritia* a person begins to know how to speak, having passed *infantia*, which is so called because it cannot speak [*fari non potest*]', *PL* 90. 521. The Isidorian etymology is correct.

[79] *Disputatio*, Chap. v (*PL* 101. 1112–13); *De Universo*, Bk. vii, Chap. i (*PL* 111. 179–85).

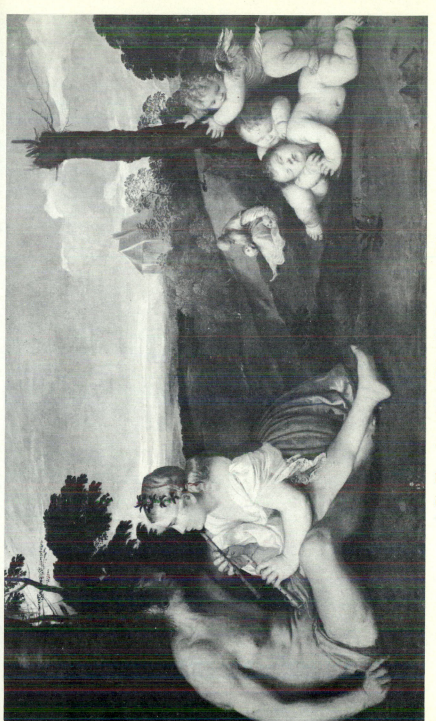

5. The Three Ages of Man: Titian, *The Three Ages of Man*

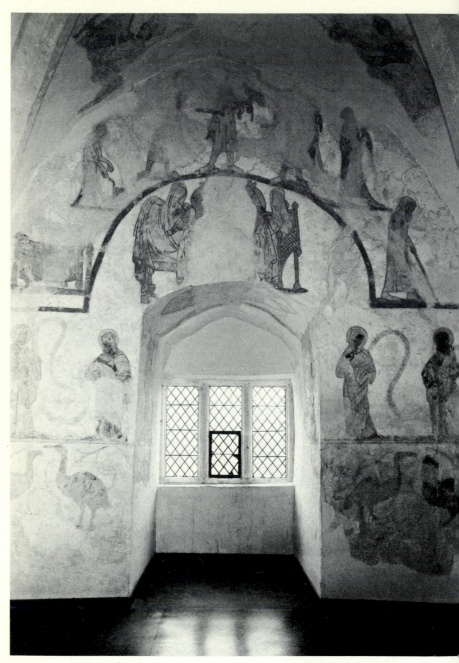

6. The Seven Ages of Man: Longthorpe Tower, Northamptonshire

came to Jacob's well at 'about the sixth hour'. The sixth hour, he explains, signifies that sixth age of humanity, its *senectus*, in which Christ came to earth: 'For the sixth age is *senectus*, just as the first is *infantia*, the second *pueritia*, the third *adolescentia*, the fourth *juventus*, and the fifth *gravitas*'. The terminology is Augustinian, and one is not surprised to discover that the exegesis is taken verbatim from Augustine himself.[80]

By Alcuin's time the Augustinian and Isidorian tradition of the six ages was well established in learned circles; and it gained wider currency thereafter through a variety of channels. Perhaps its most influential expositors were the compilers of dictionaries and encyclopaedias. Anyone, it seems, who looked up a reference book to find information about *aetates hominis* would have encountered the six. Thus the *Elementarium Doctrinae Rudimentum*, an encyclopaedic lexicon compiled by Papias in the eleventh century, presents the scheme in a neat hebdomadal form which resembles that to be found in Isidore, not in the *Etymologiae* but in his *Differentiae*:

Aetas prima hominis per septem ducitur annos, quae infantia dicitur. Secunda aetas per alios vii usque ad xiiii, quae pueritia nominatur. Tertia per duo septena usque ad xxviii annum: haec adolescentia nuncupatur. Quarta tribus septenis adjunctis usque ad xlviiii protelatur, qua iuventus vel virilitas habetur. Quinta tribus itidem ebdomadis usque ad lxx pertenditur, et senior dicitur, declinata a iuventute ad senectutem nondum senectus. Sexta aetas est hominis senectus quae nullo annorum terminatur numero: haec quoque senium dicitur.

[The first age of man, called infancy, lasts for seven years. The second age, called boyhood, lasts for another seven up to fourteen. The third, extending for two further sevens up to twenty-eight, is called adolescence. The fourth, consisting of three consecutive seven-year periods, stretches to forty-nine, and is called youth or manhood. The fifth, also consisting of three hebdomads, lasts until seventy and is called 'elder', having fallen away from youth towards old age but not yet reached it. The sixth is man's old age, which is limited to no particular number of years; and this is also called decrepitude.][81]

The *Elementarium Doctrinae Rudimentum* had a very long life. Two

[80] Alcuin, *Commentarii in Joannem*, Bk. ii, Chap. vii (*PL* 100. 792), from Augustine, *De Diversis Quaestionibus*, Bk. i, Qu. lxiv (*PL* 40. 55).

[81] Papias, *Elementarium Doctrinae Rudimentum* (Milan, 1476), s.v. *Aetas*. Papias also has entries for individual age-terms such as *infans* and *puer*, most of which draw on the *Etymologiae* (though the second *senectus* entry is an intruder).

hundred years after Papias, John of Wales still cites him as his auth-
ority for the six ages in his *Communiloquium*. The third part of
John's work concerns those varieties of condition (*differentiae*)
which a moralist or preacher should observe in his audience. It is
modelled on the section of Aristotle's *Rhetoric* discussed in my first
chapter; and John, like Aristotle, includes age among the *differen-
tiae*: 'Viri admonendi sunt de ordinato modo vivendi secundum dif-
ferentias etatum. Et ideo, sicut varie sunt viri etates, sic varias
oportet esse vivendi informationes. De variis vero etatibus ait
Papias, ostendens quod prima etas continet septem annos . . .' ['Men
must be instructed in the right way of life in accordance with the dif-
ferences in their ages. For, just as the ages of men differ, so they
should receive differing moral instruction. Papias speaks about these
various ages, showing that the first age contains seven years . . .'][82]
The rest of this section of John's work consists of six chapters, each
of which characterizes one of the six ages, employing a variety of ci-
tations from classical and patristic sources—but all contained within
the framework provided by Papias.

Lexicographers are notorious for stealing from their predecessors.
The successors of Papias continued for centuries to expound the six
ages in much the same words. The most successful of all medieval
Latin lexicons, the *Catholicon* of Joannes Balbus Januensis, com-
pleted in 1286, has quite a lengthy entry under *etas*, beginning with
an account of the six ages of man which follows Isidore closely, with
a few additions from the other authority cited by Balbus, the *Mag-
nae Derivationes* of Hugo of Pisa (d. 1210).[83] There follows an expo-
sition of the six *aetates mundi*, distinguished in Augustine's way
'metaphorice ad similitudines etatis unius hominis'—metaphori-
cally, on the strength of resemblances to the life of the individual.
Balbus then goes on to give a brief account of the rival four-age
scheme, comparing *pueritia*, *iuventus*, *senectus*, and *senium* with the
four seasons of the year. The tradition of Augustine and Isidore still
goes unchallenged a century and a half later in the first English–
Latin dictionary, compiled by a Dominican of Lynn Episcopi, Nor-
folk, in 1440: *Promptorium Parvulorum* ('A Storehouse for the

[82] *Communiloquium sive Summa Collationum* (Strasburg, 1489; facsimile, Wake-
field, 1964), Pars III, Distinctio ii, *ad init.*
[83] *Catholicon* (Venice, 1495), s.v. *Etas*.

Young'). Citing Hugo's *Magnae Derivationes* as its authority, the *Promptorium* distinguishes the ages as follows: *infantia* (seven years), *pueritia* (up to the fourteenth year), *adolescentia* (up to the twenty-ninth), *juventus* (up to the fiftieth), *gravitas* (up to the seventieth), and *senectus* (until death, with *senium* as its last part). The *Promptorium* adds a seventh age 'at the final resurrection', which is simply Augustine's sabbath age of sempiternal rest, omitted in the other entries cited here.[84]

Although the reference books of Papias, Balbus, and the Friar of Lynn are something more than dictionaries, they cannot match the wealth of information to be found in the encyclopaedias of the twelfth and thirteenth centuries. Yet Isidore remains a prime source even here. The *De Imagine Mundi* of Honorius 'of Autun' gives no more than a summary of the *sex aetates hominis et mundi* in a form not very close to Isidore; but other twelfth-century writers on the natural world are content, like Hrabanus Maurus before them, to reproduce the master verbatim: thus the anonymous authors of *De Bestiis et Aliis Rebus* and the Latin prose *Bestiary*.[85] The greatest encyclopaedist of the following century, Vincent of Beauvais, shows rather more enterprise in his chapter 'De Gradibus Aetatum' in the *Speculum Naturale*, for he cites two authorities: Isidore on the six ages and (more up-to-date) Avicenna on the four.[86] It may be noted that both here and in a later chapter Vincent draws on Isidore's *Differentiae* as well as on the *Etymologiae*, incorporating from the former some of Isidore's curious arguments to explain why later ages occupy more year-weeks than the earlier. A single week of seven years suffices for both *infantia* and *pueritia*, says Isidore, because life is simple in those ages; but two weeks are required for *adolescentia* on account of its intellectual and physical activity ('propter intellectum et actionem'). To explain the three weeks of *juventus*, one must

[84] *Promptorium Parvulorum*, ed. A. L. Mayhew, EETS, ES 102 (1908), s.v. *Agis sevyn*.

[85] *De Imagine Mundi*, Bk. II, Chap. lxxv (*PL* 172. 156), on which see Hofmeister, art. cit. 293–4; *De Bestiis et Aliis Rebus*, Bk. III, Chap. lxi (*PL* 177. 132); *The Book of Beasts*, trans. T. H. White (London, 1954), 219–20. On the theme in the twelfth century, see M.-D. Chenu, *Nature, Man, and Society in the Twelfth Century* (Chicago, 1968), 181.

[86] *Speculum Naturale* (Douai, 1624), Bk. XXXI, Chap. lxxv. 2348–9. For the passage from Avicenna, see above, p. 23. Vincent treats the *aetates mundi* separately, in Bk. XXXII, Chap. xxvi.

take account of a third consideration, bodily power ('corporis vir-
tus'), in addition to the previous two. These three considerations are
raised to four by the addition of 'animi et corporis gravitas' in the
age *senectus*, which therefore requires four year-weeks.[87] This ver-
sion of the six-age scheme, which allows no less than seventy-seven
years of continuous physical and mental improvement, provides a
striking illustration of how the search for a rational and explicable
pattern in human life could lead to results sadly at odds with com-
mon experience.

Another very widely used encyclopaedia was the *De Proprietati-
bus Rerum* of Bartholomaeus Anglicus, compiled about 1230. Like
Vincent's *Speculum*, the *De Proprietatibus* was frequently copied
and, later, printed; and it was translated into English at the end of
the fourteenth century by John Trevisa for the benefit of his patron,
Thomas, lord of Berkeley. Eight manuscripts of this translation sur-
vive; it was printed by Wynkyn de Worde; and a revised version,
Batman uppon Bartholome, was popular in Shakespeare's day. The
sixth book of the *De Proprietatibus* is concerned with the various
properties of human beings, and begins with those which arise from
'etatis varietas'. The first chapter, 'De Etate', gives a general account
of the six ages. In it Bartholomaeus makes a spirited attempt to
bring his main authority, still Isidore, up to date by drawing upon
the *Viaticum* of Constantinus Africanus for Graeco-Arabic medical
lore of the sort that was more commonly associated, as we have seen,
with the scheme of the four ages. The result is an unusually full and
interesting discussion, which nevertheless displays the difficulty of
harmonizing the two traditions. The difficulty can be seen, for in-
stance, in Bartholomaeus's account of the third of his six ages, given
here in Trevisa's Middle English:

Hereaftir comeþ the age þat hatte *adholoscencia*, þe age of a yonge stripel-
inge, and dureþ þe þridde seven ȝere, þat is to þe ende of on and twenty ȝere.
So it is saide *in viatico*. But Isidir seiþ þat it dureþ to þe ferþe seven ȝere, þat
is to þe ende of 28 ȝere. But ficicians strecchen þis age to þe ente of 30 ȝere or

[87] *Differentiae*, Bk. ii, Chap. xix (*PL* 83. 81). Isidore's arguments may be compared
with those used by Augustine to explain the varying number of generations in the
aetates mundi: see the passage from *De Diversis Quaestionibus* in the Appendix here.

of 35 ȝere. Þis age hatte *adholescencia* for it is ful age to gete children, so seiþ Isidre, and able to barnische and encrece, and fonge myȝt and strengþe.[88]

It was in the process of commenting on the Bible that St Augustine had occasion to expound the *sex aetates*; and his ideas were subsequently propagated, not only by lexicographers and encyclopaedists, but also by biblical exegetes. For them the obvious occasion was provided by the account of Creation week in Genesis. Thus Abelard, following Augustine's *De Genesi contra Manichaeos*, gives in his *Expositio in Hexaemeron* an ambitious but somewhat muddled account of the concordances between the six days of Creation and the six *aetates mundi et hominis*.[89] The topic is by no means confined to hexaemeral contexts, however. As in Augustine's *De Diversis Quaestionibus*, it is a reference by St Paul to the end of the world which prompts St Thomas Aquinas to explain how the ages of the world are to be understood 'secundum aetates hominis'.[90] The Middle English *Stanzaic Life of Christ*, after placing the incarnation of Christ in its customary position at the beginning of the sixth *aetas mundi*, then embarks on a digressive account of the corresponding *aetates hominis*, following Isidore of Seville:

> And riȝt so as this world I-wys
> Ffro bigynnyng to endyng
> In sex eldes diviset is,
> Mon is that has his fulle lyvyng.[91]

[88] *On the Properties of Things*, ed. Seymour and others, 291–2. There is no modern edition of the Latin: I have consulted the Nuremberg edition of 1483. A note inserted by Trevisa elsewhere in his translation illustrates both the confusing variety of age-limits and also the difficulty of rendering the Latin *juventus* in English. Having translated the word as 'ȝouþe', Trevisa explains: '*iuventus* is here oþirwise taken þan oure comoun speche usith. For here it is itake for þe age þat duriþ from oon and twenty ȝere oþir from eiȝte and twenty ȝere, or from þritty or fyve and þritty, to fyve and fourty or fifty ȝere' (p. 290). The discussion of the ages may also be found, modernized from Trevisa's version, in *Batman uppon Bartholome* (1582). Though *senium* might, in the Batman version, be mistaken for a seventh age, rather than the last part of the sixth, there is no justification for claiming this as the source of Shakespeare's seven ages: see Chap. 1 n. 117 above.

[89] *PL* 178. 771–3.

[90] *In Epistolam ad Hebraeos*, Chap. ix, Lectio 5, in Aquinas, *Opera* (Venice, 1746), vi. 519.

[91] *A Stanzaic Life of Christ*, ed. F. A. Foster, EETS, os 166 (1926), ll. 101–4. For the ensuing exposition, Foster proposes *Catholicon* as the source.

Further opportunities to air the topic were furnished by allegorical exegesis. Alcuin, as we have seen, followed Augustine in allegorizing the *hora sexta* at which Jesus came to Jacob's well. A set of sculptured scenes in the west door of the Baptistry at Parma even manages to turn the *horae* of the Parable of the Vineyard to account. The hiring of the workmen of the eleventh hour is there split into two separate scenes, so that, instead of the customary five, six ages are displayed.[92]

At about the same time, in the later twelfth century, new stained-glass windows were being installed in Canterbury Cathedral, including a set of windows of complex design in which scenes from the Old and New Testaments were grouped together on allegorical principles. The fourth of these 'typological windows' was concerned with the public life of Christ, portrayed in a series of six medallions down the central axis of the window, each flanked by two half-medallions representing subjects related to it.[93] The second-from-the-top of the central medallions shows Christ's first miracle at the marriage in Cana of Galilee, when he turned water into wine (John 2:1–10). To the left of this is a half-medallion headed 'Sex etates sunt mundi', in which each of the six ages of the world is represented by a seated figure: Adam, Noah, Abraham, David, Jechonias (king of Judah at the beginning of the Babylonian captivity), and Christ. To the right is another half-medallion (Plate 9 here) headed 'Sex aetates hominis'. The first of its figures, labelled *infantia*, is a baby. The second, *pueritia*, carries a curved stick like a hockey-stick in his right hand and what appears to be a ball in his left. Like the boy's whipping-top in the Longthorpe mural, the stick and ball here represent *pueritia* as the age of play. The third figure represents *adolescentia*. His beard and moustache are beginning to grow; he wears a red gown richly hemmed with gold; and he carries in his right hand a sceptre. The sceptre is very like that carried in the de Brailes Wheel of Life picture (Plate 10) by the crowned figure at the top and by two figures in the preceding quadrant.[94] It appears to represent the kingly pride of life to which *adolescentia* is already heir. The fourth Canterbury figure,

[92] W. Molsdorf, *Christliche Symbolik der Mittelalterlichen Kunst* (Leipzig, 1926), 247.

[93] See M. H. Caviness, *The Windows of Christ Church Cathedral Canterbury*, Corpus Vitrearum Medii Aevi, Great Britain, ii (London, 1981), 106–13. The scenes referred to here are reproduced in her Figs. 185, 186, and 187.

[94] On the painting by William de Brailes, see S. C. Cockerell, *The Work of W. de Brailes* (Cambridge, 1930), 15–18.

however, carries not a sceptre but a sword. This is *iuventus*, with full moustache and beard, manifesting the power of mature manhood. The fifth figure, like the penultimate age at Longthorpe, carries what appears to be a money-bag, representing the worldly preoccupations of his time of life. The label, illegible to me, has been said to read *virilitas*. If this is indeed the reading, it represents a departure from customary usage, which treats *virilitas* as synonymous with *juventus*.[95] Given that the last age is labelled *senectus*, one might expect *gravitas* here, as in *De Diversis Quaestionibus* and the *Etymologiae*. Senectus himself is a balding man with a white beard, holding in his right hand a crutch-like stick, the customary attribute of old age.

The clue to this conjunction of pictures lies in the six *hydriae* or water-pots whose contents Christ is said to have turned into wine at the marriage feast in Cana. These pots, which figure prominently in the foreground of the scene in the central medallion at Canterbury, were commonly interpreted by commentators and preachers as types of the six *aetates mundi* whose various prelusive revelations of God (these being represented by the water) were fulfilled, or turned to wine, by Christ.[96] But the only authority known to me who also refers in this connection to the six *aetates hominis* is Caesarius of Arles (d. 542). In one of his three sermons on the marriage at Cana, after stating that the six water-pots figure the six ages of the world, Caesarius continues:

Quae res etiam in humanae vitae cursu evidenter agnoscitur; primus enim gradus est quasi prima aetas infantia, secunda pueritia, tertia adulescentia, quarta juventus, quinta senectus, sexta est illa permatura, quae etiam decrepita dicitur. Non ergo tibi mirum videatur, quando audis mundum istum sex aetatibus consummari, cum hoc videas etiam in hominum aetatibus adimpleri. In istis sex aetatibus mundi quasi in sex ydriis prophetia non defuit. Plenae ergo erant istae ydriae mysteriis veteris testamenti: sed quando in illis Christus non intellegebatur, non ex ipsis vinum, sed aqua bibebatur.

[This pattern can also be clearly seen in the course of man's life. For the first stage is infancy, the first age, as it were; the second is boyhood, the third

[95] De Ghellinck, art. cit. 46, cites a passage from Ambrose in which *virilis aetas* follows *iuventus*; but this is the fifth of seven ages, being followed by *maturitas* and *senectus*.

[96] So the commentaries on John's Gospel by Augustine (*PL* 35. 1462–6), Bede (*PL* 92. 658–60), and Bruno (*PL* 165. 462), and Bede's sermon for the Second Sunday after Epiphany, when John 2:1–11 was the Gospel reading (*PL* 94. 70–3).

adolescence, the fourth youth, the fifth old age, and the sixth is that overripe age which is also called decrepit. So do not be surprised to hear that this world will come to an end after six ages, when you can see the same thing happen in the ages of man. There was no lack of divine revelation in those six ages of the world—in the six water-pots, as it were. Indeed, those pots were full of the mysteries of the Old Testament. But in so far as Christ was not understood in them, it was water rather than wine that was drunk from them.][97]

A recent authority on the Canterbury windows rightly insists that they offered not 'books for the laity' but difficult, even esoteric, images, intended primarily for the monks of the cathedral to ponder as they paid their frequent visits to the choir.[98] For such viewers, at least, the window of the water-pots might have conveyed more than a simple parallel between *aetates mundi* and *aetates hominis*. Christ, as Caesarius says, did not reject the Old Testament in establishing the New, but caused it to be understood in a fresh spiritual way: the water filling the pots was not thrown away, but changed into wine.[99] Just so, the miracle would suggest, the six ages of the old natural man may be transformed and made new by the power of Christ—the order of nature not rejected, but mysteriously fulfilled in the spirit.

III

These two chapters have illustrated how the ideas of ancient *auctores*—Pythagoras, Hippocrates, Aristotle, Ptolemy, Augustine, and the rest—flowed through the Middle Ages in many different channels: sermons and Bible commentaries, moral and political treatises, encyclopaedias and lexicons, medical and astrological handbooks, didactic and courtly poetry, tapestries and wall-paintings, table decorations and stained-glass windows. Many medieval people, we

[97] Caesarius, *Sermones*, ed. G. Morin, Pt. I. 2, CCSL civ (Turnhout, 1953), Sermo clxix (p. 692). Caesarius's age-terminology does not correspond to that in the Canterbury window, however. I know of no parallel to his use of *permatura*. It should be noted that Caesarius, like other writers, manages to include the sixth age among those whose mysteries were fulfilled in Christ by starting it with John the Baptist.

[98] M. H. Caviness, *The Early Stained Glass in Canterbury Cathedral* (Princeton, NJ, 1977), 104.

[99] Ed. cit. 694.

may suppose, knew little more about the formal doctrines of the *aetates hominum* than they might have learned from a sermon on Septuagesima Sunday or a wall-painting in a chamber. For them, and especially for the mass of peasantry, the divisions of life were determined, not by learned authority, but by native language and custom. They would have understood little or nothing of the several age-schemes with their various *comparationes* and age-termini. In communities where most individuals did not in any case know exactly how old they were, age was largely a matter of status, and status was conferred by *rites de passage* such as marriage, which occurred at intervals only loosely prescribed by custom.[100] Medieval literature as we have it, however, is largely the work of a lettered minority, whether monks such as Bede, Ælfric, and Byrhtferth, or bookish laymen such as Dante and Chaucer; and for these men, as we have seen, knowledge of the *aetates hominum* formed a modest but necessary part of scientific, computistical, and historical learning.

At the conclusion of his remarkably comprehensive survey of age-schemes, the Elizabethan writer Thomas Fortescue remarks that 'consideringe these variable opinions, I know not where most safely to arrest my selfe.'[101] I have encountered no medieval writer as comprehensive as Fortescue; but many readers of that period too must have seen enough of such variable opinions to share something of his uncertainty. There were four main traditions, each offering a different way of dividing life up into ages, whether three, four, six, or seven, not to speak of lesser traditions; and there was also, within each tradition, a good deal of variation both in naming the ages and in defining their limits. Yet medieval writers treat such differences, when they notice them at all, with a certain equanimity, as if confident that the biologists, *medici*, astrologers, and theologians can all be understood to describe, albeit from different points of view, the same great order of things. Man may participate in this order in a variety of ways: following the rising and falling arc of all living things, exhibiting in his sequence of prevailing humours the order of those qualities which also govern the elements and the seasons, subject to the influences of the seven planets, conforming to the cycles of

[100] One may compare the study of nineteenth-century French peasant society by A. Varagnac, *Civilisation traditionelle et genres de vie* (Paris, 1948), 113–245: 'Les Catégories d'âge définies par les comportements cérémoniels'.

[101] *The Foreste* (1571), 48^{r-v}.

the day and the year, and re-enacting in one little life the whole history of his kind. Thus, through their various *comparationes*, the authorities unite in stressing the individual's place in a larger order of nature and time.

Yet man is not bound to follow the *cursus aetatis* so marked out for him, as if he were a mere thing of nature like a plant or a planet. In so far as he is gifted with reason and free will, the natural course of life may represent for him no more than a norm from which he may choose, for better or for worse, to depart. So it is that the idea of the *cursus aetatis* gives rise to a variety of moral issues, to be considered in the second half of this study.

3

Ideals of Transcendence

THE title of this chapter is borrowed from a masterly study by Christian Gnilka of what he calls the 'Transzendenzideal', or transcendence ideal, in early Christian thought about the ages of man.[1] The subject had been broached by Ernst Robert Curtius, whose *European Literature and the Latin Middle Ages* was in part inspired, so he tells us, by curiosity about the theme of the aged youth or *puer senex*, which he had come upon in the writings of St Gregory.[2] Curtius was able to show that this was a common topos, originating, he thought, in the panegyric rhetoric of late pagan Antiquity and persisting in Christian writers of the Middle Ages. Gnilka's book demonstrates that the idea had much deeper roots than Curtius supposed, both in Epicurean and Stoic philosophy and in Christianity itself. For Christians, it came to form part of a more general theory of *aetates spiritales*, according to which the virtues of each natural age might be available by grace, in a more or less spiritualized form, to the faithful regardless of their years. Thus a young person could be spiritually old, in accordance with the moral definition of *senectus* given in a frequently cited verse from the Book of Wisdom: 'Senectus enim venerabilis est non diuturna, neque annorum numero computata: cani autem sunt sensus hominis, et aetas senectutis vita immaculata' ['For venerable old age is not that of long time, nor counted by the number of years: but the understanding of a man is grey hairs, and a spotless life is old age'].[3] More distinctively Christian was the complementary idea of spiritual *infantia*, that state of simplicity and

[1] *Aetas Spiritalis: Die Überwindung der natürlichen Altersstufen als Ideal frühchristlichen Lebens* (Bonn, 1972). My discussion is much indebted to this outstanding monograph.

[2] *European Literature and the Latin Middle Ages*, trans. W. R. Trask (London, 1953), 381. Curtius's discussion of the subject is to be found on pp. 98–105.

[3] Wisdom 4:8–9. Gnilka stresses the importance of this text (58, 90, etc.).

innocence to which Christ himself had called his followers of whatever age: 'Unless you be converted and become as little children, you shall not enter into the kingdom of heaven' (Matthew 18:3). In such ways could time be transcended and the limitations of the *cursus aetatis* overcome.

<p style="text-align:center">I</p>

Curtius speaks of the topos *puer senex* as a 'hagiographic cliché', and it is indeed in the biographies of saints and other Christian heroes that the influence of the transcendence ideal upon medieval writers can be most distinctly traced. The story begins, so far as England is concerned, with Latin *vitae sanctorum* composed by Anglo-Saxon monks. Men familiar with the Rule of St Benedict could hardly fail to grasp the principle involved, for their own monastic society was supposed to observe it: 'The brethren shall keep their order in the monastery according to the date of their entry, or according to the merit of their lives . . . And on no occasion whatever should age distinguish the brethren and decide their order; for Samuel and Daniel, though young, judged the elders.'[4] These were among the most frequently invoked of the many recognized Biblical types of the *puer senex*: the child Samuel who ministered unto the Lord before the aged priest Eli, and the boy Daniel who was granted by God the honour of an elder (*honor senectutis*) and sat in judgement on the two ancient admirers of Susanna.[5] Furthermore, the two main models of hagiographical writing followed by Anglo-Saxon monks both displayed in their heroes when young the pre-

[4] From Chap. 63, 'De Ordine Congregationis', of the Rule of St Benedict, ed. and trans. J. McCann (London, 1972), 143. Gnilka stresses Benedict's negation of the age-principle in his discussion of the Rule (pp. 189–202). Yet by taking date of entry into the monastery as one of his two criteria, Benedict does allow one kind—albeit a special one—of temporal seniority. Accordingly, his ensuing interpretation of the Parable of the Vineyard runs counter to Christ's own anti-temporal conclusions (the last shall be first): 'Let him, for instance, who came to the monastery at the second hour of the day (whatever be his age or dignity), know that he is junior to him who came at the first hour.' It is no easy matter to rise completely above temporal considerations.

[5] 1 Kings 3 (1 Samuel 3 in Authorized Version) and the apocryphal History of Susanna, vv. 45–64. On Biblical types of the *puer senex*, see the full discussion by Gnilka, 223–44. Besides Samuel and Daniel, he considers Abel, Jacob, Joseph, Moses, Joshua and Caleb, David, Solomon, Elisha, Josias and Joas, Jeremiah, the young men in the furnace, the seven Maccabee brothers, Jesus in the Temple, John the Evangelist, the rich young man of Matthew 19, and Timothy.

cocious piety of the *puer senex*. The *Life of St Antony*, by Athanasius, known in the Latin version by Evagrius, describes Antony in his early years thus:

Et cum jam puer esset, non se litteris erudiri, non ineptis infantium jungi passus est fabulis; sed Dei desiderio flagrans, secundum quod scriptum est, innocenter habitabit domi. Ad ecclesiam quoque cum parentibus saepe conveniens, nec infantum lascivias, nec puerorum negligentiam sectabatur.

[And when he was a boy, he could not bear to be instructed in literature or to have anything to do with silly children's stories; but burning with the love of God, as it is written, he dwelt at home in innocence. He also often went to church with his parents, and avoided both infantile games and boyish thoughtlessness.][6]

St Martin was a boy of a similar kind, according to the equally influential *Life of St Martin* by Sulpicius Severus:

Nam cum esset annorum decem, invitis parentibus ad ecclesiam confugit seque catechumenum fieri postulavit. Mox mirum in modum totus in Dei opere conversus, cum esset annorum duodecim, eremum concupivit, fecissetque votis satis, si aetatis infirmitas non fuisset impedimento. Animus tamen, aut circa monasteria aut circa ecclesiam semper intentus, meditabatur adhuc in aetate puerili quod postea devotus inplevit.

[For when he was ten years old, he took refuge without his parents' consent in a church and asked to be made a catechumen. Soon he devoted himself entirely to God's work in a most marvellous fashion; for when he was twelve he longed for a hermit's life in the desert, and he would have fulfilled his desire had not the weakness of his age stood in his way. Yet with his mind always set on hermitages and churches, he went on throughout his boyhood pondering what afterwards he was piously to achieve.][7]

In describing how their own native heroes followed such examples as Samuel and Daniel, Antony and Martin, Anglo-Saxon writers sometimes employed the very words of St Gregory the Great which first caught Curtius's eye. The second book of Gregory's *Dialogues* is devoted to the life and miracles of St Benedict; and in it the author describes Benedict's boyhood thus:

[6] *Vita Beati Antonii Abbatis*, Chap. I. (*PL* 73. 127).

[7] *Vita Martini Turonensis*, 2. 3–4, cited from the edition with French translation by J. Fontaine, *Sulpice Sévère, vie de saint Martin* (3 Vols., Paris, 1967–9), i. 254. See Fontaine, ii. 441–4, for discussion of 'la thème de la sainte enfance' in saints' lives.

Fuit vir vitae venerabilis, gratia Benedictus et nomine, ab ipso suae pueritiae tempore cor gerens senile. Aetatem quippe moribus transiens, nulli animum voluptati dedit.

[He was a man of venerable life, blessed by grace and blessed by name, who had even from the time of his boyhood the heart of an old man. In his behaviour he went far beyond his age, never giving himself up to foolish pleasure.][8]

Gregory's much-imitated phrase 'aetatem moribus transiens' expresses, with a brevity that English can hardly match, the essence of the 'Transzendenzideal'. It is itself evidently modelled on a phrase of St Cyprian; for in an earlier work Gregory had written of 'pueri qui hic annos suos moribus transcenderunt', and the context there— a catalogue of those who enjoy eternal felicity—resembled that in which Cyprian had written of 'pueri annos suos virtutibus transeuntes'.[9] It may be noted here that, since Cyprian's was a catalogue of the faithful who persevere in adversity and emerge triumphant, he appropriately used a phrase which already had heroic associations. In the *Punica* of Silius Italicus, the older Scipio Africanus was described as a boy striving to 'transcend his years in his deeds' in battle against the Carthaginians: 'annos transcendere factis'.[10] The language of transcendence had, in fact, secular as well as religious roots; and we shall see later in this chapter that in the Middle Ages, too, it could be applied to warriors and rulers, as well as to saints and ascetics.

The first English writer to adopt Gregory's formulation was Bede, writing in his *Historia Abbatum* about St Benedict's namesake, Benedict Biscop. The English Benedict was the founder and first abbot of Bede's own monastery of Wearmouth-Jarrow. Bede, writing in the 720s, notes the identity of name, and takes the opportunity of applying to the founder of his monastery what Gregory said about the author of its Rule:

Qui ut beati papae Gregorii verbis, quibus cognominis eius abbatis vitam glorificat, utar: 'Fuit vir vitae venerabilis, gratia Benedictus et nomine, ab ipso pueritiae suae tempore cor gerens senile, aetatem quippe moribus transiens, nulli animum voluptati dedit.'

[8] *Dialogorum Libri IV*, Bk. II, *ad init.* (*PL* 66. 126).

[9] Gregory, *XL Homiliarum in Evangelia Libri Duo*, Bk. I, Hom. 14 (*PL* 76. 1130); Cyprian, *Liber de Lapsis*, Chap. 2 (*PL* 4. 480). See Gnilka, p. 27 n. 4.

[10] *Punica*, ed. and trans. J. D. Duff (Cambridge, Mass., and London, 1934), IV. 426.

[To make use of the words in which blessed pope Gregory praised the life of the abbot of the same name: 'He was a man of venerable life, blessed by grace and blessed by name, who had even from the time of his boyhood the heart of an old man. In his behaviour he went far beyond his age, never giving himself up to foolish pleasure.']¹¹

To bear the same name as a saint, especially a speaking name like 'Benedictus', was to have a spiritual model; and if one succeeded in following that model, as the English Benedict did, then one inherited the praises earned by the venerable predecessor. The more perfect the 'imitatio', the less reason there was to alter the wording. Indeed, the same principle applies more generally; for in so far as all Christian heroes succeed in imitating the same supreme model, Christ himself, much the same terms can be used in the praise of them all.

In his *Historia Ecclesiastica*, written shortly after the *Historia Abbatum*, Bede applied Gregory's transcendence-formula to another seventh-century Englishman, St Wilfrid. Bede describes Wilfrid in his pious boyhood as 'puer bonae indolis, atque aetatem moribus transiens' ['a boy of virtuous disposition, and in his behaviour going far beyond his age'].¹² 'Puer bonae indolis', a Biblical phrase picked up from the earlier life of Wilfrid by Eddius, here takes the place of Gregory's more challenging 'cor gerens senile'.¹³ The resulting description of a *puer senex* provided a model for later Anglo-Saxon hagiographers. Thus Alcuin in his *Life of Willibrord* describes how the missionary saint showed from early boyhood such virtue and good sense 'that you might think that our times had seen the birth of a new Samuel, of whom it is said that "the child Samuel advanced, and grew on, and pleased both the Lord and men"'. Willibrord advanced (*proficiebat*) just like Samuel: 'Sic quotidie bonae indolis puer proficiebat, ut teneros pueritiae annos morum gravitate trans-

¹¹ *Historia Abbatum*, Chap. I, in C. Plummer (ed.), *Venerabilis Baedae Opera Historica* (Oxford, 1896), i. 364.

¹² *Historia Ecclesiastica*, Bk. v, Chap. 19, in B. Colgrave and R. A. B. Mynors (edd.), *Bede's Ecclesiastical History of the English People* (Oxford, 1969), 516.

¹³ In 1 Chronicles 12:28, Sadoc is described as 'puer egregiae indolis'. Compare Eddius Stephanus, *Life of Bishop Wilfrid*, ed. B. Colgrave (Cambridge, 1927), Chap. II: 'Cum ergo puerilis aetatis esset, parentibus oboediens, omnibus carus, pulcher aspectu, bonae indolis, mitis, modestus, stabilis, nihil inane more puerorum cupiens' ['During his boyhood he was obedient to his parents and beloved of all, fair in appearance, of virtuous disposition, gentle, modest and firm, with none of the vain desires customary in boys'].

cenderet: factusque est grandaevus sensu qui corpusculo modicus fuit et fragilis' ['Thus every day this boy of virtuous disposition advanced, so that he might transcend the tender years of his boyhood in the seriousness of his behaviour; and he became like an old man in wisdom, though slight and frail in body'].[14] Alcuin in turn furnished the model for the account of the holy boyhood of St Æthelwold by Wulfstan of Winchester, nearly two centuries later: 'Igitur quotidiano profectu crevit puer bonae indolis ... Studebat etiam teneros pueritiae annos morum honestate et virtutum maturitate vincere' ['And so this boy of virtuous disposition improved daily ... He strove, too, to overcome the tender years of his boyhood by the excellence of his behaviour and the mature quality of his virtues'].[15]

These examples, of Benedict Biscop, Wilfrid, Willibrord, and Æthelwold, are enough to show how the Anglo-Saxon writers of Latin saints' lives, at their most analytic, conceived the boyhood virtue of their heroes. Such 'new Samuels' were able to go beyond, rise above, or overcome the limitations of their youth because in them a naturally good disposition was inspired by grace to transcend the order of nature. More examples could be given from other such Latin writings of Anglo-Saxon ascetics described, though in different phrases, as having displayed preternatural virtue in their early years: Boniface in the *Life* by Willibald, Dunstan in the *Life* by Osbern, Fursa in Bede's *Historia*, Guthlac in the *Life* by Felix, Oswald in the *Life* by Eadmer, Willibald in an anonymous *Life*.[16] Thus in his *Life of Oswald* Eadmer records how, as an *adolescens*, the saint was made Dean at Winchester in preference to a much older man:

Decanus factus, adolescens praeponitur senibus; quatinus canities sensus illius et immaculata vita illius maculatam senum vitam emacularet, ac pueriles sensus illorum studio disciplinae caelestis evacuaret.

[When he was made dean, a young man was preferred to old ones, so that

[14] Alcuin, *Vita Sancti Willibrordi*, Bk. I, Chap. 3 (*PL* 101. 696).

[15] *Vita Sancti Ethelwoldi*, Chap. 6 (*PL* 137. 86). Another late Anglo-Saxon hagiographer, Eadmer, follows Bede closely in his account of the holy boyhood of Wilfrid: *Vita Wilfridi Episcopi*, in J. Raine (ed.), *The Historians of the Church of York and its Archbishops*, Rolls Series lxxi, vol. i. (1879), 165.

[16] Boniface in *Vitae Sancti Bonifatii*, ed. W. Levison, Scriptores Rerum Germanicarum (Hannover and Leipzig, 1905), 4–7; Dunstan in *Memorials of St Dunstan*, ed. W. Stubbs, Rolls Series lxiii (1874), 73–7; Fursa in Bede's *Historia Ecclesiastica*, Bk. III, Chap. 19; Guthlac in Felix's *Life of St Guthlac*, ed. B. Colgrave (Cambridge, 1956), Chap. 12; Oswald in *Historians of the Church of York*, ed. Raine, vol. ii (1886), 2; Willibald in *Descriptiones Terrae Sanctae*, ed. T. Tobler (Leipzig, 1874), 9–10.

the grey-hairedness of his mind and his spotless life might serve to purify the impure life of the old men and overcome their puerile minds by dint of spiritual discipline.][17]

This passage illustrates the characteristic Latin rhetoric of the transcendence ideal, in its paradoxes and antitheses, and also in the bold metonymy of 'canities sensus', grey-hairedness of mind—an ancient trope, going back to the verse already quoted from the Book of Wisdom: 'the understanding of a man is grey hairs [*cani*], and a spotless life is old age.'[18]

It proved difficult for writers in the vernacular to match such highly-wrought language. Faced with Gregory's description of St Benedict, the Anglo-Saxon translator of the *Dialogues*, Bishop Werferth of Worcester, conflated the two difficult Latin phrases, 'cor gerens senile' and 'aetatem moribus transiens', into the barely intelligible 'healdende ond donde swyðe ȝedafenlice ylde on his þeawum' [?'keeping and performing a very becoming age in his behaviour.'][19] The Bishop's Mercian contemporary, translating Bede's *Historia*, did better with 'aetatem moribus transiens' when he met it in the eulogy of St Wilfrid: 'he wæs godre gleawnesse cniht ond he þa yldo mid þeawum oferstigende' ['he was a boy of great sagacity, rising above that age in his behaviour'].[20] About a century later, the reviser of Werferth's translation of the *Dialogues* used the same native word, *oferstigan*, to render the Latin *transire* in a much-improved rendering of Gregory's words: 'Se of þære tide his cnihthades wæs berende ealdlice heortan ond oferstah his ylde mid godum þeawum' ['From the time of his boyhood he bore the heart of an old man and rose above his age with good behaviour'].[21] These Gregorian expressions do not occur, so far as I know, in the writings of the greatest of the vernacular hagiographers, Abbot Ælfric; but these provide further instances of the *puer*—and *puella*—*senex*, including

[17] Raine, ii. 6.

[18] On this use of *canities*, see Gnilka, 38, and compare Bede on Proverbs 20 : 29, 'Canitiem sapientiam dicit' (*PL* 91. 999).

[19] *Bischofs Wærferth von Worcester Übersetzung der Dialoge Gregors des Grossen*, ed. H. Hecht (2 vols. Leipzig and Hamburg, 1900–7), i. 94–5.

[20] *The Old English Version of Bede's Ecclesiastical History of the English People*, EETS, os 95, 96, 110, 111 (1890–1, 1898), 450.

[21] Ed. cit. i. 94–5 (MS H). The Hatton manuscript (H) preserves a revision of Werferth's translation, associated by Gneuss with the new standard Old English being developed at Winchester: *Anglo-Saxon England* i (1972), 80–1.

St Gregory himself.[22] Where Ælfric is employing that distinctive rhythmical prose in which two-stress phrases are coupled in pairs comparable to the contemporary verse-line, he twice lays out the paradox of transcended nature in antithetical half-lines. Following his Latin source, he describes St Alexander as 'iunglic on gearum, and aldlic on geleafan' ['young in years and old in faith']; and little St Agnes, martyred at the age of thirteen, is 'cildlic on gearum and ealdlic on mode' ['childish in years and old in spirit'].[23] To this example of a *puella senex* may be added, from an anonymous homily, that of the Virgin Mary. She, according to apocryphal tradition, was taken at the age of only three by her parents to the Temple and ascended its fifteen steps without once looking back at her mother and father: 'Ac heo wæs on gange and on worde and on eallum gebærum gelic wynsuman men, þe hæfde XXX wintra' ['And she walked and spoke and behaved just like a comely person of thirty years old'].[24]

These examples taken from Anglo-Saxon England will be enough to give substance to some general observations about the 'transcendence ideal'. First, as Gnilka observes, talk of such transcendence implies a strong belief in natural norms.[25] It would make no sense to speak of the 'canities sensus' of a young person if it were not the case that wisdom and virtue are normally to be expected, not from black or brown hair, but from white or grey. If everyone, or even if most people, succeeded in 'transcending their age', the whole system would collapse. Transcendence, in this mortal life, is a property of the few—mainly, in medieval writings, of saints and heroes. Outside time and nature, in eternity, the case is different, for there transcen-

[22] 'On geonglicum gearum, ða ða his geogoð æfter gecynde woruldðing lufian sceolde, ða ongann he hine sylfne to gode geðeodan' ['In his early years, at a time when in the course of nature his youthful spirit would have been attached to worldly things, he began to attach himself to God'], *Catholic Homilies: Second Series*, ed. Godden, 73.

[23] For St Alexander, see *Homilies of Ælfric: A Supplementary Collection*, ed. J. C. Pope, EETS, os 259, 260 (1967, 1968), No. xxiii, l. 7. The Latin source cited by Pope has 'iuvenis quidem aetate, sed fide senior'. For St Agnes, see *Ælfric's Lives of the Saints*, ed. W. W. Skeat, EETS, os 76, 82, 94, 114 (1881–1900), No. vii, l. 9. Compare the Old English version of Gregory's *Dialogues*, speaking of a certain Benedict: 'se wæs wintrum ʒeong ond on his þeawum eald ond gedefe', ed. cit. i. 219.

[24] *Angelsächsische Homilien und Heiligenleben*, ed. B. Assmann (Kassel, 1889), No. x, ll. 300–4. The story comes from the Gospel of Pseudo-Matthew: see below, p. 112.

[25] Gnilka, 134–5.

dence is a universal condition—if indeed one can speak of trans-
cending time where time no longer exists. The emancipation from
temporal order which men and women achieve rarely and by special
grace, eternal beings possess by right. This is most obviously true of
God himself; and it is therefore eminently appropriate that, when
the 'eternal Lord' appears as a ship's captain to St Andrew in the
Anglo-Saxon poem *Andreas*, the apostle should take him for a *juve-
nis senex*:

> Þu eart seolfa geong,
> Wigendra hleo, nalas wintrum frod;
> Hafast þeh on fyrhðe, faroðlacende,
> Eorles ondsware. Æghwylces canst
> Worda for worulde wislic andgit.

[You are yourself young, leader of man, and not at all old in years; yet you
have the power of mind, seafarer, to reply like a grown man. You can judge
the true significance of every man's words in the world.][26]

A little later Andreas gives thanks for the wisdom of the 'young
man' as a special gift of God:

> Ic æt efenealdum æfre ne mette
> On modsefan maran snyttro.

[I have never encountered greater wisdom of mind in one of his years.][27]

Some few human beings do indeed receive such a gift in their life-
time; but most can escape from the *cursus aetatis* only after death,
when they enter the eternal world, in which all differences of age are
left behind. This eschatological doctrine, when taken in conjunction
with the doctrine of the resurrection of the body, created difficulties
which could only be resolved by supposing that everyone after the
general resurrection would be of the same age.[28] Which age was a
moot point, however, since two passages of Scripture suggested dif-
ferent answers. A frequently cited saying of Isaiah, according to

[26] *Andreas and The Fates of the Apostles*, ed. K. R. Brooks (Oxford, 1961), ll. 505–9.
[27] ll. 553–4. The parallel passage from *Beowulf*, cited by Brooks, will be discussed
later in this chapter.
[28] On this matter, see the excellent discussion by Gnilka, 148–62.

which in the new heaven and new earth 'there shall no more be an infant of days there, nor an old man that shall not fill up his days', was taken by Jerome and others to mean that everyone will attain the full age of one hundred after the resurrection.[29] The more attractive alternative, favoured by Augustine and his medieval followers, was to derive a solution from St Paul's words in Ephesians: 'until we all meet into the unity of faith and of the knowledge of the Son of God, unto a perfect man, unto the measure of the age of the fulness of Christ.'[30] Augustine took this to mean that all bodies will rise from their graves at that age of maturity and perfection to which Christ himself attained on earth, that is, at about thirty.[31] Ælfric adopted this opinion:

> and hi ealle ðonne beoð on anre ylde syððan,
> on þære ylde þe Crist wæs ða ða he ðrowode,
> wæron hi on ylde deade, wæron hi on cildhade.

[And they will all then be of one age, of that age that Christ was when he suffered death, whether they died in old age or in childhood.][32]

Something like this doctrine lies behind the *Gawain*-poet's portrayal of the maiden in *Pearl* who, having died in infancy, nevertheless appears in her father's vision (albeit before the general resurrection) as

[29] Isaiah 65:20. The rest of the verse obscurely specifies one hundred years in words which, as I shall illustrate in the next chapter, were often given a quite different application: 'for the child shall die a hundred years old, and the sinner being a hundred years old shall be accursed.'

[30] Ephesians 4:13. Gnilka stresses the importance of this verse in early Christian thought.

[31] *The City of God*, Bk. XXII, Chap. 15: 'Sic accipiamus dictum ut nec ultra nec infra juvenilem formam resurgant corpora mortuorum, sed in eius aetate et robore usque ad quam Christum hic pervenisse cognovimus. Circa triginta quippe annos definierunt esse etiam saeculi huius doctissimi homines juventutem' ['Thus we may understand that the bodies of the dead will rise, not in more nor in less than a mature state, but at that very age of greatest strength to which we know Christ to have attained here on earth. For the most learned men of this world have identified the age of about thirty years as maturity'], *PL* 41. 777. On Christ's age, see the following chapter.

[32] *Homilies of Ælfric*, ed. Pope, No. XI, ll. 305–7; cf. No. XII, ll. 109–11. Elsewhere Ælfric specifies the age in question as about thirty-three, the age of Christ at the time of his death: *Catholic Homilies*, ed. Thorpe, i. 236. For other examples, see J. E. Cross, 'The Literate Anglo-Saxon', *PBA* lviii (1972), 10. John Mirk gives thirty as the age at which men, women, and children all will rise to Judgement: *Festial*, ed. T. Erbe, EETS, ES 96 (1905), 3.

a grown woman. For in heaven, 'there shall no more be an infant of days'.

To a religious mind, then, the transcendence ideal had an eschatological character. To transcend one's age was to win a victory over time and gain entry into that eternal world where age had no meaning. Yet Gnilka's term may be misleading if it suggests that 'conquering one's age' would always be valued in and for itself, irrespective of other considerations, as a feat so intrinsically admirable that it is to be applauded whatever the results. An old saint who conquered the sexual apathy natural to his advanced age would not be praised for it by monastic biographers. It obviously cannot be enough in itself that the quality achieved should belong in the order of nature to some other age of life: it must also be a quality which the writer, whether he be hagiographer or heroic poet, regards as admirable. That being so, and not otherwise, the fact that it is achieved *contra naturam* will add, in epideictic writing of this sort, an extra grace and grandeur.

It follows that, in any body of writings whose authors have an ideology in common, we may find the instances of transcendence displaying a consistent bias towards those ages whose (natural) qualities they favour. In practice this usually means either a preference for that 'upward' transcendence in which a young person achieves the virtues of old age, or else a preference for that 'downward' variety in which an old person achieves the virtues of childhood or the powers of youth.[33] In the case of the texts so far considered, there is a clear preference for transcendence of the upward sort. Thus Latin saints' lives generally give a distinctly negative account of *pueritia* (most often distinguished from *infantia* on the one side and *adolescentia* on the other).[34] The *puer*, in his natural state, has no sense of duty, seeks only pleasure, and devotes himself to games. A typical case is St Cuthbert, who, unlike more precocious saints, was a thoroughly and deplorably boyish eight-year-old:

Oblectabatur . . . iocis et vagitibus, et iuxta quod aetatis ordo poscebat, par-

[33] My terms 'upward' and 'downward' follow Gnilka, who speaks of transcendence as either 'aufsteigende' or directed 'abwärts' (p. 31).

[34] The *Vita Sancti Bonifatii* by Willibald (ed. Levison (p. 56)) displays a summary list of age-terms: 'Enumeratis igitur beati viri gestis, quibus in infantia et pueritia vel adolescentia et iuventute aut etiam in senectute floruerat . . .'

vulorum conventiculis interesse cupiebat, ludentibus colludere desiderabat
... Sive enim saltu, sive cursu, sive luctatu, seu quolibet alio membrorum
sinuamine se exercerent, ille omnes aequevos, et nonnullos etiam maiores a
se gloriabatur esse superatos.

[He amused himself with boyish games, and further, as was natural at his
age, he loved to be in the company of children and delighted to join in their
play ... Whether they were jumping or running or wrestling or exercising
their limbs in any other way, he used to boast that he had beaten all who
were his equals in age and even some who were older.][35]

The fact that the boy Cuthbert received God's call to break out of
the *aetatis ordo* and devote himself to holiness from the mouth of a
three-year-old child serves as a reminder that Christianity did indeed
value highly the spiritual qualities, not of *pueritia*, but of the very
first of man's ages, *infantia*. Christ himself said 'unless you be con-
verted and become as little children, you shall not enter into the
kingdom of heaven. Whosoever therefore shall humble himself as
this little child, he is the greater in the kingdom of heaven' (Matthew
18:3–4).[36] In a widely quoted paraphrase of this passage, St Jerome
spelled out the four virtues natural to the innocent child:

Sicut iste parvulus, cuius vobis exemplum tribuo, non perseverat in iracun-
dia, non laesus meminit, non videns pulchram mulierem delectatur, non
aliud cogitat et aliud loquitur: sic et vos nisi talem habueritis innocentiam, et
animi puritatem, non poteritis regna coelorum intrare.

[Just as the child, whose example I offer you, does not continue in wrath, nor
remember an injury, nor take pleasure in seeing a pretty woman, nor think
one thing while saying another; so you also, unless you have the same inno-
cence and purity of soul, will not be able to enter the kingdom of heaven.][37]

This beautiful passage was certainly known in Anglo-Saxon Eng-
land: both Bede and Ælfric recall it.[38] Yet hagiographers rarely
have occasion to sing the praises of infant innocence; and there is

[35] Bede's *Vita Sancti Cuthberti*, ed. and trans. B. Colgrave, *Two Lives of St Cuth-
bert* (Cambridge, 1940), Chap. i.

[36] Gnilka stresses the importance of specifically Christian ideas of spiritual child-
hood and the *senex puer*, citing 1 Corinthians 14:20 as a key text (pp. 106–11). Else-
where, however, he notes the lesser frequency of 'downward transcendence' in early
Christian writings (p. 31).

[37] Jerome, *Commentarii in Evangelium Matthaei*, Bk. iii, Chap. 18 (*PL* 26. 133),
followed by Isidore (*PL* 83. 207) and Haymo (*PL* 118. 772).

[38] Bede follows Jerome in his commentaries on Mark 10:15 and on Luke 18:17, D.
Hurst (ed.), CCSL cxx (Turnhout, 1960), 326, 559. See also Ælfric, *Catholic Homilies*,
ed. Thorpe, i. 512.

little sign in their work of the ideal which Christ's words so clearly suggest—an *infantia spiritualis* attained in later life by downward transcendence.

It is the virtues of old age which furnish the chief goals of transcendence in these writings: *maturitas*, *gravitas*, and above all *sapientia*. Thus the hagiographers make, in their own fashion, an assumption that is very widely shared in the other writings surviving from Anglo-Saxon England—the assumption that true wisdom will come, in the natural course of things, only with advancing years:

> Soð bið swicolost, sinc byð deorost,
> Gold gumena gehwam, and gomol snoterost,
> Fyrngearum frod, se þe ær fcala gebideð.

[Truth is most deceptive; treasure is most precious, gold for every man; and the old man is most sage, the man made wise through bygone years who has previously suffered many things.][39]

The word *frod*, used in this passage, means sometimes 'old', sometimes 'wise', and most often 'old and wise'. It is a favourite word of Anglo-Saxon poets, and its semantic behaviour shows better than any other evidence how inextricably interlinked were the ideas of old age and wisdom in their minds. The author of *The Wanderer* states the matter plainly:

> Swa þes middangeard
> Ealra dogra gehwam dreoseð ond fealleþ,
> Forþon ne mæg weorþan wis wer, ær he age
> Wintra dæl in woruldrice.

[So every single day this world is declining and falling; wherefore no man can become wise until he has had many winters in the kingdom of earth.][40]

'Forþon' here implies that the second proposition follows somehow from the first. Perhaps the idea is a learned and subtle one: that since the world itself is in its last age, the *senectus mundi*, only men who are themselves old can really understand it. But the poet most likely means something rather simpler: that only someone who has seen

[39] *Maxims II*, ll. 10–12, cited from T. A. Shippey, *Poems of Wisdom and Learning in Old English* (Cambridge, 1976).
[40] *The Wanderer*, ll. 62–5.

and suffered many losses (including the losses of summer joys implied in the phrase 'wintra dæl') can fully appreciate the perpetual cadency of things. Such knowledge of transience is certainly the essence of the wisdom expressed elsewhere in the poem by the man 'frod in ferðe' (l. 90), as it is also of the wisdom exhibited by the aged Hrothgar in his so-called sermon in *Beowulf* (ll. 1700–84). Out of this knowledge spring the moral and prudential counsels found in both poems: the maxims of *Wanderer* (ll. 65–72), for instance, or Hrothgar's warnings to the young Beowulf about the dangers of niggardliness and arrogance in a leader. The poem known as *Precepts* consists of ten pieces of just such moral counsel given to a son by a father who is described as 'frod guma' and 'eald uðwita'—a man of experience and an old philosopher. He advises the youth to respect his elders, avoid drunkenness, be cautious of speech, and other similar correctives to the impetuosity of his age.[41] Another example of the same genre is the *Dicts of Cato*, a vernacular version of the Latin schoolbook *Disticha Catonis*, widely used throughout the Middle Ages, in which an elder gives a young man the benefit of his experience in sayings such as the following:

Ðonne þu geseo gingran mann ðonne ðu sie, ond unwisran ond unspedigran, þonne geþenc ðu hu oft se ofercymð oþerne, ðe hine ær ofercom: swa mann on ealdum bigspellum cwið, þæt hwilum beo esnes tid, hwilum oðres.

[When you see a man younger and less wise and less prosperous than you are, bear in mind how often it happens that one man gets the better of another who previously got the better of him. As old proverbs say: at one time it is one man's hour, at another another's.]

The reference to youth as a handicap to be pitied, along with folly and poverty, is not in the Latin.[42] It gives some measure of the gap between Anglo-Saxon and modern attitudes in this matter. For this author, man's best hour was not his youth.

Anglo-Saxon writers do not ignore the physical handicaps of old age; indeed, some particularly powerful versions of the traditional

[41] Shippey's volume contains *Precepts*, along with several other pieces of the same type.

[42] 'The Old English Dicts of Cato', ed. R. S. Cox, *Anglia* xc (1972), 1–42, No. 29. It may be noted here, for its bearing upon the argument of the next chapter, that the twelfth-century manuscript of the Old English *Dicts* omits to list youth among the handicaps.

topic *incommoda senectutis* are to be found in their work.[43] Yet their stress on the moral and spiritual superiority of the old is such that, if we were to follow Philippe Ariès in supposing that every period of history favours or privileges one among the ages of man, the only possible choice for the Anglo-Saxon period would be *senectus*.[44] The difficulty of attributing such a preference in this case to a whole period of history is that the surviving texts can by no means be trusted to represent anything so comprehensive. Nearly all pre-Conquest texts survive only by the courtesy of the monastic or other ecclesiastical scribes who copied them; and they must therefore be treated as having passed through a screening process which surely favoured pious and orthodox items at the expense of whatever else there may have been. So far as our present subject is concerned, it can be assumed that such screening would have privileged old age and its wisdom, rather than, say, the loves and adventures of youth, as fit subjects for the scribe's laborious pen. Yet it is unlikely that, in a traditional society such as that of Anglo-Saxon England, monks would have been alone in giving pride of place to grey hairs. In agricultural settlements and in kings' courts, too, men must have relied more than they do today upon the wisdom of experience. In any case, we can only study what we have; and what we have, English as well as Latin, speaks most eloquently in favour of *canities sensus*.

II

The early Christian doctrine of spiritual age, studied by Gnilka, continued to be familiar throughout the medieval period. Preaching to the monks of Rochester on the occasion of their electing a prior in 1380, Thomas Brinton reminded them of the distinction between *aetas corporalis* and *aetas spiritualis*:

[43] For instance: *The Seafarer*, ll. 91–6; Alcuin, *Commentaria super Ecclesiasten, PL* 100. 716–17 (from Jerome); Ælfric, *Catholic Homilies*, ed. Thorpe, i. 614 (from Gregory); and an anonymous homily, ed. A. Napier, *Wulfstan: Sammlung der ihm zugeschriebenen Homilien* (Berlin, 1883), 147. See further the essay by J. E. Cross cited above, Chap. 2 n. 75.

[44] 'It is as if, to every period of history, there corresponded a privileged age and a particular division of human life: "youth" is the privileged age of the seventeenth century, childhood of the nineteenth, adolescence of the twentieth', *Centuries of Childhood* (Harmondsworth, 1973), 29.

Sicut verum etas dicitur corporalis qua quis ducit dies suos ab infancia sua in puericiam, a puericia in adolescenciam, ab adolescencia in iuventutem et sic deinceps, iuxta quod vulgariter solet dici *Infans, postquam puer, adolescens, post iuvenis, vir*, ita etas spiritualis est progressio de virtute in virtutem, de gracia in graciam, de bono in melius, de perfecto in magis perfectum.

[Just as we speak of bodily age, whereby we proceed from infancy to boyhood, from boyhood to adolescence, from adolescence to youth, and so forth, in accordance with the common saying 'Infant, then boy, adolescent, then youth, and man', so spiritual age is a progress from virtue to virtue, from grace to grace, from good to better, from perfection to greater perfection.][45]

Another writer of about the same time explains that the perfection of *senectus spiritualis* is not reserved exclusively for those who are naturally old, citing the standard proof-text from the Book of Wisdom: 'Senectus venerabilis est non diuturna neque numero annorum computata, etc., Þe age of worchepe stant nout in longe-lyvynge ne in numbre of ȝeris but it stant in wit and wisdam, for þe wittis of þe wiseman ben eld and sadde and a clene lyf is clepyd age of elde.'[46]

The ideal of *senectus spiritualis* continued to figure most prominently in the lives of saints. Long after Bede and Alcuin, hagiographers still described the preternatural virtues of their young heroes in the very words used by Gregory of St Benedict. Thus Matthew Paris, writing about St Edmund of Abingdon in the mid thirteenth century:

Et sic infancie principia virtutibus subarravit ut, sicut de beato Benedicto legitur, ab ipso puericie tempore cor gessit senile. Ex utero enim matris sue alter Nicholaus electus est a Deo et meditabatur a pusillo placere Deo, nitens in carne preter carnem vivere, hostiam sanctam, Deo placentem se ipsum offerre, optinere per graciam quod non poterat per naturam, gloriam scilicet sempiternam.

[And thus he so dedicated the beginnings of his infancy to virtue that, as we read of the blessed Benedict, he had even from the time of boyhood the heart of an old man. For from his mother's womb he was chosen of God like

[45] *The Sermons of Thomas Brinton*, ii. 435. Brinton advises the monks to elect as prior a man 'sufficientis etatis tam spiritualis quam corporalis.' 'Corporal' seniority remains a consideration.

[46] *Dives and Pauper*, ed. Barnum, i, Pt. 1, 347.

another Nicholas and sought to please Him even when he was tiny, striving
in the flesh to live beyond the flesh, to offer himself as a holy sacrifice pleas-
ing to God, and to win by grace what he could not win by nature, that is,
eternal glory.][47]

Jacobus de Voragine echoes the same Gregorian language of trans-
cendence in his *Legenda Aurea*, the most widely read of all hagiogra-
phical writings in the later Middle Ages. Voragine interprets the
name of the child-martyr St Celsus as the sign of his transcendent
courage:

Celsus, quasi excelsus, quia se supra se extulit, dum aetatem puerilem virtute
animi superavit.

['Celsus' as if to say 'exalted', because he raised himself above himself when
he overcame his boyish years by the power of his soul.][48]

More remarkable is the echo of Gregory in the *Tractatus super Qua-
tuor Evangelia* of Joachim of Fiore. Joachim links St Benedict with
Old Testament examples of the *puer senex* as a type of that supreme
third age of the world, an age of monks presided over by the Holy
Spirit, which he believed was to come. This age, he writes, has
already been prefigured 'in Ioseph, Samuele, Salomone, Daniele,
Iohanne evangelista, beato Benedicto et similibus, qui ab ipso pueri-
cie sue tempore cor gerens senile, facti sunt magistri senum' ['in
Joseph, Samuel, Solomon, Daniel, John the evangelist, blessed
Benedict, and others of the same sort, who, having even from the
time of their boyhood the heart of an old man, are made the masters
of the old'].[49] Thus Joachim associates his last age of the world with
senectus spiritualis and so bestows upon the *puer senex* a distinctive
apocalyptic significance, as heralding in an act of individual age-
transcendence the overthrow of old orders in the liberty of the spirit
at the end of time.

There are far too many instances of *puer senex* and *puella senex* in

[47] C. H. Lawrence, *St Edmund of Abingdon: A Study in Hagiography and History*
(Oxford, 1960), 224. See also the earlier life by Eustace of Faversham, op. cit. 203.

[48] *Legenda Aurea*, ed. Graesse, Chap. 102. In Chap. 76 of the same work, the four-
teen-year-old St Pancras meets the challenge of a pagan emperor with the claim that
'etsi puer sum corpore, cor tamen gero senile' ['though I am a boy in body, yet I have
the heart of an old man'].

[49] *Tractatus super Quatuor Evangelia*, ed. E. Buonaiuti (Rome, 1930), 92. The first
age, that of God the Father, is signified by Abraham and others who had children in
their old age; the second, that of God the Son, by David, who became king at the age
of thirty, and by Ezechiel and others, who began to preach at that age.

saints' lives of the centuries after the Norman Conquest to allow
more than a quick sampling here.[50] One favourite, referred to by
Matthew Paris in the passage quoted above, was St Nicholas: 'The
furst day that he was born, whanne he was bathed he dressed hym
upright in the basin, and he wold never take the briste but onys on
the Friday and onys in the Wednisday, and in his tendre age he
eschewed the vanitees of yonge children.'[51] At the age of seven, the
English boy-saint William of Norwich is described as occupying his
'venerabilis pueritia' in acts of piety, abstinence, and charity.[52]
Examples of the *puella senex* are readily to be found in the mid-fif-
teenth-century *Legendys of Hooly Wummen*, written by the friar
Osbern Bokenham. Here we meet again the three-year-old Mary
ascending the Temple steps like a grown-up.[53] Young St Agnes,
martyred at the age of thirteen, is described by Bokenham as 'yunge
of body and of soul sage':

> And þow she yung were by yerely computacyoun,
> Yet in hir soule she had suffycyent age,
> And so she was in dyfferent dysposycyoun
> As yunge of body and of soul sage.[54]

The scene in which little Agnes disputes with and discomforts the
pagan judge Sympronyan represents a type of encounter, common-
place in saints' lives, which may be taken as emblematic of the inver-
sions of natural seniority implicit in the transcendence ideal. Like
Daniel and their other Biblical prototypes, saintly children such as

[50] One statistical analysis has suggested that 'saintly children' are especially fre-
quent in hagiography between 1200 and 1500: D. Weinstein and R. M. Bell, *Saints
and Society* (Chicago, Ill., 1982), 45. The figures given on p. 123, however, do not
cover the period before 1000 and show quite a high total for the eleventh century, al-
beit followed by a dip in the twelfth.

[51] From the Middle English translation of the *Legenda Aurea*: Richard Hamer
(ed.), *Three Lives from the Gilte Legende* (Heidelberg, 1978), 51. Compare the descrip-
tion of the holy childhood of Nicholas in *The Early South-English Legendary*, ed. C.
Horstmann, EETS, os 87 (1887), 240–1.

[52] *The Life and Miracles of St William of Norwich by Thomas of Monmouth*, ed. A.
Jessopp and M. R. James (Cambridge, 1896), 14. St William is said to have been mar-
tyred by the Jews at the age of twelve in 1144.

[53] *Legendys of Hooly Wummen*, ed. M. S. Serjeantson, EETS, os 206 (1938), ll.
2029–46. Compare also the play of Mary in the Temple in *Ludus Coventriae*.

[54] *Legendys of Hooly Wummen*, ll. 4113–16; compare 4278–80. Elsewhere Boken-
ham, following *Legenda Aurea*, describes the pious childhood of St Elizabeth in con-
siderable detail (ll. 9545–600). Other instances are St Margaret (ll. 386–427) and St
Christina (ll. 2123–6).

Agnes show themselves wiser than their elders—'magistri senum', as Joachim puts it. The motif is not confined to saints' lives. In the popular legend of Barlaam and Josaphat (originally a Buddhist tale), Josaphat, son of a pagan king, displays such 'parfit prudence' as a child that he 'passed in kunnynge al þe men of Inde and of Perse'.[55] After receiving the Christian faith from the ancient Barlaam, Josaphat inverts the natural order of things by setting out to instruct his own father. Another well-known story of the same type concerns Epictetus, 'Ypotis' in Middle English. The philosopher is represented as a wise child, who lectures the Emperor Hadrian at length on a variety of useful and improving topics. His transcendent wisdom is sufficiently explained at the end when his true identity is revealed: he is God.[56]

Geoffrey Chaucer included Ypotis in a catalogue of heroes of romance, and the child is not altogether out of place in such company.[57] For it is not only in saints' lives that the young heroes of medieval story display precocious maturity. Indeed, one of the other names listed by Chaucer alongside that of Ypotis may be said to represent the same principle of age-transcendence, albeit operating in the secular world of romance adventure. This is Sir Lybeux, or Lybeaus Desconus. At an early age Lybeaus leaves his mother and comes to Arthur's court; but when the king offers this unknown youngster to a damsel as her champion, she responds with indignation: Arthur should not entrust her mission to 'a childe | That is witles and wylde'.[58] In the ensuing adventures, however, the boy proves his heroic mettle, and the damsel is forced to eat her words. Thus it may be the mark of a young hero in secular as well as in religious stories that he transcends his age by displaying powers which lesser mortals display only in later years, if at all. Yet it cannot be said that such upward transcendence plays an important part in Arthurian romance, even where the idea is clearly present. In the Prose *Lancelot*, for instance, Phariens utters a lament for the boy Lyonel, whom he supposes dead:

[55] I cite from the Middle English version in Peterhouse, Cambridge, MS 257, fols. 10^{r-v}, in the forthcoming EETS edition by Dr Hirsh.

[56] The Middle English *Ypotis* is edited by C. Horstmann, *Altenglische Legenden* (Heilbronn, 1881). For a study of the tradition, see W. Suchier, *L'Enfant sage* (Dresden, 1910).

[57] *Sir Thopas, Canterbury Tales*, VII. 898.

[58] *Lybeaus Desconus*, ed. M. Mills, EETS, os 261 (1969), Lambeth MS, ll. 184–5.

Com est granz domages et granz dolors, se vos iestes morz an tel aage qui estiez la mervoille et li mireors de toz les anfanz do monde, car po aviez plus de dis anz. Bien estiez com anfes d'aage, mais de san et de proesce estiez vos veillarz chenuz, se un seul petit fussiez plus amesurez de hardement.

[It is a great loss and a great sorrow if you, who were the marvel and the model of all the boys in the world, are dead at such an age, for you were little more than ten years old. You were indeed only a boy in years, but in sense and prowess you were a greybeard—if only you could have moderated your boldness a little.][59]

The *puer senex* topos had a time-honoured place in such contexts, where the young dead are praised in laments, consolations, and epitaphs.[60] Yet Lyonel is not dead, in fact; and his actual behaviour throughout the story, which is extremely boyish and headstrong, more than bears out the reservation about his 'hardement' which Phariens feels bound to express.

It is not in romance but in those writings which look back to older epic traditions that the 'Transzendenzideal' makes its main contribution to medieval secular literature. A notable example is *La Chanson de Guillaume*, an archaic *chanson de geste* preserved only in one thirteenth-century Anglo-Norman manuscript. Here little Guy, described as a beardless boy not fifteen years old, confronts his formidable uncle, William of Orange, and displays such mature good sense that the old warrior is quite won over:

> Quant l'ot Willame, prist le chef a croller,
> Plurad des oilz tendrement e suef.
> L'enfant apele, sil prist a acoler;
> Treis feiz le beise, e puis li ad mustré:
> 'A la fei, niés, sagement as parlé;
> Cors as d'enfant e si as raisun de ber.'

[59] *Lancelot do Lac*, ed. E. Kennedy (Oxford, 1980), 82. Earlier (p. 38) the author describes young Lancelot as 'sages et antandanz et cuitox et legiers et outre ce qe anfes de son aage ne deüst estre' ['well behaved, intelligent, and quick and active beyond what a child of his years would normally be']. A much less striking example from Chrétien's *Erec et Enide* is cited by C. A. Luttrell, *The Creation of the First Arthurian Romance* (London, 1974), 49.

[60] See Gnilka, 29–32, 61–3.

[When William heard him, he began to shake his head and wept soft and tender tears. He called the boy and began to embrace him. He kissed him thrice and then declared: 'By my faith, nephew, you have spoken wisely; you have the body of a boy and the good sense of a man.']⁶¹

The antithetical formula used by William here and on two later occasions (ll. 1637, 1977) speaks the praise of Guy in time-honoured form: 'Cors as d'enfant e si as raisun de ber'. But it is not only in his 'raisun' or good sense that the boy transcends his age. When later, in defiance of his uncle's wishes, Guy sets out to join him in battle against the Saracen invaders, the poet describes him as too small even for the palfrey which his aunt has lent him ('Petit est Gui e li cheval est grant'); but in the battle, even though he cannot go without food and drink for as long as a grown man, he proves a worthy companion for his uncle. The scene in which the fifteen-year-old Guy and the white-bearded Count William (rashly described at one point as three hundred and fifty years old) fight side by side represents in an extreme form what may be described, in a phrase of Gnilka's, as an 'equalization of ages' characteristic of heroic narrative. For in poems such as *La Chanson de Guillaume* transcendence can work in both directions, downwards as well as up: the very old, as well as the very young, can manifest *contra naturam* the prowess and physical strength of maturity. Thus in the Middle English alliterative *Destruction of Troy*, aged Priam is roused by the death of Hector to prodigious feats of arms. It is a wonder, remarks the poet, 'þat any freike upon feld of so fele yeres | So mightely with mayn shuld marre of his fos': Priam's grief has 'restouret hym his strenght as in stuerne yowthe'.⁶²

The example of Virgil is to be reckoned with here. In the course of his discussion of the *puer senex* in Classical literature, Curtius cites a line from the *Aeneid* in which Virgil describes Ascanius, the young son of Aeneas, as 'ante annos animumque gerens curamque virilem' (IX. 311). Gavin Douglas in his *Eneados* renders these words as follows:

⁶¹ *La Chanson de Guillaume*, ed. D. McMillan, SATF (Paris, 1949–50), ll. 1474–9.
⁶² D. Donaldson and G. A. Panton (edd.), EETS, os 39, 56 (1869, 1874), ll. 9008–9, 9043. Hector was earlier represented as a *puer senex*, with the comment 'Þof a yong man be ȝepe, and of yeres lite, | His wit shuld be waled of wis men of age' (ll. 7870–1).

Abufe al otheris in hys commonyng
Schawand the wysdome, consait and forsyght
Of agit man, and eik the curage wight.[63]

Aeneid IX. 311 inspired an imitation by the fifteenth-century Italian
humanist Maffeo Vegio, whose thirteenth book of the *Aeneid* Doug-
las also translated:

Bot with hys eyn onmovit Latyn kyng
Gan fast behald the child Ascanyus ʒyng,
Wondrand on his afferis and vissage,
And of the speche and wordis grave and sage
Of sik a childis mowth syk wyss suld fall,
And of his digest and reddy wit withall
Befor the ʒheris of maturyte. (XIII. ix. 31–7)

Virgil also provides an instance of the more distinctively heroic
'downward' transcendence, in the person of the Sicilian boxer Entel-
lus. Though Entellus is an old man, his blood 'chilled and dulled by
sluggish age', he overpowers the formidable young Trojan champion
Dares in a ferocious bout, and ends in triumph:

'Nate dea vosque haec', inquit, 'cognoscite, Teucri,
Et mihi quae fuerint iuvenali in corpore vires.' (V. 474–5)

In the version by Douglas:

'Son of the goddes, and Troianys, I ʒou pray,
Behald, and knaw by this takyn and syng, .
Quhat strenth was in my corss quhen I was ʒyng.' (V. viii. 104–6)

Entellus shares with the supernatural ferryman Charon a 'cruda vir-
idisque senectus' (VI. 304), a hardy and green old age. It is not in the

[63] *Virgil's 'Aeneid' Translated into Scottish Verse by Gavin Douglas*, ed. D. F. C.
Coldwell, STS, 3rd Ser. xxv, xxvii, xxviii, xxx (1957–64), IX. vi. 6–8. It may be noted
that none of the passages from the *Aeneid* referred to here is represented in the
twelfth-century French *Roman d'Eneas*. The grand epic theme of transcendence evi-
dently did not appeal to this romancer, in whose work it leaves only two faint traces:
Eneas, ed. J.-J. Salverda de Grave (Paris, 1925–9), ll. 5659–61 (Pallas) and ll. 7406–8
(Camilla). I find the attempt by Alfred Adler to interpret the whole poem in terms of
age-transcendence entirely unconvincing: 'Eneas and Lavine: *Puer et Puella Senes*',
Romanische Forschungen lxxi (1959), 73–91.

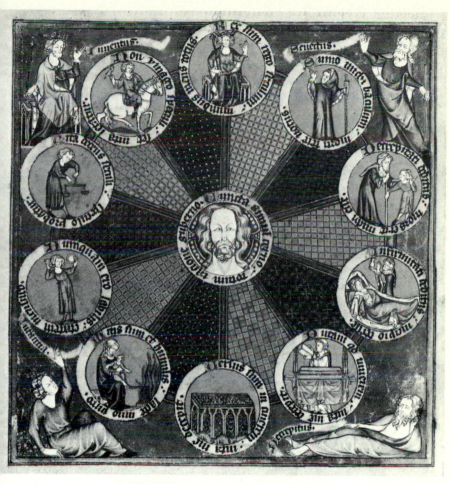

7. The Wheel of Life: the de Lisle Psalter

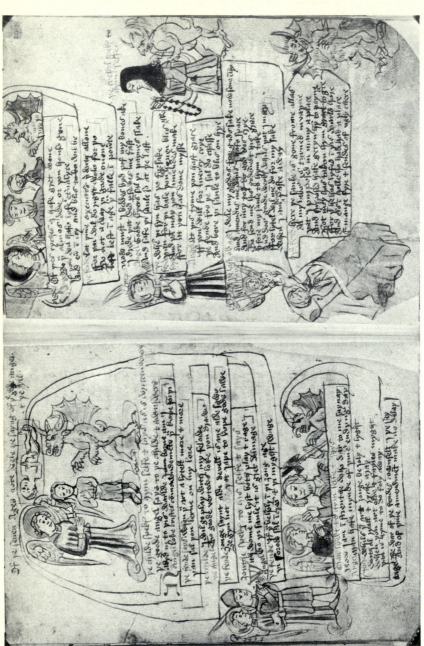

8. 'Of the Seven Ages'

order of nature for such an old man to be stronger than a young one,
any more than it is for a young one to be wiser than an old. Else-
where, Gavin Douglas's familiarity with this epic theme of the *senex
fortis* led him into a mistranslation. Addressing the Cumaean Sibyl,
Virgil's Aeneas described his dead father Anchises as one who
'endured with me all the seas and all the menaces of ocean and sky,
weak as he was, beyond the strength and lot of age':

> Ille meum comitatus iter maria omnia mecum
> Atque omnis pelagique minas caelique ferebat,
> Invalidus, viris ultra sortemque senectae. (VI. 112–14)

Douglas changes Anchises from a natural, weak old man into a
senex fortis by rendering the last line as if it were a transcendence
formula:

> He sufferit and sustenyt, for my saik,
> Ful huge pane, as he had beyn a page,
> Abufe the strenth and common curss of age.[64]

Infractions of the 'common course of age' in Virgil's epic point to-
wards a grand equalization of ages there, a convergence of old and
young characters in the direction of an ideal heroic condition which
escapes the limitations of both. One version of this ideal, albeit a
harsh and limited version, is shouted at the Trojans by the Rutulian
warrior Numanus in Book IX. Numanus contrasts the effeminate
weakness of the newcomers with the toughness of his own people:

> Durum a stirpe genus natos ad flumina primum
> Deferimus saevoque gelu duramus et undis;
> Venatu invigilant pueri silvasque fatigant,
> Flectere ludus equos et spicula tendere cornu;
> At patiens operum parvoque adsueta iuventus
> Aut rastris terram domat aut quatit oppida bello;
> Omne aevum ferro teritur, versaque iuvencum
> Terga fatigamus hasta, nec tarda senectus
> Debilitat viris animi mutatque vigorem:
> Canitiem galea premimus. (IX. 603–12)

[64] VI. ii. 72–4. Coldwell notes the comparison of Anchises with a boy ('page') as an
ineptitude due to the translator.

[A hard race by origin, we bring our sons to rivers as soon as they are born and harden them in the fierce cold of the water. Our boys stay up at nights hunting and make the very forests weary; their sports are to pull at a horse's bit or shoot arrows from a bow. Our young men, well used to work and accustomed to want, are either subduing the earth with mattocks or making cities shake in battle. Every age of our life has to do with iron: we weary our bullocks' flanks with the butt-end of spears, and sluggish old age does not at all weaken our spirit or diminish our vigour—we load even white hairs with a helmet.]

Every age (*omne aevum*) is an age of iron in this magnificently clangorous passage. Babies (*natos*) are tempered like iron by plunging them into the ice-brook; boys (*pueri*) sport with javelins and arrows; men in their prime (*iuventus*) labour with mattock and spear; and the old (*senectus*) still wear helmets and go to war, their courage and strength unabated. In his outrageously macho fashion, Numanus here expresses an authentic heroic vision of a life devoted to a single end from cradle to grave: 'omne aevum ferro teritur'.

Given such evidence for the equalization of ages in Virgil's epic, it may seem strange that Dante in *Il convivio* should have cited the *Aeneid* as one of his authorities on the 'diverso processo de l'etadi'— the *various* sequence of the ages.[65] In doing so, however, Dante was following an ancient critical tradition, according to which Virgil's poem displays 'the whole condition of human life'. This tradition was established by Fulgentius in his *Expositio Virgilianae Continentiae* (*c*.500) and perpetuated in the twelfth century by the *Commentum super Sex Libros Eneidos Virgilii* ascribed to Bernardus Silvestris.[66] Both these commentators saw in Virgil's first six books an image of man's progress through the ages of life towards wisdom and virtue, starting with *infantia* (Book I) and *pueritia* (Book II). These are followed, according to the *Commentum*, by *adolescentia* (Book III), *iuventus* or young manhood (Book IV), and *virilis aetas* or man's estate (Book V). Book VI represents in the descent of Aeneas

[65] *Il convivio*, IV. xxiv. 9. The other authors cited are Cicero and Giles of Rome.
[66] *Fulgentii Opera*, ed. R. Helm (Stuttgart, 1970), 81–107; *The Commentary on the First Six Books of the Aeneid of Vergil Commonly Attributed to Bernardus Silvestris*, ed. J. W. and E. F. Jones (Lincoln, Neb., and London, 1977). John of Salisbury also gives a Fulgentian interpretation of Virgil's first six books: *Policraticus*, ed. C. C. I. Webb (Oxford, 1909), Bk. VIII, Chap. 24.

into the underworld the achievement of wisdom in maturity.[67] This interpretation relies heavily upon allegorical readings: both Fulgentius and Bernardus, for instance, take the shipwreck in Book I as a figurative representation of birth. They both, it is true, do their best to find in the behaviour of Aeneas, book by book, features which may be regarded as literally representative of the age in question—with most success in Book IV, where Aeneas's love-affair with Dido offers itself as a straightforward example of the erotic entanglements to which young men are subject. Yet even here the prevailing mode is allegorical: Mercury represents reason or eloquence, Dido lust. Aeneas, after all, does not literally traverse the ages from birth to maturity in the story. Virgil treats these ages, the authorities agree, figuratively: 'sub figuralitatem historiae', 'in integumento', 'sub involucro fictitii'.[68] Dante makes the same point when he speaks of Virgil as presenting 'lo *figurato* di questo diverso processo de l'etadi'. Yet it may be noted that Dante elsewhere in his discussion of the ages cites Aeneas only as a literal example, and that only in the chapter on *gioventute* or the prime of life. Aeneas, he says, displays in Books IV, V, and VI all the virtues characteristic of noble maturity: temperance when he leaves Dido (the latter part of Book IV), concern for the laws when he duly rewards the victors in the Sicilian games (Book V), and courage when he descends into the underworld (Book VI).[69] Such readings according to the literal mode of exemplification can at times seem quite as strained as the allegorical readings of Fulgentius and Bernardus; but few readers of the *Aeneid* would differ from Dante when he takes Aeneas—the son of Anchises and father of Ascanius—as representing that middle age which the Italian poet calls *gioventute*. This is the age (between twenty-five and forty-five, according to *Il convivio*) at which men, still strong and

[67] The *Commentum* is unfinished, breaking off in the middle of the discussion of Bk. VI. Fulgentius pursues the interpretation through all twelve books, though he does not distinguish ages in the last six, which he evidently regards as representing *en bloc* the moral triumphs of 'perfectio virilis'. John of Salisbury concludes his interpretation with Bk. VI, which he, unlike Fulgentius or Bernardus, identifies with *senium* or decrepitude: ed. cit. 817d–818a. Gavin Douglas (Prologue to the Sixth Book, ll. 33–8) refers Bk. VI to the period after death: 'In all his warkis Virgil doith discrive | The stait of man, gif thou list understand, | Baith lif and ded in thir fyrst bukis fyve; | And now, intil this saxt, we have on hand, | Eftir thar deth, in quhat plyt saulis sal stand. | He writis lyke a philosophour naturall.'

[68] Fulgentius, 90; Bernardus, 3; John of Salisbury, 817a. 'Integumentum' and 'involucrum' were technical terms in twelfth-century allegorical interpretation: see W. Wetherbee, *Platonism and Poetry in the Twelfth Century* (Princeton, NJ, 1972), 36–48.

[69] *Il convivio*, IV. xxvi.

already wise, can shoulder the burdens of leadership; for in them there may exist naturally that ideal combination of *fortitudo* and *sapientia* to which the young and the old attain only by the special grace of heroic transcendence. Such a one, according to Dante, is Aeneas.

Transcendence themes are most at home in the high-mimetic worlds of saints and heroes; but they are by no means confined to epic and hagiography. In his discussion of the subject, Curtius cites evidence to show how in the schools of the twelfth and thirteenth centuries writers treated the *puer senex* and *senex juvenis* topoi as clichés of rhetorical description. Thus the English rhetorician Geoffrey of Vinsauf, in his *Poetria Nova* (*c*.1200), illustrates the amplifying art of *oppositio* or antithesis as follows:

> Hoc sit in exemplum: *Sapiens est illa juventa.*
> Pone juventutem vultus vel tolle senectam:
> *Ista juventutis est et non forma senilis.*
> Pone senectutem mentis vel tolle juventam:
> *Ista senectutis est mens et non juvenilis.*
> Ut pote si tali decurrat limite lingua:
> *Ista senectutis non est gena, sed juvenilis;*
> *Ista juventutis non est mens, immo senilis.*

[Consider this example: 'That young man is wise.' Affirm the youthfulness of his countenance and deny its age: 'His is the appearance of youth and not of old age.' Affirm the maturity of his mind and deny its youthfulness: 'His is the mind of mature age and not of youth.' The account may perhaps continue along the same line: 'His is not the cheek of age but of youth; his is not the mind of youth but of age.']⁷⁰

This passage illustrates, in painfully slow motion, how rhetorical eulogy could find in transcendence a rich source of antithetical word-play. Geoffrey's dedication to Pope Innocent at the beginning of *Poetria Nova* provides an example of exceptional virtuosity, for here the pope appears to be transcending in both directions at once:

> Trans homines totus: ubi corporis ista juventus
> Tam grandis senii, vel cordis tanta senectus

⁷⁰ E. Faral (ed.), *Les Arts poétiques du XII^e et du XIII^e siècle* (Paris, 1924), ll. 674–81, following those manuscripts which reverse the order of ll. 675 and 676; trans. M. F. Nims. *Poetria Nova of Geoffrey of Vinsauf* (Toronto, 1967), 40.

> Insita tam juveni? Quam mira rebellio rerum:
> Ecce senex juvenis!

[You quite transcend the human condition: where will physical youthfulness
like yours be found in a man of such age, or where a heart so mature
implanted in one so young? What strange conflict in the nature of things: a
youth of ripe age!][71]

The rhetorician Matthew of Vendôme, Geoffrey's contemporary,
gives in his *Ars Versificatoria* several models of correct 'descriptio
personarum', among them a description of Ulysses in which occur
the following characteristic lines:

> Aetatem virtute domat, sua cana juventus
> Consilio redolet interiore senem.
> Vota juventutis virtute supervenit, aevi
> Jura supergreditur mentis honore suae.
> Mentis canities aevi castigat habenas.

[By virtue he overcomes his age, and his hoary youth derives from inner wis-
dom the flavour of old age. By virtue he rises above the desires of youth, and
by honourable qualities of mind he transcends the norms of his age. The
hoariness of his mind controls the reins of his youth.][72]

Such 'mannered trifling', as Curtius justly calls it, could hardly be
matched by the vernacular writers of the time. Indeed, so far as
Middle English writers in general are concerned, it cannot be said
that they took more than a passing interest in the paradoxes of age-
transcendence. The ideal of *senectus spiritualis* continued to exercise
the hagiographers, as in Anglo-Saxon times; but in the much richer
and more varied literature of post-Conquest England, saints' lives
do not occupy the central and commanding position which they
hold in the mainly monastic corpus surviving from the earlier
period. As we shall see in the following chapter, new genres such as
romance and love-allegory bring with them, from the twelfth cen-
tury, new emphases on youth and on naturalness. In such writings

[71] Ed. cit. ll. 20–3, trans. Nims, 15–16. 'Senex juvenis' might as easily mean 'an old
man who is young' here. Geoffrey cites a clear example of downward transcendence
from Sidonius Apollinaris in his *Documentum de Arte Versificandi*, ed. Faral, ii. 3,
paras. 57, 101. All these examples, together with *Poetria Nova* 174–6, are cited by
Curtius, 100 n. 33.

[72] Faral (ed.), *Les Arts poétiques*, i, para. 52. ll. 45–9. Compare Matthew's descrip-
tion of the young bridegroom in his widely read metrical paraphrase of the Book of
Tobias, *PL* 205. 959, cited by Curtius, 100 n. 33.

the *puer senex*, if not actually condemned, can occupy only a marginal place.

Such is the case in Chaucer's *Canterbury Tales*. It is appropriate that the Monk should here cite the very example of a *puer senex* which St Benedict had invoked in his Rule; but his reference to Daniel, though correctly phrased ('wiseste child'), is no more than a passing one:

> The faireste children of the blood roial
> Of Israel he leet do gelde anoon,
> And maked ech of hem to been his thral.
> Amonges othere Daniel was oon,
> That was the wiseste child of everychon.[73]

A more significant case is that of Griselda, heroine of the *Clerk's Tale*. In Chaucer's Latin original, Petrarch described her as a young woman in whose virgin breast there dwelt a spirit manly and old: 'virilis senilisque animus virgineo latebat in pectore.'[74] Chaucer's version of these words balks at 'virilis' and tones down 'senilis':

> But thogh this mayde tendre were of age,
> Yet in the brest of hire virginitee
> Ther was enclosed rype and sad corage.[75]

Chaucer's Griselda remains a *puella senex*: she is said to have attracted Walter by 'hir vertu, passynge any wight | Of so yong age, as wel in chiere as dede.'[76] Yet as the poem proceeds, the wonder of a mature and settled spirit in one so young is superseded by other

[73] *Canterbury Tales*, VII. 2151–5. 'Child' is here equivalent to 'puer', despite Skeat's gloss 'young man'. On Daniel as *puer senex*, see Gnilka, 236–9.

[74] *Epistolae Seniles*, Bk. XVII, Letter iii, ed. J. B. Severs, in W. F. Bryan and G. Dempster (edd.), *Sources and Analogues of Chaucer's Canterbury Tales* (Chicago, Ill., 1941), Pt. II, ll. 8–9.

[75] *Canterbury Tales*, IV. 218–20. The French version of Petrarch's Latin, also used by Chaucer, has: 'et toutesfoiz courage meur et ancien estoit muciez et enclos en sa virginité' (*Le Livre Griseldis*, ed. Severs, Pt. II, ll. 11–12). Chaucer's 'rype' corresponds to the French 'meur' ('mature'); but his 'sad' ('settled') moves further away from Petrarch's 'senilis' than the French 'ancien'.

[76] *Canterbury Tales*, IV. 240–1. Petrarch (II. 16–17) has 'virtutem eximiam supra sexum supraque etatem' ['extraordinary virtue, beyond her sex and age']. Petrarch also says that Walter gazed at Griselda 'non iuvenili lascivia sed senili gravitate' (II. 15–16). Chaucer tones this down (IV. 236–8).

wonders more powerful and puzzling, and the *puella senex* is left behind. Nor do transcendence themes play any part, where we would expect to find them, in the Second Nun's Life of St Cecilia or in the Prioress's Miracle of the Virgin. The seven-year-old hero of the latter tale is indeed compared to that most frequently cited saintly example of the *puer senex*, St Nicholas:

> But ay, whan I remember on this mateere,
> Seint Nicholas stant evere in my presence,
> For he so yong to Crist dide reverence.[77]

Yet the Prioress's hero is not a prodigy of piety like Nicholas, who fasted even at the breast. On the contrary, Chaucer portrays him with the most delicate naturalism. At the age of seven he stands on the threshold between *infantia* and *pueritia*, still innocent but already a schoolboy. He first learns to honour the Virgin from his widowed mother, and the lesson sticks in his mind as such things do, 'for sely child wol alday soone leere'. His fatal fascination with the anthem *Alma Redemptoris Mater*, which he first hears sung by older boys at school, has a further natural source in the psychology of schoolboys. The boy's earnest request to an older friend to explain the anthem testifies to his reverence for the Virgin, certainly; but it is also touched by a humble, yearning curiosity about work in higher forms. Although the Prioress compares her hero to St Nicholas, he belongs, in truth, to a different world.

III

I shall have more to say about Chaucer in the following chapter. For the moment, to conclude this discussion of the 'Transzendenzideal' on a more positive note, let me return to the Anglo-Saxon period, and to its greatest poetic monument, *Beowulf*. *Beowulf* falls to be discussed here because, in it as in other heroic poems, transcendence themes serve to mute contrasts between youth and age. Before considering this 'equalization' of the ages, however, it will be necessary to see how the ages themselves are distinguished in this text.

Each of the schemes discussed in the first two chapters of this book offered a set of terms which between them divided life up into a continuous sequence of *aetates*, most commonly three, four, six, or

[77] *Canterbury Tales*, VII. 513–15. The Prioress later refers to another boy saint, Hugh of Lincoln (VII. 684).

seven. Often, too, the length of each age was precisely specified: *infantia* for the first seven years, *pueritia* for the next seven, and so on. All this belongs, as will have been obvious, to the learned tradition, depending upon such scholarly disciplines as biology, physiology, numerology, astrology, history, and scriptural exegesis. In *Beowulf* the case is different. Whereas the Latin saints' lives written in Anglo-Saxon England most often use age-terms (especially the sequence *infantia–pueritia–adolescentia*) in accordance with learned tradition, *Beowulf* exhibits a much less systematic vernacular usage, untouched, so far as I can see, by Latin scholarship. The poet's use of the word 'cniht' is typical. In the late Anglo-Saxon period, as has already been pointed out, Ælfric and Byrhtferth employ 'cniht' as the regular vernacular equivalent of *adolescens*: in such monastic usage the English word acquired something of the semantic precision of a Latin *aetas*-term. In earlier native texts, however, it covered a wider and less clearly distinguished range, referring sometimes to boys and sometimes to youths.[78] Such seems to be the case in *Beowulf*, where the word occurs three times. Hrothgar says that he knew Beowulf when the latter was a 'cniht' ('cnihtwesende', l. 372); and Beowulf himself, defending himself against Unferth's attack, claims that he and Breca engaged in their rash swimming-match 'cnihtwesende':

> Wit þæt gecwædon cnihtwesende
> Ond gebeotedon—wæron begen þa git
> On geogoðfeore—þæt we on garsecg ut
> Aldrum neðdon.[79]

[As 'cnihts' we declared and vowed—we were both still young at the time—that we would hazard our lives out on the ocean.]

Finally, Wealhtheow refers to her sons, Hrethric and Hrothmund, as 'cnihtas'. In the glossary to his edition, Klaeber renders 'cniht' as 'boy' in all three cases, citing as a parallel the Old English Bede, where the word translates 'puer'; but readers of Bäck's excellent monograph on the subject will know that the parallel is not a safe one. Bäck himself cannot decide whether 'cnihtwesende' in *Beowulf* refers to boyhood or youth. Perhaps in the *Beowulf*-poet's usage the

[78] See H. Bäck, *The Synonyms for 'Child', 'Boy', 'Girl' in Old English*, Lund Studies in English ii (Lund, 1934).

[79] *Beowulf*, ll. 535–8. All quotations are from F. Klaeber's third edition with supplements (Boston and London, 1950).

word 'cniht', something like the modern English 'lad', covered the whole period between the end of infancy and the beginning of mature manhood. The point, in any case, is that one should not look here for the precision to which Latin age-schemes aspire.

Piecing together the evidence provided by the poem, however, it is possible to form some conception of the main divisions in the lives of the kind of people *Beowulf* describes—the Anglo-Saxon warrior aristocracy.[80] The first of these divisions is referred to with unusual precision by Beowulf himself:

> Ic wæs syfanwintre, þa mec sinca baldor,
> Freawine folca æt minum fæder genam;
> Heold mec ond hæfde Hreðel cyning. (ll. 2428–30)

[I was seven winters old when the lord of treasures, the ruler of peoples, received me from my father; King Hrethel held and had me.]

Just so Bede, as he recalls in a passage at the end of his *Historia Ecclesiastica*, was given at the age of seven to Abbot Benedict to be educated. It would appear that the age of seven (the only exact age mentioned in *Beowulf*) was a customary time at which children destined to become warriors or monks left the family hearth to begin their training in monastery or hall.[81] Beowulf joined the household of his grandfather Hrethel, who treated him, he says, like a son. The period of training which followed would have ended, presumably, with the taking of arms. In his *Germania*, Tacitus describes the ceremony which, among the Germanic tribes of his much earlier day, effected this coming-out: 'They do no business, public or private, without arms in their hands; yet the custom is that no one take arms until the state has endorsed his competence: then in the assembly itself one of the chiefs or his father or his relatives equip the young man with shield and spear; this corresponds with them to the toga, and is the youth's first public distinction; hitherto he seems a member of the household, now a member of the state.'[82] It is likely that

[80] Although the poem is set in the Scandinavian heroic past, its age-divisions, like other features of the warrior life it portrays, evidently belong to contemporary English society.

[81] *Historia Ecclesiastica*, Bk. v, Chap. 24, ed. Colgrave and Mynors, 566. See Klaeber's note to *Beowulf*, ll. 2428 ff., and J. Grimm, *Deutsche Rechtsalterthümer*, 4th edn., ed. A. Heusler and R. Hübner, vol. i (Leipzig, 1899), 567–9.

[82] Trans. M. Hutton (Cambridge, Mass., and London, 1914), Chap. 13.

this *rite de passage* had some equivalent in Anglo-Saxon warrior circles, but no satisfactory description survives.[83] Perhaps Wiglaf is referring to such a ceremony when he recalls how his father kept a precious sword and corslet,

> oð ðæt his byre mihte
> Eorlscipe efnan swa his ærfæder;
> Geaf him ða mid Geatum guðgewæda,
> Æghwæs unrim. (ll. 2621–4)

[until his son could perform noble deeds like his father before him; then he gave him among the Geats a countless number of pieces of war-equipment.]

By the time we first see Beowulf, on his arrival in Denmark to help Hrothgar combat Grendel, the hero has evidently already received that Germanic equivalent of the *toga virilis*. He is, as he tells Unferth, no longer the lad who swam with Breca. Yet he is still at this stage of the poem young: Wealhtheow addresses him as 'hyse' or young man, and Hrothgar calls him 'geong' (ll. 1217, 1843). When Beowulf in old age looks back on the deeds of his 'geogoð' (ll. 2426, 2512), he evidently uses the term in a broad and entirely untechnical sense, just as in modern English one may contrast 'youth' with 'age'; and it is that simple binary opposition between 'yldo' and 'geogoð', articulated in lines 2111–12, which modern criticism has found most significant in the poem's age-structure. It may be noted here, however, that the term 'geogoð' also enters into another significant opposition, with 'duguð'.[84] The description of the banquet at Heorot after the killing of Grendel makes it clear that the two bodies of men designated by these words sat in different parts of the hall. After carrying the wine-cup to the old king and his nephew, Wealhtheow turns to the 'geogoð':

> Hwearf þa bi bence, þær hyre byre wæron,
> Hreðric ond Hroðmund, ond hæleþa bearn,

[83] The Blickling homilist describes how St Martin was obliged by his parents to take up weapons at the age of fifteen: *Blickling Homilies*, ed. R. Morris, EETS, os 73 (1880), 213. The author, however, is following the Latin *Life of St Martin* by Sulpicius Severus. The same source may have influenced Felix's *Life of St Guthlac*, where the native saint is said to have taken up arms at the same age (ed. Colgrave, Chap. 16). On the taking of arms in Germanic society, see A. Heusler, *Institutionen des deutschen Privatrechts* (Leipzig, 1885–6), i. 54–6.

[84] At ll. 160, 621, 1674. The importance of this opposition is stressed by A. Pirkhofer, *Figurengestaltung im Beowulf-Epos* (Heidelberg, 1940), 17–18.

> Giogoð ætgædere; þær se goda sæt,
> Beowulf Geata be þæm gebroðrum twæm. (ll. 1188–91)

[She passed then among the benches to where her children were, Hrethric and Hrothmund, and the sons of warriors, the whole company of young men together; good Beowulf the Geat sat there, beside the two brothers.]

Later, in his report to Hygelac, Beowulf recalls that it was Hrothgar himself who assigned him this honourable place beside the two princes: it is an act of hospitality and respect, but it also places Beowulf where at this stage of his career he belongs, among the 'geogoð'. The distinction between 'geogoð' and 'duguð', symbolized by the seating arrangements at Heorot, was related only indirectly to a warrior's age. As one historian observes, the poet's distinction 'agrees well with one distinguishable in the writings of Bede between the older men with an establishment of their own, who spend only part of their time at court, and young followers who have not yet received a landed endowment.'[85] The transition from one status to the other was effected by a royal grant of land which, in the words of another historian, 'came at the turning-point in a nobleman's career, rewarding fame, sustaining rank, permitting marriage, making him a landed *comes*, and so translating him from *geoguð* to *duguð*'.[86] In the light of these observations, a small episode at the end of the first part of *Beowulf* assumes its true significance. Beowulf has returned to his homeland and reported his victories to Hygelac. The king rewards him with a sword—and a great landed estate:

> him gesealde seofan þusendo,
> Bold ond bregostol. Him wæs bam samod
> On ðam leodscipe lond gecynde,
> Eard eðelriht, oðrum swiðor
> Side rice þam ðær selra wæs. (ll. 2195–9)

[85] D. Whitelock, *The Beginnings of English Society* (Harmondsworth, 1952), 57. According to Colgrave's note (*Bede's Ecclesiastical History*, 75), Bede uses 'comes' for retainers of the king who had a household of their own, 'miles' for retainers who had not yet received such an establishment. The Old English version of Bede renders 'comes' by 'gesiþ' and 'miles' by 'þegn'. In *Beowulf* 'gesiþ' sometimes means simply companion; but the more specific meaning seems likely at ll. 23, 853, and especially 1297, where Hrothgar's trusty counsellor Æschere is assigned to 'gesiðes had'.

[86] T. M. Charles-Edwards, in *English Medieval Settlement*, ed. P. H. Sawyer (London, 1979), 100. Charles-Edwards discusses *Beowulf* in this connection (p. 99), as does Eric John, '*Beowulf* and the Margins of Literacy', *Bulletin of the John Rylands Library* lvi (1974), 409–10.

[He gave him seven thousand hides of land, a hall, and a high seat. Both of them had a natural right to land in that country, an estate and a patrimony, though the whole kingdom had gone by preference to the one of higher rank.]

With these lines, the story of Beowulf's adventures in Denmark is brought to an end; and we thereafter see the hero (in the very next sentence, indeed) as an old king who has reigned for fifty years and now faces the threat of the dragon. If Hygelac's grant of land, hall, and high seat does mark the passage of the hero from 'geogoð' to 'duguð', then the first part of the poem's action can be said to restrict itself very precisely to the period of Beowulf's 'youth'—only that term must be understood, not in the abstract mathematical fashion of the monks, but as marking a particular socio-economic role and function.[87]

When he became a member of the 'duguð', a warrior was supposed to have settled down, so far as that was ever possible in the conditions of the time. He now had home responsibilities, and was no longer free to seek adventure and glory wherever they were to be found. From this point in his career, accordingly, Beowulf no longer undertakes on his own initiative adventures to help others ('for arstafum', l. 458), such as his expedition to Denmark—still less, adventures merely to indulge the spirit of adventure ('for wlence', l. 508), such as his earlier swimming-match with Breca. The adventurous and ill-fated Viking raid against the Franks, on which he loyally accompanies his lord Hygelac, reflects only, as the poem makes abundantly clear, on the judgement of the latter. King Beowulf's own battles are fought in defence of his hall, land, and people; and it is in that cause that he dies, fighting the dragon. For, though he lives to be a very old man, Beowulf never reaches the last stage of a warrior's life, marked by the laying-down of his arms.

'It is essentially a balance, an opposition of ends and beginnings. In its simplest terms it is a contrasted description of two moments in a great life, rising and setting; an elaboration of the ancient and

[87] G. J. Engelhardt, 'On the Sequence of Beowulf's *Geogoð*', *MLN* lxviii (1953), 91–5, conflates the two word-pairs, 'geogoð'–'duguð' and 'geogoð'–'yldo', to give a three-age scheme: 'geogoð'–'duguð'–'yldo'. But this is not borne out by the poet's usage. Engelhardt also speculates on the stages of Beowulf's early career, as does K. Malone, *JEGP* xxxvi (1937), 21–3.

intensely moving contrast between youth and age, first achievement
and final death.'[88] The grounds for this frequently cited observation
about *Beowulf*, made by J. R. R. Tolkien, are evident enough. The
two moments in question are separated by no less than fifty years,
and that, even allowing for the extended span of 'great lives', would
be enough to ensure the contrast in question, even if Beowulf were
not called young in the first part and old in the second. Yet I am not
alone in thinking that the 'contrast between youth and age' is much
less clearly marked in the poem than Tolkien's account suggests.
Kenneth Sisam expresses the same opinion in his book *The Structure
of Beowulf*. Sisam's arguments are as follows: that in more than two
thousand lines devoted to the Danish expedition, the poet makes
only two references to Beowulf's youth ('hyse' (l. 1217) and 'geong'
(l. 1843)); that Beowulf is at this stage portrayed as already 'a confi-
dent and proved hero'; and that the Beowulf of the dragon fight,
though frequently described as old, is just as good at fighting mon-
sters as he ever was. Sisam sums up: 'If the two parts of the poem are
to be solidly bound together by the opposition of youth and age, it is
not enough that the hero should be young in the one part and old in
the other. The change in his age must be shown to change his ability
to fight monsters, since these fights make the main plot. Instead,
Beowulf is represented from beginning to end as the scourge of mon-
sters, always seeking them out and destroying them by the shortest
way.'[89]

Sisam's observations can be amplified and developed, in the
present context, by taking account of transcendence themes in the
poem. As for the Beowulf of the dragon-fight, it is certainly true, as
Sisam himself concedes, that he is frequently characterized as old:
'frod cyning' (l. 2209), 'eald eþelweard' (l. 2210), 'frod folces weard'
(l. 2513), 'se gomela' (ll. 2817, 2851), 'ealdhlaford' (l. 2778), 'har hil-
derinc' (l. 3136). He also exhibits some of the natural characteristics
of old age, as J. C. Pope has best shown in his analysis of Beowulf's
long speech recalling the days of his youth.[90] Though the wisdom of

[88] J. R. R. Tolkien, '*Beowulf*: The Monsters and the Critics', *PBA* xxii (1936), 271.

[89] K. Sisam, *The Structure of 'Beowulf'* (Oxford, 1965). 24.

[90] 'Beowulf's Old Age', in *Philological Essays in Honour of H. D. Meritt*, ed. J. L.
Rosier (The Hague and Paris, 1970), 55–64: 'The poet thus brings Beowulf as close to
the condition of an ordinary old man as is compatible with his design before causing
him to sum non up the huge reserve of strength and determination that has made him
a hero' (p. t 4).

the hero's decision to tackle the dragon himself has been much
debated by recent critics, even those who doubt it (wrongly, I think)
must acknowledge that the poet does not withhold from him the epi-
thet so commonly bestowed by Anglo-Saxon writers on the old:
aged Beowulf is 'se wisa' (l. 2329), 'wishycgende' (l. 2716), and,
according to Wiglaf, 'wis' (l. 3094). But if Beowulf is indeed a king
old and wise ('frod cyning'), he does not display the physical infirmi-
ties of age, as Hrothgar does: 'There is no suggestion that age was a
disadvantage in his fight with the Dragon—that he would have done
better had he been younger. He still trusts to his own unaided
strength (ll. 2540 ff.). The demonstration that no sword could bear
the force of his stroke is reserved for this last fight (ll. 2684 ff.). The
contest is beyond the power of any other man (ll. 2532 ff.).'[91]
Although he is now a grey-haired warrior, in fact, Beowulf's great
strength or 'mægenstrengo' is no more in doubt than his courage
and resolution. We can recognize here a clear case of that downward
transcendence already noticed in other heroic poems. Beowulf may
be the mildest of men, 'manna mildust', to his own people; but he is
still, in extreme old age, a ferocious adversary to his foes. Consider
the wonderful moment when, like young Siegfried in Wagner's
opera, he rouses the dragon from its lair:

> Let ða of breostum, ða he gebolgen wæs,
> Weder-Geata leod word ut faran,
> Stearcheort styrmde; stefn in becom
> Heaðotorht hlynnan under harne stan. (ll. 2550–3)

[Then in his anger the prince of the Geats let loose speech from his breast.
Stout of heart he stormed, and his battle-clear voice went roaring in under
the grey stone.]

There is a berserk ferocity in the old man's shout which the poet
could not have found in Virgil's *Aeneid*, supposing he knew it. Paral-
lels to this particular version of the *senex fortis* are to be looked for
rather in Germanic writings. In *Beowulf* itself we elsewhere hear of
Healfdene 'old and fierce in battle' ('gamol ond guðreouw', l. 58),
and of the Swedish king Ongentheow, 'old and terrifying' ('eald ond
egesfull', l. 2929), who puts up such a savage resistence before losing
his life. There is also the old spearfighter ('eald æscwiga', l. 2042)
who stirs up strife between Danes and Heathobards. The figure cor-
responding to this last in *The History of the Danes* by Saxo Gram-

[91] K. Sisam, *Structure*, 23–4.

maticus, where another version of the Heathobard episode occurs, is Starkather; and in one of his songs this fierce old warrior himself expresses the heroic claims of the *senex fortis* in these words:

> Albicet quamquam senio capillus,
> Permanet virtus eadem vetustis,
> Nec fluens aetas poterit virile
> Carpere pectus.

[Although the hair may grow white with age, courage remains the same in old men, nor can the passage of time enfeeble a manly heart.][92]

The scene in which old Beowulf and his young comrade Wiglaf combine to kill the dragon might be compared with that already noticed in *La Chanson de Guillaume*, where young Guy and the ancient Count William fight shoulder-to-shoulder against the Saracens; or with that scene in *The Battle of Maldon* which brings together the grey-haired warrior Byrhtnoth ('har hilderinc', l. 169) and Wulfmær, a youth not yet grown to manhood ('hyse unweaxen', l. 52). The heroic 'equalization', or at least convergence, of the ages which such scenes represent may require, as we have seen, not only that old men should transcend their age in virility and *virtus*, but also that the young should transcend theirs in prudence and wisdom. For youth is weak where age is strong: according to the natural order of things, it is a time of folly and, in warriors, of rashness.[93] Like young saints, however, young heroes can display a wisdom beyond their years. Such is the case with Wiglaf—and also with the young Beowulf. In his attempt to explain why the Beowulf of the Danish adventure, though he certainly is young, should fail to seem so, Sisam might have drawn attention to the fact that the one and only reference to the hero as 'young' occurs in a passage where old Hrothgar is praising him as a *juvenis senex*:

> Þe þa wordcwydas wigtig Drihten
> On sefan sende; ne hyrde ic snotorlicor
> On swa geongum feore guman þingian.

[92] *Saxonis Gesta Danorum*, Bk. VI, Chap. ix, ed. J. Olrik and H. Ræder, vol. i. (Copenhagen, 1931), 170, ll. 15–18, cited by Pirkhofer, 22. Professor Shippey suggests to me Old Norse parallels in Víga-Glúmr and Egill Skallagrímsson, and an Old High German parallel in Hildebrand.

[93] The association between youth and rashness may help to explain why Hygelac, whose expedition against the Franks is condemned as rash and foolish, should be called 'young' (ll. 1831, 1969) in defiance of other chronological evidence in the poem: see Klaeber's note to *Beowulf*, l. 1831b.

> Þu eart mægenes strang, ond on mode frod,
> Wis wordcwida! (ll. 1841–5)

[The all-knowing Lord sent those utterances into your mind. I have never heard a man speak in public more wisely at so young an age. You are strong in might and also mature in mind, prudent in speech.]

The emphasis here falls not upon 'geong', but upon 'snotor', 'frod', and 'wis'.[94] Hrothgar is speaking the traditional language of eulogy, already familiar to us from many other Anglo-Saxon writers. The antithetical formula in line 1844 resembles those cited previously from the hagiographical writings of Ælfric ('cildlic on gearum and ealdlic on mode', for instance); and the preceding lines resemble the passage already quoted from *Andreas* so closely that scholars commonly suppose that the *Andreas*-poet was imitating *Beowulf* itself.[95] In both a young man is credited with displaying in his utterances ('wordcwidas') a special God-given wisdom; and both speakers declare that they have never seen anything like it:

> Ic æt efenealdum æfre ne mette
> On modsefan maran snyttro. (*Andreas*, ll. 553–4)

[I have never encountered greater wisdom of mind in one of his years.]

The present study may suggest caution in supposing a direct connection between the two passages; but they do provide a striking illustration of how transcendence themes are shared by the two high-mimetic modes, heroic and hagiographic.[96]

It is through the precocious wisdom of which Hrothgar speaks that the young Beowulf is able, as the poet twice expresses it, to 'hold' or govern his prodigious strength (ll. 1705–6, 2181–3). He seems already to exhibit, in fact, something approaching that ideal combination of *fortitudo* and *sapientia* which represents, in heroic poetry, the meeting-point of youth and age. Consider, for instance, his response to the news of Æschere's death, announced by the

[94] Wiglaf is called 'snotor' at l. 3120. Compare the description of Hygelac's queen, Hygd: 'Hygd swiðe geong, | Wis welþungen, þeah ðe wintra lyt | Under burhlocan gebiden hæbbe' (ll. 1926–8) ['Hygd was very young, but even though she may have passed few years in the stronghold, she was wise and accomplished'].

[95] See above, p. 103.

[96] On interactions between the ideals of heroism and sainthood, see H. Mayr-Harting, *The Coming of Christianity to Anglo-Saxon England* (London, 1972), Chap. 13. Comparisons between *Beowulf* and saints' lives are made by M. E. Goldsmith, *The Mode and Meaning of 'Beowulf'* (London, 1970). Klaeber sees in *Beowulf* ll. 1844–5 the Christian formula 'thought, word, and deed' adapted to the heroic ideal: *Anglia* xxxv (1911), 457.

grieving old Danish king. The series of sententious generalizations with which he begins might well have come from the mouth of the 'frod guma' in some gnomic poem: 'Each of us must endure an end of life in the world.' The old man Egeus says much the same in Chaucer's *Knight's Tale*, on the occasion of the death of Arcite. Yet Beowulf's consolatory words, unlike those of Egeus, carry with them the promise of action. Indeed the whole speech, for all its spacious wisdom, moves powerfully towards the summons 'Arise!' and the hero's vow of vengeance:

> Ne sorga, snotor guma! Selre bið æghwæm
> Þæt he his freond wrece, þonne he fela murne.
> Ure æghwylc sceal ende gebidan
> Worolde lifes; wyrce se þe mote
> Domes ær deaþe; þæt bið drihtguman
> Unlifgendum æfter selest.
> Aris, rices weard, uton hraþe feran,
> Grendles magan gang sceawigan.
> Ic hit þe gehate: no he on helm losaþ,
> Ne on foldan fæþm, ne on fyrgenholt,
> Ne on gyfenes grund, ga þær he wille! (ll. 1384–94)

[Do not grieve, wise man! It is better for a man that he should avenge his friend than that he should much mourn. Each of us must endure an end of life in the world; let him who can gain glory before his death—that is the best thing afterwards, when a man is no longer alive. Arise, guardian of the kingdom, and let us quickly go to follow the trail of Grendel's kinswoman. I promise you this: she will not find any cover, not in the depths of the earth, nor in the mountain woods, nor at the bottom of the sea, go where she will!]

Unlike Hrothgar, whose wisdom is no longer matched by his strength, Beowulf is indeed both 'mægenes strang' and 'on mode frod'. He exemplifies just that combination of qualities stipulated by Isidore of Seville for a hero: 'Heroes appellantur viri quasi aerii et caelo digni propter sapientiam et fortitudinem' ['Heroes are men so called as being aerial and deserving of heaven on account of their wisdom and fortitude.']⁹⁷

[97] *Etymologiae*, ed. Lindsay, Bk. I, Chap. xxxix, para. 9; cited by R. E. Kaske, '*Sapientia et Fortitudo* as the Controlling Theme of *Beowulf*', *Studies in Philology* lv (1958), 424. To Kaske's Germanic citations may be added a passage from *Waltharius*, where Hagen and Walther, attached as 'adolescentes' to the court of Attila the Hun, are described as *juvenes senes*: 'Qui simul ingenio crescentes mentis et aevo | Robore vincebant fortes animoque sophistas' ['Growing at once in age and in mental capacity, they surpassed the strong in might and the learned in intelligence'], *Waltharius of Gaeraldus*, ed. A. K. Bate (Reading, 1978), ll. 103–4.

There is, of course, no complete 'equalization of ages' between Beowulf the *juvenis senex* and Beowulf the *senex fortis*. His expedition against the Grendels, though sharply distinguished from his exploits with Breca, may be understood as the kind of thing that only a member of the 'geogoð' would be free to undertake, whereas his fight with the dragon is prompted by the heavy responsibility of a king to avenge his ravaged land (ll. 2333–6). Again, Beowulf's decision to tackle Grendel without armour or weapons may be seen as an act of youthful daring, and as such contrasted with his prudent preparation of an iron shield to withstand the dragon's fiery breath. Although the latter contrast is somewhat undercut by the facts that, in the event, the iron shield does not save him, whereas the earlier rash decision turns out fortunately, since Grendel could not be killed by a sword, yet the awareness that things are no longer going Beowulf's way, now that he is 'fæge' or doomed to die, itself makes a contribution to that sense of old age and approaching death which the last part of the poem so powerfully conveys. I hope to have shown, however, that transcendence themes do serve to mute that 'contrast between youth and age' which Tolkien found in the poem. In this respect, *Beowulf* may be regarded as representative both of the epic tradition to which it belongs and also of the surviving literature of Anglo-Saxon England.

4

Ideals of Nature

'OUR nature, when good and straight, follows a seasonable pro-
cedure in us, as we see the nature of plants doing in them; and there-
fore different ways and different deportment are suitable at one age
more than at another, wherein the ennobled soul proceeds in due
order, exercising its acts in their times and ages according as they are
ordained for its ultimate fruit.'[1] Dante's vision of the noble soul fol-
lowing its natural course of development, 'exercising its acts in their
times and ages', represents the loftiest of the conceptions with which
this chapter will be concerned. This is the 'nature ideal' at its most
elevated. A few saints and heroes may by special grace be enabled to
transcend the limitations of the *cursus aetatis* and exhibit powers
and virtues quite out of season; but for the rest, departures from
natural order are less likely to result in transcendent excellence than
in folly and vice. The ridiculous *senex amans* is a figure more com-
monly encountered than the *senex fortis*; and ordinary mortals who
display precocious wisdom in their early years are as often suspected
as praised. For the majority of men, in short, the seasonableness of
which Dante speaks will have a positive value: it represents a high
norm to be conformed to, rather than a low norm to be transcended.

I

This distinction between two ways of looking at the *cursus aetatis*
manifests itself with peculiar clarity in the case of Christ; for Christ's
double nature as both God and man required that he should be seen

[1] *Il convivio*, IV. xxiv. 8. Compare I. i. 17: 'certi costumi sono idonei e laudabili ad
una etade che sono sconci e biasmivoli ad altra' ['certain ways are suitable and laud-
able at one age which are foul and blameworthy at another'].

as somehow both fulfilling the natural order in his perfect humanity and also transcending it in his consummate Godhead.

The 'Transzendenzideal' enters into medieval treatments of the life of Christ at two points: in the episode of the Adoration of the Magi and in that of Christ among the Doctors. According to a tradition going back at least as far as the sixth century, each of the three Magi represents a different age of man: youth, maturity, and old age.[2] Thus, in an English carol preserved in Richard Hill's commonplace book, the first offering to Christ is made by 'the eldest kyng of them thre', the second by 'the medylmest kyng', and the third by 'the yongest kyng'.[3] The same distinction is very commonly made in pictorial representations of the Adoration, such as that reproduced in Plate 11 here: one king will have a white beard, one the dark facial hair of maturity, and one the hairless cheeks of youth.[4] The Magi are therefore taken to represent, not only (as was customary) all three known continents, but also all three stages in life's course: *augmentum*, *status*, and *decrementum*. In their persons men of all nations and all ages bow the knee to Christ. The resulting scene has a further significance, however, for the Christ to whom they bow is a baby. Though the Magi observe normal rules of seniority among themselves, in so far as it is usually the old king who makes the first offering, that natural order is quite overturned in their relation to the infant Christ. The image of a mere baby receiving the homage of grown men (traditionally kings, at that) forcefully expresses the transcendent standing of the incarnate God in his relation to customary human hierarchies. Where Christ is concerned, ordinary rules of seniority can be stood on their head. Old men submit to infants.

[2] See Gertrud Schiller, *Iconography of Christian Art* (London, 1971–2), i. 94–114, citing H. L. Kehrer, *Die heiligen drei Könige in Literatur und Kunst* (Leipzig, 1908–9). Beryl Rowland, *Chaucer Review* ix (1975), 345, quotes Pseudo-Bede, according to whom Melchior is 'senex et canus', Casper 'juvenis imberbis', and Balthasar 'fuscus, integre barbatus' (*PL* 94. 541).
[3] This poem is No. 123 in R. L. Greene (ed.), *The Early English Carols*, 2nd edn. (Oxford, 1977). In the York play of the Adoration, the third king yields precedence to the first: 'for honnoure and elde | Brother, ȝe shall begynne', *York Plays*, ed. R. Beadle (London, 1982), Play xvi, ll. 307–8.
[4] For other pictorial examples, see the plates in Schiller's *Iconography*, vol. i, especially Plates 264, 268, 288 (Giotto), 289–93, 296, 297 (Roger van der Weyden), and 298 (Botticelli).

The doctrine of the double nature of Christ led to some knotty problems concerning the development of his intellectual powers. If one considered him simply as God, one person of the Trinity, then there could be no question of any such development, since he would possess the full measure of divine knowledge and wisdom even as an infant. Thus the author of the Middle English *Speculum Sacerdotale* avers that Christ 'was in the first day of his birthe of as gret myght and wysdom as he was in his thritti yere.'[5] Seen through human eyes, then, the young Christ might be expected to provide a striking example of the *puer senex*; and so he does indeed appear in Luke's account of how Mary and Joseph found the twelve-year-old boy in the Temple: 'sitting in the midst of the doctors, hearing them and asking them questions. And all that heard him were astonished at his wisdom and his answers' (Luke 2:46–7). Taking up Luke's reference to the astonishing wisdom ('prudentia' in the Vulgate) of the boy's answers, authorities such as Origen, Jerome, and Augustine concluded that he actually taught his learned elders.[6] The scene could therefore take its place alongside the Adoration of the Magi as an instance of that inversion of natural precedence which the 'Transzendenzideal' often entails. The boy Christ surpassed doctors in wisdom, just as the infant surpassed kings in power. This version of Christ among the Doctors appears frequently in medieval art and literature. In a stained-glass window in Canterbury Cathedral a representation of the boy Christ instructing eight bearded doctors is flanked by one of the young Daniel judging the elders, with the following inscription: 'Mirantur pueri seniores voce doceri; sic responsa [Dei sen]sumque stupent Pharisei' ['The elders are astonished to be instructed by the voice of a boy; just so the Pharisees wonder at

[5] E. H. Weatherly (ed.), EETS, os 200 (1936), 41. Mandeville attributes to Saracens the belief that Jesus could speak as soon as he was born: *Mandeville's Travels*, ed. M. C. Seymour (Oxford, 1967), 96–7. A Wycliffite sermon tries to have it both ways: 'owre Iesu, siþ he was þis manhede and suget to oþre men, and growyde in waxyng and in elde, he profiȝtude in connyng wyche þat cam of his wittes. But he hadde connyng of godhede and blessyde connyng of man, by whiche he was in al his tyme ylyche wys and knew alle þing', *English Wycliffite Sermons*, vol. i, ed. Anne Hudson (Oxford, 1983), Sermons on the Sunday Gospels, Sermon 32, ll. 40–5.

[6] See Gnilka's discussion of Christ among the Doctors as *puer senex*, pp. 239–41. Gnilka also refers to a scene in the apocryphal Gospel of Thomas (Chaps. VI–VIII) in which the five-year-old Jesus confounds his old teacher Zacchaeus. Alcuin takes the 'puer sapiens' of Ecclesiastes 4:13 as a prophecy of the young Christ (*PL* 100. 687), following the Fathers cited by Gnilka.

the wise answers of God'].[7] Christ is here juxtaposed with one of the best-known Old Testament types of the *puer senex*, himself traditionally twelve years old at the time in question.[8] Another representation of Christ among the Doctors, from the Queen Mary's Psalter, may be seen in Plate 12. Here the transcendent status of the boy Christ is represented rather literally, by seating him on what appears to be a high bar-stool so that his small and didactically gesticulating figure can dominate the group of grey-bearded experts by which it is surrounded.[9] A corresponding literary treatment of the scene occurs in the fourteenth-century poem, *A Disputison bitwene Child Jhesu and Maistres of the Lawe of Jewus*. The twelve-year-old Jesus, speaking *ex cathedra* ('He sat in see, he nolde not stonde'), instructs the Jewish masters in the mysteries of the Trinity.[10] They are impressed by his 'wonder wit', but object to his taking the role of teacher upon himself: 'Þou scholdest lerne, and nouȝt teche'. To this Christ replies enigmatically: 'I am ful old, þeih I be ying' (l. 51). The English mystery cycles treat this scene in similar fashion, representing Christ as a *puer senex* who instructs and confounds the Jewish doctors. In the four closely related Doctors plays from Chester, York, Wakefield, and Coventry, the experts are at first scornful and incredulous, even though (in three of the plays) they recall David's prophetic words in Psalm 8: 'Out of the mouth of infants and of sucklings thou hast perfected praise.' They are silenced by the boy's exposition of the Ten Commandments (a not very prodigious feat, one would have thought) and recognize him as a 'chylde of wysedome grett'.[11] The independent version in *Ludus Coventriae* shows Christ expounding the mysteries of the Trinity and informing the doctors of his 'dobyl byrth':

[7] See Caviness, *The Windows of Christ Church Cathedral Canterbury*, 102–3 and Figs. 173 and 176. The other flanking scene, which portrays Moses listening respectfully to Jethro (Exodus 18:24), suggests the different reading of Christ's behaviour in the Temple discussed below.

[8] On Daniel as *puer senex*, see Gnilka, 236–9.

[9] For other pictorial examples, see the plates in Schiller's *Iconography*, vol. i, Plates 53, 339–43; vol. ii, Plate 24.

[10] *The Minor Poems of the Vernon MS*, Pt. ii, ed. F. J. Furnivall, EETS, os 117 (1901), 479–84. The boy's exposition of the letter A as a sign of the Trinity, being a single letter formed of three strokes, derives from the Gospel of Thomas: trans. M. R. James, *The Apocryphal New Testament* (Oxford, 1924), 51, 62.

[11] *Two Coventry Corpus Christi Plays*, ed. H. Craig, EETS, es 87, 2nd edn. (1957), The Pageant of the Weavers, l. 1148.

Ffor be my ffadyr kynge celestyall
Without begynnyng I am endles;
But be my modyr þat is carnall
I am but xii ȝere of age, þat is expres.[12]

The theological danger of considering the boy Christ purely as a *puer senex* was that his 'carnall' or human nature might be lost sight of. In so far as he was 'verus Deus', there could be no limit to his wisdom and knowledge; but he was also 'verus homo', truly a man, and as such he must be thought of as following (albeit in exemplary fashion) the *cursus aetatis* natural to men. St Luke himself suggests as much when he speaks of the young Jesus as advancing or maturing in wisdom, age, and grace: 'Et Jesus proficiebat sapientia, et aetate, et gratia apud Deum et homines' (Luke 2:52). It is this Christological problem, according to Gnilka, which explains the unexpectedly mixed feelings displayed by the early Fathers about representations of Christ as *puer senex*: 'The childhood of the Redeemer should not be made out to be too very wonderful, because the natural childhood and, more generally, the natural sequence of the ages of Christ's life served to guarantee his true humanity.'[13] There was also another, less technical consideration. Christ's life as a man on earth was commonly held up, by preachers and others, as an example for all men to follow—a model of how the life of Everyman should ideally be. Hence it was necessary to show that his life's course was governed by that principle of *tempestivitas*, or seasonableness, which only saints could neglect with impunity. In the first phase of his life this Christ, the Christ of the nature ideal, sets an example to all children by honouring his human parents, according to the fourth commandment.[14] Nor does his conduct in the Temple, considered from this point of view, display any unnatural precocity. According to St Gregory, Christ's parents found him there not lecturing the Doctors but 'hearing them and asking questions'—an august example to deter young enthusiasts who might seek the office

[12] *Ludus Coventriae*, ed. K. S. Block, EETS, ES 120 (1922), Christ and the Doctors, ll. 161-4.

[13] Gnilka, 241, in my translation.

[14] So the Old English translation of *De Duodecim Abusivis*, ed. R. Morris, EETS, OS 34 (1868), 299-300; Ælfric, *Catholic Homilies*, ed. Thorpe, i. 442; Philippe de Novare, *Les Quatre Âges de l'homme*, ed. de Fréville, 3; *Dives and Pauper*, ed. Barnum, i, Pt. 1, 323. Compare Luke 2:51.

of preacher before they are ready for it ('intempestive').[15] In one of
his Ezechiel homilies, Gregory expresses the point forcibly:

Ipse Dominus anno duodecimo aetatis suae in medio doctorum in templo
sedens, non docens, sed interrogans voluit inveniri. Ut enim non auderent
homines in infirma aetate praedicare, ille anno duodecimo aetatis suae inter-
rogare homines est dignatus in terra, qui per divinitatem suam semper ange-
los docet in caelo.

[The Lord himself chose to be found at the age of twelve sitting among the
doctors in the Temple not teaching but asking questions. To show that men
should not be so bold as to preach at an immature age, he who by virtue of
his divinity eternally teaches the angels in heaven thought fit on earth at the
age of twelve to ask questions of men.]

Gregory goes on to refer to the apparent counter-examples of Jere-
miah and Daniel. It is true, he says, that such boys can by special
grace receive the gift of prophecy; but 'miracula in exemplo opera-
tionis non sunt trahenda ... aliud est quod nos de doctrinae usu
atque disciplina dicimus, aliud quod de miraculo scimus' ['miracles
are not to be taken as models of behaviour ... there is a distinction
between what we affirm by way of doctrine and moral teaching and
what we know concerning the miraculous'].[16]

Gregory's distinction between the natural order and the transcen-
dent realm of the miraculous, and his sensible advice that ordinary
folk should not look for models in the latter, are repeated by Bede,
who quotes the passage from Gregory's Ezechiel homily in his Com-
mentary on Luke.[17] In the same work, commenting on Luke 2:46,
Bede remarks that Christ in his human nature observed 'aetatis
humanae congruentiam' and behaved with the Doctors in the Tem-
ple as an 'exemplar humilitatis'.[18] Elsewhere, in a homily on the
same chapter of Luke's Gospel, he treats the young Christ as an
example of humility in his submitting to the natural order of man's

[15] *Liber Regulae Pastoralis, PL* 77. 98. For the Old English version of this passage,
see *King Alfred's West-Saxon Version of Gregory's Pastoral Care*, ed. H. Sweet,
EETS, os 45 (1871), 385.
[16] *Homiliae in Hiezechihelem Prophetam*, ed. M. Adriaen, CCSL cxlii (Turnhout,
1971), Bk. i, Hom. 2 (pp. 18, 19).
[17] Bede, *In Lucae Evangelium Expositio*, ed. D. Hurst, CCSL cxx (Turnhout,
1960), 85 (on Luke 3 : 23).
[18] Ed. cit. 72. Christ is, at the same time, in his divine nature a 'fons sapientiae'. In
his Commentary on Habakkuk, Bede says that Christ asked questions of the Doctors
'quasi homo parvulae aetatis', but replied to them 'quasi Deus aeternae majestatis'
(*PL* 91. 1239).

life: 'sequamur iter humanitatis eius', 'let us follow the path of his humanity'. He goes on to describe Christ's 'iter humanitatis', in a comment on Luke 2:52 ('And Jesus advanced in wisdom and age'): 'Iuxta hominis naturam proficiebat aetate quia de infantia ad pueritiam, de pueritia ad iuventutem, consueto hominibus crescendi ordine pervenit' ['In accordance with man's nature he advanced in age, for he passed from infancy to boyhood and from boyhood to maturity, following the order of growth customary with men'].[19]

The idea that Christ as man fulfilled to perfection the 'ordo crescendi' of human life provided medieval students of the Bible with an explanation for the curious fact that the Gospels record no events in his life after his encounter with the Doctors until the time when, at the age of about thirty ('quasi annorum triginta', Luke 3:23), he received baptism from John and began his public ministry of preaching and healing. It was supposed that Jesus lived privately, 'advancing in wisdom and age', for these eighteen years, until in the course of nature he arrived at full maturity. Only then did he appear as a teacher among men. In the words of Ælfric: 'he wolde abidan his wæstma timan on þære menniscnysse, swa swa hit gecyndelic is on mancynne' ['it was his wish to await the time of his maturity as a human being, in the way natural to mankind'].[20] The Church Fathers took this as a perfect model of *tempestivitas*, showing that men should not too early take upon themselves the functions of teacher or priest, despite the tempting precedents set by 'wise children' such as Daniel. Thus Gregory in his *Liber Regulae Pastoralis*:

Redemptor noster, cum in coelis sit conditor et ostensione suae potentiae semper doctor angelorum, ante tricennale tempus in terra magister noluit fieri hominum; ut videlicet praecipitatis vim saluberrimi timoris infunderet, cum ipse etiam, qui labi non posset, perfectae vitae gratiam non nisi perfecta aetate praedicaret.

[Our Redeemer, although in heaven he created the angels and teaches them eternally by displays of his power, did not wish on earth to become a teacher of men until he had spent thirty years here, in order that he might inspire a very wholesome fear in the overhasty, seeing that he himself, who could not err, would not preach the gift of perfect life except at a perfect age.][21]

More specifically, Christ's age at his baptism was held to establish

[19] *Homeliarum Evangelii Libri II*, ed. D. Hurst, CCSL cxxii (Turnhout, 1955), 136, 139.

[20] Ælfric, *Catholic Homilies*, ed. Thorpe, i. 142.

[21] *PL* 77. 98.

the minimum age at which a man could become a priest. Bede comments on Luke 3:23: 'Iesus annorum triginta baptizatur et tunc demum incipit signa facere et docere, legitimum videlicet et maturum tempus ostendens aetatis his qui omnem aetatem vel ad sacerdotium vel ad docendum putant oportunam' ['Jesus is baptised at the age of thirty and only then begins to work miracles and teach, thus exemplifying the right, mature time of life for the benefit of those who reckon any age opportune for priesthood or teaching'].[22] Petrarch, speaking of Christ in one of his letters, sums the matter up: 'Annum ergo trigesimum expectavit et non amplius, idque non propter necessitatem sed propter exemplum nostrum' ['He waited until his thirtieth year but no later, and that not because he needed to but because he wished to set us an example'].[23]

Thus Christ's life on earth could be regarded as describing in exemplary fashion that part of the natural arc which culminates in the 'perfecta aetas' of achieved maturity. He is a model of that due order in which the submissiveness of the young learner is succeeded, at the right moment, by the authority and confidence of the grown master. Everything follows in its season, 'from infancy to boyhood and from boyhood to maturity, following the order of growth customary with men.' Some authorities even went so far as to claim that Christ lived through all the ages of man.[24] But this conflicted with the evidence of the Gospels, which was most commonly interpreted as showing that Christ suffered crucifixion at the age of thirty-three.

[22] *In Lucae Evangelium Expositio*, ed. Hurst, 85. Bede himself was thirty years old when he became a priest and began to write treatises, according to *Historia Ecclesiastica*, Bk. v, Chap. 24, ed. Colgrave and Mynors, 566. On patristic discussions of the baptism of Christ as establishing the 'legitimum tempus' for ordination, see Gnilka, 182–5.

[23] From a letter addressed to Boccaccio, *Seniles* II. i, in *Francesco Petrarca: Prose*, ed. G. Martellotti, P. G. Ricci, E. Carrara, E. Bianchi (Milan and Naples, 1955), 1062, 1064. Petrarch cites the episode of Christ among the Doctors, interpreted as an example of age-transcendence, to establish that the incarnate God could have preached at any age, had he so wished (p. 1062). The whole discussion (pp. 1052–64) is of interest in the context of the present study. Petrarch is defending himself against the charge that in his Latin epic *Africa* he made a *iuvenis* utter grave sentiments proper only to an old man. After citing the opinions of Cicero, Augustine, and Isidore on the age at which *senectus* begins, he goes on to justify the passage in his poem by recalling examples of precocious wisdom and maturity from ancient history, as if his *iuvenis* were an instance of heroic transcendence (appropriate enough in a neoclassical epic such as the *Africa*). Yet he also argues, citing the example of Christ, that the character in question was at an age (in his forties, we are now told) when such grave utterance was entirely seasonable. So Petrarch has it both ways.

[24] Gnilka, 115, 241.

In *Il convivio*, Dante was so bold as to suggest that if Christ had lived out his natural span he would have died, or rather 'been changed from mortal body to eternal', in his eighty-first year, thus sharing with mankind even the experience of decrepitude.[25] But Christ chose to die in his thirty-fourth year because, Dante explains, although it was fitting that having passed through the lowly age of *puerizia* he should reach the summit of life's arc, yet 'non era convenevole la divinitade stare in cosa in discrescere': it was not fitting for the Godhead to reside in a thing in decline, that is, a decaying human body.[26]

Another poet who showed an interest in the 'iter humanitatis' followed by Jesus was William Langland. In the course of a long and complex account of Christ's life in *Piers Plowman* B, xix. 26–199, Conscience explains to Will how Christ 'comsede wexe | In the manere of a man'. As a young knight, before he grew into either king or conqueror, he was known as Jesus *filius Marie*. This knightly title, in contrast to his later titles as king and conqueror (*filius David* and *Christus*, respectively), represented him as a member of a human family. Indeed, he was still 'Mary's boy', according to Conscience, even as late as his first miracle at Cana of Galilee, when in the presence of his mother he turned water into wine. The Latin term 'juventee' which Langland uses here (xix. 108) could well refer to a thirty-year-old; but it is surprising to hear Jesus described at this stage of his life as if he were still a *puer senex*: 'a fauntekyn ful of wit, *filius Marie*' (xix. 118). It was only later, 'whan he was woxen moore, in his moder absence', that Jesus is said to have reached full maturity, as *filius David*, King of the Jews.

Earlier in *Piers Plowman*, Langland had employed the same conceit of Christ as a knight to explore the mystery of God's submission to the 'ordo crescendi' of humanity in the incarnation (B, xvi. 90 ff.). The call of humanity is here represented not by Mary but (in the B Text) by Piers Plowman himself, cast in the role of an experienced older knight who acts as mentor to the young knight Jesus, rather as Gornemant de Goort does for the young Perceval in Chrétien's *Conte du graal*. In his bold and brilliant sketch of the relationship

[25] *Il convivio*, iv. xxiv. 6. Dante cites the example of Plato, who, according to Cicero's *De Senectute*, died happy in his eighty-first year.

[26] *Il convivio*, iv. xxiii. 10. St Thomas Aquinas used the same argument, adding that the fact of Christ's death and resurrection 'in iuvenili aetate' was also to be understood as prefiguring the state of perfect maturity assumed by all bodies at the general resurrection: *Summa Theologica*, 3 q. 46 a. 9 ad 4. See above, p. 104.

between Piers and Jesus, Langland manages to suggest that the natural *cursus aetatis*, with all its enforced limitations and delays, represented for the incarnate God an unfamiliar discipline to which he had to learn to submit:

And in the wombe of that wenche was he fourty woukes,
Til he weex a faunt thorugh hir flessh, and of fightyng kouthe,
To have yfoughte with the fend er ful tyme come.
And Piers the Plowman parceyved plener tyme,
And lered hym lechecraft, his lif for to save,
That though he were wounded with his enemy, to warisshen hymselve;
And dide hym assaie his surgenrie on hem that sike were,
Til he was parfit praktisour, if any peril fille. (XVI. 100–7)

The knightly art of healing is a skill which even Jesus must take time to learn; and it is only when he performs the *meisterwerk* of raising Lazarus from the dead that he knows that the time has come for that supreme encounter in which he is to raise himself from the dead. This is the *plenitudo temporis* or fullness of time (XVI. 93) of which St Paul spoke in Galatians 4:4, a 'ful tyme' which only Piers, in his humanity, could teach Jesus to await in accordance with 'aetatis humanae congruentiam'.[27] For Langland, the 'iter humanitatis' was not a road which Jesus walked easily; yet his Jesus, like Dante's, offers a model of how the human soul may proceed in due order 'exercising its acts in their times and ages according as they are ordained for its ultimate fruit.'

II

In speaking of ideals of transcendence and nature one is concerned, not with systematically articulated theories, but with loose clusters of ideas. Having seen how Christ could be taken as a model of seasonable and natural behaviour, let us now approach the matter from its other, negative, side and consider some medieval notions of the

[27] See D. Aers, '*Piers Plowman' and Christian Allegory* (London, 1975), 108. The C Text (ed. Pearsall, XVIII. 138) substitutes Liberum Arbitrium for the Piers of B, XVI. 103, yielding a weaker but easier sense: God of his own free will chose to await *plenitudo temporis*.

unseasonable and unnatural. I shall discuss two of the types of unna-
turalness most commonly encountered in the texts, borrowing labels
for them from a medieval proverb, 'Young saint, old devil'. The
young saint and the old devil, as negative types, correspond roughly
to the two positive types considered in the last chapter, the *puer
senex* and the *senex fortis*. Thus, the 'young saint' may be said to be,
in many cases, nothing but a *puer senex* seen from a hostile point of
view: what seems to one observer a youngster's preternatural and
God-given wisdom may strike another as odious precocity.

Learned opinion in the Middle Ages agreed that there were cer-
tain offices, notably those of king and priest, which could properly
be filled only by persons of mature years. Solomon himself had
warned of the danger of young kings: 'Woe to thee, O land, when thy
king is a child'.[28] Patristic authorities such as Gregory and Bede, as
we have seen, took a similar view of young preachers. In his *Liber
Regulae Pastoralis*, Gregory compares young enthusiasts who take
on the office 'intempestive' to baby birds trying to fly before they are
fledged, buildings erected on unset foundations, and prematurely
delivered babies.[29] Nor did scholars always look kindly on the early
development of the precocious child. In his book on the ages of man,
the learned Elizabethan Henry Cuffe takes it for granted that 'chil-
dren that are too ripe witted in their childhood are for the most part
either shortest lived, or els toward their old age most sottish, accord-
ing to our Proverbe, *Soone ripe, soone rotten*.' The explanation, he
says, is that 'from the beginning they had but little moisture, over
which their heat soone prevailed.'[30] According to the old physio-
logy, as we have seen, life depended upon the heat of the body con-
suming the moisture which is its fuel, just as the flame of a lamp con-
sumes its oil. Early attainment of that moderate level of moisture
associated with maturity suggests that there was 'but little moisture'
to start with. One may therefore expect the vital fuel to run out
abnormally soon in such cases, which means either early death or
premature senility. Perhaps Chaucer's Doctor of Physic has the
same physiological model of human development in mind when he
warns against allowing young girls (his heroine Virginia is only
twelve) to attend feasts and dances with the grown-ups:

[28] Ecclesiastes 10:16, cited by Langland, *Piers Plowman* B, Prol. 196.
[29] *PL* 77. 98.
[30] Cuffe, *The Differences of the Ages*, 95.

Swich thynges maken children for to be
To soone rype and boold, as men may se,
Which is ful perilous, and hath been yoore.[31]

It was not only the doctors who saw in early maturity a perilous condition. Cuffe's proverb 'Soon ripe, soon rotten', which is first recorded in *Piers Plowman*, testifies to a more popular version of the same idea.[32] The analogy here (as in the Latin *praecox*, 'early ripe') is with fruit which ripens too soon and drops too early. Hence the old wives' saying gloatingly quoted by Shakespeare's Richard III: 'So wise so young, they say, do never live long.'[33] Where wisdom is in question, however, popular thinking evidently came into conflict with the official morality of the age: it was one thing for St Gregory to deprecate preaching by the young, quite another to regard wisdom and even virtue as unnatural and unwholesome in early life. The elementary schoolbook *Disticha Catonis* might advise its young readers that it was sometimes prudent to simulate foolishness; but that is prudence, not foolishness.[34] To encourage the latter would be a manifestation of the 'nature ideal' quite unacceptable to the guardians of learning and morality. Yet such seditious ideas evidently had considerable popular currency. It seems that ordinary folk, then as now, were only too ready to admire, or at least to forgive, naughty boys and wild young men, on the grounds that such behaviour was only natural at their age; while they might look on good children and virtuous youths with a certain coolness, suspicion, or even outright hostility. There is an amusing testimony to hostility of this sort in the *Ludus Coventriae* play of Christ among

[31] *Canterbury Tales*, VI. 67–9.

[32] *Piers Plowman*, C Text (ed. Pearsall), XII. 222. See B. J. Whiting, *Proverbs, Sentences, and Proverbial Phrases from English Writings mainly before 1500* (Cambridge, Mass., 1968), R142.

[33] *Richard III*, III. i. 79. The corollary, which sees high promise in late development, finds expression in popular stories such as that of Jack and the Beanstalk. This fairy-tale motif may be spotted in *Beowulf*, where the same hero who so impresses Hrothgar as a *juvenis senex* is also said to have to have been considered particularly slack and ignoble in his earlier years: *Beowulf*, ll. 2183–8.

[34] *Disticha Catonis*, ed. M. Boas (Amsterdam, 1952), ii. 18: 'Insipiens esto, cum tempus postulat ipsum, | Stultitiam simulare loco, prudentia summa est' ['Be foolish when the occasion requires, for to make a show of folly is, in its place, the height of wisdom']. Barbour cites this maxim in describing how young James Douglas lived a wild life in Paris 'as ye cours askis off ȝowtheid'. Such 'feynȝeyng off rybbaldy', Barbour observes, enables one to acquire 'knawlage off mony statis': *Barbour's Bruce*, ed. M. P. McDiarmid and J. A. C. Stevenson, STS, 4th Ser. xii, xiii, xv (1980–5), i. 332–44. 'Cato' and Barbour would have approved of Shakespeare's Prince Hal.

the Doctors. The Virgin Mary, anxiously looking for the boy Jesus who is lost, expresses the fear that his precocious goodness and wisdom have made him enemies among his contemporaries:

> I am aferd þat he hath fon
> For his grett wyttys and werkys good;
> Lyke hym of wytt forsoth is non,
> Every childe with hym is wroth and wood.[35]

In his *Adagia*, Erasmus quotes from Apuleius the proverb, 'Odi puerulos praecoci sapientia', 'I hate small boys who are wise before their time'. He explains this as follows: 'Vulgo invaluit opinio, ut credant puerulos maturius sapientes, aut non fore vitales, aut dementes futuros, simulatque ad aetatem maturam pervenerint' ['It was a common belief that prematurely wise boys either would not live long or else would lose their wits once they came to mature years.'][36]

In his *Moriae Encomium* Erasmus attributes the same Apuleian proverb to Folly, who cites it in the course of her eulogy of childish thoughtlessness.[37] Here, in his own more complex and ironical fashion, Erasmus follows a well-established medieval custom of attributing such sentiments to wicked or misguided speakers, who seek to lure young people from the straight and narrow path by unscrupulous appeals to doctrines of naturalness. The frequency with which medieval moralists report such arguments, albeit with disapproval, testifies to their currency. A few examples will suffice. In the twelfth-century Latin comedy *Alda*, the slave Spurius advises his master not to allow his father's stinginess to turn him into an old man before his time:

> Lude, satisfacias annis operosus amator
> Nec senis invigiles moribus ante senem!

[35] Block (ed.), Christ and the Doctors, ll. 221–4.

[36] *Adagiorum Chiliades* (Basle, 1515), No. 3100. Compare Adage 2210, 'Ante barbam doces senes' ['You teach old men before you yourself have a beard'], where Erasmus cites the same proverb from Apuleius (*Apologia*, Chap. lxxxv), observing that precocious prudence is commonly considered a thing of bad omen.

[37] *Moriae Encomium*, ed. C. H. Miller, *Opera Omnia* iv. 3 (Amsterdam and Oxford, 1979), 82, ll. 210–12: 'Quis enim non ceu portentum oderit atque execretur puerum virili sapientia? Astipulatur et vulgo iactatum proverbium, *Odi puerulum praecoci sapientia*' ['For who does not hate and loathe as a monstrosity a boy who displays the wisdom of a man? Witness the oft-repeated proverb, "I hate a small boy who is wise before his time"'].

[Have fun, and lead a busy lover's life as your years require! Do not become an old man until you *are* old.][38]

In the *South English Legendary*, an old whore tries to persuade St Agatha that her young blood—here as often to be understood as the moist and hot humour dominant in early life—will not allow her to abstain from love:

> how miȝte a swuche creature, þus gent and þus freo,
> Hende and milde and swete inouȝ, withoute jolifte beo?
> Þi ȝongue blod nolde it þolie nouȝt, scholde þi joie beon þe binome.[39]

A later Middle English poem, *The Mirror of the Periods of Man's Life*, which gives a moralizing account of the whole life of man from infancy to decrepitude, incorporates several versions of the argument. The wicked angel tells the boy (in his second year-week, between seven and fourteen) that 'course of kynde is for ȝouþe to be wilde'; Lechery advises the man in his twenties to indulge his lust, 'for if þou in ȝouþe sparist þanne þee, | Þou maist falle in greet perille'; and the man in his thirties defends himself against Conscience in a similar fashion:

> ȝouþe axiþ delice;
> For ȝouþe þe course of kynde wole holde;
> But ȝouþe were a foole and nyce,
> How schulde wisdom be founde in oolde?[40]

Texts such as these treat appeals to 'þe course of kynde' as at best weakly defeatist and at worst diabolic. It is the same in the morality plays. In *Wisdom* Lucifer himself, finding the soul in pious mood, invokes the great Biblical statement of the doctine of timeliness, in the third chapter of Ecclesiastes: 'Omnia tempus habent . . .', 'All

[38] G. Cohen (ed.), La 'Comédie' latine en France au XII^e siècle (Paris, 1931), ll. 265–6.

[39] The Early South-English Legendary, ed. C. Horstmann, EETS, os 87 (1887), 194, ll. 15–17.

[40] F. J. Furnivall (ed.), Hymns to the Virgin and Christ, EETS, os 24 (1867), ll. 79, 227–8, 273–6. This poem distinguishes three initial year-weeks, followed by eight decadal ages.

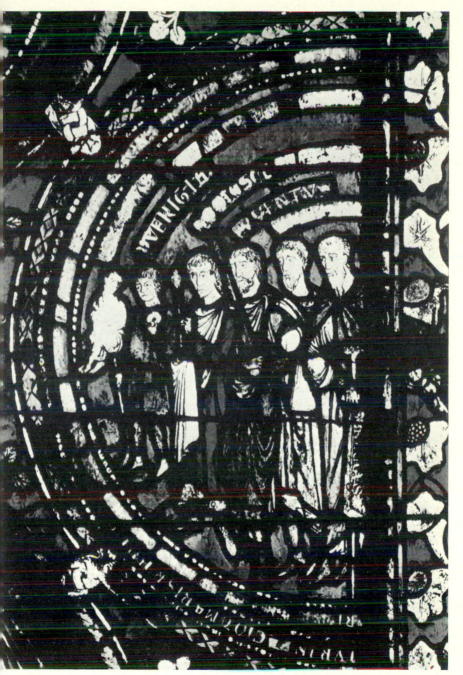

9. The Six Ages of Man: Canterbury Cathedral

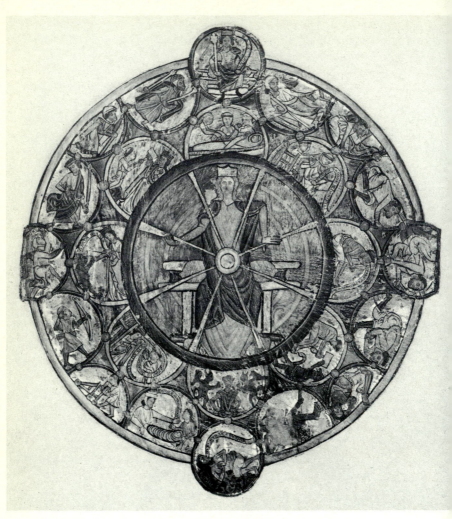

10. The Wheel of Life: William de Brailes

things have their season: and in their times all things pass under
heaven. A time to be born, and a time to die . . .':

> All thynge hat dew tymes,
> Prayer, fastynge, labour, all thes.
> Wan tyme ys not kept, þat dede ys amys.[41]

Similarly, in *The Castle of Perseverance*, the wicked angel advises
young Humanum Genus to leave virtue for his old age:

> Wyth þe Werld þou mayst be bold
> Tyl þou be sexty wyntyr hold.
> Wanne þi nose waxit cold,
> Þanne mayst þou drawe to goode.[42]

The popular proverb 'Young saint, old devil' makes the most pro-
vocative of all these appeals to the natural order of things; for its
implicit comparison between the young saint and the old devil into
which he will probably grow represents the former's virtue as an
aberration which carries with it the promise, not merely of early
death or premature senility, but of utter moral depravity in later life.
The phrase 'young saint', so used, boldly challenges both the hagio-
graphers and the moralists. Yet the proverb was evidently widely
used. One preacher speaks of it as 'a comond proverbe both of
clerkes and of laye men'; and it occurs in two fifteenth-century Eng-
lish school manuscripts, accompanied in each case by its Latin equi-
valent: 'Angelicus iuvenis senibus satanizat in annis' ('An angelic
young man becomes a devil in old age').[43] Predictably, however,
medieval writers do their best to counteract the baneful influence of
such a thought. Vincent of Beauvais describes the proverb as 'detes-
tabile', Philippe de Novare as 'grant folie ou mençonje', and the
author of *Dives and Pauper* as 'synful'.[44] It is also commonly

[41] *The Macro Plays*, ed. M. Eccles, EETS, os 262 (1969), *Wisdom*, ll. 401–3.

[42] Ibid., *The Castle of Perseverance*, ll. 416–19. The wicked angel uses a similar
argument to Humanum Genus later, in his middle age: ll. 1575–84.

[43] British Library MS Additional 37075, fol. 70ᵛ; British Library MS Harley 3362,
fol. 2ʳ. The Latin hexameter appears without the English in three other fifteenth-
century manuscripts written in England. See my essay, '"Young Saint, Old Devil":
Reflections on a Medieval Proverb', in Burrow, *Essays on Medieval Literature*, 177–
91, for more details on this and other matters.

[44] Vincent of Beauvais, *De Eruditione Filiorum Nobilium*, ed. A. Steiner (Cam-
bridge, Mass., 1938), Chap. xxxiii, ll. 116–18; Philippe de Novare, *Les Quatre Âges de
l'homme*, ed. de Fréville, 54; *Dives and Pauper*, ed. Barnum, i, Pt. 1, 128.

assigned to tempting voices, as in the dialogue poem 'Of þe seven
Ages':

þe childe: I wil go play with my felowe.
þe angel: To goode vertews loke þou drawe.
þe fende: ʒonge saynt, alde devell, is ane alde sawe;
 Begyn not þat jape to kepe gode lawe.
 ʒouthe spekes to his selfe and says:
 With women me lyst both play and rage.
 Angel: To þi saule it is gret dammage.
þe fende: If þou be holy in þi ʒong age
 Þi sorow sal incres and þi myght swage.[45]

 In response to such devilish promptings, orthodox moralists mus-
ter a variety of arguments. Erasmus and William Dunbar observe
that piety is never out of season in any age; Vincent of Beauvais and
Philippe de Novare distinguish between true virtue and youthful
hypocrisy; an English preacher warns young men that they may die
and face judgement any day; and the author of *Dives and Pauper*, cit-
ing Solomon on the need for discipline in youth, invokes examples of
the *puer senex* from Scripture: 'in holy wryʒt Seynt Ion Baptist,
Tobye, Ieremie, Sampson, Samuel and manye othere been preysid
for here holynesse in here ʒougthe'.[46] The battery of counter-argu-
ments testifies to the power of the sinful proverb's appeal—not only
to fun-loving young people and superstitious old wives, but also to
anyone who believed that in human life, as in the natural world, 'all
things have their season'.
 In the case of old age, doctrines of naturalness presented no such
challenge to orthodox opinion; for the very natural processes from
which youth derived its dangerously attractive wildness were held to
foster in old age precisely the qualities of virtue and wisdom which
moralists most esteemed. As the fires of life burned low, a few rather

[45] British Library MS Additional 37049, fol. 28ᵛ (see Plate 8). Further examples,
from Lindsay's *Satyre of the Thrie Estaitis* and a sermon by Hugh Latimer, are cited
in my essay (pp. 182–3).
[46] *Dives and Pauper*, ed. Barnum, i, Pt. 1, 128. All the Biblical figures mentioned,
except Samson, are discussed by Gnilka as types of *puer senex*. For the other argu-
ments referred to, see Erasmus, *Colloquia*, ed. L. E. Halkin, F. Bierlaire, R. Hoven,
Opera Omnia i. 3 (Amsterdam and Oxford, 1972), 172; Dunbar, 'The Merle and the
Nychtingall', ll. 41–5; Vincent, loc. cit.; Philippe, loc. cit.; *Middle English Sermons*, ed.
W. O. Ross, EETS, os 209 (1940), 159–60.

unattractive vices might be left glowing among the embers, as Chaucer's old Reeve confesses:

> Foure gleedes han we, which I shal devyse,—
> Avauntyng, liyng, anger, coveitise.[47]

Yet pagan and Christian moralists agreed in stressing rather the spiritual benefits which should follow from the progressive cooling of the body. As the passions lose strength, it becomes easier to resist their destructive influence on behaviour and on thinking. Although wisdom and virtue may never be out of season, it is only in old age that they can be deemed positively natural. It follows that, from this point of view, the persistence of youthful characteristics into old age must be deplored as at best ridiculous and at worst vicious. Thus, according to Varro, 'tam ridenda in sene puerilitas, quam obstupescenda in puero optimorum morum constantia': 'boyishness is just as much to be laughed at in the old as perseverance in virtue is to be wondered at in a boy.'[48] The Stoic moralist Seneca treats 'puerilitas' as a threat to the ideal *apatheia* or passionlessness of old age:

Adhuc enim non pueritia sed, quod est gravius, puerilitas remanet. Et hoc quidem peior est, quod auctoritatem habemus senum, vitia puerorum, nec puerorum tantum, sed infantum. Illi levia, hi falsa formidant, nos utraque.

[For it is not boyhood that still stays with us, but something worse—boyishness. And this condition is all the more serious because we possess the authority of old age, together with the follies of boyhood, yes, even the follies of infancy. Boys fear trifles, children fear shadows, we fear both.][49]

In another of his letters, Seneca speaks of the folly of the 'elementarius senex' or aged beginner: 'Turpis et ridicula res est elementarius senex; iuveni parandum, seni utendum est' ['An old man learning his A B C is a disgraceful and absurd object; the young man must store up, the old man must use'].[50] Montaigne recalls this saying of Seneca in his essay on the theme 'toutes choses ont leur saison':

[47] *Canterbury Tales*, I. 3883–4.

[48] Cited by J.-P. Neraudau, *La Jeunesse dans la littérature et les institutions de la Rome républicaine* (Paris, 1979), 143.

[49] Seneca, *Ad Lucilium Epistulae Morales*, ed. and trans. R. M. Gummere (London and New York, 1917–25), IV. 2.

[50] XXXVI. 4.

On peut continuer à tout temps l'estude, non pas l'escholage: la sotte chose
qu'un vieillard abecedaire!
> Diversos diversa juvant, non omnibus annis
> Omnia conveniunt.

[A man may alwaies continue his studie, but not schooling. O fond-foolish
for an old man to be ever an *Abcedarian*.
> Diverse delights to diverse, nor to all
> Do all things at all yeares convenient fall.][51]

In the Middle Ages Seneca was a recognized authority on the subject
of old age. The twelfth-century writer Peter of Blois borrows from
him the phrase 'elementarius senex' in one of his letters. He is trying
to persuade Raoul of Beauvais that he ought not to spend his old age
in teaching grammar to the young:

Vos circa litteram et syllabam, et circa hujusmodi elementares doctrinae pri-
mitias, vestrum adhuc ingenium exercetis; et, dicere fas est, vos, puer centum
annorum, et elementarius senex, docetis sapientiam.

[You continue to exercise your mind on letters and syllables and suchlike
rudimentary learning; and one may say that you give instruction being your-
self no better than a hundred-year-old child and an aged beginner.][52]

Peter of Blois here couples Seneca's phrase with another, 'puer
centum annorum', which derives from a Biblical text very commonly
cited in the same connection, Isaiah 65:20: 'Non erit ibi amplius
infans dierum et senex qui non impleat dies suos, quoniam puer cen-
tum annorum morietur, et peccator centum annorum maledictus
erit' ['There shall no more be an infant of days there, nor an old man
that shall not fill up his days: for the child shall die a hundred years
old, and the sinner being a hundred years old shall be accursed'].
This text enjoyed a remarkable career in the Middle Ages. Accord-
ing to modern scholars, the Trito-Isaiah is in fact prophesying long
life for all the faithful in the era of salvation: 'No more is there there
an infant that lives but a few days or an old man who does not fill
out his days, but the youngest shall die a hundred years old, and he
who does not attain to this is held accursed.'[53] As mistranslated in
the Vulgate, however, the latter part of the verse was held to threa-

[51] Montaigne, *Essais*, Bk. II, Chap. 28, in *Œuvres complètes*, ed. A. Thibaudet and
M. Rat (Paris, 1962), 682. Translation by Florio.
[52] *PL* 207. 18.
[53] Translated from the Hebrew by Claus Westermann, *Isaiah 40–66: A Commen-
tary* (London, 1969), 407. See Westermann's comments (p. 409), and Gnilka, 41–2.

ten death and damnation to the old man who persists in childish sin-
fulness. St Gregory is among the authorities cited in support of this
interpretation, according to which the *puer centum annorum* (identi-
fied with the *peccator* of the same age) becomes a kind of anti-type of
the *puer senex*. The one virtuously anticipates the wisdom of old age
in childhood, while the other viciously persists in the follies of child-
hood into extreme old age.[54] Isaiah's words are quoted in this sense
both by Bede and by Ælfric. In his Commentary on Tobias, Bede
speaks of impious old people who are bent double under a load of
vice:

De qualibus dicit Isaias: *Centum annorum morietur puer, et peccator centum
annorum maledictus erit*. Merito pro peccatis suis maledictioni subjacebit,
qui cum multis annis vixerit, puerilis tamen animi levitatem nunquam deser-
ere curavit.

[Of whom Isaiah says, 'The child shall die a hundred years old, and the sin-
ner being a hundred years old shall be accursed.' Justly on account of his
sins will this curse fall upon the man who takes no care, though he has lived
many years, to cast aside the shallowness of a childish soul.][55]

One of Ælfric's homilies follows a citation of St Paul on the need to
put away childish things with a telescoped version of Isaiah's words:

Eft cwæð sum witega, *Puer centum annorum maledictus erit*: Hundteontig-
wintre cild byð awyrged. Ðæt is on andgite, Se mann ðe hæfð ylde on
gearum, and hæfð cildes þeawas on dysige, þæt se byð awyrged. Ælc treow
blewð ær þan þe hit wæstmas bere, and ælc corn bið ærest gærs. Swa eac ælc
godes cinnes mann sceal hine sylfne to godnysse awendan, and wisdom
lufian, and forlætan idelnysse.

[Again, a certain prophet said, 'the child of a hundred years shall be
accursed', which is as much as to say that the man who is old in years and
like a child in foolishness shall be accursed. Every tree flowers before it bears
fruit, and every grain is first grass. So too every man of good disposition
must turn to virtue, and love wisdom, and leave vanities.][56]

[54] Gregory on Job 24:23, *Moralia*, Bk. XVII, Chap. 6 (*PL* 76. 14). However,
Gregory takes 'puer centum annorum' to refer to a merciful lengthening of life, which
the 'peccator' is too foolish to take advantage of.

[55] *In Librum Tobiae Allegorica Interpretatio, PL* 91. 936. Compare Haymo's Com-
mentary on Isaiah, *PL* 116. 1072. Haymo also provides another interpretation of the
verse, according to which it refers to man's perfect age at the resurrection: so Jerome,
PL 24. 670–2. See above, p. 103–4.

[56] *Homilies of Ælfric*, ed. Pope, No. XIX, ll. 19–25. The antithesis 'ylde on gearum
. . . cildes þeawas on dysige' may be contrasted with antithetical transcendence formu-
lae cited from Ælfric in the last chapter (p. 102).

This vision, very congenial to the Anglo-Saxon mind, of man growing naturally like a tree or plant towards piety and wisdom in old age leaves the *puer centum annorum* exposed as an offence against order and decency.

The theme of childishness persisting into old age (to be distinguished both from the second childhood of decrepitude and from the childlike innocence preached by Christ) continued to attract the attention of moralists throughout the Middle Ages. The *Glossa Ordinaria*, citing Gregory, made the traditional interpretation of Isaiah's words widely available: '*Puer centum annorum* etc. Ille scilicet, qui etsi diu, tamen pueriliter vivit, serviens vitiis' ['He, that is, who lives long but childishly, a slave to vices'].[57] A century later, in the course of his discussion of the six ages of man in his *Communiloquium*, John of Wales cites Seneca on the need to live virtuously in order to die well in old age, and continues:

Qui enim talis non fuerit erit puer centum annorum maledictus, sicut exponit illud Ysaie penultimo Gregorius Moralia xvii. Unde ait Seneca, Epistula xiiii: Nihil est turpius quam senex incipiens bene vivere.

[But whoever is not such will be accursed as a child of a hundred years, according as Gregory in *Moralia* XVII expounds that phrase from the penultimate chapter of Isaiah. Therefore Seneca says in his fourteenth letter: Nothing is baser than an old man just beginning to live virtuously.][58]

Another century later, Francis Petrarch couples Isaiah with the very phrase quoted from Seneca by Peter of Blois, 'elementarius senex'. Petrarch is attacking those philistine anti-humanists who, according to him, occupy themselves in old age with wire-drawn syllogisms instead of attending to matters of serious human consequence proper to grown men: 'Tu autem, puer centum annorum maledictus a Deo, et elementarius senex irrisus a Seneca, ibi senectutem agis, ubi pueri-

[57] *PL* 113. 1311. In another twelfth-century work, *De Bestiis et Aliis Rebus*, the author gives as one reason for calling a person 'puer', 'pro ruditate et ignorantia. Unde: *Puer centum annorum morietur*', *PL* 177. 132. In the Latin dialogue between wise Solomon and the rude churl Marcolf, Solomon cites Isaiah's words in their telescoped version, 'Puer centum annorum maledictus erit', to which the churl cynically replies 'It is too late to put a dog on a leash when he is old': *Salomon et Marcolfus*, ed. W. Benary (Heidelberg, 1914), 110[a-b].

[58] *Communiloquium sive Summa Collationum* (Strasburg, 1489), Pars III, Distinctio ii, Cap. vi. The reference to Seneca is to *Epistulae* XIII. 17.

tiam exegisti' ['But you, like that "child of a hundred years" accursed by God and that "aged beginner" mocked by Seneca, occupy your old age in just the same way as you occupied your boyhood'].[59] English writers also cite Isaiah's verse. The fourteenth-century treatise *Vices and Virtues*, an English version of the *Somme le Roi*, advises men of consequence to act with circumspection lest they be taken for children or fools:

For as seiþ a gret philosophre: 'A child of age and a child of witt and of maneres is al on.' And holi writ seiþ bi þe prophete þat a child þat is an hunder wynter old schal dye and þe synful of an hundred wynter is cursed.[60]

Other English writers quote from Isaiah in their discussions of the fourth commandment. A preacher laments that it is difficult nowadays to honour old people because they are so full of vices: 'and so þei be but children. And þerfor cursed is þe child of an hundreþ ȝere old—maledictus puer centum annorum".'[61] In *Dives and Pauper*, Dives protests that such old devils deserve to be publicly rebuked:

Oftyn tyme eld folc ben mor schrewys þan oþre and ben wol hard to amendyn þei arn so rotyd in synne; and þerfor, as me þynkyth, hem nedith to ben hard undirnomyn and scharplyche, for God seith þat þe child of an hondryd ȝer schal deyyn, and þe synner of an hondrid ȝer schal ben cursyd, Ysa.[62]

The phrase 'puer centum annorum' was evidently so familiar by this time, and its supposed significance so well understood, that authors could ring the changes on it. In William Dunbar's 'Tretis of the Tua Mariit Wemen and the Wedo', the cynical widow, speaking of the need for mature women to conduct their love-affairs with circumspection, offers a boldly feminized version of Isaiah's words:

> Thoght I want wit in warldlynes I wylis haif in luf
> As ony happy woman has that is of hie blude:
> Hutit be the halok lase a hundir ȝeir of eild![63]

That is, the elderly woman who behaves like a feather-headed girl ('hallock lass') deserves public ridicule. The substitution of 'hooted'

[59] *Invective contra Medicum*, ed. P. G. Ricci (Rome, 1978), Bk. III, ll. 568–70.
[60] *The Book of Vices and Virtues*, ed. W. N. Francis, EETS, os 217 (1942), 287.
[61] *Middle English Sermons*, ed. Ross, 119–20.
[62] *Dives and Pauper*, ed. Barnum, i, Pt. 1, 332.
[63] *The Poems of William Dunbar*, ed. J. Kinsley (Oxford, 1979), ll. 463–5. Kinsley offers an unconvincing translation of l. 465: 'derided may the guileless lass [i.e. one without 'wylis . . . in luf'] be till she is a hundred years old'

for the prophet's 'maledictus' in Dunbar's alliterative line is a fine touch, indicating that there are social as well as spiritual sanctions operating against old people who will not 'be their age'. In the widow's version, indeed, the pious interpretation of the biblical saying is shamelessly outfaced. Her point is not that the older woman should have put the follies of love behind her, but that she should have learned enough 'wiles' in her lifetime to be capable of keeping them secret. If she cannot manage that, she deserves to be laughed at in the street. Petrarch makes an even more deeply buried allusion to Isaiah's words in his *Secretum*, where he brings them to bear on the same question of sexuality in advancing years. In this remarkable work, written in his forties, Petrarch imagines a dialogue between himself (Franciscus) and St Augustine (Augustinus), in the course of which the saint attempts to persuade the poet that the time has come for him to free himself from the shackles of sexual desire, now that his mirror shows him grey hairs gleaming at his temples. He is no longer a boy—unless, indeed, he is to be 'a boy of ninety years':

Nonagenarios pueros videmus passim de rebus vilissimis altercantes, pueriliaque nunc etiam sectantes studia. Dies nempe fugiunt, corpus defluit, animus non mutatur. Putrescant licet omnia, ad maturitatem suam ille non pervenit . . . Pueritia quidem fugit; sed, ut ait Seneca, puerilitas remanet. Et tu, michi crede: non adeo, ut tibi videris forsitan, puer es. Maior pars hominum hanc, quam tu nunc degis, etatem non attingit. Pudeat ergo senem amatorem dici; pudeat esse tam diu vulgi fabula.

[We often see ninety-year-old boys arguing about the most trivial matters and still pursuing puerile interests. The days are flying past, for sure, and the body is declining, yet the soul undergoes no change. It will not achieve its maturity even when everything else is rotting . . . Boyhood indeed passes; but, as Seneca says, boyishness remains. And believe me, you yourself are not as much of a boy as you perhaps think. The majority of men never reach your present age. You should be ashamed, then, to be known as an aged lover, and to be such a longstanding object of common gossip.][64]

'Pudeat ergo senem amatorem dici.' No species of old devil appears more commonly in medieval literature than the *senex amans*— the man (it is usually a man) whose amatory activities are prolonged

[64] *Secretum*, in *Prose*, ed. Martellotti *et al.*, 182. The Senecan passage to which Petrarch refers is cited above, p. 151.

beyond the term set for them by Nature. The right time for love is youth, and most people in all periods have shared the opinion of Montaigne, that 'l'amour ne me semble proprement et naturellement en sa saison qu'en l'aage voisin de l'enfance.'[65] The old physiology gave this opinion scientific support. Sexuality was held to be a function of that same 'calor naturalis' or bodily heat whose gradual cooling, as the fuelling moisture ran out, caused the processes of ageing. Hence it was easy to see why the fires of love should die down in the later ages of life, when colder humours prevail. Those who attempt to 'transcend' these natural processes gain no sympathy from the moralists. Chaucer's Parson compares senile lechers ('olde dotardes holours') to dogs: 'for an hound, whan he comth by the roser or by othere bushes, though he may nat pisse, yet wole he have up his leg and make a contenaunce to pisse.'[66] In the Prologue to Book IV of his translation of the *Aeneid*, Gavin Douglas cries shame upon old men and women who engage in unseasonable amours:

> Thou auld hasard lichour, fy for schame,
> That slotteris furth evermar in sluggardry.
> Out on the, auld trat, agit wyfe, or dame,
> Eschamys na tyme in rouste of syn to ly!
> Thir Venus warkis in ȝouthed ar foly,
> Bot into eild thai turn in fury rage.[67]

Moralists especially deplore marriages between old men and young women. Numerous vices may attend such mismatches: jealousy and anger as well as lechery on the part of the old husband, and on the part of the young wife covetousness, lying, and adultery. It is, as Langland says, an ugly business:

> It is an uncomly couple, by Crist! as me thynketh—
> To yeven a yong wenche to a yolde feble.[68]

[65] *Essais*, Bk. III, Chap. 5 (ed. cit. 874). 'L'aage voisin de l'enfance' is doubtless adolescence.

[66] *Canterbury Tales*, x. 858.

[67] *Virgil's 'Aeneid' Translated into Scottish Verse by Gavin Douglas*, ed. Coldwell, Bk. IV, Prologue, ll. 164–9.

[68] *Piers Plowman* B, IX. 162–3. 'Yolde' (a conjectural emendation by Kane and Donaldson for the manuscript reading 'olde') means 'impotent'. Compare Philippe de Novare: 'Mout est grant honte au viel de contrefaire le jone, et especiaument de fame panre espousée; car s'il la prant jone, toz jors doit cuidier que li jone home l'emportent' ['It is a very shameful thing for an old man to pretend to be young, and especially to take a wife in marriage; for if he takes a young one, he will suspect all the time that young men are carrying her off']: *Les Quatre Âges de l'homme*, ed. de Fréville, 95.

On this matter of unnatural marriages, popular opinion appears to have been for once fully in accord with the moralists. Traditional peasant communities in France used to express their disapproval of such mismatches through the institution of the charivari: 'a serenade of "rough music", with kettles, pans, tea-trays, and the like, used in France, in mockery and derision of incongruous or unpopular marriages.'[69] In a gruesome passage in the *Moriae Encomium* of Erasmus, Folly testifies to the general laugh which greets old men and women who (like Mann's Aschenbach or Proust's Charlus) dye their hair or wear wigs, and smear their faces with make-up, in their effort to prolong an impotent and unnatural love-life.[70] Almost equally grotesque are the three old husbands described by Chaucer's Wife of Bath (herself no longer, at the time of the pilgrimage, a model of seasonable sexuality):

> Unnethe myghte they the statut holde
> In which that they were bounden unto me.
> Ye woot wel what I meene of this, pardee!
> As help me God, I laughe whan I thynke
> How pitiously anyght I made hem swynke![71]

In Dunbar's 'Tretis of the Tua Mariit Wemen and the Wedo', the 'hooting' is more raucous. Both the first married woman and the widow ridicule their impotent and jealous old husbands, with an unsparing catalogue of shameful physical detail.[72] More remarkably, the same rough music attends the figure of Joseph in the mystery cycles—Joseph being portrayed as an old.man and Mary as a very young woman at the time of Christ's birth. Following apocryphal tradition, all four surviving cycles show old Joseph reacting to his discovery of Mary's pregnancy with bitterness and shame: 'It is

[69] The definition is from the *Oxford English Dictionary*. On charivaris in old France, see A. Varagnac, *Civilisation traditionnelle et genres de vie* (Paris, 1948), 197–201. Varagnac stresses the importance of 'age categories' in French peasant communities (p. 110). He also observes: 'Nous en savons assez sur l'assimilation primitive de l'ordre social à l'ordre de la nature pour comprendre que toute infraction à la traversée régulière et unilatérale des âges de la vie devait apparaître comme un attentat mettant en péril non seulement les bonnes mœurs mais la progression heureuse des saisons' (p. 101).

[70] *Moriae Encomium*, ed. Miller, 108, ll. 678 ff.

[71] *Canterbury Tales*, III. 198–202.

[72] ll. 89–145, 275–95. The reference to phlegm in both passages (ll. 91, 272) follows the physiological theory according to which cold and moist humour is dominant in old age.

ill cowpled of youth and elde'. Impotent old men, he reflects, cannot expect young wives to be faithful:

> 3a, 3a, all olde men to me take tent,
> And weddyth no wyff in no kynnys wyse
> Þat is a 3onge wench, be myn asent,
> For doute and drede of swych servyse.
> Alas, alas, my name is shent;
> All men may me now dyspyse,
> And seyn 'Olde cokwold, þi bow is bent
> Newly now after þe Frensche gyse.'[73]

The case is an unusual one, however, in part because Joseph errs in supposing himself a cuckold, but also because his ill-matched marriage, like Elizabeth's conception of John the Baptist in her old age, is a portent marking a time when the order of nature is to be utterly transcended in the Virgin Birth. It is therefore comically inappropriate here for Joseph to invoke popular wisdom based on the ordinary course of events.

Where the *senex amans* has the opportunity to speak for himself, his case can appear more complex than popular ridicule allows. In the *Merchant's Tale*, Chaucer paints a picture of senile sexuality almost as unsparing as Dunbar's. Old January is grotesquely mistaken when he compares his white hair to a blossoming tree and the rest of him to an evergreen laurel. His very name cries out against the projected marriage to May.[74] When 'oold fissh' and 'yong flessh' come together on their wedding night, the conjunction is hideous. Yet at the same time, and conflictingly, Chaucer invites the reader to see January's 'fantasye' as a manifestation, however

[73] *Ludus Coventriae*, ed. Block, Joseph's Return, ll. 49–56. The prime source is the apocryphal *Protevangelium*: see R. Woolf, *The English Mystery Plays* (London, 1972), 169–73.

[74] On the parallels between the ages of man and the months of the year, see above, pp. 76–9. W. Matthews, *MLR* li (1956), 218, compares Ballade No. 880 by Deschamps, which is directed against the folly of old men marrying young women: 'Que diriez vous du froit mois de Janvier | S'il se vouloit marier a Avril?' In a curious derivative of the *Merchant's Tale* formerly ascribed to Lydgate, a philosopher, writing to dissuade an elderly friend from marriage, tells the cautionary tale of an old man called December who marries an unscrupulous young wife called July: *A Selection from the Minor Poems of Lydgate*, ed. J. O. Halliwell, Percy Society ii (London, 1840), pp. 27–46. For discussion of January as *senex amans*, see A. E. Hartung, *Mediaeval Studies* xxix (1967), 1–25, and E. Brown, *Neuphilologische Mitteilungen* lxxiv (1973), 92–106.

degraded, of universal human longings. It is not only old men who seek a delusory 'paradys terrestre' in marriage; and the 'gardyn walled al with ston' in which January attempts to realize that dream derives a tantalizing beauty from its association both with the earthly paradise itself and with the garden of love in the *Roman de la Rose*.[75] According to Guillaume de Lorris, as we shall see, the old have no place in that garden of love; yet Chaucer's January is not the only old man to have gained access to it. *Le Livre du voir-dit* provides a remarkable example. Here the fourteenth-century French poet and musician Guillaume de Machaut represents himself as an elderly gentleman, suffering from infirmities such as gout, who nevertheless carries on a long, flirtatious *affaire* with a young lady. So far from making any concessions to vulgar prejudice (as it must here seem), Guillaume takes a high courtly line. He claims to be capable of performing 'œuvre de jonesce' because he has been rejuvenated by the beauty of his mistress, just as Iolaus was made young again by the goddess of youth, Hebe.[76] What makes *Le Livre du voir-dit* such an audacious work is that this courtly affirmation of 'downward transcendence' nowhere receives its expected check. In the same passage in which he speaks of his rejuvenation, Guillaume does acknowledge that everyone must 'pay Nature her dues' by growing old; but the narrative of his *affaire* ends, not with a renunciation of unseasonable love, but with a rondel in which the young woman simply reaffirms her 'tres-fine amour' for her elderly admirer. In this respect Guillaume's work differs from John Gower's *Confessio Amantis*, another courtly work which treats a *senex amans* with uncommon sympathy; for Gower's poem does end with a renunciation of love. Yet the English poet is so far from ridiculing the unseasonable passion of his Amans that it is only in the eighth and last book that the reader is given to understand that the lover is in fact no longer young. Up to that point (VIII. 2368) Gower allows us to see the love-affair only through the eyes of Amans himself, in his confessions; and what Amans sees is not his own grey hairs but the youthful beauty of the lady whom he faithfully serves. More than any other medieval poem known to me, accordingly, *Confessio*

[75] *Canterbury Tales*, IV. 2031–3

[76] *Le Livre du voir-dit*, ed. P. Paris (Paris, 1875, repr. Geneva, 1969), ll. 4837–77. Machaut alludes to Ovid, *Metamorphoses*, Bk. IX, ll. 394–438.

Amantis conveys what it must feel like to be a *senex amans*—which is much the same as what it feels like to be any other sort of lover.[77]

However, the courtly or polite tradition of vernacular literature to which both Machaut and Gower belong does not by any means always treat a *senex amans* so sympathetically. Courtly writers commonly contribute their own smoother kind of rough music to the general chorus of hostile comment. In his treatise *De Amore*, Andreas Capellanus offers a medical explanation for the fact that men over sixty and women over fifty, though they can engage in sexual intercourse, are incapable of love:

quia calor naturalis ab ea aetate suas incipit amittere vires, et humiditas sua validissime inchoat incrementa fovere atque hominem in varias deducit angustias et aegritudinum diversarum molestat insidiis, nullaque sunt sibi in hoc saeculo praeter cibi et potus solatia.

[because from that age natural heat begins to lose its force, and moisture starts to increase very greatly and causes man various distresses and lies in wait for him with divers diseases, so that he has no pleasures left in the world except food and drink.][78]

According to this doctrine, love is not only unnatural but actually impossible in the elderly. It evidently follows that an old husband can claim no rights at all, so far as love is concerned, over a young wife. Such is the case in the *Lais* of Marie de France. Marie's ruthless treatment of the old husbands in *Guigemar* and *Yonec* contrasts sharply with her customary delicacy of feeling. In *Guigemar* the grotesquely jealous and possessive old husband is treated as fair game for the young hero, who carries off his beautiful wife with no questions asked:

> Gelus esteit a desmesure;
> Kar ceo purportoit sa nature.
> Ke tut li veil seient gelus—
> Mult hiet chascun ke il seit cous—
> Tels est de eage le trespas.

[77] See further my essay 'The Portrayal of Amans in *Confessio Amantis*', in *Gower's 'Confessio Amantis': Responses and Reassessments*, ed. A. J. Minnis (Cambridge, 1983), 5–24, where it is noted that most of the manuscript illustrations which portray Amans in Bk. I confessing to Genius represent him as a young man.

[78] *Andreae Capellani Regii Francorum De Amore Tres*, ed. E. Trojel (Copenhagen, 1892), 11–12.

[He was inordinately jealous, for it was his nature to be so. All old men are jealous and hate to be cuckolded: such is the perversity of age.][79]

In *Yonec*, too, Marie treats the 'viel gelus' as a natural and proper victim of the young wife and the young hero. Another example of the same sort is the tenth story on the second day of Boccaccio's *Decameron*, where the rich old judge Ricciardo di Chinzica learns the hard way, like John the Carpenter in Chaucer's *Miller's Tale*, 'how foolish he had been to take a young wife when he was so impotent.' Stories such as these invoke doctrines of nature against 'old devils', not in the interests of Christian morality or social convention, but in the interests of those young lovers whose point of view they unreservedly adopt.

III

There is no reason in strict principle why either transcendence ideals or nature ideals should display any bias towards particular ages in the sequence of life. In medieval writings, however, downward transcendence is distinctly less common than its opposite. Where characters are praised for transcending their age, it is most often youth whose natural limitations they escape and old age whose virtues they achieve out of season. The high regard for *senectus* which that eulogistic commonplace implies persisted throughout the Middle Ages and beyond. In England, it is especially characteristic of the Anglo-Saxon period, in so far as that is represented by the surviving Latin and vernacular texts. By the twelfth century, however, it becomes possible to speak also of a cult of youth, manifesting itself first in the courtly writings of France and Provence and thence in other European literatures. In such texts, and especially in the romances of the new age, heroes and heroines are conspicuously young. Their stories are stories of love and adventure, considered as the natural preoccupations of warm-blooded youth. In such a world, ideals of transcendence have only a small part to play. It is as natural attributes of old age that wisdom and piety command respect—attributes most commonly displayed at some distance from the main centres of narrative

[79] *Marie de France: Lais*, ed. A. Ewert (Oxford, 1947), *Guigemar*, ll. 213–17.

interest, as by the retired knights who people the hermitages of Arth-
urian romance. The young principals, in the meantime, enjoy their
heyday on the rising quadrant of life's arc.

Anglo-Saxon writers rarely deal in such youthful heroes. The
young protagonist of the first part of *Beowulf* exhibits few of the
characteristics of his age. The only writings surviving from this
period which anticipate the positive, youthful world of medieval ro-
mance are *Alexander's Letter to Aristotle* and *Apollonius of Tyre*.
Alexander's account of his exploits, addressed to his old tutor Aris-
totle, breathes the true spirit of adventure. He even glories in a
boyish prank, reporting how he visited his adversary, Porrus of
Inde, in disguise and delighted him by describing himself, Alex-
ander, as so old and feeble that he can get warm only by a fire. The
exploit has no practical purpose—it is more like an undergraduate
hoax than an act of policy—and Alexander laughs about it when he
gets back to camp.[80] Equally unusual in its period is the *Apollonius*, a
late Anglo-Saxon version of a story from Greek love-romance. It
displays, as one scholar has remarked, 'a tone of courtesy and sym-
pathy with romantic love which cannot be paralleled till the days of
the Middle English romances'.[81] By contrast, the three short poems
in the Exeter Book which treat of love between men and women
create no such impression of blushing youthfulness. The love re-
lationship in each case is mature and established, though also
passionate (especially in 'Wulf and Eadwacer'); and the modern
titles '*Wife*'s Lament' and '*Husband*'s Message' seem entirely appro-
priate, even if not strictly justified by the text. There survives in the
whole corpus of Anglo-Saxon verse only one passage which speaks
in praise of youth; and even that, after a full-throated opening, ends
in yet another affirmation of the wisdom of experience. In *Guthlac A*,
the hermit Guthlac is tempted to despair by a diabolical vision of
young monks living in worldly pleasure and pride 'as is the custom
of youth'. To this he replies:

> God scop geoguðe ond gumena dream;
> Ne magun þa æfteryld in þam ærestan
> Blæde geberan ac hy blissiað

[80] *Letter of Alexander the Great to Aristotle*, in *Three Old English Prose Texts*, ed.
S. Rypins, EETS, os 161 (1924), 26–8.
[81] C. L. Wrenn, *A Study of Old English Literature* (London, 1967), 256.

Worulde wynnum oððæt wintra rim
Gegæð in þa geoguðe þæt se gæst lufað
Onsyn ond ætwist yldran hades
De gemete monige geond middangeard
Þeowiað in þeawum; þeodum ywaþ
Wisdom weras, wlencu forleosað,
Siððan geoguðe gæst aflihð.

[God created young people and human happiness. They cannot in their first blossoming bear the fruits of a later age; but they take pleasure in the joys of the world until their youth is overtaken by the passage of time and their spirit comes to love the appearance and the substance of an older state, such as many men throughout the world duly observe in their conduct. These men manifest their wisdom to the nations and forsake pride, once their spirit has escaped from the folly of youth.][82]

The opening lines of this passage represent the joys of youth as a natural and proper phase in a God-created order governing the life of men—even, apparently, monks. Youth is like the blossoming time of a fruit tree ('blæde geberan'). Yet it is also a phase whose passing the poet goes on to celebrate as a transit from folly to wisdom. The 'yldra had' or older state holds pride of place even here.

In the more complex and prosperous societies represented in vernacular literatures of the twelfth century and after, the wisdom of the old no longer went unchallenged. Certain circles in lay society now begin to express, in consciously up-to-date courtly and learned writings, an aggressive preference for new things and young people. The French scholar Matthew of Vendôme seems simply to take such a preference for granted when, in his *Ars Versificatoria* (before 1175), he picks on *senex* and *puer* as his examples of 'bad' and 'good' epithets respectively:

Est autem epithetum accidens alicui sustantivo attributum, pertinens ad bonum vel ad malum vel ad indifferens: ad malum ut 'Laertesque senex', quia, teste Oratio, 'Multa senem circumveniunt incommoda'; ad bonum ut 'Telemacusque puer', quia exultat levitate puer.

[An epithet is a quality attributed to some substantive, whether good, bad, or indifferent: bad as in 'old man Laertes', for, as Horace says, 'many miser-

[82] *Guthlac A*, ll. 495–504, cited from *The Guthlac Poems of the Exeter Book*, ed. J. Roberts (Oxford, 1979). See T. D. Hill, 'The Age of Man and the World in the Old English *Guthlac A*', *JEGP* lxxx (1981), 13–21.

ies beset the old man'; good as in 'the boy Telemachus', for boys walk on air.][83]

The Horatian theme of the *incommoda senectutis* is a perennial one, strongly represented already in pre-Conquest writings; yet it is hard to imagine any Anglo-Saxon grammar master making Matthew's bald assumption: *senex* bad, *puer* good. But twelfth-century France, along with Provence, was the home of a new courtly literature in which the loves and adventures of young people play an over-whelmingly preponderant part. In a seminal essay, the historian Georges Duby has stressed the importance in northern France at this time of the 'juvenes' or 'bacheliers'. These are the young knights, not yet married and settled down, who lived an errant life in search of adventure and a bride. The French romances of chivalry reflect the tastes and daily experience of these young men, who constituted, or so Duby suggests, 'le public par excellence de toute la littérature que l'on appelle chevaleresque'.[84] Corresponding groups in the south of France, according to Erich Köhler, played a similar part in the de-velopment of troubadour poetry. Indeed, some troubadour lyrics exhibit the 'cult of youth' in a quite extreme form, as Köhler shows in his analysis of the Provençal term *joven*. This derivative of the Latin *juventus*, often coupled with words for love and joy, comes to denote a moral and spiritual condition of the highest value: 'la somme des vertus qui définissent la *cortesia* dans toute son ampleur'. To be courtly is to be young, 'jove', at least in spirit; and to be old, 'vielh', is to be the enemy of *cortesia*.[85]

Readers of medieval French literature will need no demonstration of the fact that, from the twelfth century onwards, both the ro-mances of chivalry and the lyrics and allegories of courtly love con-sistently give pride of place to the amours and adventures of the

[83] Faral (ed.), *Les Arts poétiques*, i, para. 2. The Horace passage to which Matthew alludes may be found in the Appendix here.

[84] Georges Duby, 'Les "jeunes" dans la société aristocratique dans la France du Nord-Ouest au XIIe siècle', in his *Hommes et structures du moyen âge* (Paris, 1973), 213–25.

[85] Erich Köhler, 'Sens et fonction du terme "jeunesse" dans la poésie des trouba-dours', in P. Gallais and Y.-J. Riou (edd.), *Mélanges offerts à René Crozet* (Poitiers, 1966), i. 569–83. Köhler cites from Rigaut de Berbezilh a remarkable variant of the *puer senex* topos. The poet praises his mistress for being transcendently 'old' in a most peculiar sense: 'Sa "vieillesse" consiste en la perfection avec laquelle elle réalise ce qui fait le contenu de *joven—vieill'en tot ben ioven*.'

young—often, the very young. Two examples will suffice. In one of the most widely read of all Arthurian romances, the thirteenth-century Prose *Lancelot*, the hero Lancelot is still described as 'juesnes anfes sanz barbe', a beardless youth, after he has been knighted at Arthur's court; and it is as a 'bacheler' that he performs the feats in love and war with which the rest of the story is largely concerned.[86] The exclusion of the old from the love-experience of which Lancelot is a supreme representative is most forcefully represented in the *Roman de la Rose* of Guillaume de Lorris. Among the enemies of courteous love whose images are portrayed on the outer face of the wall enclosing Deduit's garden, Guillaume includes Vielleice. As described here, she is no unworthy companion to Avarice, Hatred, Envy, Sorrow, and the rest.[87] She is shrunken, ugly, white-haired, dried-up, wrinkled, hairy-eared, and toothless; she cannot move without a stick and has to wear furs to keep warm; and she has no more strength or mental capacity than a one-year-old child. All in all, as the Middle English translation puts it:

> Iwys, great qualm ne were it non
> Ne synne, although her lyf were gon.[88]

The narrator of the *Roman*, by contrast, is in his twentieth year at the time when he dreams:

> El vintieme an de mon aage
> El point qu'Amors prent le paage
> Des jones genz.[89]

He dreams of a time some five years earlier when, as an 'enfes' (l. 3436), he entered the garden of love. Deduit, the owner of the garden, is a 'joines demoisiaus' (l. 817); his mistress, Leesce, has granted him her love at the age of only seven (l. 832); Biautez is 'jonete et

[86] *Lancelot do Lac*, ed. Kennedy, 199. See also Kennedy's glossary, under *bacheler*.

[87] *Le Roman de la Rose*, ed. F. Lecoy (Paris, 1965–70), ll. 339–404. In the *Anticlaudianus* of Alain de Lille, Senectus is numbered among the adversaries of Nature's perfect man (Bk. IX, Chap. 4), just as Juventus is among the virtues present at his creation (Bk. I, Chap. 2).

[88] *The Romaunt of the Rose*, ed. Robinson, ll. 357–8.

[89] 'In the twentieth year of my age, when Love takes his toll of young people', *Roman*, ll. 21–3.

blonde' (l. 1014); and Joinece herself is present, no more than twelve years old, kissing a boy of the same age (ll. 1257–76). For Guillaume de Lorris, youth was evidently the inseparable companion of love and courtesy. Yet the supreme value of youth does not go unchallenged in the poem. Already in Guillaume's part, Reson (herself neither young nor old, l. 2962) blames the dreamer for his 'folie et enfance' (l. 2982); and very early in Jean de Meun's continuation the same character delivers herself of a long tirade, citing Cicero's *De Senectute* as her authority for the praise of old age and the condemnation of youth. Thus, in the Middle English version:

> For Youthe sett man in all folye,
> In unthrift and ribaudie,
> In leccherie and in outrage,
> So ofte it chaungith of corage.[90]

It is clear that the new valuation of youth in twelfth-century French courtly culture, like many other developments in France at that time, exerted its influence upon the course of literature in England. We may take it as a straw in the wind that a twelfth-century English scribe, copying the pre-Conquest *Dicts of Cato*, omitted youth from among the list of handicaps under which a man might labour.[91] It is hard to find any parallel in England for the extreme and uncompromising high-courtly cult of *jovens* to be found in some Continental authors; but the voice of youth makes itself very clearly heard in post-Conquest writings—much more so, certainly, than in the literature of the Anglo-Saxons. One quite early example is *Le Petit Plet*, an Anglo-Norman poem composed about the year 1200, perhaps in the West of England. An English reader of old-fashioned tastes might well have been perplexed by this curious dialogue poem,

[90] *Romaunt*, ll. 4925–8. In the French, Reson's description of youth and age occupies ll. 4400–514. The author of *Les Echecs amoureux*, an early commentary on the fourteenth-century poem *Les Echecs d'amour*, counters the praise of youth in his text, first with praises of middle age taken from Giles of Rome (see above, pp. 9–10), then with praises of old age taken from Cicero's *De Senectute*. He justifies the hostile portrait of old age which his author derived from Guillaume de Lorris by explaining that it referred to decrepitude, the second part of that age, not to the good first part: *The Chess of Love*, trans. J. M. Jones, Univ. of Nebraska, Ph.D. diss. (1968), 753–84. See P.-Y. Badel, *La Roman de la Rose au XIVᵉ siècle* (Geneva, 1980), 299. Badel observes that the author of *Les Echecs amoureux* read the *Roman de la Rose* itself as 'un tableau des âges de la vie menant l'homme de la jeunesse, où une certaine folie est naturelle, à la maturité, où sa persistance serait condamnable' (p. 288).

[91] See above, p. 108.

for in it, as its most recent editor remarks, the author appears to be 'reversing the usual debating roles of the old man and the youth'.[92] Instead of the old man instructing the youth, as in such Anglo-Saxon works as *Precepts* or *Dicts of Cato*, it is the youth (l'Enfant) who instructs the old man (le Veillard), arguing him out of his gloom and anxiety. Furthermore, the arguments used by l'Enfant are, to begin with, distinctively youthful in character. He speaks against 'tristur' and 'dolur' in the name of 'jolifté' and 'enveisure'—gaiety and pleasure. It is wrong, he says, to neglect the joys which God grants, and especially so if one is young:

> Si jeo preisse le secle trop a fes,
> Ke tant sui jofnes e leger,
> Jo me porreie tant charger
> De tant penser e tant duleir
> Ke jo cherreie en nunpoier.
> Mult tost chanu en devendreie,
> E pus aprés mult tost porreie
> Par teu dolur haster ma fin. (ll. 142–9)

[If I, being so young and lightsome, took life too seriously, I could so overload myself with worry and grief that I would be good for nothing. I would very soon go grey and could easily hasten my end by such grief.]

Such advocacy of youth and joy seems to mark l'Enfant as a spokesman of courtly fashion, and it is indeed he who later speaks in praise of the cultured ladies of England and their chivalrous admirers (ll. 1261–70). Yet as the discussion proceeds, the youth speaks more and more in the voice of reason and experience, offering his elder the conventional consolations of *contemptus mundi*.[93] By the end, indeed, he is barely distinguishable from such a *puer senex* as Josaphat in *Barlaam and Josaphat*—a version of which accompanies *Le Petit Plet* in two of its three manuscripts.[94] He appears to transcend the

[92] *Le Petit Plet*, ed. B. S. Merrilees, ANTS 20 (Oxford, 1970), xxxiii. See the comments by M. D. Legge, *Anglo-Norman Literature and its Background* (Oxford, 1963), 200.

[93] Merrilees, xxxiv, observes that many of the arguments used by l'Enfant are borrowed from those used by Ratio to instruct Sensus in the *De Remediis Fortuitorum* sometimes ascribed to Seneca.

[94] British Library MS Cotton Caligula A. ix, and Jesus College, Oxford, MS 29. *La Vie de Seint Josaphaz* is edited by J. Koch, *Chardry's Josaphaz, Set Dormanz und Petit Plet* (Heilbronn, 1879).

limitations of that age for whose natural claims he at first seemed to speak; and the poem consequently leaves a confused impression, as if uneasily balanced between the new cult of youth and an older morality.

The same two manuscripts which couple the *Petit Plet* with the *Josaphaz* also contain the only two surviving copies of *The Owl and the Nightingale*. As the editor of the Middle English poem remarks, the attitudes to life represented by its two disputing birds correspond roughly to those expressed by le Veillard and l'Enfant in its Anglo-Norman companion piece.[95] We may here notice particularly the Nightingale's sympathetic defence of young girls who have love-affairs:

> 3ef maide luveþ dernliche
> Heo stumpeþ and falþ icundeliche . . .
> An 3unling not hwat swuch þing is,
> His 3unge blod hit dra3eþ amis. (ll. 1423–4, 1433–4)

[If a girl has a secret love-affair, she trips and falls in a natural way . . . A young thing does not understand such matters, its young blood leads it astray.]

However, it is only in the passage about Nicholas of Guildford that the author (most likely Nicholas himself) makes a specific application to the ages of man. When the Nightingale proposes Nicholas as the judge to decide between them, the Owl readily agrees:

> Ich granti wel þat he us deme,
> Vor þe3 he were wile breme,
> And lof him were ni3tingale
> And oþer wi3te gente and smale,
> Ich wot he is nu suþe acoled;
> Nis he vor þe no3t afoled,
> Þat he for þine olde luve
> Me adun legge, and þe buve.
> Ne schaltu nevre so him queme
> Þat he for þe fals dom deme.
> He is him ripe and fastrede,
> Ne lust him nu to none unrede:

[95] *The Owl and the Nightingale*, ed. E. G. Stanley (London and Edinburgh, 1960), 34.

Nu him ne lust na more pleie,
He wile gon a riȝte weie. (ll. 201–14)

[I am very happy that he should judge us, for though he was formerly wild and took pleasure in nightingales and other such gracious, slender creatures, he is now, I know, very much cooled off. He will not be so taken in by you as to prefer you to me on account of his former affection for you. You will never entice him into passing a false judgement in your favour. He is mature and reliable, and takes no pleasure now in folly. He has no further desire for trifling now: he will follow the right path.]

The Owl's description of Nicholas as 'nu suþe acoled' implies that version of the natural *cursus aetatis* which was propagated throughout the Middle Ages by physiologists and moralists alike. Young blood, the moist and hot humour that prevails in early life, fosters amorousness (implied here by the epithets 'gente and smale'), wildness, and folly. Maturity and good judgement come only later, when the fires of life are beginning to burn lower and cooler humours prevail. Like conventional moralists before and since, of course, the Owl thoroughly approves of the resulting 'ripeness'; but no reader of the whole poem, in which the opinions of the two birds are so consistently played off against each other, will take the Owl's version of Nicholas as the last word. It was, after all, the Nightingale and not the Owl who proposed Nicholas as judge in the first place—and that must imply that she at least does not regard him as an enemy to young blood. The fact that the two birds, who agree on little else, agree so readily in their choice of judge suggests a strong and subtle compliment to their chosen arbiter.[96] His judgement is not reported, but the reader is invited to suppose that it would have manifested a wisdom partial to neither young nor old—not the 'ripeness' of which the Owl speaks, but a mature and balanced recognition of life in *all* its natural phases, such as one finds in the essays of Montaigne.

In later Middle English literature the courtly ideal of youth is best represented by Chaucer's Squire—the only one of the Canterbury pilgrims to be described as 'young'. The Squire's life, like that of

[96] Parallels may be drawn from pastoral poetry. In the *Conflictus Veris et Hiemis*, ascribed to Alcuin, young Dafnis and old Palemon unite in praise of the cuckoo: P. Godman (ed.), *Poetry of the Carolingian Renaissance* (London, 1985), ll. 43–4. In the February Eclogue of Spenser's *Shepheardes Calender*, young Cuddie and old Thenot unite in praise of Chaucer. The common model is perhaps Virgil's Ninth Eclogue, where young Lycidas and Moeris who is no longer young unite in their admiration for the poet Menalcas (Virgil himself).

Palamon and Arcite in his father's tale, is governed by Venus and Mars. He is 'a lovyere and a lusty bacheler', twenty years of age, who travels abroad and fights 'in hope to stonden in his lady grace'. His unfinished tale was evidently to be influenced by the same conjunction of Venus and Mars, in so far as it concerned the three young Tartars, Algarsyf, Cambalo, and Canacee.[97] Even their father, King Cambyuskan, is assimilated to the prevailing youthfulness, being described as 'yong, fressh, and strong, in armes desirous | As any bacheler of al his hous' (v. 23–4). The Squire's type was entirely familiar to later medieval readers: the 'lusty bacheler', adventurous and amorous by turns. The allegorical figure of Youth itself, in *The Parlement of the Thre Ages*, conforms to this type:

> He was ȝonge and ȝape and ȝernynge to armes,
> And pleynede hym one paramours and petevosely syghede.[98]

Such are the heroes of many Middle English romances. In *King Horn*, for instance, the young hero follows just the course described by Duby in his account of French 'juvenes'. At the age of fifteen, Horn sets off for a life of errancy as leader of a band of twelve coevals dedicated for the time being to a life of 'armes' and 'paramours'. He explains this to Rymenhild:

> We beþ kniȝtes ȝonge,
> Of o dai al isprunge,
> And of ure mestere
> So is þe manere:
> Wiþ sume oþere kniȝte
> Wel for his lemman fiȝte,
> Or he eni wif take.[99]

I know of no better description of this phase in the life of a young gentleman than that given by Sir David Lindsay in his *Squire Meldrum*. The subject of this poem was a Fifeshire acquaintance of Lindsay. The poet declares his intention to

[97] The course of the unfinished story is projected in v. 651–9.

[98] Offord, ll. 171–2.

[99] *King Horn*, ed. J. Hall (Oxford, 1901), MS C, ll. 547–53. See Hall's notes on ll. 17–18 and 19–20, and compare Duby, *Hommes et structures*, 219: 'Pendant toute son errance, la bande des jeunes se trouvait animée par l'espoir du mariage'. Such peer-groups of *juvenes* are discussed in U. Helfenstein, *Beiträge zur Problematik der Lebensalter in der mittleren Geschichte* (Zurich, 1952), Chap. III. See also *Guy of Warwick*, ed. J. Zupitza, EETS, ES 42, 49, 59 (1883–91), Auchinleck MS, ll. 1219–32.

> Descryve the deidis and the man;
> Quhais 3outh did occupie in lufe,
> Full plesantlie, without reprufe;
> Quhilk did as monie douchtie deidis
> As monie ane that men of reidis.[100]

At the age of twenty, Squire Meldrum sets out to 'begin his vassa-
lage'. Lindsay describes his adventures in Ireland, France, and Scot-
land, comparing him with the greatest of all 'lusty bachelers', Sir
Lancelot du Lac:

> his hie honour suld not smure,
> Considering quhat he did indure,
> Oft times for his ladeis sake.
> I wait Sir Lancelote du lake,
> Quhen he did lufe King Arthuris wyfe,
> Faucht never better with sword nor knyfe,
> For his ladie in no battell,
> Nor had not half so just querrell.[101]

Such youthful deeds are the stuff of romance, in England as in
France and elsewhere; but they are not the whole business of life
even in romance. Chaucer's young Squire rides at the side of his
father, the Knight, whose fustian tunic contrasts with the flowery
embroidery and long-sleeved gown of his fashionable son. Where
the Squire fights for his lady, the Knight fights for earthly and
heavenly lords. This contrast between youth and maturity is
mirrored in the Knight's own romance tale. Here the personal pre-
occupations of Palamon and Arcite are distinguished from the pub-
lic concerns which motivate Duke Theseus. It does not seem,
however, that Chaucer thereby intends to show the young people in
a bad light. In the very act of joking about the follies of Palamon and
Arcite, who are risking their lives for love, Theseus confesses that he
himself has been a 'servant' or lover in his time:

> But all moot ben assayed, hoot and coold;
> A man moot ben a fool, or yong or oold,—

[100] *The Historie of Squyer Meldrum*, ed. D. Hamer, *Works*, vol. i, STS 3rd ser. i
(1931), ll. 36–40.
[101] ll. 45–52. Meldrum compares himself to Lancelot at l. 1079.

I woot it by myself ful yore agon,
For in my tyme a servant was I oon.[102]

The second of these lines implies a pressing awareness of the natural
course of things, similar to that implicit in the proverb 'Young saint,
old devil'. It is clearly better, if no one can escape experience of love,
to be a young fool than an old one. Perhaps, indeed, love in its
season is a folly at all only in the eyes of those who have outgrown it
without achieving that more comprehensive maturity represented in
The Owl and the Nightingale.

Contrasts between youth and maturity, considered as successive
seasons in the life-cycle portrayed in romance, do not always turn on
the question of love. 'Dans le monde chevaleresque,' writes Duby,
'l'homme de guerre cesse donc d'être tenu pour "jeune" lorsqu'il est
établi, enraciné, lorsqu'il est devenu chef de maison et souche d'une
lignée.'[103] The distinction in twelfth-century French society between
the footloose young knight and the established 'chef de maison' cor-
responds roughly to the distinction between 'geogoð' and 'duguð' in
Anglo-Saxon society. In romances of chivalry, it commonly takes
the form of a contrast between the knight-errant and the knight-
householder. This can be observed in the Middle English *Sir Gawain
and the Green Knight*. That poem can be seen to conform to the tra-
ditions of its genre in favouring the young and the new, most
obviously in its sharply contrasted portraits of the old woman and
her young companion at Hautdesert, where the former is described
quite as unsparingly as Vielleice in the *Roman de la Rose*. Whereas
the young woman impresses the hero as even more beautiful than
Guinevere, the 'olde auncian wyf' repels him by her withered, dis-
coloured skin and unshapely body.[104] Elsewhere in the poem, too,
'old' functions as an *epithetum ad malum*. When Gawain finally
comes upon the Green Chapel, he finds it 'nobot an olde cave, | Or a
crevisse of an olde cragge' (ll. 2182–3). One might contrast such dis-
missively contemptuous usages with the *Beowulf*-poet's description

[102] *Canterbury Tales*, I. 1811–14. See further my *Essays on Medieval Literature*,
27–48.

[103] *Hommes et structures*, 214.

[104] J. R. R. Tolkien and E. V. Gordon (edd.), rev. N. Davis (Oxford, 1967), ll.
943–69. One may compare Matthew of Vendôme's pair of contrasting descriptions of
young Helen (*ad laudem*) and ancient Beroe (*ad vituperium*): *Ars Versificatoria*, ed.
Faral, *Les Arts poétiques*, i, paras. 56–8.

of the dragon's barrow as 'eald enta geweorc', the ancient work of giants.[105] In *Sir Gawain* things are praised for being new, not old. Gawain carries a 'pentangel nwe' on his shield, and he sits on a saddle 'ayquere naylet ful nwe, for þat note ryched'. At Camelot, 'nwe nakryn noyse' accompanies the feast; and at Hautdesert, 'carolez newe' are danced after supper. The opening scene of the poem is set at a time when 'Nw 3er watz so 3ep þat hit watz nwe cummen', and Arthur's court shares the fresh newness of the year: 'For al watz þis fayre folk in her first age' (l. 54). 'First age' cannot be precisely interpreted here, in the absence of the rest of the set to which it belongs (the first of how many?); but it evidently covers quite a wide range, something like Dante's *adolescenza*. Arthur himself exhibits an ideal sanguine youthfulness, which is not without a touch of the boyish:

> Bot Arthure wolde not ete til al were served,
> He watz so joly of his joyfnes, and sumquat childgered:
> His lif liked hym ly3t, he lovied þe lasse
> Auþer to longe lye or to longe sitte,
> So bisied him his 3onge blod and his brayn wylde. (ll. 85–9)

However, youth does not have things all its own way in *Sir Gawain and the Green Knight*. Though old age may be beyond the courtly pale, the poem presents, like Chaucer's *Knight's Tale*, a powerful image of the middle age, in the person of Sir Bertilak de Hautdesert. We see Sir Bertilak first at Camelot as the Green Knight, playing the part of challenger with great relish and scorning the knights of the Round Table as 'berdlez chylder'; but in the central portion of the poem he appears in a different role, as the knight-householder.[106] The castle of Hautdesert has, for all its fairy appearance, a solid reality as Bertilak's house and home: 'hys lef home'.[107] Here he figures very much as the 'chef de maison', presiding as host over the Christmas festivities and as huntsman over the sport in his home woods. Although he is once referred to as 'þe *olde* lorde of þat leude' (l. 1124), that epithet can only be understood either as a term relative to

[105] *Beowulf*, l. 2774. In *Beowulf*, when applied to material things, 'eald' is generally an *epithetum ad bonum* ('time-honoured' or 'well-tried').

[106] See H. Wirtjes, 'Bertilak de Hautdesert and the Literary Vavassour', *English Studies* lxv (1984), 291–301.

[107] l. 1924. Hautdesert is frequently referred to as 'home': ll. 268, 1534, 1615, 1922, 2121, 2463.

Gawain's youth, or else as a colloquial expression of familiarity; for he is elsewhere clearly portrayed as a man in the prime of life:

> A hoge haþel for þe nonez, and of hyghe eldee;
> Brode, bryȝt, watz his berde, and al bever-hwed,
> Sturne, stif on þe stryþþe on stalworth schonkez,
> Felle face as þe fyre, and fre of hys speche. (ll. 844–7)

The great reddish-brown beard is enough to establish that 'high eld' must here refer to that age in which a man stands at the top of life's arch, not to an older age, as has been suggested.[108] Bertilak is man in his prime, the married and established knight-householder. By contrast, Sir Gawain is the adventurous knight-errant, travelling light as such knights do (ll. 1808–9). As the lady of the house points out (for her own purposes, admittedly), he is 'ȝong' and 'ȝepe', like Arthur and his fellows of the Round Table (l. 1510). The contrast between the two men has tempted some readers to suppose that the poem is implying criticism of the immaturity of Camelot, or else to see in the poem a story about 'the establishment of the hero's independence and maturity'.[109] There is a sense, certainly, in which Gawain may be judged more 'mature' at the end of the poem than at the beginning, in that he has learned by experience 'þe faut and þe fayntyse of þe flesche crabbed'. But he can hardly be said to 'grow up', like the hero of a *Bildungsroman*. He may be a sadder and a wiser man when he returns to Camelot, but neither he nor the poet shows any sign of repudiating the life of risk and adventure to which his young blood calls him. The somewhat paternal teasing to which Bertilak subjects him at the Green Chapel no more amounts to a condemnation of such youthful activity than does Theseus's speech to Palamon and Arcite in the grove outside Athens. In *Sir Gawain*, as in the *Knight's Tale*, middle age confronts youth not as its refutation but as its eventual successor in the order of things.

The contrast between the adventurous young knight and the older knight-householder plays a more essential part in another English

[108] E. Suzuki, 'A Note on the Age of the Green Knight', *Neuphilologische Mitteilungen* lxxviii (1977), 27–30, suggests 'advanced age', comparing *Cleanness*, l. 656.

[109] D. Brewer, *Symbolic Stories: Traditional Narratives of the Family Drama in English Literature* (Cambridge, 1980), 72. Brewer's interpretation of the theme of growing up in the story does not, however, align him with those who see ironies in the poet's praise of the youthful court.

romance, dating from about the same time as *Sir Gawain: The Avowing of King Arthur*. Like the better known but by no means superior *Awntyrs of Arthur*, this fine poem takes the form of a diptych, consisting in this case of two exactly equal parts.[110] On the left panel, the poet paints vivid night scenes of adventure set in the mysterious forest of Inglewood. Here Arthur and his three companions, Gawain, Kay, and Baldwin, make their 'avowings' in the presence of a fearsome boar. In the evening and night which follow, Arthur and Gawain perform their vows: the king kills the boar single-handed, and Gawain keeps vigil at the adventurous Tarn Wadling, rescuing a distressed damsel in the process—something which Kay, equally characteristically, has failed to do. This half of the poem ends with the knights' return in triumph to the court at Carlisle, bearing their spoils: 'bothe þe birde and þe brede', the rescued damsel and the boar-meat (l. 491). The second half of the poem concerns Sir Baldwin, and is mainly set at his home. Like his companions, Baldwin made an avowing in the presence of the boar; but his vows were more in the nature of general resolutions or rules for living: never to be jealous of his wife, never to refuse his food to any man, and never to fear for his life. These are by no means unchivalrous resolutions; but since they did not involve any promise of immediate adventure, Baldwin was able to go straight home to bed, leaving Arthur to tackle the boar, Gawain to wake the tarn, and Kay to ride the forest:

> Boudewynne turnes to toune,
> Sum þat his gate lay,
> And sethun to bed bownus he. (ll. 155–7)

The tests to which Arthur and his companions submit Baldwin's resolutions in the second part of the poem display in him an unshakeable and smiling equanimity in the face of challenges to his life, his hospitality, and his marriage. This finds characteristic expression in proverbs:

> Þenne Bawdewyn smylit and on him logh;
> Sayd, 'Sir, God hase a gud pluȝe;
> He may send us all enughe.
> Qwy schuld we spare?' (ll. 777–80)

[110] Thirty-six tail-rhyme stanzas in each, as Dr Stokes points out to me. Stanza 18 has presumably lost four lines in transmission, which explains why the line-totals are not exactly equal. I use the edition by R. Dahood (New York and London, 1984).

Or, of death:

> Welcum is hit.
> Hit is a kyndely thing. (ll. 1044–5)

When the tests are all done, Arthur asks Baldwin, now his host, why he behaves the way he does, and Baldwin replies by recalling three incidents which occurred when he was besieged by Saracens in a castle in Spain:

> Hit befelle in ȝour fadur tyme,
> Þat was þe kyng of Costantyne
> Purvayed a grete oste and a fyne,
> And wente into Spayne. (ll. 913–16)

The reference to King Arthur's father makes explicit a difference in age between Baldwin and his fellow knights which has already been implicit in the portrayal of him as a householder, with a wife of many winters, hunting in his home woods, and presiding at his festal board. This more settled existence does not, any more than Berti- lak's, imply criticism of the life of vow and adventure—in which, in- deed, Baldwin is ready to join. Nor does his wisdom conflict with the ethic of the knight-errant: rather it represents that ethic deepened by experience and touched with religious feeling. Baldwin is no longer young, but neither has he yet entered upon that last phase of the chivalric life in which knights may give up the profession of arms altogether and become hermits. There is about him a certain genia- lity and good humour which, here as in *Sir Gawain*, may be taken as a sign of the poet's assent to the principle of *tempestivitas*.

IV

Most ancient and medieval authorities speak of the course of human life not as a process of continuous development but as a series of transits from one distinct stage to another. Even though they did not agree on how many such stages there were or on when the passages between them occurred, they persisted in describing each of the *aetates hominum* as a specifiable period of years during the whole of which, through the influence of a reigning planet, a prevailing humour, or some other cause, a certain stable set of characteristics would normally appear. They generally saw the transitions between these *aetates* as datable events rather than gradual processes.

Medieval narrative displays a corresponding lack of interest in the process of change from one age to another. Most often a character will belong firmly to a single age-category and display the deportment appropriate to that age throughout the story. Thus, although the events of Chaucer's *Knight's Tale* occupy more than a decade, Palamon and Emily remain 'young' throughout. Only rarely does a character occupy a marginal position in relation to the categories, as when Chaucer places the young hero of his *Prioress's Tale*, at the age of seven, on the frontier between *infantia* and *pueritia*, and portrays him accordingly. When the case requires that a character should figure in the course of the story at more than one age, it is not the processes of change from the one age to the other which occupy the writer's attention. Beowulf is shown young, and he is shown old; but he is not shown ceasing to be young or beginning to feel old. Even those morality plays which take a whole human life as their theme treat its constituent ages discontinuously. The protagonist in *Mundus et Infans*, first named 'Infans', is given a new name, 'Wanton', at the age of seven, after which he exhibits the character of a schoolboy up to the age of fourteen, when he is renamed 'Lust and Liking'. Thereafter he appears as a lover until the age of twenty-one, when he is renamed 'Manhood'. The transitions between these strongly differentiated blocks of time are rendered, if at all, very sketchily. Morality plays are not concerned with the experience of growing up—the *Bildungsroman* is not a medieval genre—nor with what it feels like to grow old.

> I gynne to waxyn hory and olde.
> My bake gynnyth to bowe and bende,
> I crulle and crepe and wax al colde.[111]

That is all Humanum Genus has to say, in *The Castle of Perseverance*, about the onset of his old age; and by the end of the same stanza, he has already assumed the well-established role of the old man and is displaying all the appropriate characteristics: cold body, warm clothes, grey hair, and dripping nose.

. The most notable exceptions to this generalization occur in the poetry of courtly love, in connection with a theme there which might be described in Petrarchan terms as the Triumph of Time, or in Wagnerian terms as the Renunciation of Love. High romantic opi-

[111] *The Castle of Perseverance*, ed. Eccles, ll. 2482–4.

nion, in Chaucer's day as in Shakespeare's, held that 'love is not love which alters when it alteration finds'. In narratives such as the *Knight's Tale*, where time brings no alteration, this doctrine is easily upheld; but lovers who, unlike Palamon, cease to be young, or even become old, with the passage of time present a more difficult case. One possible response, exemplified in *Le Livre du voir-dit* of Guillaume de Machaut, was simply to defy time and maintain the right even of elderly lovers to serve their mistress as if they were still young. But this very high courtly position proved extremely difficult to defend, even by writers otherwise ready to entertain claims for the transcendent character of human love. For one thing, it was open to attack from learned authorities of every sort, especially the *medici* with their doctrine of the diminution of bodily heat, and the moralists with their prescription of wisdom and piety as the proper business of old people. Although popular hostility to elderly lovers and amorous old husbands could always be dismissed as mere vulgar prejudice, it could not be denied that courtly tradition itself often exhibited much the same hostility in a somewhat politer form. For gentlemen, as well as for physiologists, moralists, and churls, the *senex amans* was at best a questionable figure. Hence we find some courtly writers setting out to portray that delicate transitional stage in the life of a lover at which, recognizing that he is no longer young, he bids farewell to love and composes the lover's equivalent of a last will and testament.

Froissart's *Le Joli Buisson de Jonece* may be read as a lover's 'testament', in this sense. In this poem, it will be recalled, the poet wakes from his dream of love in youth to find himself, at the age of thirty-five, facing the present realities of approaching death and judgement. Coming to himself, and ruefully feeling his grizzled moustache, Froissart brings the poem to a conclusion with an elaborate lay addressed to the Virgin Mary. Such an ending could not fail to satisfy the pious reader; but it could also be considered, from another point of view, not as a volte-face but as a graceful and stylish sign of submission to that very order of nature in which love also had its place. As Froissart says, 'il faut son cours Nature avoir.'

Another fourteenth-century book of secular love which ends with a hymn to the Virgin Mary is the *Rerum Vulgarium Fragmenta*, better known as the *Canzoniere*, of Francis Petrarch. The relationship between love and time is a recurrent preoccupation in the *Canzoniere*. The passage of time is represented even, it has been

suggested, by the number of poems making up Petrarch's final ver-
sion of the sequence: 'With the actual total of 366 poems corres-
ponding, minus the Prologue-sonnet *Canzone* I, to the number of
days in the year, the poet could very well have intended his book to
represent his entire life as symbolically reduced to one "year".'[112]
Petrarch's entire life as a lover is indeed represented in the collection.
In the Prologue-sonnet, he addresses his hearers as

> Voi ch'ascoltate in rime sparse il suono
> Di quei sospiri ond'io nudriva 'l core
> In sul mio primo giovenile errore
> Quand'era in parte altr'uom da quel ch'i' sono.

[You who hear in scattered rhymes the sound of those sighs that were my
heart's food at the time when I first went astray in youth, when in part I was
another man from what I am now.][113]

These prefatory lines establish a range in time for the whole se-
quence: from a past period of 'giovenile errore' to a more sober
present where the poet is, in part at least, a different man. For
Petrarch, as for Froissart in the *Joli Buisson*, the experience of pas-
sionate love belongs to his vanished youth. He fell in love with
Laura, he recalls, in the April both of the year and of his life: 'era de
l'anno e di mi' etate aprile'.[114] Many of the poems in the collection,
of course, either were or purport to have been written in youth as
expressions of 'giovenil desio' (CCCLX. 36). They give utterance to
what, in the retrospective Prologue-sonnet, Petrarch can call 'the
vain hopes and vain suffering' of young love. Although the poems
do not form a consistently chronological narrative, a number of
them acknowledge the action of time upon the lover-poet. Already
in *Canzone* LV, Petrarch speaks of himself as having arrived at a
chilly time and less fresh age ('freddo tempo . . . età men fresca'); and
in several later poems he speaks of his hair going grey (LXXXIII. 2,

[112] K. Foster, *Petrarch: Poet and Humanist* (Edinburgh, 1984), 96. One might
prefer to follow Franco Betti, who identifies the odd poem out as the hymn to Mary.
Betti suggests that this hymn represents, by contrast with the time-bound three-
hundred-and-sixty-five, 'l'immobilità senza tempo tanto desiderata dal Petrarca',
Forum Italicum ii (1968), 213.

[113] *Le rime*, I. 1–4. All citations are from *Rime, trionfi e poesie latine*, ed. F. Neri,
G. Martellotti, E. Bianchi, N. Sapegno (Milan and Naples, 1951). The translation in
this case is Foster's.

[114] CCCXXV. 13. Elsewhere Petrarch says that he first entered the labyrinth of love
at the hour of prime on the sixth of April, 1327 (CCXI. 12–14), both the hour of the day
and the day of the year being in harmony with the poet's age at the time (twenty-two).

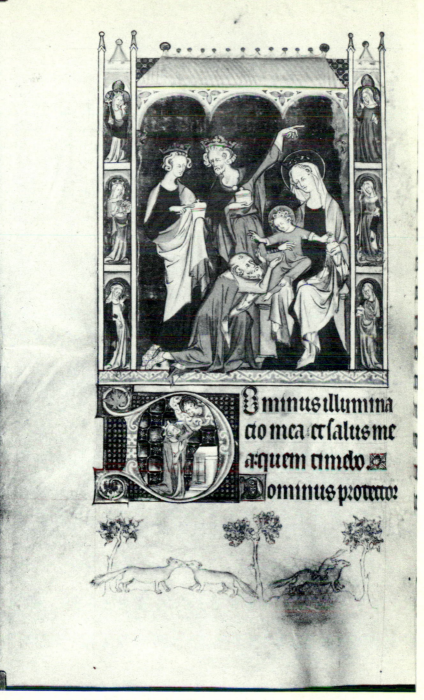

11. The Three Ages of Man: the Adoration of the Magi

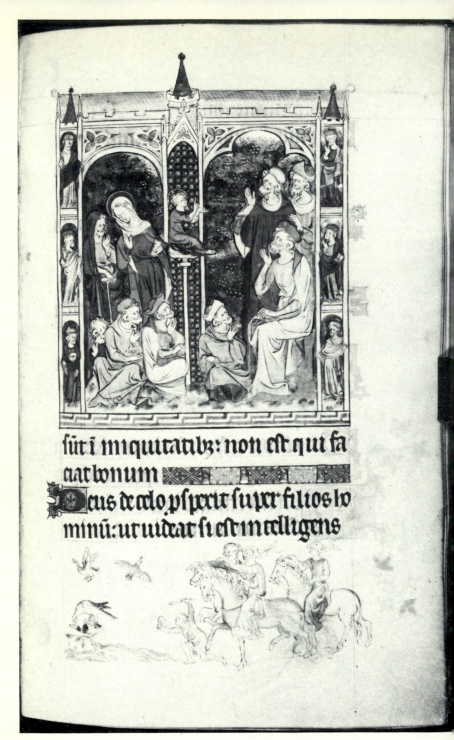

12. Christ as *Puer Senex*: Christ among the Doctors

CXCV. 1, CCX. 14, CCLXIV. 115–16, CCLXXVII. 14, CCCLX. 41). It is the poet's mirror which obliges him to confront, first the approach of a time unfavourable to love (CLXVIII), and later the actual decline of his mental and physical powers (CCCLXI).[115]

In some poems, Petrarch speaks as if his passion were not affected by the passing of youth: 'per etate il mio desir non varia' (CLXVIII. 13). Even though his body is cooling, his flame continually burns bright (LV. 1–3). He is, he ruefully admits, still caught on love's fish-hook and stuck with bird-lime to the branch of his green laurel-tree (a somewhat inelegant reference to Laura, CXCV. 1–4). As late as *Canzone* CCCLX we find the same complaint:

> Ché vo cangiando 'l pelo,
> Né cangiar posso l'ostinata voglia. (ll. 41–2)

[For here am I with my hair changing, yet I cannot change my obstinate desire.]

It will be evident, however, that these passages make no triumphant claims for the transcendence of love over time; and they are in any case belied by other passages which speak of the poet's love for Laura as being indeed subject to modification by time:

> Ma variarsi il pelo
> Veggio e dentro cangiarsi ogni desire. (CCLXIV. 115–16)

[But I see my hair altering and all my desires changing inwardly.]

Although Love can still warm, it can no longer burn him, now that his temples are turning grey (LXXXIII). In a touching group of three sonnets (CCCXV–CCCXVII), Petrarch describes how, before Laura died, he was already within sight of a time when there could have been a truce between them and they could have talked together of a more tranquil passion which no longer precluded friendship:

> Presso era 'l tempo dove Amor si scontra
> Con Castitate, ed agli amanti è dato
> Sedersi inseme e dir che lor incontra.

[The time was approaching when Love encounters Chastity, and it is given to lovers to sit down together and talk over what they have experienced.][116]

[115] The mirror plays a similar part in the *Secretum*, in *Prose*, ed. Martellotti *et al.*, 176 and 184 ('inventa sunt specula, ut homo ipse se nosceret').

[116] CCCXV. 9–11. In *Epistola Posteritati*, Petrarch speaks of Laura's death as extinguishing a fire which was already losing its heat ('iam tepescentem ignem', *Prose*, 4).

Petrarch's attitude to these natural changes is not simple. He feels regret as well as relief at the passing of youthful passion; yet the prevailing response is one of acceptance of the *cursus aetatis* as inevitable, natural, and right. As life draws on, love becomes a source of shame ('vergogna') as well as sorrow.[117] The poet now must listen to the voice of his 'faithful mirror', which tells him:

> Non ti nasconder più, tu se' pur veglio;
> Obedir a natura in tutto è il meglio,
> Ch'a contender con lei 'l tempo ne sforza. (CCCLXI. 4–6)

[Do not hide it from yourself any longer: you are indeed an old man. It is best to obey nature in all things, for time has deprived you of the strength to resist her.]

It is as if, in these last sonnets of the sequence, Petrarch has woken out of a long and heavy sleep; and from a vision of Laura in heaven approving his change of heart (CCCLXII), he can move easily and naturally to a Christian conclusion. He repents his sublunary love, prays for a peaceful death, and sings his hymn to the Virgin. In the parting petition to Mary that she may pray her son to receive the poet's soul at last in peace, the *Canzoniere* has passed beyond the order of nature; yet the moment of passage itself is dictated by that same order, in conformity with the principle enunciated by Petrarch in one of his Latin eclogues:

> cum tempore sensim
> Omnia mutantur; studium iuvenile senecte
> Displicet, et variant cure variante capillo.

[All things alter gradually with the passing of time; in old age youthful occupations no longer give pleasure, for as our hair changes our interests change.][118]

The same principle is at work in a later book of lyrics of love, the

[117] CCCLV. 8. Compare CCVII. 7–13 (''n giovenil fallir è men vergogna'), and the passage from the *Secretum*, cited above, p. 156.

[118] Eclogue VIII, ll. 76–8 (*Rime, trionfi e poesie latine*, 822). It may be noticed here, however, that Petrarch several times praises Laura for possessing wisdom out of season, in accordance with the epideictic topos studied in the previous chapter: 'sotto biondi capei canuta mente' ['a grey-haired mind beneath blond tresses', CCXIII. 3], 'frutto senile in sul giovenil fiore' ['the fruit of age amongst the flowers of youth', CCXV. 3], 'penser canuti in giovenile etate' ['grey-haired thoughts in youthful age', *Triumphus Pudicitie*, l. 88, in *Rime*, 512].

so-called 'Livre de pensée' of the French prince Charles d'Orléans.[119]
Its workings can be observed most clearly in the first part of the
book, a sequence of poems most of which were evidently composed
by Charles during his long period of captivity in England after Agin-
court (1415–40). This sequence begins with 'La Retenue d'Amours',
continues with seventy-one ballades, and ends with 'Le Songe en
complainte'.[120] 'La Retenue d'Amours', thought to have been written
when Charles was about twenty, describes how Dame Nature, hav-
ing first committed the poet to the care of Enfance, sends her mes-
senger Aage (Aetas rather than Senectus, here) with the command
that he be transferred to the care of Dame Jennesse.[121] Jennesse intro-
duces Charles to the court of Cupid, who retains him as one of love's
servants and publishes the fact by a formal 'lettre de retenue'. The
sequence of ballades which follows, representing the poet's experi-
ences as a young retainer in Cupid's court, is brought to an end by
the remarkable 'Songe en complainte', dated 1437 when Charles was
forty-three years old.[122] Like Petrarch, Charles has suffered the death
of his mistress, and in a dream he encounters Aage, now described as
an old man, who warns him of the approach of Vieillesse and coun-
sels him to give up love whilst he can still do so with honour:

> Si vous vault mieulx, tantdis qu'avez Jennesse,
> A vostre honneur de Folie partir,
> Vous eslongnant de l'amoureuse adresse;
> Car en descort sont Amours et Vieillesse:
> Nul ne les peut a leur gré bien servir. ('Songe', ll. 34–8)

[So the best thing for you, while you still have Youth, is to part from Folly

[119] The title is derived (somewhat dubiously) from Charles's Rondel xxxiii by his
editor, Pierre Champion. Champion applies it to the sequence as it stands in the poet's
personal copy, Bibliothèque nationale MS fr. 25458, upon which his standard edition
is based: *Charles d'Orléans, Poésies*, ed. Champion, 2 vols. (Paris, 1923–7). Charles
had an Italian mother and may have known Petrarch's *Canzoniere*: see A. Planche,
Charles d'Orléans, ou la recherche d'un langage (Paris, 1975), 93.

[120] The Middle English version, which may well be by Charles himself, lacks about
four hundred lines at the beginning of the sequence because of the loss of a gathering
in the sole surviving manuscript, but otherwise has the same structure as the French:
The English Poems of Charles of Orleans, ed. R. Steele and M. Day, EETS, os 215, 220
(1941, 1946, reissued as one vol. with bibliographical supplement, 1970).

[121] Charles consistently employs a set of three age-terms in his writings: *enfance*,
jennesse, and *vieillesse*. See especially Ballade lxxx.

[122] Cupid seals Charles's 'quittance' (the document releasing him from the service
of love) on All Souls' Day, 1437: 'Songe en complainte', ll. 407–14.

with your honour intact, and leave the paths of love; for Love and Old Age
are at odds: no one can serve to the satisfaction of both.]

Love is a proper activity for young people, but in the old it attracts
nothing but ridicule:

> Chascun s'en rit, disant: Dieu quelle joye!
> Ce foul vieillart veult devenir enfant!
> Jeunes et vieulx du doy le vont moustrant,
> Moquerie par tous lieux le convoye. ('Songe', ll. 45–8)

[Everyone laughs at him, saying, 'God, what happiness! This foolish old fel-
low wants to become a child again!' Young and old point the finger at him,
and scorn accompanies him everywhere he goes.]

In the 'Songe en complainte', as in Froissart and Gower, the waking
of the poet from a dream precipitates his recognition of the realities
of advancing years. Trembling, Charles writes a letter of renunci-
ation to Cupid and Venus; and the God of Love grants him a 'quit-
tance' or letter of release from service, returning his heart to him
wrapped in a piece of black silk. Charles departs to take up residence
in the manor of Nonchaloir ('No Care' in the Middle English ver-
sion). He is not yet condemned to the gloomy willow-walk of Old
Age ('Songe', ll. 450–1); so he can for the time being simply rest after
the turbulence of youth, seeking comfort in the quieter pleasures of
mature years.

Charles's allegory presents a witty, melancholy, and essentially
secular version of the farewell to love. Like the great nobleman that
he was, the prince makes a most stylish and dignified withdrawal.
The *ordo aetatis* represented by Aage forms part of the larger order
of Nature.[123] Any attempt to resist or transcend it will merely expose
the man of honour to ridicule and humiliation; so it is better to
accept the inevitable, take one's heart back (elegantly wrapped), and
retire to one's childhood home in the country, the 'ancien manoir' of

[123] 'De l'émerveillement de la jeunesse à la résignation de la vieillesse, chaque
étape de son destin confirme la soumission à l'ordre des choses', D. Poirion, *Le Poète
et le Prince: l'évolution du lyrisme courtois de Guillaume de Machaut à Charles
d'Orléans* (Paris, 1965), 612. Chap. VII of this book, devoted to Charles, has many
relevant observations. On nature and the ages in the writings of Charles, see Planche,
346–52.

Nonchaloir.[124] In what follows, after the 'Songe en complainte', Charles amuses himself by adopting a variety of middle-aged roles. He celebrates his retirement from love by making his jubilee (Ballade LXXII); he invites young lovers to a feast at his house, offering them instead of quails and larks the little rondels of love which he has composed for their delectation (English Ballade 84); and he presides like a herald over the love-tourneys of his juniors:

> J'ay esté poursuivant d'Amours,
> Mais maintenant je suis herault;
> Monter me fault en l'eschaffault,
> Pour jugier des amoureux tours. (Rondel IV)

[I have been Love's pursuivant in my time, but now I am a herald, so I must mount my umpire's stand and judge the bouts of lovers.]

Like Theseus in Chaucer's *Knight's Tale*, Charles can speak mockingly of the 'plaisant folie' of love (Ballade XCII); but like him he also acknowledges its force:

> Car au jourduy n'a soubz les cieulx
> Qui en aucun temps ne fouloye.

[For there is no one on earth nowadays who does not make a fool of himself at one time or another.][125]

Indeed, unless all the love poems in the latter part of the 'Livre de pensée' are to be read as titbits for younger lovers, it would appear that Charles had other affairs after his solemn farewell to Love. As late as the last poem in the book, he is still bidding his farewells:

> Amoureus fus, or ne suy ge mye,
> Et en Paris menoys bonne vie;

[124] 'C'estoit vers l'ancien manoir | Ou en enffance demouroye, | Que l'en appelle Nonchaloir', 'Songe en complainte', ll. 444–6. Compare Poirion, 574: 'La réforme que le poète veut opérer en lui consiste à rechercher la liberté d'indifférence, celle qui régnait sur son âme avant les engagements de la passion amoureuse.' Planche's extended discussion of 'nonchaloir' (pp. 612–26) displays Charles's mixed feelings on the subject.

[125] Poirion comments: 'La sagesse n'efface pas l'amour, mais elle le dépasse, ou au moins le remplace, dans l'ordre d'une succession naturelle qui fait suivre la saison des amours d'un "âge de raison"' (p. 580).

> Adieu bon temps, ravoir ne vous saroye! (Rondel CCCCXXXV)

[I have been a lady's man, though I am so no more, and I have lived the good life in Paris; farewell, good times, I can have you no more!]

There is about Charles a quicksilver quality and a rather grand neglect of consistency which reminds the English reader of Lord Byron. Yet this aristocratic nonchalance also testifies, in his poems, to that deeper condition of detachment which he called 'nonchaloir'—an ironic detachment which had one of its chief sources in his sense of man's subjection to the *ordo aetatis*:

> Mais il convient que je l'endure,
> Puis que c'est le cours de nature. (Ballade CXXI)

During his twenty-five years of captivity in England, the French prince could hardly have failed to learn something of an English poem then much in vogue, the *Confessio Amantis*; so it is not surprising to find that his 'Songe en complainte' bears a distinct resemblance to the closing pages of Gower's poem. The treatment of the Farewell to Love in these pages can stand comparison with the work of any continental master.[126] Gower's lover, Amans, is old from the start; but neither he nor the reader succeeds in realizing the fact until after his long confession to the priest Genius is completed. In the last phase of that confession, Genius had offered priestly counsel: withdraw from human passion, follow reason, and 'tak love where it mai noght faile' (VIII. 2086). In *Confessio Amantis*, however, this particular 'conclusioun final' proves ineffective, as it does not in Chaucer's *Troilus*. Such advice could only be offered, Amans protests, by one who has not himself felt the full force of love. In the event, it is only when Amans is at last brought face to face with the realities of his old age that he proves capable of taking his leave of a passion against which reason had no power. Thus, as Petrarch put it:

> Iam quod non potuit ratio, natura diesque
> Longa potest.

[Now where Reason has failed, Nature and the length of days succeed.][127]

[126] I have discussed Gower's Farewell to Love previously in A. J. Minnis (ed.), *Gower's 'Confessio Amantis': Responses and Reassessments* (Cambridge, 1983), 5–24.
[127] Metrical Epistle to Barbato, ll. 58–9, in *Rime*, 708.

After rejecting the priest's advice, Amans composes a letter to Venus and Cupid, like Charles in his 'Songe'—in this case, a 'supplication' petitioning for an end to his sufferings. There follows a beautiful scene between Venus and the lover. Here the goddess speaks for the first time in the poem of the man's advancing years, in a tone of tender mockery, and draws the inevitable conclusion:

> Er thou make eny suche assaies
> To love, and faile upon the fet,
> Betre is to make a beau retret.[128]

Accompanying Latin verses make the same point in, characteristically, a more uncompromising fashion. Winter, they say, cannot match what Summer does, nor does Nature grant to December the properties of May; 'so it would seem appropriate that those whom hoary age afflicts should henceforth cultivate bodily chastity':

> Conveniens igitur foret, ut quos cana senectus
> Attigit, ulterius corpora casta colant.[129]

Thereafter, in the *Confessio* as in the 'Songe', the truth of the lover's condition finally comes home to him in a vision. In a chill swoon, Amans sees the followers of Cupid divided into two companies, the young laughing and dancing 'after the lust of youthes heste', while the old smile quietly and dance 'a softe pas'. They cluster round Amans, commenting sadly on his 'sotie' or folly, as Cupid draws the dart of love out of his heart. After Venus has anointed the wound with a cooling salve, she gives him a mirror in which he sees his own face disfigured by the passage of time. Like Petrarch in the *Canzoniere*, Amans learns the truth about himself from a mirror; and he recovers from his swoon barely able even to recall what love might be. Thus, as I have written elsewhere, 'the poem manages to suggest that such profound changes in life occur not in full consciousness but mysteriously. One moment we imagine that things might be different, the next moment they already are. So Amans awakes from his dream to find it, like Adam's, true.'[130] In full recognition now of his unsuitability to be a servant of Venus, Amans takes his leave of her and receives as a parting gift a rosary of black beads inscribed

[128] Macaulay (ed.) VIII. 2414–16. The same image of an orderly and dignified withdrawal from the battle of love is used by Charles d'Orléans in Chanson LI.

[129] VIII. iii. 9–10 (after VIII. 2376).

[130] *Gower's 'Confessio Amantis'*, ed. Minnis, 18–19.

with the words 'Por reposer'. There follows the 'beau retret' of which Venus spoke: Amans returns home 'a softe pas' to end his life in repose and peace. It is an exquisite image of submission to the natural *ordo aetatis*.[131]

V

Although the present study has drawn a marked distinction between them, 'ideals of transcendence' and 'ideals of nature' should not be taken to represent competing ideologies. Indeed, there is in medieval texts little sign of any rivalry between them. Both in theory and in practice they complement one another; and writers draw on one cluster of ideas or the other as the occasion requires. Saints, for instance, might be expected to 'transcend their age' and would be praised for it by their biographers; but no preacher would propose such an ideal to a congregation of ordinary mortals. Exceptional cases were not to be offered as general models of conduct: 'miracula in exemplo operationis non sunt trahenda'.

Yet the balance between these two complementary sets of moral ideas does not remain constant in the texts from medieval England which have been chiefly under consideration here. We have seen that what Gnilka called the 'Transzendenzideal' plays a much more prominent part in the surviving literature of the Anglo-Saxons than it does in the literature of post-Conquest England. The literary historian will assimilate this shift to his general theory of a transition in medieval literature 'from Epic to Romance'; and it is indeed an essential fact that ideals of transcendence proved to be less at home in the new literature of love and adventure which emerged in twelfth-century France than they had been in the older high-mimetic modes of heroic and hagiographic writing characteristic of Anglo-Saxon times. Yet, although such considerations of genre must be given full

[131] In a passage found only in the first version of *Confessio Amantis* (VIII. 2950*-55*) Venus asks Amans to convey to Chaucer her command that now 'in hise daies olde' he should give up writing love-poetry and formally dispose of the matter by drawing up his 'testament of love'. It was a commonplace of literary apologetics to excuse licentious writings as the follies of youth; but behind such conventional apologies lay larger conceptions of an ideal literary *cursus* (often represented by the example of Virgil). Thus Dante justifies the difference in character between *Il convivio* and his earlier *Vita nuova* by invoking the principle that 'altro si conviene e dire e operare ad una etade che ad altra' ['a different thing is fitting to say and do at one age than at another', *Il convivio*, I. i. 17]. This matter would repay further investigation.

weight, the shift in question cannot be understood as a purely and exclusively literary phenomenon. Thus, the 'cult of youth' which has been noticed in certain later medieval writers clearly represents a fundamental characteristic of their new courtly culture, as against an older monastic culture in which the transcendence ideal worked towards a denaturing and devaluation of that particular age. To the end of the Middle Ages and beyond, hagiographers persist in employing the ancient epideictic theme of the *puer senex*; but such types of transcendence appear increasingly stiff and archaic in the later period, whose literature reflects a renewed sense of the rich and various order of nature in which every age of life, and not least youth, can claim its legitimate place.

Appendix

Loci Classici

Elegiac Verses ascribed to Solon. From Philo Judaeus, *On the Account of the World's Creation*: trans. F. H. Colson and G. H. Whitaker (New York and London, 1929), 85.

In seven years the Boy, an infant yet unfledged,
Both grows and sheds the teeth with which his tongue is hedged.
When heaven has made complete a second week of years,
Of coming prime of youth full many a sign appears.
In life's third term, while still his limbs grow big apace,
His chin shows down; its early bloom now quits his face.
In the fourth heptad each one full of strength doth seem—
Strength, which of manly worth best earnest all men deem.
Let him in his fifth week of years a bride bespeak,
Offspring to bear his name hereafter let him seek.
The sixth beholds the man good sense all round attain;
Not now can reckless deeds as once his fancy gain.
Now see him seventh and eighth, fresh heptads, duly reach
In insight strongest now, strongest in power of speech.
In his ninth week of years, strong still but softer far
For high achievement's venture speech and wisdom are.
Then should the man, ten bouts complete, attain life's end
Fate, no untimely gift, death's call may fitly send.

Aristotle, *Rhetoric*, Bk. II, Chaps. 12–14: trans. W. Rhys Roberts (Oxford, 1924).

Let us now consider the various types of human character, in relation to the emotions and moral qualities, showing how they correspond to our various ages and fortunes. By emotions I mean anger, desire, and the like; these we

have discussed already. By moral qualities I mean virtues and vices; these also have been discussed already, as well as the various things that various types of men tend to will and to do. By ages I mean youth, the prime of life, and old age. By fortune I mean birth, wealth, power, and their opposites—in fact, good fortune and ill fortune.

To begin with the Youthful type of character. Young men have strong passions, and tend to gratify them indiscriminately. Of the bodily desires, it is the sexual by which they are most swayed and in which they show absence of self-control. They are changeable and fickle in their desires, which are violent while they last, but quickly over: their impulses are keen but not deep-rooted, and are like sick people's attacks of hunger and thirst. They are hot-tempered and quick-tempered, and apt to give way to their anger; bad temper often gets the better of them, for owing to their love of honour they cannot bear being slighted, and are indignant if they imagine themselves unfairly treated. While they love honour, they love victory still more; for youth is eager for superiority over others, and victory is one form of this. They love both more than they love money, which indeed they love very little, not having yet learnt what it means to be without it—this is the point of Pittacus' remark about Amphiaraus. They look at the good side rather than the bad, not having yet witnessed many instances of wickedness. They trust others readily, because they have not yet often been cheated. They are sanguine; nature warms their blood as though with excess of wine; and besides that, they have as yet met with few disappointments. Their lives are mainly spent not in memory but in expectation; for expectation refers to the future, memory to the past, and youth has a long future before it and a short past behind it: on the first day of one's life one has nothing at all to remember, and can only look forward. They are easily cheated, owing to the sanguine disposition just mentioned. Their hot tempers and hopeful dispositions make them more courageous than older men are; the hot temper prevents fear, and the hopeful disposition creates confidence; we cannot feel fear so long as we are feeling angry, and any expectation of good makes us confident. They are shy, accepting the rules of society in which they have been trained, and not yet believing in any other standard of honour. They have exalted notions, because they have not yet been humbled by life or learnt its necessary limitations; moreover, their hopeful disposition makes them think themselves equal to great things—and that means having exalted notions. They would always rather do noble deeds than useful ones: their lives are regulated more by moral feeling than by reasoning; and whereas reasoning leads us to choose what is useful, moral goodness leads us to choose what is noble. They are fonder of their friends, intimates, and companions than older men are, because they like spending their days in the company of others, and have not yet come to value either their friends or anything else by their usefulness to themselves. All their mistakes are in the

direction of doing things excessively and vehemently. They disobey Chilon's precept by overdoing everything; they love too much and hate too much, and the same with everything else. They think they know everything, and are always quite sure about it; this, in fact, is why they overdo everything. If they do wrong to others, it is because they mean to insult them, not to do them actual harm. They are ready to pity others, because they think every one an honest man, or anyhow better than he is: they judge their neighbour by their own harmless natures, and so cannot think he deserves to be treated in that way. They are fond of fun and therefore witty, wit being well-bred insolence.

Such, then, is the character of the Young. The character of Elderly Men—men who are past their prime—may be said to be formed for the most part of elements that are the contrary of all these. They have lived many years; they have often been taken in, and often made mistakes; and life on the whole is a bad business. The result is that they are sure about nothing and *under-do* everything. They 'think', but they never 'know'; and because of their hesitation they always add a 'possibly' or a 'perhaps', putting everything this way and nothing positively. They are cynical; that is, they tend to put the worse construction on everything. Further, their experience makes them distrustful and therefore suspicious of evil. Consequently they neither love warmly nor hate bitterly, but following the hint of Bias they love as though they will some day hate and hate as though they will some day love. They are small-minded, because they have been humbled by life: their desires are set upon nothing more exalted or unusual than what will help them to keep alive. They are not generous, because money is one of the things they must have, and at the same time their experience has taught them how hard it is to get and how easy to lose. They are cowardly, and are always anticipating danger; unlike that of the young, who are warm-blooded, their temperament is chilly; old age has paved the way for cowardice; fear is, in fact, a form of chill. They love life; and all the more when their last day has come, because the object of all desire is something we have not got, and also because we desire most strongly that which we need most urgently. They are too fond of themselves; this is one form that small-mindedness takes. Because of this, they guide their lives too much by considerations of what is useful and too little by what is noble—for the useful is what is good for oneself, and the noble what is good absolutely. They are not shy, but shameless rather; caring less for what is noble than for what is useful, they feel contempt for what people may think of them. They lack confidence in the future; partly through experience—for most things go wrong, or anyhow turn out worse than one expects; and partly because of their cowardice. They live by memory rather than by hope; for what is left to them of life is but little as compared with the long past; and hope is of the future, memory of the past. This, again, is the cause of their loquacity; they are continually

talking of the past, because they enjoy remembering it. Their fits of anger are sudden but feeble. Their sensual passions have either altogether gone or have lost their vigour: consequently they do not feel their passions much, and their actions are inspired less by what they do feel than by the love of gain. Hence men at this time of life are often supposed to have a self-controlled character; the fact is that their passions have slackened, and they are slaves to the love of gain. They guide their lives by reasoning more than by moral feeling; reasoning being directed to utility and moral feeling to moral goodness. If they wrong others, they mean to injure them, not to insult them. Old men may feel pity, as well as young men, but not for the same reason. Young men feel it out of kindness; old men out of weakness, imagining that anything that befalls any one else might easily happen to them, which, as we saw, is a thought that excites pity. Hence they are querulous, and not disposed to jesting or laughter—the love of laughter being the very opposite of querulousness.

Such are the characters of Young Men and Elderly Men. People always think well of speeches adapted to, and reflecting, their own character: and we can now see how to compose our speeches so as to adapt both them and ourselves to our audiences.

As for Men in their Prime, clearly we shall find that they have a character between that of the young and that of the old, free from the extremes of either. They have neither that excess of confidence which amounts to rashness, nor too much timidity, but the right amount of each. They neither trust everybody nor distrust everybody, but judge people correctly. Their lives will be guided not by the sole consideration either of what is noble or of what is useful, but by both; neither by parsimony nor by prodigality, but by what is fit and proper. So, too, in regard to anger and desire; they will be brave as well as temperate, and temperate as well as brave; these virtues are divided between the young and the old; the young are brave but intemperate, the old temperate but cowardly. To put it generally, all the valuable qualities that youth and age divide between them are united in the prime of life, while all their excesses or defects are replaced by moderation and fitness. The body is in its prime from thirty to five-and-thirty; the mind about forty-nine.

Horace, *Ars Poetica*, ll. 156–78.

> Aetatis cuiusque notandi sunt tibi mores,
> Mobilibusque decor naturis dandus et annis.
> Reddere qui voces iam scit puer et pede certo
> Signat humum, gestit paribus colludere, et iram

Concipit ac ponit temere et mutatur in horas.
Imberbis iuvenis, tandem custode remoto,
Gaudet equis canibusque et aprici gramine campi,
Cereus in vitium flecti, monitoribus asper,
Utilium tardus provisor, prodigus aeris,
Sublimis cupidusque et amata relinquere pernix.
Conversis studiis aetas animusque virilis
Quaerit opes et amicitias, inservit honori,
Commisisse cavet quod mox mutare laboret.
Multa senem circumveniunt incommoda, vel quod
Quaerit et inventis miser abstinet ac timet uti
Vel quod res omnes timide gelideque ministrat,
Dilator, spe longus, iners, avidusque futuri,
Difficilis, querulus, laudator temporis acti
Se puero, castigator censorque minorum.
Multa ferunt anni venientes commoda secum,
Multa recedentes adimunt. Ne forte seniles
Mandentur iuveni partes pueroque viriles,
Semper in adiunctis aevoque morabimur aptis.

You must represent the distinctive behaviour of each age and assign what is appropriate to the characters as they change with the changing years. The child, now able to utter words and treading the earth with a steady foot, delights in playing with his fellows; he is quick to conceive anger and equally quick to forget it, and changes from hour to hour. The beardless youth, at last free of his guardian, rejoices in horses and dogs and the grass of the sunny sports field; to vice he is easily moulded like wax, sharp with his critics, slow to make provision for necessities, lavish with money, high-minded and affectionate, but quick to change the objects of his affections. The mature man, with different concerns in mind, desires wealth and useful connections, seeks preferment, and avoids doing things that he will have to labour to change later. Many miseries beset the old man, whether it be that he seeks to get, yet in his wretchedness denies himself what he has got, being afraid to use it, or else manages all things in a tentative and spiritless fashion; he is a procrastinator, long in hope, inactive, always greedy for what is to come, hard to please, a grumbler, a praiser of days gone by when he was a boy, a critic and castigator of his juniors. The years as they come bring with them many benefits, but they take many away as they depart. Thus, to avoid giving the role of an old man to a youth, or that of a mature man to a boy, we must always adhere to what is suitable to each age.

Ovid, *Metamorphoses*, Bk. xv, ll. 199–236: ed. and trans. F. J. Miller (New York and London, 1916).

'Quid? non in species succedere quattuor annum
adspicis, aetatis peragentem imitamina nostrae?
nam tener et lactens puerique simillimus aevo
vere novo est: tunc herba nitens et roboris expers
turget et insolida est et spe delectat agrestes;
omnia tunc florent, florumque coloribus almus
ludit ager, neque adhuc virtus in frondibus ulla est.
transit in aestatem post ver robustior annus
fitque valens iuvenis: neque enim robustior aetas
ulla nec uberior, nec quae magis ardeat, ulla est.
excipit autumnus, posito fervore iuventae
maturus mitisque inter iuvenemque senemque
temperie medius, sparsus quoque tempora canis.
inde senilis hiems tremulo venit horrida passu,
aut spoliata suos, aut, quos habet, alba capillos.
 'Nostra quoque ipsorum semper requieque sine ulla
corpora vertuntur, nec quod fuimusve sumusve,
cras erimus; fuit illa dies, qua semina tantum
spesque hominum primae matris habitavimus alvo:
artifices natura manus admovit et angi
corpora visceribus distentae condita matris
noluit eque domo vacuas emisit in auras.
editus in lucem iacuit sine viribus infans;
mox quadrupes rituque tulit sua membra ferarum,
paulatimque tremens et nondum poplite firmo
constitit adiutis aliquo conamine nervis.
inde valens veloxque fuit spatiumque iuventae
transit et emeritis medii quoque temporis annis
labitur occiduae per iter declive senectae.
subruit haec aevi demoliturque prioris
robora: fletque Milon senior, cum spectat inanes,
illos, qui fuerant solidorum mole tororum
Herculeis similes, fluidos pendere lacertos;
flet quoque, ut in speculo rugas adspexit aniles,
Tyndaris et secum, cur sit bis rapta, requirit.
tempus edax rerum, tuque, invidiosa vetustas,
omnia destruitis vitiataque dentibus aevi
paulatim lenta consumitis omnia morte!'

Then again, do you not see the year assuming four aspects, in imitation of our own lifetime? For in early spring it is tender and full of fresh life, just like

a little child; at that time the herbage is bright, swelling with life, but as yet without strength and solidity, and fills the farmers with joyful expectation. Then all things are in bloom and the fertile fields run riot with their bright-coloured flowers; but as yet there is no strength in the green foliage. After spring has passed, the year, grown more sturdy, passes into summer and becomes like a strong young man. For there is no hardier time than this, none more abounding in rich, warm life. Then autumn comes, with its first flush of youth gone, but ripe and mellow, midway in time between youth and age, with sprinkled grey showing on the temples. And then comes aged winter, with faltering step and shivering, its locks all gone or hoary.

'Our own bodies also go through a ceaseless round of change, nor what we have been or are to-day shall we be to-morrow. There was a time when we lay in our first mother's womb, mere seeds and hopes of men. Then Nature wrought with her cunning hands, willed not that our bodies should lie cramped in our strained mother's body, and from our home sent us forth into the free air. Thus brought forth into the light, the infant lay without strength; but soon it lifted itself up on all fours after the manner of the beasts; then gradually in a wabbling, weak-kneed fashion it stood erect, supported by some convenient prop. Thereafter, strong and fleet, it passed over the span of youth; and when the years of middle life also have been spent, it glides along the downhill path of declining age. This undermines and pulls down the strength of former years; and Milon, grown old, weeps when he looks at those arms, which once had been like the arms of Hercules with their firm mass of muscles, and sees them now hanging weak and flabby. Helen also weeps when she sees her aged wrinkles in the looking-glass, and tearfully asks herself why she should twice have been a lover's prey. O Time, thou great devourer, and thou, envious Age, together you destroy all things; and, slowly gnawing with your teeth, you finally consume all things in lingering death!'

Ptolemy, *Tetrabiblos*, Bk. IV, Chap. 10: trans. F. E. Robbins (Cambridge, Mass., and London, 1940).

In the matter of the age-divisions of mankind in general there is one and the same approach, which for likeness and comparison depends upon the order of the seven planets; it begins with the first age of man and with the first sphere from us, that is, the moon's, and ends with the last of the ages and the outermost of the planetary spheres, which is called that of Saturn. And in truth the accidental qualities of each of the ages are those which are naturally proper to the planet compared with it, and these it will be needful to observe, in order that by this means we may investigate the general questions of the temporal divisions, while we determine particular differences from the special qualities which are discovered in the nativities.

For up to about the fourth year, following the number which belongs to the quadrennium, the moon takes over the age of infancy and produces the suppleness and lack of fixity in its body, its quick growth and the moist nature, as a rule, of its food, the changeability of its condition, and the imperfection and inarticulate state of its soul, suitably to her own active qualities.

In the following period of ten years, Mercury, to whom falls the second place and the second age, that of childhood, for the period which is half of the space of twenty years, begins to articulate and fashion the intelligent and logical part of the soul, to implant certain seeds and rudiments of learning, and to bring to light individual peculiarities of character and faculties, awaking the soul at this stage by instruction, tutelage, and the first gymnastic exercises.

Venus, taking in charge the third age, that of youth, for the next eight years, corresponding in number to her own period, begins, as is natural, to inspire, at their maturity, an activity of the seminal passages and to implant an impulse toward the embrace of love. At this time particularly a kind of frenzy enters the soul, incontinence, desire for any chance sexual gratification, burning passion, guile, and the blindness of the impetuous lover.

The lord of the middle sphere, the sun, takes over the fourth age, which is the middle one in order, young manhood, for the period of nineteen years, wherein he implants in the soul at length the mastery and direction of its actions, desire for substance, glory, and position, and a change from playful, ingenuous error to seriousness, decorum, and ambition.

After the sun, Mars, fifth in order, assumes command of manhood for the space of fifteen years, equal to his own period. He introduces severity and misery into life, and implants cares and troubles in the soul and in the body, giving it, as it were, some sense and notion of passing its prime and urging it, before it approaches its end, by labour to accomplish something among its undertakings that is worthy of note.

Sixth, Jupiter, taking as his lot the elderly age, again for the space of his own period, twelve years, brings about the renunciation of manual labour, toil, turmoil, and dangerous activity, and in their place brings decorum, foresight, retirement, together with all-embracing deliberation, admonition, and consolation; now especially he brings men to set store by honour, praise, and independence, accompanied by modesty and dignity.

Finally to Saturn falls as his lot old age, the latest period, which lasts for the rest of life. Now the movements both of body and of soul are cooled and impeded in their impulses, enjoyments, desires, and speed; for the natural decline supervenes upon life, which has become worn down with age, dispirited, weak, easily offended, and hard to please in all situations, in keeping with the sluggishness of his movements.

Augustine, *De Diversis Quaestionibus LXXXIII*, Bk. I, Qu. LVIII, *PL* 40. 43.

Finis autem saeculorum tanquam senectus veteris hominis, cum totum genus humanum tanquam unum hominem constitueris, sexta aetate signatur, qua Dominus venit. Sunt enim aetates sex etiam in uno homine; infantia, pueritia, adolescentia, juventus, gravitas, et senectus. Prima itaque generis humani aetas est ab Adam usque ad Noe. Secunda, a Noe ad Abraham: qui articuli sunt evidentissimi et notissimi. Tertia, ab Abraham usque ad David: sic enim Matthaeus evangelista partitur. Quarta, a David usque ad transmigrationem in Babyloniam. Quinta, a transmigratione in Babyloniam usque ad adventum Domini. Sexta, ab adventu Domini usque in finem saeculi speranda est: qua exterior homo tanquam senectute corrumpitur qui etiam vetus dicitur, et interior renovatur de die in diem. Inde requies sempiterna est, quae significatur sabbato. Huic rei congruit quod homo sexto die factus est ad imaginem et similitudinem Dei. Nemo autem ignorat hominum vitam jam aliquid administrantem, cognitione et actione fulciri. Nam et actio temeraria est sine cognitione, et sine actione ignava cognitio. Sed prima vita hominis, cui nulla administratio recte creditur, quinque sensibus corporis dedita est; qui sunt visus, auditus, olfactus, gustus, tactus. Et ideo duae primae aetates generis humani denis generationibus definiuntur, tanquam infantia et pueritia; quinario scilicet geminato, quoniam generatio utroque sexu propagatur. Sunt ergo generationes decem ab Adam usque ad Noe, et inde usque ad Abraham aliae decem; quas duas aetates infantiam et pueritiam generis humani esse diximus. Adolescentia vero et juventus et gravitas, id est, ab Abraham usque ad David, et inde usque ad transmigrationem in Babyloniam, et inde usque ad adventum Domini, 'quatuor denis generationibus figurantur; septenario geminato ad eamdem generationem utriusque sexus, cum quinario qui est in sensibus corporis, actio et cognitio addita fuerit. Senectus autem solet etiam tantum tenere temporis, quantum reliquae omnes aetates. Nam cum a sexagesimo anno senectus dicatur incipere, et possit humana vita usque ad centum viginti annos pervenire, manifestum solam senectutem posse tam longam esse, quam omnes aetates caeterae priores sunt. Aetas igitur ultima generis humani, quae incipit a Domini adventu, usque in finem saeculi, quibus generationibus computetur incertum est.

The end of the world, which corresponds to the old age of the 'old' man if you take the whole human race as one man, represents the sixth age, in which the Lord comes. For there are also six ages in the individual: infancy, boyhood, adolescence, youth, maturity, and old age. So the first age of the human race extends from Adam to Noah, and the second from Noah to

Abraham—self-evident and very familiar divisions. Then, according to the divisions made by the evangelist Matthew (1:17), the third age extends from Abraham to David, the fourth from David until the Babylonian captivity, and the fifth from the Babylonian captivity until the coming of the Lord. The sixth is to be hoped for from the coming of the Lord until the end of the world, during which time the exterior or 'old' man is wasted by old age, while the interior man is from day to day renewed. Thence comes that sempiternal rest which is signified by the sabbath. It is therefore appropriate that man should have been made in the image and resemblance of God upon the sixth day. Furthermore, everyone knows that the life of any man with duties to perform depends upon two things, knowledge and action; for action without knowledge is rash, and knowledge without action is worthless. But the first part of life, to which no duties are properly entrusted, is given over entirely to the five bodily senses (sight, hearing, smell, taste, and touch). Accordingly, the first two ages of the human race, corresponding to infancy and boyhood, are restricted to ten generations each—five being doubled because two sexes are involved in generation. There are therefore ten generations from Adam to Noah and another ten up to Abraham—the two ages which we call the infancy and boyhood of the human race. But its adolescence, youth, and maturity, that is, the periods from Abraham to David, thence to the Babylonian captivity, and thence to the coming of the Lord, are represented by fourteen generations each. This is because action and knowledge are added to the five bodily senses, and the resulting seven is doubled, again because two sexes are involved in generation. Old age, however, lasts as long as all the other ages put together; for, since old age may be said to begin with the sixtieth year and human life can last as long as one hundred and twenty years, it is evident that old age can be as long in itself as all the other earlier ages. That is why we cannot know how many generations will make up the last age of the human race, which begins with the coming of the Lord and ends with end of the world.

Isidore of Seville, *Etymologiae*, Bk. XI, Chap. 2: ed. W. M. Lindsay (Oxford, 1911).

De aetatibus hominum. Gradus aetatis sex sunt: infantia, pueritia, adolescentia, iuventus, gravitas atque senectus. Prima aetas infantia est pueri nascentis ad lucem, quae porrigitur in septem annis. Secunda aetas pueritia, id est pura et necdum ad generandum apta, tendens usque ad quartumdecimum annum. Tertia adolescentia ad gignendum adulta, quae porrigitur usque ad viginti octo annos. Quarta iuventus firmissima aetatum omnium, finiens in quinquagesimo anno. Quinta aetas senioris, id est gravitas, quae est declinatio a iuventute in senectutem; nondum senectus sed iam nondum iuventus, quia senioris aetas est, quam Graeci πρεσβύτην vocant. Nam senex apud

Graecos non presbyter, sed γέρων dicitur. Quae aetas a quinquagesimo anno incipiens septuagesimo terminatur. Sexta aetas senectus, quae nullo annorum tempore finitur; sed post quinque illas aetates quantumcumque vitae est, senectuti deputatur. Senium autem pars est ultima senectutis, dicta quod sit terminus sextae aetatis. In his igitur sex spatiis philosophi vitam discripserunt humanam, in quibus mutatur et currit et ad mortis terminum pervenit.

Of the Ages of Man. The stages of life are six: infancy, boyhood, adolescence, youth, maturity, and old age. The first age, infancy, belongs to the child entering life and extends for seven years. The second age is boyhood, an age of purity not yet able to produce offspring, which lasts until the fourteenth year. The third is adolescence, an age mature enough for reproduction, which extends up to twenty-eight years. The fourth is youth, the strongest of all the ages, ending in the fiftieth year. The fifth is the age of the elder, or maturity, which is a period of decline from youth towards old age. It is not yet old age, but neither is it any longer youth: it is that age of the elder which the Greeks call πρεσβύτην (an old man being called by the Greeks not 'presbyter' but γέρων). This age begins in the fiftieth year and ends in the seventieth. Sixth comes old age, which is limited to no particular number of years, for whatever remains of life after the previous five ages is assigned to it. Decrepitude is the last part of old age, to be understood as the conclusion of the sixth age. Thus it is that the authorities have divided human life into these six stages, through which it suffers change, and hurries by, and arrives at its conclusion in death.

Bede, *De Temporum Ratione*, Chap. xxxv: ed. C. W. Jones, *Bedae Opera de Temporibus* (Cambridge, Mass., 1943).

Hiems enim, utpote longius sole remoto, frigidus est et humidus; ver, illo super terras redeunte, humidum et calidum; aestas, illo superfervente, calida et sicca; autumnus, illo ad inferiora decidente, siccus et frigidus. Sicque fit ut, amplexantibus singulis medio moderamine quae circa se sunt, orbis instar ad invicem cuncta concludantur; quibus aeque qualitatibus disparibus quidem per se sed alterutra ad invicem societate connexis, ipsa quoque mundi elementa constat esse distincta. Terra namque sicca et frigida, aqua frigida et humida, aer humidus et calidus, ignis est calidus et siccus; ideoque haec autumno, illa hiemi, iste veri, ille comparatur aestati. Sed et homo ipse, qui a sapientibus microcosmos, id est minor mundus, appellatur, hisdem per omnia qualitatibus habet temperatum corpus, imitantibus nimirum singulis eius quibus constat humoribus, modum temporum quibus maxime pollet. Sanguis siquidem, qui vere crescit, humidus et calidus; cholera rubea, quae aestate, calida et sicca; cholera nigra, quae autumno, sicca et frigida; phleg-

mata, quae hieme, frigida sunt et humida. Et quidem sanguis in infantibus
maxime viget, in adolescentibus cholera rubea, melancholia in transgressori-
bus, id est fel cum faece nigri sanguinis admixtum, phlegmata dominantur in
senibus. Item sanguis eos in quibus maxime pollet facit hilares, laetos, miser-
icordes, multum ridentes et loquentes; cholera vero rubea faciunt macilen-
tos, multum tamen comedentes, veloces, audaces, iracundos, agiles; nigra
bilis stabilis, graves, compositos moribus, dolososque facit; phlegmata tar-
dos, somnolentos, obliviosos generant.

Winter is cold and moist, because the sun is then furthest away from us;
spring is moist and hot, as the sun is then returning to our climes; summer,
when the sun burns most fiercely, is hot and dry; autumn, as the sun sinks
lower, is dry and cold. Thus it comes about that the seasons are all linked
together in the manner of a circle, each one joined to its neighbours by a
common quality. We also find that the very elements of the world are
marked by the same qualities, each combination of which is distinct in itself
but joined in an association with its neighbours. For earth is dry and cold,
water cold and moist, air moist and hot, fire hot and dry; and so they are
compared, respectively, with autumn, winter, spring, and summer. Also
man himself, whom sages call 'microcosmos' or a lesser world, has a body
compounded according to the same ubiquitous qualities, with the individual
humours of which it consists imitating the nature of the seasons in which
they are most powerful. Thus blood, which increases in spring, is moist and
hot; red cholers, which increase in summer, are hot and dry; black cholers,
which increase in autumn, are dry and cold; and phlegms, which increase in
winter, are cold and moist. Furthermore, blood is at its greatest strength in
children, red cholers in young people, melancholy (that is, bile mixed with
the dregs of black blood) in the mature, and phlegms predominate in old
people. Blood makes those in whom it most prevails merry, delightful, ten-
der-hearted, and much given to laughter and talk; red cholers make people
lean (even though they eat heartily), swift-footed, bold, irritable, and active;
black cholers make them solid, serious, settled in their ways, and guileful;
and phlegms produce people who are sluggish, sleepy, and forgetful.

Bibliography

This bibliography lists all modern (i.e. post-medieval) studies concerned with the ages of man that are cited in the present book.

Adler, A., 'Eneas and Lavine: *Puer et Puella Senes*', *Romanische Forschungen* lxxi (1959), 73–91.

Ariès, P., *Centuries of Childhood* (Harmondsworth, 1973).

Bäck, H., *The Synonyms for 'Child', 'Boy', 'Girl' in Old English*, Lund Studies in English ii (Lund, 1934).

Boll, F., *Kleine Schriften zur Sternkunde des Altertums* (Leipzig, 1950), 156–224: a reprint of 'Die Lebensalter: Ein Beitrag zur antiken Ethologie und zur Geschichte der Zahlen', *Neue Jahrbücher für das klassische Altertum* xxxi (1913), 89–145.

Burrow, J. A., 'Chaucer's *Knight's Tale* and the Three Ages of Man', in Burrow, *Essays on Medieval Literature* (Oxford, 1984), 27–48.

—— 'Langland *Nel Mezzo del Cammin*', in P. L. Heyworth (ed.), *Medieval Studies for J. A. W. Bennett* (Oxford, 1981), 21–41.

—— 'The Portrayal of Amans in *Confessio Amantis*', in A. J. Minnis (ed.), *Gower's 'Confessio Amantis': Responses and Reassessments* (Cambridge, 1983), 5–24.

—— '"Young Saint, Old Devil": Reflections on a Medieval Proverb', in Burrow, *Essays on Medieval Literature* (Oxford, 1984), 177–91.

Chew, S. C., *The Pilgrimage of Life* (New Haven, Conn., 1962).

Cuffe, H., *The Differences of the Ages of Mans Life* (London, 1607).

Curtius, E. R., *European Literature and the Latin Middle Ages*, trans. W. R. Trask (London, 1953).

Dal, E., and Skårup, P., *The Ages of Man and the Months of the Year* (Copenhagen, 1980).

Duby, G., 'Les "jeunes" dans la société aristocratique dans la France du Nord-Ouest au XIIe siècle', in Duby, *Hommes et structures du moyen âge* (Paris, 1973), 213–25.

Eyben, E., 'Die Einteilung des menschlichen Lebens im Römischen Altertum', *Rheinisches Museum für Philologie*, NF cxvi (1973), 150–90.

Fortescue, T., *The Foreste or Collection of Histories* (London, 1571).

Ghellinck, J. de, 'Iuventus, Gravitas, Senectus', in *Studia Mediaevalia in Honorem R. J. Martin* (Bruges, 1948), 39–59.

Gnilka, C., *Aetas Spiritalis: Die Überwindung der natürlichen Altersstufen als Ideal frühchristlichen Lebens* (Bonn, 1972).

Helfenstein, U., *Beiträge zur Problematik der Lebensalter in der mittleren Geschichte* (Zurich, 1952).

Hill, T. D., 'The Age of Man and the World in the Old English *Guthlac A*', *JEGP* lxxx (1981), 13–21.

Hofmeister, A., 'Puer, Iuvenis, Senex. Zum Verständnis der mittelalterlichen Altersbezeichnungen', in A. Brackmann (ed.), *Papsttum und Kaisertum* (Munich, 1926), 287–316.

Klibansky, R., Panofsky, E., and Saxl, F., *Saturn and Melancholy* (London, 1964).

Köhler, E., 'Sens et fonction du terme "jeunesse" dans la poésie des troubadours', in P. Gallais and Y.-J. Riou (edd.), *Mélanges offerts à René Crozet* (Poitiers, 1966), I, 569–83.

Levinson, D. J., *The Seasons of a Man's Life* (New York, 1968).

Nardi, B., 'L'Arco della Vita', in Nardi, *Saggi di filosofia dantesca*, 2nd edn. (Florence, 1967), 110–38.

Neraudau, J.-P., *La Jeunesse dans la littérature et les institutions de la Rome républicaine* (Paris, 1979).

Pirkhofer, A., *Figurengestaltung im Beowulf-Epos* (Heidelberg, 1940).

Rowland, B., 'The Three Ages of *The Parlement of the Three Ages*', *Chaucer Review* ix (1975), 342–52.

Rushforth, G. McN., 'The Wheel of the Ten Ages of Life in Leominster Church', *Proceedings of the Society of Antiquaries of London*, 2nd ser. xxvi (1913–14), 47–60.

Tristram, P., *Figures of Life and Death in Medieval English Literature* (London, 1976).

Turville-Petre, T., 'The Ages of Man in *The Parlement of the Thre Ages*', *Med. Aev.* xlvi (1977), 66–76.

Varagnac, A., *Civilisation traditionelle et genres de vie* (Paris, 1948).

Index